Mastering Photographic Composition, Creativity, and Personal Style

Mastering Photographic Composition, Creativity, and Personal Style

Alain Briot

Mastering Photographic Composition, Creativity, and Personal Style
by Alain Briot (www.beautiful-landscape.com)

Editor: Gerhard Rossbach
Production Editor: Joan Dixon
Proof Reader: Sarah Castellanos
Layout and Type: Almute Kraus, www.exclam.de
Cover design: Helmut Kraus, www.exclam.de
Cover photos: Alain Briot
Printer: Friesens Corporation, Altona, Canada
Printed in Canada

ISBN 978-1-933952-22-2

1st Edition
© 2009 Alain Briot
Rocky Nook, Inc.
26 West Mission Street, Ste 3
Santa Barbara, CA 93101-2432

www.rockynook.com

Library of Congress Cataloging-in-Publication Data

Briot, Alain.
 Mastering photographic composition, creativity, and personal style / Alain Briot. --
1st ed.
 p. cm.
Includes bibliographical references.
ISBN 978-1-933952-22-2 (alk. paper)
1. Composition (Photography) I. Title.
TR179.B75 2009
771--dc22
 2009003899

Distributed by O'Reilly Media
1005 Gravenstein Highway North
Sebastapool, CA 95472

This book is printed on acid-free paper.

Table of Contents

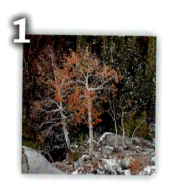
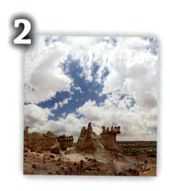
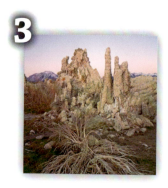

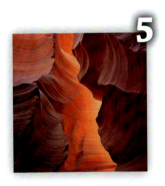
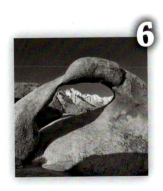

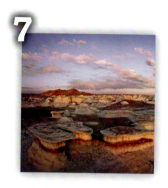

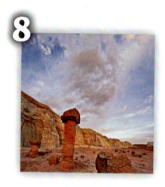

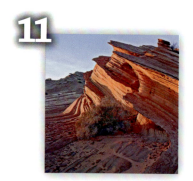

Section D: You and Your Audience

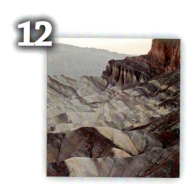

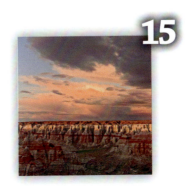

Foreword

After a decade of leapfrogging technological advances and increasingly expensive high-end digital cameras, we have reached a plateau of sorts. Of course, there will continue to be advances in digital cameras, but the large leaps will be replaced with finer and more precise upgrades. Professional quality DSLRs can produce top quality files for any use, from stock images to fine art prints. But, just having the right equipment and software does not an artist make. Many photographers are great at getting compelling imagery and are marginal at software optimization. Conversely, some average photographers are practically software gurus, relying on their software expertise to create and output outstanding final images. I know only a handful of photographers who are as equally skilled at making great images as they are in bringing the image to fruition through software expertise. Alain Briot is a masterful landscape photographer as well as an expert in using Photoshop to optimize his fine art prints. Alain lives in the moment, creating consistently compelling landscape imagery. He also has an astronomer's knowledge of the skies, a mathematician's ability to determine where and when the sun/moon will appear based on sophisticated calculation tables, a graphic artist's computer/software/design skills, and an artist's detailed eye for composition and color: a rare combination indeed.

The care and expertise applied to every aspect of Alain's work—from planning for the picture, to the final software optimization, and to the final print—is apparent upon viewing his work. Every image is bold, compelling, simple, capturing a moment, and perfectly optimized.

Teaching with Alain made me aware of his humility and generosity in sharing knowledge with students. This book is an extension of that propensity for sharing. Like all of you, I look forward to delving into the wealth of information that is contained herein.

Tony Sweet
June 2009

Preface

When subject matter is forced to fit into preconceived patterns, there can be no freshness of vision. Following rules of composition can only lead to a tedious repetition of pictorial cliches.

EDWARD WESTON

This book is about composition as I see it and as I practice it when I create my photographs. It is not about what I call the *traditional* approach to composition. Instead, it is about composition as I use it in my work; about what I call a new approach to composition. In this sense this book is about how I compose my images.

If you want to learn how I compose my images, then this book is for you. My goal when writing it was that it would open doors to new ways of seeing and composing images, doors that other books have not opened.

This book does not reiterate many of the compositional rules presented in books that approach composition from a more traditional perspective. I see no need to repeat what has already been said. Instead, I see a need to say what has not been said; a need to present a new approach to composition. In doing so, I see my purpose as enlarging the field of photographic composition to include subjects that have not, traditionally, been associated with composition. These subjects include how to compose images with color, with black and white, and with light; how to consider your future audience while creating a photograph; taking your color palette into account, and the nuances of grays you want to use; doing all this, and more, both while capturing a photo-graph in the field and while processing your photographs in the studio.

In this book I cover taking notes in the field about the colors of the elements in your image, as well as the contrast, the light, and all the other visual elements so that you can later draw on your memory to recreate the emotions you experienced while in the field. Also covered are how color works and how the three variables of color—saturation, hue, and lightness—interact so that you can control the colors in your photographs as if you were a painter in control of your color palette rather than a photographer at the mercy of the camera. Finally, I explain how these elements of composition will help you develop a personal style. All in all, the subjects in this book include learning to control all the elements that have a visual effect in the photograph.

My approach to composition, while specifically addressing photography, comes from my study and practice of painting. In other words, my experience as a painter shapes my approach to photography and to composition. If this approach strikes a chord with you, and if learning to approach photographic composition with the freedom and knowledge of an artist appeals to you, then this book will be a delight. It is my sincerest hope that such is the case.

Composition is a vast subject. Unfortunately, this subject is too often narrowed down to what is referred to as "the rules of composition". Certainly, rules are important. But to limit the entire subject of composition to a set of rules is to limit what composition is as a whole. These rules may also limit how photographers (both newcomers and experienced practitioners) perceive what the field of composition encompasses.

For this reason I prefer to refer to the subject as the *field of composition* rather than as just *composition*. The word "field" implies that there are multiple dimensions to the subject of composition and that, implicitly, composition is not limited only to a set of rules.

Composition is about much more than a set of rules. Composition is about how each photographer uses light, color, and contrast. It is about how each photographer sees the world and how each photographer wants to represent this world to his or her audience. In short, composition—when approached from an individual perspective—is about your way of seeing the world. It is about your way of sharing what you see with your audience; sharing what you see with those that will look at, study, and admire (or criticize) your work.

About Composition

*Photography is more than a medium for factual communication of ideas.
It is a creative art.*

ANSEL ADAMS

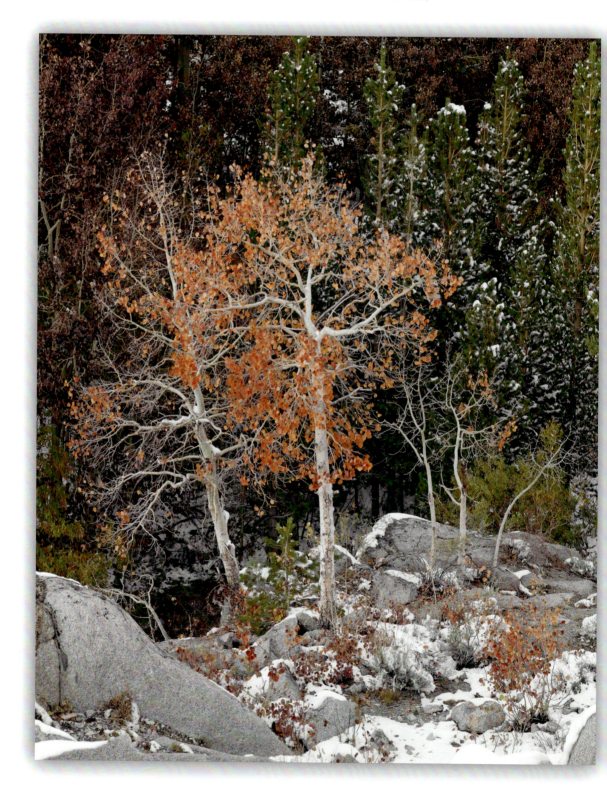

Art, Facts, and Landscape Photography

In this book I approach photography as an art form. This book is written for people who desire to practice photography as an art form, and who either consider themselves artists or have the desire to become artists. I consider this to be an important statement because photography, like any medium of communication and representation, is not necessarily an art form. Painting, music, sculpture, or any other medium is not imbued with the ability to create art *a priori*. Any medium can have multiple uses. The thing that makes a medium an art form is not the medium itself but the intent of the practitioner who uses this medium.

Photography can have many uses. Photographs can be used to record scenes or events. Photographs can be used to create visual documents for future study or research. Photographs can be used as forensic evidence. Photographs can be used on passports, ID cards, and for other administrative purposes. Photographs can be used to document news articles. Photographs can be taken for record keeping, for insurance purposes, as souvenirs, and for many other uses.

Hardly any of these uses can be considered art. Why? Because the photographer did not intend to express an emotional response to the subjects being photographed. Instead, the goal of the photographer was to record a place, an event, a person, or an object.

Art is not concerned with record keeping. Art is concerned with expressing emotions, feelings, and opinions. Record keeping is based on facts, and is concerned with capturing reality and recording things as they are. Art is non-factual and is concerned with interpreting reality rather than with capturing reality as-is.

Record keeping is a necessity. We use photographs to document forensic analysis, legal evidence, research findings, and news reports, for example. We use images of our belongings and of ourselves for insurance purposes, for official identification, and for many other purposes.

Art is not a necessity. Art is something we want, not something we need. Artists create art because they want to, not because they have to. Similarly, collectors purchase art because they want to, not because they have to. We all can live without making or collecting art. Arguably, our lives may be less enjoyable and less meaningful without art, but without it we would not perish the way we would if we did not have food, clothing, or shelter.

These two different goals—factual and artistic representations—result in two drastically different approaches to photography. While factual representation is concerned with documenting facts, artistic representation is concerned with expressing emotions.

When capturing facts one must be careful not to distort reality so as not to modify the facts being recorded. The value of a factual photograph lies in how accurately it depicts the scene, the object, the people, or the event represented in the image. A factual photograph is about the subject of the photograph, not about the person who took the photograph. As such, the person taking the photograph must be careful not to allow his emotions to become mixed with the facts being recorded. In many ways the factual photographer must remove himself from the process so as to become "invisible" to those seeing the photograph. His presence or personality must not be felt when looking at the photograph.

Figure 1-1: *Sierra Fall*

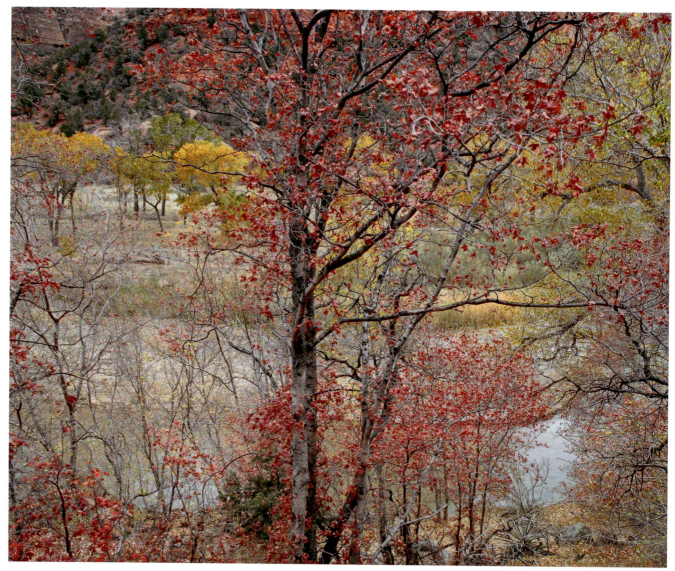

Figure 1-2: *Trees in Fall Colors* – Zion National Park, Utah

When capturing emotions one must be sure to take into account one's feelings about the scene, the object, the people, or the event being photographed. An artistic photograph is about the response of the photographer to the subject of the photograph. It is first about the person who takes the photograph, and then it is about the subject of the photograph. In fact, the more a photograph veers in the direction of art, the more it becomes an image about the photographer and less an image about the subject itself. The personality of the photographer must be present in the image for an artistic photograph to have value.

The Differences Between Composing Factual and Artistic Photographs

What I am seeking is not the real and not the unreal but rather the unconscious, the mystery of the instinctive in the human race.

AMEDEO MODIGLIANI

Composing a factual photograph is entirely different than composing an artistic photograph. Both the techniques used and the mindset of the photographer must be different. A factual photograph is concerned with showing the subject in a realistic manner; therefore, seeing the details of this subject is very important. For example, in portrait photographs taken for US Immigration purposes, there are many requirements such as a full-face view, the subject looking straight at the camera, a white background, etc. Similarly, photographs taken to record scenes, events, or objects must be detailed enough so that the subject is clearly visible.

Often, factual photographs will be taken using a flash when ambient light is insufficient. This is done to guarantee even lighting across the subject and that the subject will appear as sharp as possible. The goal here is not to have the most pleasing lighting but rather to have enough light to guarantee that the subject will be clearly visible, and the same light quality is used from one photograph to the next to guarantee a level of consistency. Finally, colors are balanced to match the original subject as closely as possible.

Composition in factual photographs is concerned with showing either the entire subject or a selected part of the subject that is of interest. The goal is not to dramatize how this subject is located in the frame, nor to emphasize one aspect over another, nor to use a rule of composition aimed at furthering the creativity of the photographer. The goal is not to take a creative photograph. Instead, the goal is simply to take an *accurate* photograph; a photograph that can be relied upon as evidence by the intended audience.

On the other hand, artistic photographs are rarely concerned with showing the entire subject. Instead, they often rely on the fact that *less is more*, and following this credo, the artist seeks to eliminate all elements that do not contribute to making the image stronger. In keeping with this rule, certain important elements may be cropped so that only parts of these elements show in the image. Or, elements that may be deemed absolutely necessary in a factual photograph may be removed entirely, with the reasoning that the absence of these elements makes the image either stronger or more intriguing.

Similarly, light is used creatively in artistic photographs. While some artists may prefer soft and even lighting, others may favor more dramatic types of lighting such as contrejour (backlight) or chiaroscuro (the contrast between light and dark areas of a scene). Some artists may use both types of light alternatively depending on their mood and the effect they seek to create.

None of these types of lighting are prone to revealing the essential details of a scene in a realistic fashion. While the former reduces contrast, the later exaggerates it. Neither are concerned with "the truth", whatever that truth may be. Instead, artists using either types of light are concerned with expressing their feelings toward a particular scene. Their goal is to use light as a way to share their emotional response to the subject with their audience.

The artist is concerned with aspects of composition that the factual recorder, or the "scientist" I should say, has little or no concern for. The scientist is concerned with showing the subject objectively and accurately, and asks himself if the photograph is a faithful representation of this subject.

The artist, on the other hand, asks himself a totally different set of questions. For example, the artist may wonder if elements in the picture agree or disagree in their artistic form; he may be concerned with how negative space contrasts with positive space; or he may question whether unity is achieved or if the image is out of balance.

As you can see, the motivations of the factual recorder and the artist are poles apart. Still, both of them use the same medium: photographs, to capture the subject they are interested in. It's no wonder that many practitioners of various skill levels and involvement question whether or not photography is art. The answer is that photography can be both. It can be art or it can be a factual form of visual recording, depending on how it is used, and depending on the intent and the goals of the photographer.

In this book we are going to study how to create artistic compositions. This is not to say that factual compositions do not need to be studied. Rather, this is simply to say that our focus will be on learning how to compose expressive images with the purpose of sharing our emotional response to the subject with our audience. As we will see, achieving this purpose is a multi-step process that starts with analyzing the differences between what we see and what the camera captures, continues through the study of the possible approaches to composition, and culminates in developing a personal style.

In the following chapters we will explore the process through which inspiration leads to creativity, vision, and eventually, personal style. Also, we will study how composition can help us express our creativity and our personal style.

Photography is Not Dead

When I am finishing a picture, I hold some God-made object up to it—a rock, a flower, the branch of a tree or my hand—as a final test. If the painting stands up beside a thing man cannot make, the painting is authentic. If there's a clash between the two, it is bad art.

MARC CHAGALL

The case has been made in magazine articles, online forums, and other media that "photography is dead". I always raise an eyebrow anytime such a sweeping statement is made about any field of human activity. Certainly, such a statement is guaranteed to generate reader curiosity. However, such statements are usually more provocative than accurate.

In this case the point that is usually made is that digital photography, with its many automatic functions, has killed photography because now just about anyone can create good photographs. All it takes to create a good photograph, or so the argument goes, is the ownership of a good camera and the knowledge of how to use Photoshop or other image processing software. The hardware and the software will do the job; placing talent, hard work, and years of study in the closet and labeling them as passé and unnecessary.

In the past, or so the argument continues, artists used to study, work hard, and use their talent to express their emotions through their

art. Today, all they need to do is buy a digital camera and Photoshop. Times have changed. The old is out and the new is in. We just need to get used to this situation.

Or so the belief goes. And it is a belief and nothing else. Automatization is not a replacement for talent, hard work, and study. Automatization simply means that certain tasks that were formerly completed manually are now automatic. What are these tasks?

- **Focusing:** Focusing is hardly a creative or challenging endeavor, *except* when selective focusing is desired or when maximum depth of field is desired. Both are areas where the hardware is unable to perform automatically and where the practitioner is required to step in and make choices and decisions.
- **Exposure:** Exposure can be automatically set, *except* when a specific type of exposure is required; one that differs from the exposure calculated by the camera. In this case, the photographer has to step in and modify the settings manually.
- **Color Balance:** Color balance can be automated, *except* when color balance as chosen by the camera is unpleasing to the photographer, and a different color balance has to be manually chosen, usually during RAW conversion or post-processing of the image.
- **Contrast Control:** Contrast may be set to automatic, *except* when a certain type of contrast is desired by the photographer or when the contrast of specific areas of an image have to be controlled individually.

The list goes on and on. What remains constant is the pattern that emerges from this list: the camera or the software chooses and the photographer needs to step in when the automatic choices aren't satisfying. In other

Figure 1-3: *Garden of the Gods* – Escalante Grand Staircase, Utah

words, the photographer has to make choices and decisions.

And on what basis are these choices and decisions made? On the basis of talent, study, and hard work. Only these three factors will give us the experience we need to make difficult choices that the hardware and the software alone cannot make. Why can't hardware and software make these decisions? Because

it requires thinking and because, above all, it requires artistic decisions; decisions that cannot be programed, although, further down the road, software and hardware may have the ability to "think".

The decisions the photographer must make are based on the basis of feelings and emotions—decisions that are aimed at expressing our emotional response to a scene, our perception of the subject we desire to photograph, and our personal artistic approach. All of these represent individual choices that we are usually unaware of until we find ourselves in the act of capturing a specific subject with a lens and a camera. Consequently, this process prevents camera designers and software engineers to program either the hardware or the software to automatically express our response to the subject.

So what am I getting at in this explanation? I am getting at the fact that no matter how advanced and automatized the equipment and the software we use, there is no substitute for individual input and expression.

What I am also getting at is the fact that the field of endeavor, where this individual input is best expressed, is the field of composition. Why? First, because composition is about personal choices: very few, if any, aspects of composition can be automated. Second, because composition is a field of endeavor composed of multiple facets and not just a set of rules. If composition were just a set of rules, it would, in thoery, be possible to think that these rules could be embedded in camera or computer software and that such software could have the ability to "compose" photographs based on these rules, or in the very least, our equipment could have the ability to give us directions aimed at helping us compose images in a specific way. The rule of thirds, for example,

could be implemented in such a way that the camera would tell us when the image is divided into three equally spaced areas. Or, with the help of a software-controlled, 3-way mechanized ballhead operated by servo-motors, the camera could conceivably find this composition itself, making the photographer little more than a passive observer of his cutting-edge hardware. In such a scenario, which right now may seem a little ahead of its time but which very well may become a reality in a short while, the photographer's skill would be limited to purchasing the proper equipment and then finding the location to set up such a camera.

But would this camera, if it existed, be able to express the inner feelings of the photographer? Would it be able to know the emotional response of the photographer to the scene he or she is photographing? Would this equipment be able to include, in the moment captured by the camera and in the print later made by the photographer, the complexity of emotions and the many possible ways of seeing this scene?

And if such a camera existed and was made widely available so that the limiting factor of ownership would be cost rather than availability, wouldn't such a system create images that would be representative of the system's designers and engineers ways of seeing, rather than the photographer's way of seeing? And wouldn't the photographer be little more than a "mule"; a carrier of equipment designed to express the equipment makers' view of the world, rather than the individual photographer's view of the world? As such, wouldn't the owner of such equipment be furthering the cause of the machine that he is using rather than his own cause by expressing the vision of the manufacturer rather than

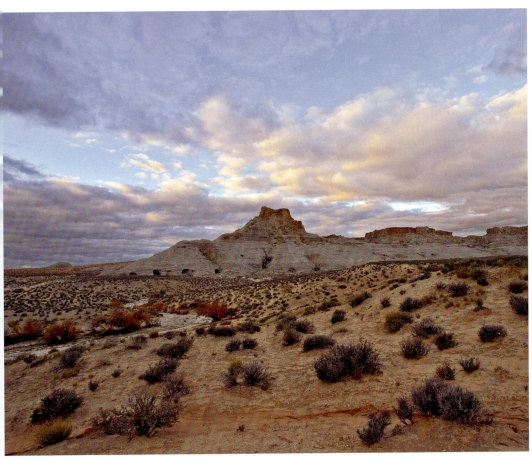

Figure 1-4: *Sunrise* – Colorado Plateau, Southern Utah

his own visionMy answer to these questions is "of course", and my solution is to write the book you are reading. Through this book, and through the description of the many aspects of the field of composition, I want to share my belief that composition cannot be automatized because composition is the way through which an individual expresses his or her vision of the world.

I have already explored the field of photography in my first book, *Mastering Landscape Photography*. In this second book I want to explore, specifically, how I approach photographic composition and how composition is related to the differences between what we see and what the camera captures. I also want to explore the relationship between composition and light, color, and more. Finally, I want to study how art interacts with technique, allowing us to express our inspiration and, eventually, to develop a personal style.

So, without further delay, let us embark on this exciting journey of learning and discovery.

Section A:

The Differences Between What We See and What the Camera Sees

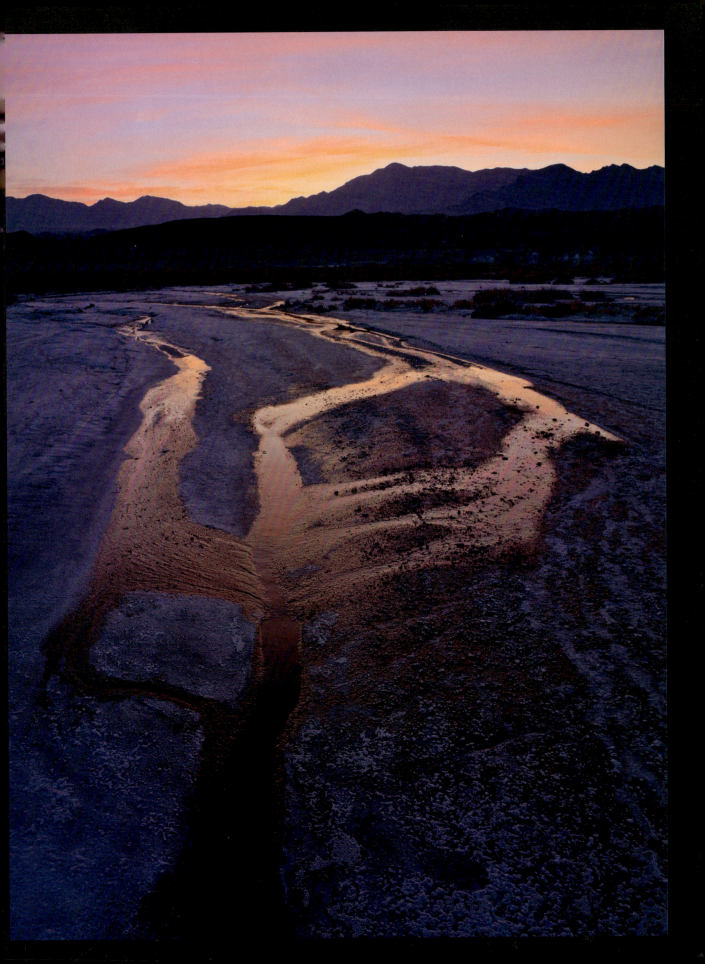

2 Learning to See Like a Camera

Each problem that I solved became a rule which served afterwards to solve other problems.

RENE DESCARTES

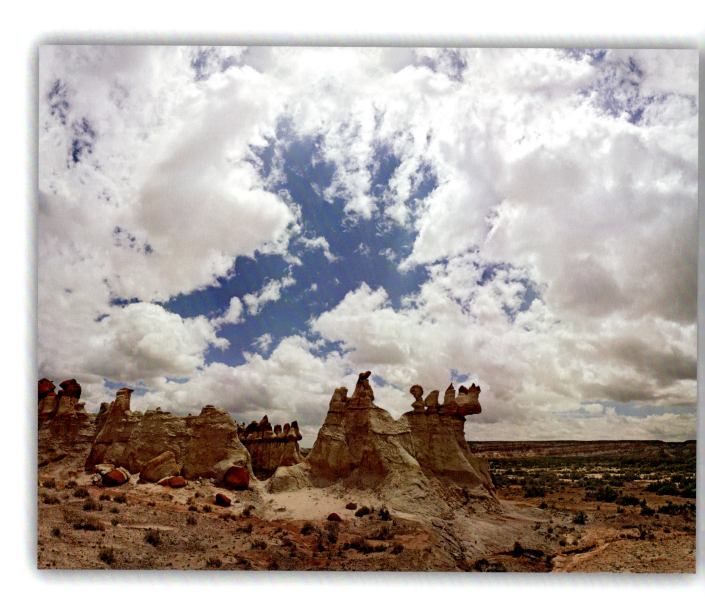

Of Cameras and Art

I hear it regularly at art shows: "Your photographs are amazing. You must have a very good camera". I often hear, "Your colors are beautiful, you must use filters". And finally, I also hear, "Your images are fantastic! You must use Photoshop". These statements come in different variations, but the message is essentially the same: for a certain audience, the reason why my work is beautiful is not due to my artistic skills but to the equipment I use.

At first I was dumfounded. Later on I was insulted. After talking to other photographers and learning that they received the same comments, I started wondering why people think this. I now believe I have the answer.

Good Cameras Equal Good Photographs

The fact that part of the public believes that the camera is responsible for the quality of my work left me dumbfounded at first. How could they believe that? After all, the camera is but a tool, a mechanical recording device and nothing more. The comments kept coming under difference guises, some commenting on how good my camera must be, others commenting on how bad theirs was, resulting in the consensus that my photos were better than theirs only because I owned a better camera. This left me feeling insulted, so I argued that years of work and study, and not simply ownership of a good camera, were responsible for the work I had on display. I also argued that my early photographs, some of which are on display at my shows, were not taken with that great of a camera because I could not afford one when

I started. All this explaining was to no avail. While some believed me, most left the show still convinced that a good camera was the key to getting good photographs and that if they had the camera I had, they would get good photographs too.

The fact that they did not have the camera I had made them revel in the fact that their theory, which really was an entrenched belief, was at no risk of being challenged. I could have loaned them my camera, told them to take a couple of photographs with it, but unless I followed them home, waited for them to get their film developed and their photos printed, I would not be in a position to make my point. What point? That their photos were not as good as mine even though they were using the same camera? And how do you compare? By putting a print made at the local drugstore next to a print made by a master printer, both from transparencies taken with the same camera?

Suspicions in the public at large about the veracity of photographs and about potential reasons for cameras delivering results that are significantly superior to those of the general public have been around for a long time. To follow my theory that the non-initiated public believes that everything happens in the camera, let me bring up the matter of filters.

A Matter of Filters

If at a show of my work someone doesn't tell me that I must have a good camera, chances are that someone will ask which filters I used. The assumption is that professional photographers use filters to magically turn an average scene into a stunning photograph. With this belief, the audience follows the same logic as

Figure 2-1: *Blue Canyon*

I discussed previously, that the quality of a printed photograph was determined when the shutter was released. The photographer may have used an excellent camera, he may have used filters, or he may have used both: a good camera and filters. How can an amateur compete with such equipment? It is simply not fair, and for part of the audience, it explains everything in regard to the quality of my work.

Well, this is simply not the case. We all know that filters can have some effect on photographs—for example, polarizing filters darken the sky or remove reflections, gradual density filters reduce contrast, and colored filters either balance the color of a scene or introduce a noticeable color cast—but to my personal chagrin, a filter that has the ability to turn a scene that is remarkable for its banality into a stunning image, a filter that can create beautiful photographs at will, simply does not exist.

Modifying What the Camera Captures

A problem well stated is a problem half solved.
CHARLES F. KETTERING

Let's now look at the problem the same audience I just described has with Photoshop. Here is an application whose purpose is to modify what the camera captured. According to the general public, Photoshop serves one purpose and one purpose only: to manipulate the photograph. Since a great photograph comes out of a great camera without any additional work required, why would anyone take that photograph into Photoshop? Nothing needs to be done to this photograph! The belief is that there can be only one reason to use

Photoshop: to manipulate the photograph, to do things to it in order to deceive the audience into thinking that what is in the photograph is real when it really isn't.

This belief on the part of the audience is strengthened by photographers who claim that they do not manipulate their photographs in any way, shape, or form: photographers who claim that their efforts stop when they press the shutter; photographers who claim that the negative, transparency, or RAW file is printed without any changes to the appearance of the original whatsoever; photographers who explain that they "do not use digital". Now, I have no doubt that some, if not all, of these photographers are speaking the truth. But the fact is that they still have to work with a master printer, or be master printers themselves, in order to get a fine art print. But to get a fine art print, countless things have to be done to the original, whether the process is digital or chemical. By the time the multitude of things has been done, the look of the printed photograph is different from the look of the original negative or transparency. The amount of difference varies from photographer to photographer, but different it is. There isn't a single print in existance that is an exact representation of the negative, transparency, or RAW file.

Differences in Print Quality

t might help to have a name for the problem.
 NINA ALLEN FREEMAN

A photograph is only as good as the print one makes from it. Without really knowing it at the time, it was really the difference in print quality I was arguing about when I was attempting to defend the practice of image manipulation.. That was the key to explaining the frustration I was experiencing when hearing remarks about my camera being better than the cameras most people have.

What I came to understand is this: many people believe that, by the time the shutter is triggered, the appearance of a photograph is sealed. In other words, the prints that they see framed at my shows, prints which are the result of days and days of work adjusting contrast, color saturation, and countless other details, are believed to be the direct reproduction of the negative or transparency I exposed in my camera, or of the RAW file created by the camera's digital sensor.

The fact that each photographic film and sensor has a specific color palette, contrast ratio, and resolution, as well as grain or noise structure, is of no consequence to people who are skeptical about the use of Photoshop. They assume that the capture device is a neutral variable. They assume that all films and all sensors are created equal, and that whether we use negative film or transparencies, low or high color saturation, slow or high ISO, or small or large sensors, it makes no difference whatsoever as far as the resulting photograph is concerned.

Similarly, the fact that a RAW file has a very low saturation and contrast level when in its original state, and that virtually no RAW files are printed without some amount of saturation and contrast adjustments, is equally of no concern to the audience.

The fact that, until a few years ago, the general public used low-color-saturation negative films, and had their prints made at the local drugstore or other mechanized photo printing service, and the fact that the resulting images did not look like mine, was blindly believed to be due to their camera not being as good as mine and not to the mass-production processing labs that they used to process and print their work.

The fact that the general public now uses digicams and shoots JPEGs, which are processed in-camera and to which saturation and contrast control are applied "invisibly", and the fact that the public either takes their CF cards to the local drugstore or prints their JPEGs themselves without further image processing, changes little to this situation. It does, however, raise the issue of "manipulation" which I will address shortly.

Such is the logic at work. Somehow, my camera has magical properties that theirs does not have, and no amount of explaining on my part will cause them to think otherwise. For this audience, the photographic process is something that involves a camera and a camera only. This is the only part of the process they are familiar with. And because of that, the camera, and specifically the quality of the camera, is the only thing they consider when trying to determine how a good photograph was created.

Figure 2-2: *Barrio Abstract Two –*
Canon 1DsMk2, 17-40 zoom, Lexar 80x 2GB CF card

I rarely do abstracts, but on this one occasion I just
couldn't help it. I was leading a workshop in the
Barrio Historico, during which we focused on the
colorful, Spanish-influenced architecture of this
historic area of Tucson. I found a fence made of cor-
rugated aluminum sheets covered with patterns
that can best be described as "a photographer's
dream come true". I don't know exactly how much
time I spent photographing it; all I know is I filled
several CF cards on the 1DsMk2 and had to stop
because the rest of the group had abandoned me.
I used the best CF cards money can buy.

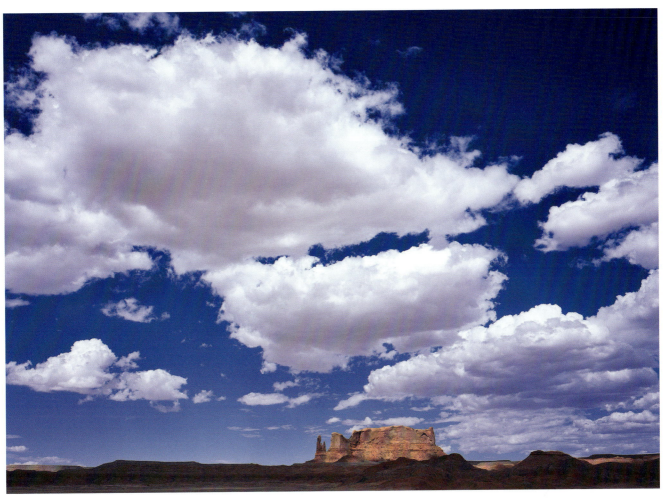

Figure 2-3: *Round Rock Clouds* –
Linhof Master Technika 4x5, Fujinon 90 mm, Fuji Provia

I saw the clouds building up over Round Rock. I waited
patiently for the clouds to create a composition that I liked,
and that also gave movement to the scene, from the top left
cloud, the largest in the scene, to the bottom right clouds
that diminish progressively as they recede in the distance. I
used an excellent camera.

It's the Print, Silly

Every problem has a gift for you in its hands.
 RICHARD BACH

Book after book has been written on how to create a fine art print. Countless workshops are offered each year on how to use Photoshop to get the finest print from either your scans or your RAW files. As experienced photographers, we know there is no such thing as a straightforward print. Even if we wish to remain as faithful as we can to the original, a machine print from a negative or a transparency, or a print done from a RAW file converted with automatic or 'standard' settings, will only be a pale version of what can be achieved from the same original that is processed and printed by a master printer.

The title *Master Printer* itself says it all. Why would we need a Master to print our work, or why would we need to become Master Printers ourselves, if the print was but a straight enlargement of the original film or raw file? A technician with basic knowledge of how to operate printing equipment would then suffice.

Most photographers know the important roll that printing—fine art printing as it is called—plays in the final appearance of their work. But for the audience at large, this knowledge is not so widespread. I am not trying to put anybody down. I am simply expressing a fact that I learned by exhibiting and selling my work to tens of thousands of people who are not very knowledgeable about photography. It is their lack of knowledge in regards to the photographic process as a whole that is responsible for their belief that the camera is solely responsible for the quality of the photograph.

For most people who fall in this category, what happens after the shutter is pressed is inconsequential insofar as the appearance of the final print is concerned. By the time the shutter is pressed, the camera used has sealed the fate of the photograph captured by it. The rest of the process—development, RAW conversion, scanning, printing, etc.—are steps that must be done in order to get a print, but steps that are inconsequential in regards to the quality of the photograph in front of them. The camera, somehow, does it all. As hard as it is for me to believe that, I know that this belief really exists. The hundreds, if not thousands, of remarks I have heard are there to testify to it.

I Should Have Known

The field of consciousness is tiny. It accepts only one problem at a time.
 ANTOINE DE SAINT-EXUPERY

I should have known long ago about the beliefs of the general public. I should have seen the writing on the wall. When I was in college I had a collection of photographs . All were 5 x 5 color prints from medium format negatives taken with a Hasselblad 500C, except of one 3 x 9 panoramic print of a negative taken with a Kodak disposable panoramic camera. All the photographs were mounted on cream mat board, bringing visual unity through the size and the presentation to this grouping. The print from the disposable camera was a sunset scene of Totem Pole in Monument Valley. It showed bright red spires and canyon walls and a deep blue sky overhead with some streaked clouds. It was a machine print, but somehow it printed very nicely, at

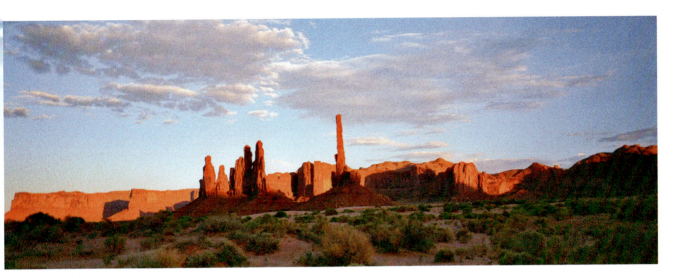

Figure 2-4: *Monument Valley Panorama –*
Kodak Panoramic disposable camera, Kodak negative film, plastic lens

least to my eyes at the time, in part because the camera had somehow exposed the negative properly.

I shared this collection to my college roommate, showing him the panoramic print last. Since the first photographs I showed him were taken with medium format, and since I had told him so, his comment when looking at the panorama, which was his favorite, was a classic: "It is very good. But again, you have a Hasselblad!" To prove to him that it was taken with a disposable camera and not a medium format camera, I had to show him the negative. Proving my point was easy: the exposed area was 1/3 the size of a regular 35mm frame because what the disposable panoramic camera did was crop the top and bottom of the full-size 35mm frame. I loved every minute of it, because for once I was able to make my point without the shadow of a doubt—*it isn't*

the camera that makes a great photograph, but the person behind the camera. I don't think I changed his mind though. I just gave him a headache.

The Artist and His Tools

The belief that a good photograph is the result of a good camera places the importance upon the equipment rather than upon the photographer. It emphasizes the machine rather than the person, the tool rather than the artist, the technology rather than the artistic intent. It is as if Monet had been told that the reason why his paintings were so beautiful was because he had such good paintbrushes. Or as if Paul Bocuse's culinary excellence was explained away by his use of superlative pots and pans. Or again if Yo-Yo Ma had been informed that

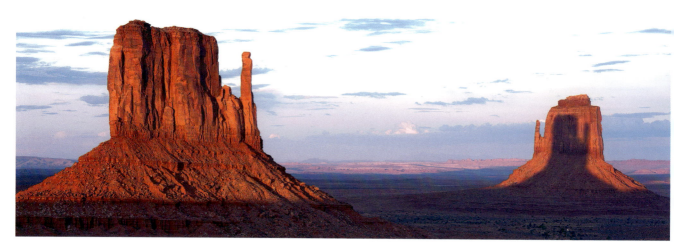

Figure 2-5: *Monument Valley Shadows –*
Linhof Master Technika 4x5, Schneider 150 mm, Fuji Provia

his Stradivarius was solely responsible for the stunning quality of his music.

Certainly, a master needs a masterful instrument, be it a camera, paintbrushes, pots and pans, or a violin, as in my examples, or another tool, since this list can be expanded to include many other professions. But to say that the quality of the art is caused solely by the quality of the instrument is to miss the point altogether about the importance of the artist. It is missing the point about the human factor, about the man or the woman that actually made use of this instrument. After all, art is made by artists and not by tools. Tools are inanimate objects that need someone to set them in motion. And to set a tool in motion so that art is created through the use of this tool, an artist is needed.

This light and shadow situation happens only at a specific time of the year. I planned to be there on that day, and the only thing that could have prevented me from capturing this scene were clouds obscuring the sun. Clouds there were, but they parted just in time for the sun to shine at sunset and cast the shadow I wanted to capture. I used an excellent lens.

It's Only a Matter of Time

The best way to escape from a problem is to solve it.
ALAN SAPORTA

Certainly, I may be preaching to those who are already converted. If such is the case, let it be known that I am not trying to convince you as much as I am trying to provide you with explanations and arguments that you can use should you find yourself in the situation I found myself in. And if you exhibit your work, you will find yourself in such a situation: maybe not the first time, maybe not the second time, maybe not the third time, but eventually you will. And when that time comes it is best not to take it personally. Instead, see it for what it is: a lack of understanding of a process that, to the uninitiated, is still arcane and unfamiliar.

The next chapter will focus on the nature of the differences between what we see with our eyes and what the camera actually captures. In many ways, this next chapter is a continuation of the topic you are presently reading about. It is also a case in point against the popular belief that the camera is solely responsible for the quality of the photograph.

3 The Eye and the Camera

The difference in "seeing" between the eye and the lens should make it obvious that a photographer who merely points his camera at an appealing subject and expects to get an appealing picture in return, may be headed for a disappointment.

ANDREAS FEININGER

The Difference Between Photography and Reality

Students and photographers often ask me, "What should be done to a photograph to make it match what we saw?" This is an important question because it addresses the difference between what we see and what the camera captures. It addresses the difference between our visual apparatus—our eyes and brain—and the camera's image-capture apparatus—the lens, filters, camera, film, or sensor (from now on referred to as "the camera"). The differences between the two are not only notable, they are also damaging to the reality we see because the camera introduces numerous changes to this reality.

In order to create an image that *matches what we saw*, we not only have to become aware of what this damage is, we also need to learn how we can fix this damage. Only then will we be able to create an image that not only "matches what we saw" but also expresses how we felt when we took the photograph. Only then will we be able to create an image that represents what our eyes and brain saw and not just what the camera captured, an image which is not only a factual record of what was in front of the camera, but also a visual expression of our emotional response to the scene we photographed.

Two Categories of Differences

The differences between what we see and what the camera captures fit into two categories: art and science. In this chapter we will see what the differences in each category consists of, starting with the science category that encompasses all things technical about photography and continuing with the artistic category that encompasses all things related to our emotions, our inspiration and our personal style. As I move along from one area to the next, I will point out solutions that can be used to fix defects in the way cameras record reality. As I point out these solutions, I will only do so in passing and make no effort to delve into a detailed technical explanation of how these solutions can be implemented. In doing so I will follow my premise that this is a chapter on the differences between what we see and what the camera captures, not on the workflow needed to fix these differences. If you are interested in learning how to transform a RAW file or scan into a fine art print I have created a DVD titled *The Printing Mastery Workshop on DVD*.

As I often say, rule number 1: one step at a time. Rule number 2: before we can fix the problem we first have to define the problem. This chapter is aimed at following rules number 1 and 2 by taking a step by step approach in defining the problem that preoccupies us today.

What the Camera Captures that the Eye Never Sees

The camera does not see the way we do. I address what the general differences between the two are in chapter 1 of my book *Mastering Landscape Photography*. In this section I want to focus on differences that I did not detail in my earlier book. These differences are found when a close inspection of a photograph is conducted and when the result of this inspection is compared to a close inspection of what we see with our eyes. The differences between the two are numerous and I will try to list as many as I can, in no particular order.

Figure 3-1: *Dawn at Mono Lake*

A - Contrast and Dynamic Range

The dynamic range represents the amount of contrast a given capture device can record. Film and digital sensors are able to record a fixed range of contrast. This range varies from film-to-film and sensor-to-sensor, or rather analog to digital converter (A/D converter) since in a digital camera it is the converter that controls dynamic range. Even a 16-bit A/D converter can only capture a dynamic range of 16 stops at the very maximum. However, most Digital Single Lens Reflex cameras as of Fall 2006 use a 10- to 14-bit A/D converter, which translates into a dynamic range of 10 to 14 stops. Even then this dynamic range is limited by noise levels, meaning that shadow areas in the image where detail was captured may exhibit so much digital noise as to be visually unattractive and best rendered as pure black.

On average, sensors are far better than film when it comes to dynamic range, as they are able to capture a much wider dynamic range. However, this range pales in comparison to the human eye which is not only able to see details in a scene containing a contrast range of nearly 24 stops, but is also able to instantly change its contrast-perception ability in order to see, alternatively, details in highlights and in shadow areas without the conscious awareness that we are doing so. In other words, the human eye/brain apparatus is not limited to a fixed dynamic range, but instead can adapt to whatever the light situation calls for. If you doubt this statement, or find yourself calculating the exact difference in dynamic range between sensor "x" and the human eye, pause for a second and ask yourself if you ever heard someone say, "I cannot see this landscape because it exceeds the maximum dynamic range that my eyes can capture". Indeed you haven't, because when it comes to contrast, humans do not see the world like cameras see it.

The fact is that our eyes are far superior to the best films or digital sensors currently available. It is this superiority that, in part, causes us to be disappointed when we see the results of our efforts at capturing what we see with a camera.

Resolving this contrast issue means creating an image whose contrast is closer, or similar, to what we saw. This means either reducing or increasing the contrast of the photograph to make it match what we saw. In some instances, such as with photographs where large areas of shade and sunlight are present in the same image, it means both increasing and decreasing the contrast of the scene, again to match the way our eyes adjust to seeing shadowed and directly-lit areas. Our eyes see these two areas differently—reducing and increasing contrast alternatively—and the photograph of such a scene needs to be altered in a manner that reproduces this approach.

B - Lenses: Wide-Angle Distortion

Lenses are one of the main causes of differences between what we see and what the camera captures. This is a large topic, so let's start with the distortions introduced by wide-angle lenses.

Lenses can be classified into three categories: wide, normal, and telephoto (learn more about choosing the best lens in chapter 3 in my book *Mastering Landscape Photography*). While normal and telephoto lenses create little or no distortion, wide-angle lenses are famous for distorting what nature created. To some extent photographers desire this distortion. After all, we use wide angle lenses to see more than what our eyes see, which

in turn means distorting reality as we see it with our eyes. But some of these distortions are unwanted, such as a curved horizon, the stretching of elements located in the corners of the image, or trees and buildings that are tilted up or down.

Some photographers like to keep some of these "effects" for artistic purposes. I personally see them as unwanted defects and my goal is to remove them as completely as possible. They stand as a reminder that the photograph is a distant reproduction of the scene that I saw. They stand as an obstacle, a "filter" of sorts, placed between the viewer and the photograph, constantly reminding the viewer that this is an image, a pale reproduction of reality afflicted by the technical limitations of the photographic medium. I want the photograph to be as close as possible to the scene that I saw. Anything that reminds me or my audience that this is a photograph is something I want to remove, fix, or otherwise overcome.

Removing lens distortions can be done in two ways. First, get the finest, most distortion-free lenses you can buy. Determine which lenses are the best for your camera system and which you can afford. As always, you get what you pay for.

The second way to remove lens distortions is through the use of software. The first step is the RAW converter, and for this task DxO stands alone. DxO, currently at version 5.3 (Spring 2009) is the only RAW converter that doubles-up as lens correction software. Using calibration data targeted to each specific lens, f-stop, focusing distance, and camera-body combination, DxO calculates the distortion imparted by these variables and proceeds to remove them. The result is a new image, an image different from the one captured by the camera in regards to the geometry of the image. Depending on the kind of distortions introduced by the lens-camera combination, after processing in DxO the horizon may be leveled, elements in the corners may be "unstretched", and buildings or trees may be straightened out. The result is nothing short of a visual miracle and demonstrates the ever-increasing presence that digital technology has on the final outcome of our photographic efforts.

Photoshop, beginning with its implementation of CS2, also offers tools to remove a certain amount of lens distortion through the *Lens Distortion filter*. To some extent this filter is useful, but because the image has already been converted from the RAW format, the filter is acting on the photograph one step later than DxO, resulting in a correction that is less thorough.

C - Lenses: Vignetting

Let us now look at a plethora of such problems, again, in no particular order, and without any claim that these problems affect all lenses, or are present in lenses at the same time.

Distortion is but one of the many possible problems introduced by lenses. Not all lenses are created equal. Some lenses are nearly free of problems while others are plagued by a multitude of technical issues.

The world, when we frame it into either a rectangular, panoramic, or square composition, does not suddenly get darker at the corners of our composition. Instead, the world continues to be the same tone as it is in the center of the image, or along the image borders, or anywhere else in the framed composition for that matter.

Yet, in a photograph, and of course depending on which lens you use, the corners of the

Figure 3-2: *Monument Valley Cloud* – Original RAW conversion

This is the photograph as it emerged from the RAW converter. Compare it to the final version.

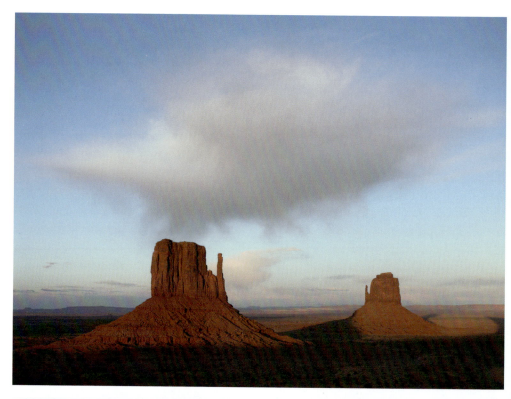

Figure 3-3: *Monument Valley Cloud* – Final version

This is the same file as above, but after two days of work optimizing the image file. Because my vision for this image was dependent on the impact of the cloud over the monuments, a lot of time was spent on that part of the image. However, every other aspect of the image was optimized as well. When comparing the *before* and *after* versions, I find it difficult to believe that I am looking at the same photograph.

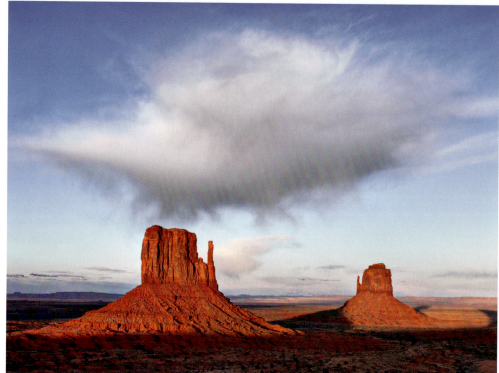

image are sometimes darker than the rest of the image. This is called vignetting, and it is caused by a variety of factors including lenses that vignette naturally, filters added to the front of a lens which obscure the corners of the image, lenses not adapted to the film or sensor format, objects obstructing the corners of the image, lenses used without their dedicated center filter, use of a non-dedicated center filter, and more.

Without delving any deeper into technical considerations, the fact is that some lenses, especially wide angle lenses, unnaturally darken the image corners and this darkening is not something that we naturally witness in nature. Rather, this is a purely photographic effect, which to me is a defect unless I choose to darken the corners purposefully. As a result, this defect must be removed from the image if our goal is to create an image that reflects reality.

One way to do this is to use the Lens Correction filter in Photoshop (CS2 and after). A second way is to dodge the corners of the image. A third is to create an adjustment curve with a layer mask restricting the density adjustment to the corners of the image.

D - Lenses: Chromatic Aberration

Another defect introduced by lenses is halos. This defect reveals itself through the presence of colored outlines along the edges of objects. These lines are frequently found when a sharp edge separates two objects with a significant difference in color, contrast, or both. For example, the area where the top of a mountain meets the sky, or where a canyon wall is superimposed onto an area of a different color, are often prone to halos.

As with vignetting, we do not see this effect when we look at the real world. In other words, a red/cyan fringe does not follow the shape of a snowy mountain peak where it meets the sky. Nor does a blue/yellow fringe follow the shape of a sandstone formation standing in front of a shadowed area. Halos are not phenomena found in nature. Halos are a defect introduced by the lens-camera combination, a defect that has to be removed during RAW conversion, using the Chromatic Aberration slider available in several RAW converters, or in Photoshop, using the aforementioned *Lens Correction filter* or by hand using the clone tool in color mode.

E - Color Changes

Lenses, film, and digital sensors all introduce changes to the colors we perceive in the real world. These changes vary from lens to lens, film to film, and sensor to sensor. These changes can be reduced or eliminated through the use of light-balancing filters when using film, or careful color adjustments when using digital cameras or scanned film.

Furthermore, lenses, films, and sensors also change the color contrast of the scene. In fact, specific brands of lenses are desired by specific photographers for the unique color and contrast they impart to the landscape. These subtle color and contrast changes become part of the personal style of specific photographers.

Similarly, films are frequently sold on the basis of their unique color and contrast qualities, so much so that certain films have become the trademark not only of specific photographers, but also of entire generations of photographers. Films have built-in contrast and color boosters, as well as highlight compression, to make pictures look more pleasing and to give each film a unique look. Kodak Ektachrome, characterized by its ability to reproduce blue tones, was widely used

by landscape photographers from the 1960s
to the mid-1980s. Kodak Kodachrome, char-
acterized by its warm tone and its ability to
reproduce reds, was the film of choice (and the
film they had to use) of photographers work-
ing for *National Geographic*. Fuji Velvia, charac-
terized by high contrast, high color saturation,
and the ability to reproduce warm tones and
greens, became the film of choice of an entire
generation of landscape photographers start-
ing in the late 1980s and continuing until
today. By the time digital imaging came of age
in the late 1990s, the majority of landscape
photographers had switched from Ektachrome
to Velvia.

Here too, as we saw before, the world does
not change color to our eyes when we replace
the film in our camera, change lenses, or use
a different sensor. The colors of the world are
fixed at any given time. Certainly, they change
throughout the day as well as according to the
weather and the seasons. But at any specific
time they are fixed. The colors of the world are
what they are. Yet, to different films, differ-
ent lenses, and different sensors, the colors
of the world are not fixed. According to films,
lenses, and sensors, colors are not what they
are in reality. Instead, colors are what each
film, each lens, and each sensor sees them as,
records them as, and, in fact, *modifies* them as.
This color modification is the challenge, for
it results in a significant difference between
what we see and what the camera captures.

The changes introduced by film were set in
stone because relatively little could be done
to make significant changes to the contrast
and color of a specific film during the print-
ing process. Certainly, some changes could be
made, but they required expert knowledge and
equipment far beyond the reach of the aver-
age photographer. The same holds true for the
color casts introduced by lenses, for which the
only solution was filtering either during image
capture or during printing.

F - The RAW Conversion Transformation

Things are vastly different now that photo-
graphs can be captured in digital format and
processing can be done digitally. For one, the
image captured by a digital camera is not really
an image. If shooting in RAW format (the
format used by most fine art photographers
because it results in the highest quality image
a given sensor can deliver) the camera cap-
tures RAW data in a single channel file. This
RAW data needs to be converted into a specific
color space in order to create a photograph.
This is done through the use of RAW conver-
sion software. The goal of the RAW converter
is both technical and artistic. On the techni-
cal side the RAW converter is responsible for
converting the color gamut and dynamic range
of the scene photographed into the color space
chosen by the photographer. On the artistic
side the RAW converter offers the opportu-
nity for the artist to modify the conversion
settings to match his original vision for the
photograph.

To me, the term "conversion" is somewhat
of an understatement. I much prefer to use
the term "transformation". RAW conversion is
such an important transformation that tech-
nical terms are used to describe the *before* and
the *after* aspects of this process. The before,
meaning the RAW file captured by the digital
camera, is called the *Scene-Referred* image.
The after, meaning the photograph created
after RAW conversion, is called the *Output-*

Referred image.[1] The reasoning behind these two terms is simple. The RAW file refers to the scene photographed, while the converted photograph refers to the color space and indirectly to the color device—either a monitor, a printer, or the web—where this photograph is going to be displayed or printed. The Output-Referred image also contains the adjustments made by the photographer in order to make the converted image match his personal vision (e.g., dynamic and color gamut changes).

With digital photography, just about any color can be changed to whatever the photographer's heart desires. Similarly, contrast range (the difference between the lightest and darkest tones of a photograph) is no longer solely controlled by the film or sensor used. Rather, it is controlled by the photographer to match his vision. Not only do digital sensors (or rather A/D converters) offer a density range larger than film, as we previously saw, but digital images can also be exposed separately for shadows and highlights, and then combined into a single image in Photoshop using a range of options such as layered files with layer masks, or image combination plug-ins such as Fred Miranda's *PhotoMerge*, Photoshop CS2's *Merge to HDR*, or a number of stand-alone applications such as *Photomatix* and others.

The fact is, through digital capture and processing, the photographer has nearly complete control over color and contrast. This control radically changes how we approach the color and contrast changes introduced by films, lenses and digital sensors. Instead of seeing these changes as ineluctable, we now have it in our control to modify these changes so that the resulting image, the final print, matches what we saw rather than what the camera captured. Rather than being limited by what the film could capture and the lab could process and print, we are now limited only by our imagination, our inspiration, and our vision of the image. In this new world, it is the photographer, and not the equipment, that is the limiting factor.

This is one of the most profound changes introduced by digital photography. Prior to that, choosing a specific film, camera, and lens meant also choosing a specific color range, color contrast, and image contrast for the photograph. Today, choosing a specific film, lens, or digital sensor is only a point of departure, a decision far more neutral (if there can be such a thing in photography) than it was in the days of film photography. Among photographers who continue to use film, Velvia, with its high color and scene contrast, has been dislodged as the film of choice and replaced by Provia and even Sensia, because these other films have far less contrast and far less color saturatation than Velvia. The logic behind this change is that contrast and color saturation can be easily increased in Photoshop, and that starting from a more neutral and softer image, in terms of color and contrast, gives the photographer more latitude for change than starting from an over-saturated and over-contrasty original.

[1] I found some of the information on dynamic range, as well as the Scene-Referred and Output-Referred terminology, in a white paper published by the International Color Consortium (ICC). This white paper is titled *Digital Photography Color Management Basics* and it is available at this link: http://www.color.org/whitepapers.html.

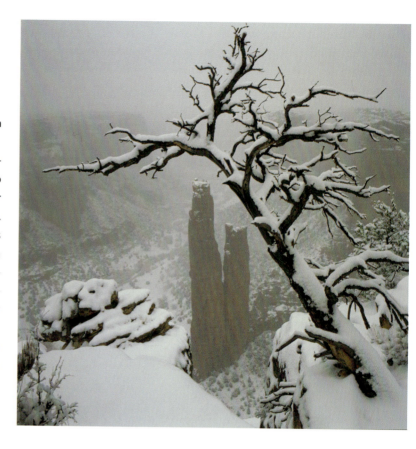

Figure 3-4: *Spiderock in Snowstorm* – Original scan

This is the original film-scan for Spiderock in Snowstorm. Just like with RAW conversions, I prefer to create a scan that has a full tonal range and later make color and contrast corrections in Photoshop. In this instance the problems that plagued this image included gray snow, an overall greenish cast, excessive contrast, lack of brilliance, inappropriate format, and more. The work I did on the image was aimed at recreating the scene that I saw and felt and to which the camera did a number, fortunately one that was repairable. It is amazing how much can be done to restore an image that at first seems hopelessly lost, as long as your memories of the original scene are intact and your technical abilities are up to the task at hand.

F - Film Grain and Sensor Noise

When we look at the natural world we do not see a fine pattern composed of little dots of irregular size and of various colors superimposed over the landscape. Yet, when we record the world in a photograph (and depending on the film, sensor, and ISO setting, as well as on how much light is available) we do get such patterns superimposed over our images. And, when the light level is too low for the capture device to record a continuous-tone image, lines in shadow areas on digitally captured images or on scans may be added to these aberrations. These unwanted patterns in our images are called "noise".

Noise and film grain may be some of the easiest defects to remove. The use of fine grain film or a low ISO setting on your digital camera, or exposing to the right of your histogram to maximize the quantity of information captured by the digital sensor will take care of the matter. The logic for exposing to the right is based on the fact that digital data increases logarithmically. As a result, an image that receives more exposure during capture will have more digital data than an image that receives less exposure during capture. This is true until the image exceeds the limit of the sensor's density range; a limit that is represented by the extreme right side of the histogram. The resulting overexposure is easily adjusted back to normal during RAW conversion. (See "How to Determine the Best Exposure for a Specific Photograph", chapter 6 of my book *Mastering Landscape Photography*.)

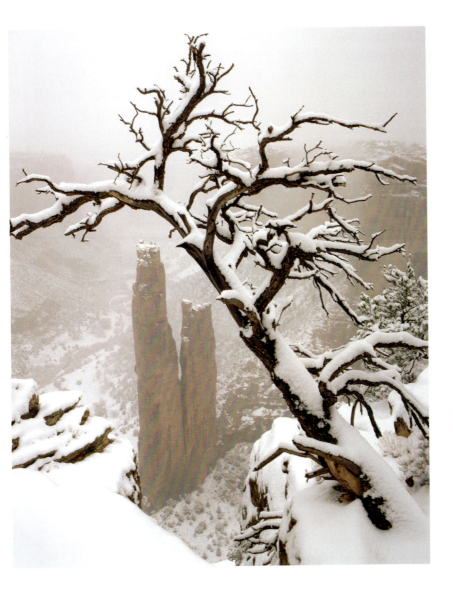

Figure 3-5: *Spiderock in Snowstorm –* Final version

This is *Spiderock in Snowstorm* as it appears in my Navajoland Portfolio. As with *Monument Valley Cloud,* compare this image to the image of the original scan to study the changes made to the photograph. Do keep in mind, as with all reproductions in print, on the web or in PDF files, that the actual print has a quality of color, tone, contrast, brilliance, and texture that is simply and purely lost in reproductions.

G - Color Shifts

Color shifts are a problem that differs from the problem of color casts. Color shifts are introduced by certain digital sensors and manifest themselves on photographs as a magenta or green cast in specific areas of the image. They are most often encountered with digital backs used on a view camera when shifts (and to a lesser extent tilts) are used. These color casts have to be removed with a curve and a layer mask either during or after RAW conversion.

We do not see the world with a magenta cast in the right or left side of our field of view when we shift our head right or left, nor do we see a green cast in the lower or upper area of our field of view when we tilt our head forward or backward. Clearly the world is radically altered by the camera, to the point that this altering has to be removed so that a believable reality can be presented to the audience.

H - Out of Focus and Blurred Images

When we look at the world with our eyes, our view is consistently focused wherever we look (provided we have good vision or wear the proper corrective glasses). We don't see some areas that are in-focus and others that are out of focus. Similarly, we don't see selective areas that are blurred or slightly fuzzy.

In contrast to the way the human eye sees, a camera can only focus on a single plane and relies on a set depth of field, which is controlled by the lens's aperture to create sharpness throughout the image. A camera is affected by slow shutter speeds or focusing issues, both of which can adversely affect the sharpness of the image.

Our eyes don't have to contend with a preset depth of field, slow shutter speeds, or focusing issues the way a camera does. You may argue that human vision isn't as perfect as I stated above, and that depth of field is also present in human vision. Maybe. But think about it this way: Have ever heard anyone say that they couldn't see things sharply because the light level was too low for their eyes to use a fast enough shutter speed? Or that their vision was blurred because they couldn't hold their head steady while looking at far away objects? Or that they could not set the proper pupil aperture to see things sharply? Clearly, the camera sees very differently than the way the human eye does, and while there are similarities, comparing these similarities to the way a camera operates is akin to turning people into cameras, which is the exact opposite of what we are trying to achieve here.

The Soul of Photography

A camera is a machine; a mechanical recording device. No matter how much we would like to believe that a camera has a soul, the truth is that it does not. Certainly, a carefully constructed camera—hand made or of limited production, for example—has an ineffable quality that a mass-produced digicam will never have. But a soul—the ability to feel and impart emotions to the images it captures? Sorry, this is not to be.

The soul part of photography—the ability to impart emotions in our images—is not within the domain of abilities of the camera. Instead, it is our responsibility. It is our domain; a *burden* if we so choose to perceive this part as difficult or a *blessing* if we choose to perceive this part as a pleasure.

To say that a camera is an inanimate object is not far off the mark, though it shows far less respect than photographers usually pay to their equipment. Yet, what concerns us here is the nature of the equipment, its ability to do certain things and not others, and above all, the differences that are introduced between what we see and what the camera records. To define the camera as a *soulless and inanimate object* serves our purpose well. So let's go with it.

Soulless we are not. As artists—and we either are artists or are working toward becoming one—soul is what we are all about. Soul is what we want to express. Inanimate we are not; in fact we are anything but. We are motivated by the passion for photography that inhabits us.

In short, we are faced with a conflict, a paradox that can be stated as such: As artistically inclined photographers, our passion must make use of an inanimate and soulless

object for our vision to become reality. How can this be and how can this work? Or rather, a better question is, can it be or can it work? Some may answer that there must be a way to muster this tool into submission. The artistic aspect of photography and the fact that the camera alone is simply unable to impart this artistic aspect is the source of great frustration for many budding photographers. Let us now explore the various areas that cause this frustration.

A - Five Senses into One

When we experience the world, we do so through all our senses. Not only do we see the landscape, we also hear the wind, the birds, and the other ambient sounds; we smell the rain, the flowers, and all the other scents; we feel the wind on our skin, the warmth of the sun, the cold of the snow, or the wetness of the rain. On occasion even our sense of taste adds to our experience, if for example we put a twig in our mouth. Yet, when we capture a scene with a camera, only the sense of sight is captured.

Only what we saw is recorded on the photograph, and even then with all the defects that I listed previously. Assuming that these defects are understood and will be taken care of during image processing, let us ask what happens to the information gathered by our other four senses; what we heard, smelled, tasted, and touched. What happened to this non-visual information that, potentially, could be four times more powerful than the visual information recorded by our camera? Do you really want to know? In short, bluntly and metaphorically: this non-visual information went out of the camera frame. It was discarded, tossed aside, pushed back as if it never existed. And it never did exist... for the camera

that is. It existed only for us. And that is the difference. A photograph exists in a world that is purely visual, and a camera is designed to do one thing and one thing only—to capture the visual aspect of the world. We, on the other hand, exist in a full-sensory world; a world in which visual information is but one of the five ways we experience the world.

If we use a camera to record a scene that enthralls us for non-visual reasons, the resulting photograph will not only be disappointing, but also frustrating. Why? Because what we liked in the scene was not captured in the image; it is forgotten and forever absent because it was recorded only in our memories.

While there are ways to express feelings beyond the visual in a photograph, expressing these feelings must be done in a visual manner, for this is all we have to work with in photography. How to do so may very well be the goal of a lifetime of work and research. Learning how to do so, while extremely important, is beyond the purpose of this chapter. Here, my purpose is simply to point out, as with all the other aspects of photography we previously discussed, that if we want to create an image that truly represents what we felt and not only what we saw, the ability of the camera to capture only the visual reality of the world is a defect that must be overcome.

B - Learning How to See

Untrained photographers will often see something of interest in a selective fashion. A specific object or particularly attractive lighting in a scene may capture their visual attention. However, when they take a photograph of this selective area of interest, the camera photographs everything in the scene. The camera captures interesting objects and lighted areas as well as less interesting objects and poorly

lit areas. We see the world selectively, but the camera captures everything in front of the lens. The proverbial tree or telephone pole appearing to grow out of somebody's head is a case in point. While it can be said that such photographs are the result of monocular capture applied to binocular sighting, it is also the result of seeing only one thing in the scene rather than noticing everything in the scene.

Cameras also capture the world within a specific format and aspect ratio. At the risk of stating the obvious, let me say that 4 x 5 cameras capture the world in 4 x 5 inch format, 35mm in 24 x 36 mm format, 6 x 17 cameras in 6 x 17 cm format, and so on. But the world comes as it is, in full size, all around us, as well as above and below us. As the Navajos say in this excerpt from the Navajo Beauty Way Ceremony chant:

With beauty above me I walk.
With beauty below me I walk.
With beauty all around me I walk.

The camera however, if it could speak, would most likely say:

With beauty in 4 x 5 format I shoot.
With beauty in 6 x 17 format I shoot.
With beauty in 35mm format I shoot.

Pardon the parody, but I have lived long enough among the Navajos to know that their sense of humor far outweighs what some readers may consider disrespect on my part. The fact is that cameras do not have religious experiences. Cameras do not see beauty all around them. Cameras capture the world in the format they were designed for. It is our responsibility to choose the proper format at the time of capture or to crop the image in the

most appropriate manner at the time of image processing and optimization.

The problems of selective vision I just described can only be fixed by learning how to see. By this I do not mean seeing solely in terms of developing a unique way of seeing the world or a personal style. I mean seeing in terms of looking at everything in the scene and not just at the object that captures our attention. Only then—when we have learned to see the entire scene, when we have learned to see beauty all around us as we walk—can we stop including unintentional things in our photographs; things we should have seen but failed to notice. If we fail to learn this fundamental photographic skill, we will equally fail to fix one of photography's most prevalent defects, a defect I like to call *the camera's nonselective vision*. This nonselective vision is another significant difference between how we see the world and how the camera captures it.

C – Capturing the Emotion Behind the Lens

I desire to capture the emotions generated within me by the landscape in front of me. These emotions are located in my heart and soul. The camera however captures only what is in front of the lens. The camera does not know my feelings and is unable to capture what is in my heart.

I recently photographed a storm as it was moving over Black Mesa on Navajoland (figures 3.6 and 3.7). The scene I saw and experienced was one of gloom and active weather, a scene where gray, fast-moving clouds menaced the surrounding plains with heavy rains. There was little about this scene to look forward to if one found himself in the path of the storm.

Because I was driving at the time I noticed the approaching storm, I simply pulled over to the side of the road, took my Canon 1DsMk2

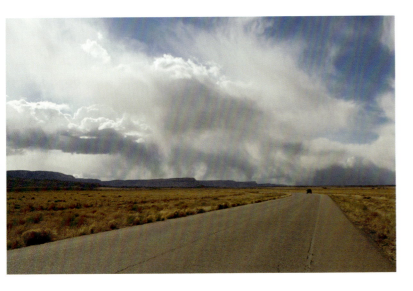

Figure 3-6: *Storm over Black Mesa, Navajoland –* Original, uncropped RAW conversion using "as shot" settings

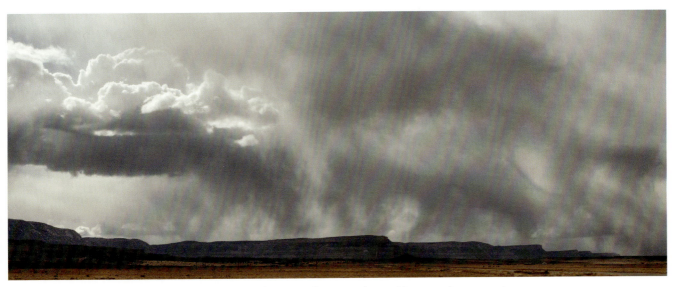

Figure 3-7: *Storm over Black Mesa, Navajoland –* Final Version after cropping and image enhancement

camera with whatever lens was on it at the time, and photographed the scene hand-held while standing in front of my vehicle. Because there was some traffic, I did not feel comfortable pulling my camera bag out of my vehicle and trying different lenses.

When I captured the photograph in figure 3.6 I knew I would crop out the road and that the final image would be composed as a panorama. I did not know the exact cropping I would use, but I was about 75% sure of what it would be. I was also aware that the image

could only be printed to a moderate size, given the sizable amount of cropping that was to be done.

I did not think of crossing the road and photographing from the other side, a move that would have allowed me to avoid getting the road in the photograph. Why didn't I think of it? Probably because I felt uncomfortable being parked on the side of the road, and probably because I knew I was going to crop the image as a panorama. In the end, it did not make any difference whether I cropped out the road or cropped out the field of grass. No matter what was in the foreground, it was not going to be in the final image.

The resulting photograph, as I first saw it in the RAW converter, possessed few, if any, of the attributes I remembered and that I just described. In the RAW file the sky was a soft whitish-gray with subtly outlined clouds. The grass was a relatively saturated yellow, reminiscent of a clear summer day rather than of a spring storm moving in. And of course, the road with a car on it was dominating the foreground. Where was the scene that I saw and experienced? How could I make it emerge out of the reality presented to me by the camera, a reality so far away from my recollection that, was I not the photographer, I could not put the two together?

The reality was there, embedded somewhere in the RAW image data, waiting for me to bring it out. This reality was not going to surface on its own, nor was I going to experience this scene again through the photograph without serious work on my part and without clearly remembering what I saw and felt when I took the photograph.

In brief, the steps I took in Photoshop were to darken the sky, increase the density of the clouds, and selectively desaturate the image.

I focused my efforts onto further desaturating the grass because the yellow color was completely inappropriate. I did this in order to communicate to the audience the feelings I had at the time I took the photograph.

Through my knowledge of the differences between what I see with my eyes and feel in my heart, and what the camera sees with the lens and captures on the film or sensor, I was able to 'interpret' the RAW image and turn it into what I remembered. I was able to move the image beyond what the camera recorded. If I had not done so, or if I had failed in my attempts at expressing what I saw, the image would have been miles away from the reality I experienced.

Conclusion

Once you reach a certain level of experience and proficiency as a photographer, when looking at an inspiring scene, you start to see a finished print in your mind. You no longer see just the scene. You see the image recorded as a histogram. You see areas that may be clipped if converted to the wrong color space. You see the modifications that you will have to make in order to correct the defects introduced by the camera. You see ink on paper and, more precisely, specific shades of ink on specific types of paper. You see the image displayed with a mat and frame; even with a specific mat size and in a specific frame moulding.

Yet, while all this is going on in your mind, the scene in front of you is still unframed, unmatted, unprinted, uncorrected, and unphotographed. It is, as I said before, exactly what it is, nothing more and nothing less, but certainly not a matted and framed photograph in a specific print size. What the camera will

capture is exactly what is in front of the lens, and depending on the exact equipment, exposure, and settings used to capture the photograph, it will impart a number of defects to the natural scene.

In other words, as experienced photographers we see a final print in our mind. The camera on the other hand sees and captures exactly what is in front of the lens. Certainly, not all the defects I listed in this chapter will be present in every one of our photographs. However, no photograph will be left untouched by the differences between what we see and what the camera captures.

As detailed above, going from what the camera captured to what we saw and felt in the field demands proficiency in image processing. The process of capturing the photograph ends in pressing the shutter release button. However, the end of this process marks the beginning of a process that is complex, demanding, and can stretch over days, weeks, months, and occasionally years. This process consists of recreating on paper what we saw and felt at the time we pressed the shutter and took the photograph.

Through this long and arduous process (which I call *Image Optimization*, but which is also an *interpretation* of the original photograph) our guiding light will be only one thing: our memories of the original scene and our memories of the feelings we have associated with it. Should this memory fade, or vanish altogether, our chances of creating a print that comes close to what we saw and felt will similarly fade.

So what is a photographer to do? Simply this: take time to record your feelings about the scenes you photograph. Preferably, use pen and paper or a voice recorder to take notes in the field while you photograph. Record the colors you see, the contrast level of the landscape, the color and nature of the light, the kind of clouds in the sky, the time of day and year, the weather pattern, the color of the plants and rocks around you, the feelings you have, the emotions that made you decide to record this scene as a photograph, and any other detail which is important to you. Take notes as extensively as you can for these will be your guide later on when the process you started by pressing the shutter will enter its second, and usually its longest, phase.

Also, hone your technical skills. The extent to which you will be able to overcome the defects introduced by the camera is equal to your technical knowledge. If your goal is to achieve the highest level of photographic quality, you need to develop mastery of the photographic medium. I believe mastery is reached by practicing your art on a continuous basis, day-in and day-out, until the technical aspects of photography, be it in the field or in the digital darkroom, become second nature. Mastery is reached through repetition and a desire for perfection. Obtaining mastery is a matter of perseverance combined with hard work, a refusal to give up and a constant search for solutions that afford you the finest image quality.

Section B:

New Rules of Composition

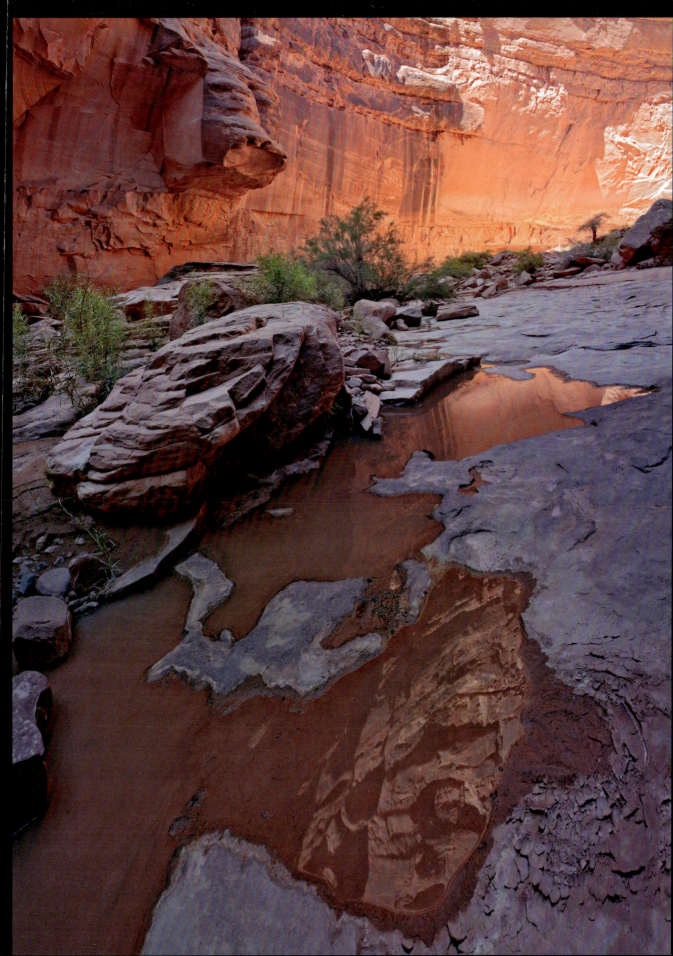

Composing with Light

You have to get away from relying only on the subject. Light is the imagination's main tool. It is something you work with in defining anything you want to, whether subject or landscape.

David Muench, Outdoor Photographer Magazine

Essential Elements

Every art or craft makes use of an essential material that is at the foundation of that art or craft. It is the nature and the treatment of this fundamental material that will define the quality of the finished product.

For the winemaker, the essential element is the grapes. It is not the recipe used in the creation of the wine, nor the barrels in which the wine is kept, nor the aging process, nor the conditions in which the wine is aged, although all of these are very important. The material at the basis of wine making is the grapes. Without grapes there would be no wine, no matter how skilled the winemaker, how good his equipment, or how extensive his knowledge might be. And without good grapes there would be no good wine. A master winemaker knows more about grapes than about anything else in his trade. A master winemaker loves grapes and everything that surrounds their growth, their history, and a million other details that, to those who do not share his passion, seem uselessly boring and unnecessary to remember.

For a chef the essential element is the products that are to be cooked; the vegetables, fruits, poultry, meats, cheeses, spices, herbs, and countless other products that are necessary to complete each dish. It is not the pots and pans, nor the recipes, nor the years of training, although all of these are very important. It is the products used in the making of the dishes that are essential, because without the finest products one cannot cook the finest dishes. No amount of sauce, spice, or skill can turn a poor quality product into a great dish. Nothing can duplicate the taste of a grain-fed chicken that was raised in the farmyard and allowed to roam freely. Nothing can duplicate the taste of garden-grown, fertilizer-free vegetables. Nothing can take the place of hormone-free beef or whole, non-pasteurized milk and butter. To some these are simply unnecessarily expensive and troublesome to purchase. To a chef they are indispensable.

The artist's essential material does not have to be physical. For example, a musician's essential element is sound. Regardless of the instrument played, a fine musician pays more attention to the sound produced by his instrument than to any other variable. In that respect the instrument itself is also important because it is the instrument that creates the sound. But the love a musician has for sound exceeds the love he has for his instrument because sound can exist without an instrument. Sound is found in nature, in the wind, the rustle of leaves in the forest, the babble of a creek, the sounds of birds, of animals and of other beings. The instrument is a way to reproduce sound but the instrument is not all that sound is. Therefore, a musician seeks to learn as much about sound as possible. A musician loves sound; both sound created by nature and sound created by musical instruments. For a musician the quality of the sound is of primordial importance.

For a photographer the essential element is light. The essential element is not the camera, nor the film, nor the digital processing software, nor the chemicals used in the darkroom, although all these are very important. It is light, because without light there would be no photograph.

The word "photography" literally means writing with light; derived from the Greek *Photos* (light) and *Graphos* (writing or drawing). Light is photography and photography is light. A fine photographer who desires to advance his art as far as possible will seek

Figure 4-1: *Summer Solstice, Hanlibinkya*

to learn as much about light as possible. He will study light more than he will study any other aspect of his art. Light will become his obsession and the focus of his attention. Not just natural light, but any type of light, be it artificial or natural light, be it the light of the sun or the light of a tungsten bulb, the light of the stars and the moon at night or the light of a flickering candle. Light in all of its manifestations is the photographer's blessing, the element without which there would be no photographs. A fine photographer loves light as much as a fine winemaker loves grapes, a fine chef loves natural products, and a fine musician loves sound. For a photographer, the quality of the light is everything.

Without these essential elements there can be no trades, because all trades rely on these fundamental elements that define their existence. Everything else is built upon this one thing: tools are developed around it and focused on how to best use this essential element. Knowledge is developed around it and focused on how to best work with this essential element. Education and training is focused on the nature of this element, on its particular characteristics and on the unique creative possibilities that it offers.

The audience often focuses upon the finished product; the wine, the music, the dish, or the photographic image. The artisan and the *artist* focuses instead on the essential element that is the foundation of their art. They know that the quality of the final product is dependent upon the quality of this foundational element. The artist knows that the quality he seeks can be found only by being able to recognize this element in its finest implementation, and by knowing where to find it and how to use it.

Light and Composition

My first thought is always of light.

GALEN ROWELL

Since light is the main element in photography, light cannot be removed from composition. Light is an integral part of composition. Light *is* composition. As photographers we compose first with light and second with objects and elements, because without light we couldn't even see these elements and objects. We must have light not only to photograph but also to see.

However, to produce great photographs we need more than just light, just as a chef needs more than just produce, poultry, spices, and so on. We need *great* light. In this sense the quality of the light is what we really need to learn about.

Quality of light determines image quality. Great light is the ingredient behind every great image. Of course, great light alone is not enough. I've been in situations where great light was present, and yet I was unable to compose a great photograph, or even a photograph at all. At such times I was overwhelmed by the beauty of the light and lost myself in experiencing the light instead of photographing the light. There is nothing wrong with that, except that one needs to go past this stage if one is intent on becoming a better photographer.

Certainly, experiencing stunning natural light, such as a rainbow at sunset or a fantastic sunrise, is a stage in one's development as a photographer. It is a stage of learning and of emotional reckoning, when one takes stock of the awesomeness of natural light. It is a stage during which one discovers what nature can create when nature puts forth its best show for a few seconds of fleeting light. However,

this discovery is not the final stage. The final stage is being able to experience a tremendously beautiful natural event and still keep your wits together so that you can not only photograph it, but you can also compose an image that takes advantage of this awesome light in such a way that you can share both your emotions and the natural beauty that you witnessed with your audience.

We must therefore look at the quality and direction of the light when evaluating the potential of a scene for a strong composition. Eventually, we have to physically see what light can do in order to fully evaluate the potential for composing images. Why? Because light can sculpt the landscape in ways that are difficult to imagine. In other words, it is difficult, or nearly impossible, to imagine what light can do to a scene. I have witnessed many instances of this fact, either while being at a location myself and seeing something I had never seen before, or when looking at photographs taken by other photographers and seeing a lighting situation that I would never have imagined could happen. Light can do things to a landscape that are beyond what we can imagine. We just have to be there on the right day at the right time and have the knowledge and the experience required to capture it in a meaningful photograph.

Finding the Best Light

You only get one sunrise and one sunset a day, and you only get so many days on the planet. A good photographer does the math and doesn't waste either.

GALEN ROWELL

In my first book, *Mastering Landscape Photography*, I described the different types of natural light. To not duplicate this information, I will not describe them again here.

The main subject I want to cover is learning how to find good light, or the "best" light if there is such a thing. I say that because, the meaning of the word "best" varies from one photographer to the next. Eventually, what we want to find is the best light for a specific personal style. While we will tackle the subject of personal style later on, we can already say that light is an essential component of your personal style. What light you like to work with, what light you consider to be the best for your work, and what light you find most exciting are personal choices rather than absolute choices. These are matters of taste that are bound to vary from one photographer to the next.

Finding good light is a matter of experience, knowledge, and using the right tools. We will start with experience.

Weather

The first thing to keep in mind is that what makes for good light in photography is very different than what makes for good light in other aspects of our lives. For example, we will choose entirely different times to be out in the landscape depending on whether we want to take good photographs or whether we want to go on a picnic. This is best exemplified by the fact that what may be considered as bad weather for a picnic often creates great opportunities for good photographs. In other words, bad weather equals good photographs. By bad weather, I mean active weather. Active weather is weather that is changing quickly. The times either right after a storm or between two storms are excellent examples.

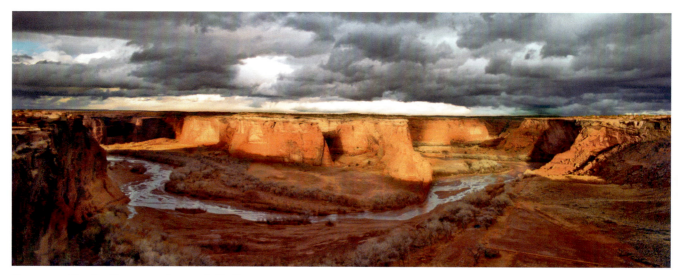

Figure 4-2: *Clearing Storm over Canyon de Chelly*

If a heavy rainstorm is coming to an end and the clouds start to open up to allow the sun to shine through, that time, right then, is one of the best times for photography you will ever find.

The photograph below was taken in such a situation. A heavy rainstorm fell on Canyon de Chelly all afternoon. The clouds were dark, menacing, and very impressive, and I knew that if the sun were to shine through the clouds, I would have an incredible photographic opportunity. So I drove to Tsegi Overlook, only ten minutes away from where I lived, and I waited, hoping that the sun would come out. When it did, I was able to take this photograph. The span of time between total overcast and full sunlight, the transition time from the storm to a sunny afternoon, lasted only a couple of minutes. That was all I had and all I needed. Photography freezes time, and when looking at this image one has no way of knowing (nor does it matter) whether this lighting situation lasted a minute or an hour. All that matters is the graphic quality of

the light and the drama that this light created. A few minutes later, this scene became as commonplace as it can be, and looked the way it looks on countless afternoons every year. But that one moment captured in this image was incredible.

In figure 4-2, notice how the patterns of light and shade help define the depth of the canyon and create three-dimensionality in the entire scene. In many ways, the light defines the composition of the image. It shows which rock formations are in front of or behind each other. In other words, the light gives depth to the image. If the whole landscape was in the light, or if the whole landscape was in the shade, it would look flat and two-dimensional. By being partly in the light and partly in the shade, it has depth and looks three-dimensional.

The light also outlines what is most and least important in the scene. By definition, the human eye will first notice the areas of an image that are either the brightest or that have the most contrast. Here, these

attention-drawing areas are the canyon wall and the clouds which are in the middle of the image, in the distance, and behind the river. These areas are the ones emphasized by the light. They are also the most important in the composition because they have the most remarkable shapes in regard to the canyon walls. Because of the patterns of light and shade in the clouds, the clouds become very important and attract the eye considerably. They take on much more importance than the foreground which is in the shade and where little drama, if any, takes place. This foreground is fairly empty of recognizable shapes, and is not very important. It plays a lesser role; a fact emphasized by the light which is soft and non-dramatic, in that area.

In other words the light not only *makes* this photograph, the light *composes* this photograph. The lighting patterns unique to this natural lighting event in Canyon de Chelly created what I consider to be one of the most perfect compositions for this specific location. To prove this point I have taken countless other photographs of this same location, using the same composition or one very similar to it, and although I have many other nice images, none come close to the drama and the impact of this one.

Bad (or active) weather is a tremendous help in our quest to find good light. The weather at the end of a storm is particularly propitious. If you are in the field and the weather is bad, don't retreat to your house or to your hotel room. Instead, wait out the storm and look at the sky in the direction of the sun. If something is going to happen, it will happen there. Try to predict what might happen, meaning if and when the sky will open up and the sun will shine through the clouds, then think of a nearby location that would be ideal for this

light and go there. Eventually, you will be rewarded with great photographs.

Chiaroscuro

There are other instances where light makes the photograph, or to put it more in terms of our discussion in this chapter, where light *creates the composition* of the image.

One such situation is *Chiaroscuro* (*clair obscur* in French, *light and dark* in English). The word "Chiaroscuro" is derived from the Italian, meaning light-dark. I like the Italian and French terms best because, to me, they describe the light better than the English term by placing two terms together that are not normally associated. We talk of things that are light, and we talk of things that are dark. We talk of things that are lit, and we talk of things that are not lit. We do this all the time, but only rarely do we talk about things that are, at the same time, lit and not lit, or dark and light. That is what chiaroscuro is. Lit yet unlit, dark and yet light. Chiaroscuro is a *contrast* of two lighting situations that are opposites of each other. Chiaroscuro is a conflict between lightness and darkness, and the best images composed with chiaroscuro are those in which this conflict is never quite resolved, no matter how long we look at them and study the composition of the image.

In the image that I selected to illustrate this point, "Chiaroscuro in Antelope Canyon" (figure 4-3), the light source is a beam of sunlight that shines into a narrow canyon through an opening at the top of the canyon. When the light reaches the floor of the canyon, it bounces off the floor. By reflecting the beam of sunlight, the canyon floor becomes a virtual light source.

Reflected light can be quite powerful. The full moon is an excellent example, because the

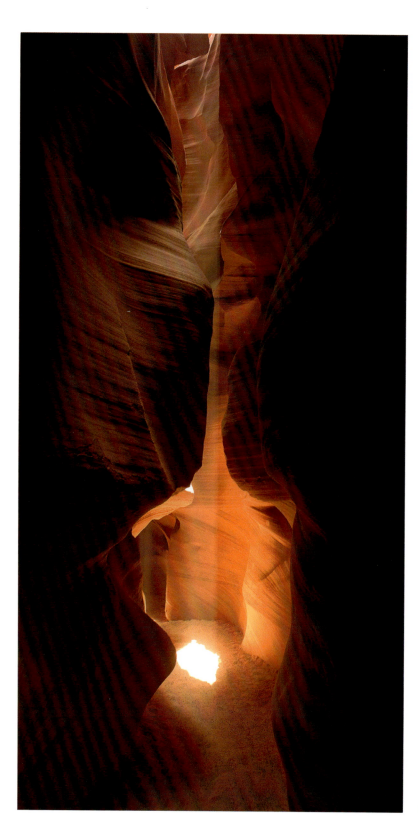

moon does not generate light, rather it reflects the light of the sun. However, the sunlight reflected off the moon is powerful enough to illuminate a landscape and create shadows at night.

In figure 4-3 the light beam reflected off the canyon floor is powerful enough to light the canyon from the bottom up. Because of the depth of the canyon, this light does not reach all the way to the top. However it does go up quite a ways, and creates an inverted lighting situation in which the canyon is lit more brightly from below than from above. In nature, we are used to seeing objects lit more brightly from above than from below. Therefore, this inverted lighting situation gives this image a strange and unexpected look.

The Chiaroscuro effect in this image is created by the juxtaposition of brightly lit areas and deep shadows. The transition from one area to the other takes place over a short distance, making these two areas almost touch each other. As viewers, we see these bright and dark areas as neighboring values and our eyes goes from one to the other, back and forth, in rapid succession. The act of comparing light and dark, and the difficulty of deciding which of the two is the most important, is what chiaroscuro is all about. If one of these two areas takes over, the effect is gone. But if this ambiguous light quality is maintained, the effect is successful.

Weather and Chiaroscuro are but two examples of composing with light. Later in this chapter we will look at other examples of how light can transform a common scene into a unique natural event.

Figure 4-3: *Chiaroscuro in Antelope Canyon*

Finding Sunrise and Sunset Times

It is light that reveals, light that obscures, light that communicates. It is light I "listen" to. The light late in the day has a distinct quality, as it fades toward the darkness of evening. After sunset there is a gentle leaving of the light, the air begins to still, and a quiet descends. I see magic in the quiet light of dusk. I feel quiet, yet intense energy in the natural elements of our habitat. A sense of magic prevails. A sense of mystery. It is a time for contemplation, for listening - a time for making photographs.

JOHN SEXTON

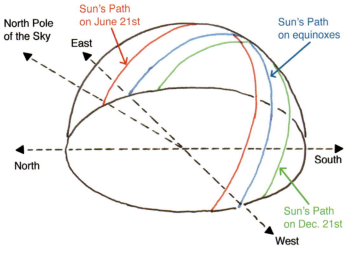

Figure 4-4: The sun's path

The Path of the Sun

In our quest to find the best light and to learn to compose with light, knowing where the sun is going to be at a given time of the year is essential. It is essential because the sun's position in the sky varies greatly from one time of the year to another. The greatest difference is between the summer and the winter solstices, between December 21st and June 21st. These are the times of the year when the sun is, respectively, the furthest south and the furthest north.[1] In such a situation, the position of the sun in the sky, across the calendar year, is as shown on figure 4-4.

As you can see, the angle of the sun is very different on the summer and the winter solstice. On the summer solstice the sun is shining nearly straight down when it is at the zenith, while on the winter solstice the sun is shining at a very steep angle.

You can think of the zenith as being noon. While not totally accurate due to variations between time zones, this is nevertheless helpful. The point here is that, for photography, light shining onto the subject at a steep angle is better than light shining straight down. This is why sunrise and sunset light are so good for photography. At sunrise and sunset the sun shines onto the landscape at a very steep angle. In fact, at the point where the sun just rises or sets over the horizon, the light is virtually horizontal, meaning it is shining onto the subject at the steepest possible angle.

If you photograph during the summer, around the time of the summer solstice, you will have vertical light most of the day and horizontal light only at sunrise and sunset.

[1] I am here speaking about the sun's position in the northern hemisphere. If you live in the Southern Hemisphere, simply invert what I just wrote. In Australia for example, the summer solstice will be on December 21st and the winter solstice on June 21st. And of course, if you live on the equator, there is hardly any difference between winter and summer solstice. The sun stays virtually straight overhead all year long, in which case most of the remarks made in this section simply do not apply.

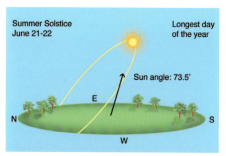 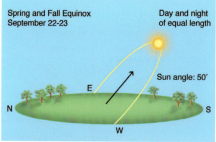 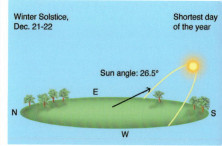

Figure 4-5: These three drawings show the position of the sun on the summer solstice, the equinox, and the winter solstice. The equinox is the time of year at which the sun is precisely half way between the winter and summer solstices.

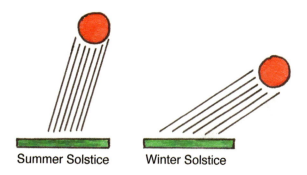

Figure 4-6: The reason why the sun's position in the sky is so important for photography is because the position of the sun greatly influences the angle of the sunlight. Here we see the angle of the sunlight on the summer solstice and on the winter solstice, when the sun is at the zenith, which is at the highest point in the sky for any given day.

This limits the time during which the light is most propitious for photography. Basically, in the summer months, you have an hour after sunrise and an hour before sunset to photograph in the best light. This is sometimes referred to as "the golden hour" or "the magic hour". Others call it "showtime". Before and after these times the sun is at a steep angle and the light quality is far less favorable for good photography. This time provides one of the finest lights for photography, and even if it lasts only about an hour, that hour is worth waiting for all day. However, you have to work fast because sunset and sunrise light changes rapidly.

Often, after photographing sunrise or sunset, when I start to organize equipment left amiss from the flurry of activity that accompanies an exciting shoot, I ask my wife Natalie, "did I get it?" meaning did I capture the peak of sunrise or sunset light on a photograph? Most likely I did, and most likely on many frames, but the event seems to have happened so quickly that I cannot say for sure. I become so absorbed in capturing this event that when it is over I cannot precisely remember how

many photographs I took or which exact compositions I created.

If you photograph during the winter months around the time of the winter solstice, you will certainly have horizontal light at sunrise and sunset as in the summer months. However, you will also have light shining at a steep angle onto the subject just about all day long. This means that you will have far more opportunities for good light during the winter. In fact, in the winter, you can sometimes photograph all day long with relatively good light. While sunrise and sunset will continue to offer the finest light in the winter, daytime can also be used for successful photographs under direct light.

Alain's Field Notes

I spend a considerable amount of time studying the location where the sun rises and sets across the year, for each of the locations that I photograph. Doing so is time consuming but worth it because it helps me plan my photographs and allows me to know when to be there to get the light I am looking for. In other words, the time I spend at home planning a shoot saves me time in the field because I know exactly when to be there at the perfect time. As a result I spend less time on location waiting for the light.

I am going to explain the planning I did for a photo shoot of Monument Valley, located on the border of Utah and Arizona.

The first step was to figure out the azimuth, in degrees, where the sun would rise and set on the winter and summer solstices and on the equinox for that particular location (figure 4-7). The azimuth is the location on the horizon, in degrees, where the sun will rise, set, or be positioned at a given time of the day. The azimuth is found by pointing a compass in the exact direction you want to measure, and

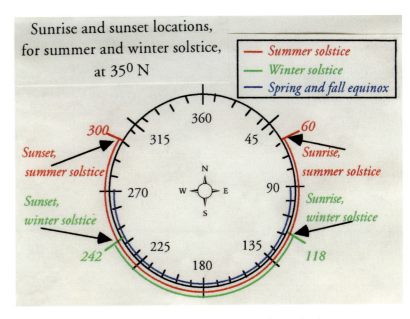

Figure 4-7: On this diagram the red line represents the path of the sun during the summer solstice, the blue line represents the path of the sun during the equinox, and the green line represents the path of the sun during the winter solstice

then reading the azimuth, in degrees, on the compass. The azimuth is measured from 0 to 360 degrees, the circumference of a circle. This circle is a metaphorical representation of the earth since the earth is circular.

A lot of information is contained in this simple diagram. First, the difference between the azimuth of sunrise and sunset between the summer and winter solstice is 58 degrees (118-60 or 300-242). This is a very significant amount that accounts for the extreme difference in light angle between summer sunrise and sunset, and winter sunrise and sunset, at Monument Valley.

It also explains why one will not get the same lighting at all if one is there in the summer or in the winter. If you saw a photograph of Monument Valley taken in the winter,

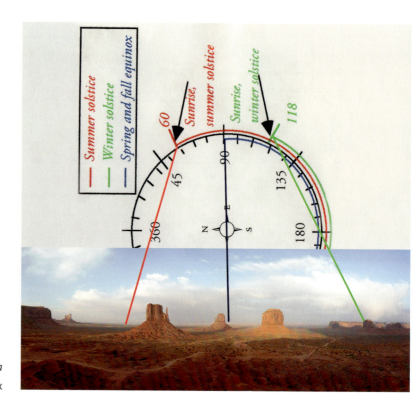

Figure 4-8: *Monument Valley Panorama* with sunrise azimuths for solstices and equinox

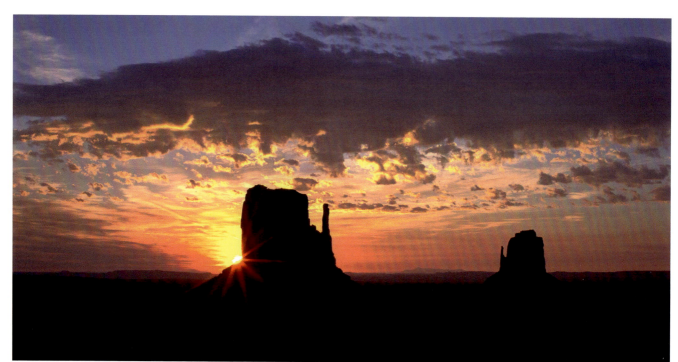

Figure 4-9: *Summer Solstice Sunrise, Monument Valley* (June 21st)

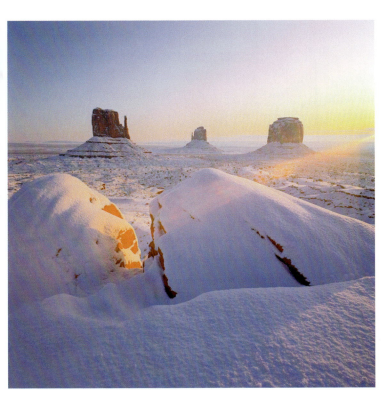

Figure 4-10: *Winter Solstice Sunrise, Monument Valley* (December 21st)

and you go there in the summer planning to take the same photograph, you will be disappointed because the light will be totally different!

This information also allows you to know where the sun will rise and set at any given time of the year. This is best shown by figure 4-8.

In this diagram and photograph the red, blue, and green lines on the diagram are connected to the corresponding locations on the photograph where the sun will rise on the summer solstice, the spring and fall equinox, and the winter solstice (the sun rises in the same place on the spring and the fall equinox). The photograph was taken looking directly eastward where the sun rises. A similar photograph and diagram could be made looking directly westward, where the sun sets.

However, at this location I was interested in photographing toward the east, which is why I made this diagram looking east. This information will be valid for a very long time since the locations of sunrise and sunset will not change during our lifetimes.

Figures 4-9 and 4-10 show two photographs exemplifying the extreme difference that I discussed in my presentation of the earlier diagram. Both photographs were taken at sunrise: the first photograph was taken on the summer solstice while the second photograph was taken on the winter solstice. These two buttes in Monument Valley are called the Left Mitten and the Right Mitten because, as you might has guessed, they are shaped like mittens. In the first photograph the sun rises to the left of the Left Mitten while on the

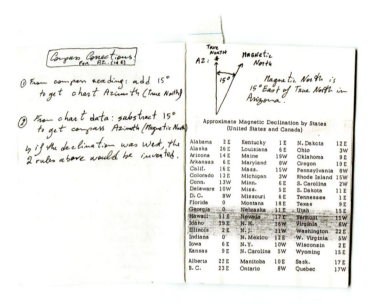

Figure 4-11: Notes

Figure 4-12: Notebook

second photograph the sun rises to the right of the Right Mitten. On the winter solstice the sun rises so far to the south (on the right in the photograph) that it is not even visible in the image. However, the sun streak (or lens flare) in the photograph points to the location where the sun is rising.

Here you see the notes and diagrams I made for this specific location. These are scans of my actual notebooks used for capturing the panoramic photograph of Monument Valley (figures 4-11 and 4-12).

Magnetic Declination Table

When calculating a precise azimuth with a compass, you have to take the magnetic declination into account for your location. This is because compasses point to the *magnetic* north while maps and charts indicate *true* north. In other words, the same chart can be used for

any location if you adjust the azimuth on the chart for your location. You adjust the azimuth by adding or subtracting the magnetic declination value for each specific location.

In other words, an azimuth chart is not normally calculated for a given location. Instead, it is calculated for a given latitude. Technically, latitude is an angular measurement in degrees (marked with °) ranging from 0° at the equator (low latitude) to 90° at the poles (90° N or +90° for the North Pole, and 90° S or –90° for the South Pole). Each specific latitude runs east-to-west and is parallel to the equator. On maps, latitude lines are shown as horizontal lines running around the earth.

To continue with our example, Monument Valley is located at 37 degrees of latitude north, meaning it is 37 degrees north of the equator. However, many other locations around the earth are also located at 37 degrees

of latitude north. Therefore, having a chart giving the azimuth for a given latitude is much simpler than having multiple charts giving azimuths for each location along a specific latitude. To find all of the locations along a given latitude, all you have to do is take a map and draw a line at 37 degrees of latitude north. A similar line can be drawn for any degree of latitude. Latitude lines are called *parallels* because they are parallel to each other.

If we were to draw a line along the vertical axis of the earth, running north and south instead of east and west, that line would indicate longitude. Longitude lines are called *meridians* from the Latin *meridies*, meaning "midday" because the sun crosses a given meridian midway between the times of sunrise and sunset. The terms AM and PM mean ante meridian and post meridian, and they indicate whether the hour is before or after the sun has crossed the meridian line for a specific time zone. The prime meridian, which indicates a longitude of 0, passes through Greenwich, England, where the British Royal Observatory is located and where the prime meridian was established in 1851.

The longitude of Monument Valley is 110 degrees west, meaning it is 110 degrees west of Greenwich. Together, the latitude and the longitude values allow you to precisely find any location on earth. A global positioning system (GPS) is controlled by several satellites that calculate the latitude and longitude (also called the coordinates) for your particular location. Using this information, it can then direct you to a specified destination.

The numbers I gave for Monument Valley were rounded to the closest digit. To be completely accurate, the exact latitude and longitude of Monument Valley is 37 degrees, 0 minutes, 56 seconds of latitude north and 110

35^0N		W.S.	Eqx.	S.S.
	Sunrise	118^0	90^0	60^0
	Sunset	242^0	270^0	300^0
Moon Range	Rise	66^0 to 114^0		
	Set	246^0 to 294^0		

Use bottom dial on compass. Substract 15^0 from these azimuths to get compass bearing (magnetic North).

- From compass reading: add 15^0 to get true North bearing
- From chart number: substract 15^0 to get magnetic North bearing

Figure 4-13: Magnetic declination table

degrees, 11 minutes, 57 seconds of longitude west. The terms north and west indicate north of the equator and west of Greenwich. That is the longhand version. The short hand version is $37^0 0' 56^2$ and $110^0 11' 57^2$, which is the way a GPS will display latitude and longitude.

Below I describe several ways that can help us find the azimuth and the times of sunrise and sunset for a specific location and a specific time of year.

The Old Farmer's Almanac
A source of reliable of information that I use extensively is the *Old Farmers Almanac.* I use this brand of almanac specifically, although there are several other almanacs available. I find the *Old Farmers Almanac* to be the most comprehensive.

Almanacs are primarily written and intended for farmers, gardeners, hunters, and others who work outdoors tending fields, plants, animals, etc. Because their occupations are seasonal and because their lives are organized around the seasons and the

WHERE THE SUN RISES AND SETS

By using the table below and a compass, you can determine accurately where on the horizon the Sun will rise or set on a given day. The top half of the table is for those days of the year, between the vernal and autumnal equinoxes, when the Sun rises north of east and sets north of west. March 21 through June 21 are listed in the left column. June 21 through September 22 appear in the right column. Similarly arranged, the bottom half of the table shows the other half of the year when the Sun rises south of east and sets south of west. Here's how it works. Say you live in Gary, Indiana, and need to know where the Sun will rise or set on October 10. Use the Time Correction Tables (p. 56-60) to determine the latitude of your city or the listed city nearest to you. Gary is at 41° latitude. Find the 40° latitude column and you see that on October 10 the Sun rises 8° south of east and sets 8° south of west. Of course, you can determine figures for other latitudes and days not actually shown in the table by using extrapolation.

Latitude / Date	0°	10°	20°	30°	40°	50°	60°	Latitude / Date
Mar. 21	0°	0°	0°	0°	0°	0°	0°	Sept. 22
Mar. 31	4° N	4° N	4° N	4° N	5° N	6° N	8° N	Sept. 14
Apr. 10	8° N	8° N	8° N	9° N	10° N	12° N	15° N	Sept. 4
Apr. 20	11° N	12° N	12° N	13° N	15° N	18° N	23° N	Aug. 24
May 1	15° N	16° N	16° N	17° N	20° N	23° N	31° N	Aug. 14
May 10	17° N	18° N	19° N	20° N	23° N	28° N	37° N	Aug. 4
May 20	20° N	21° N	21° N	23° N	26° N	32° N	43° N	July 25
June 1	22° N	22° N	23° N	26° N	29° N	36° N	48° N	July 13
June 10	23° N	24° N	24° N	27° N	31° N	37° N	51° N	July 4
June 21	23½° N	25° N	25° N	27° N	31° N	38° N	53° N	June 21
Sept. 22	0°	0°	0°	0°	0°	0°	0°	Mar. 21
Oct. 1	3° S	3° S	3° S	3° S	4° S	5° S	6° S	Mar. 14
Oct. 10	6° S	7° S	7° S	7° S	8° S	10° S	13° S	Mar. 5
Oct. 20	10° S	11° S	11° S	12° S	13° S	16° S	20° S	Feb. 23
Nov. 1	15° S	15° S	15° S	16° S	18° S	22° S	29° S	Feb. 12
Nov. 10	17° S	18° S	18° S	20° S	22° S	27° S	36° S	Feb. 2
Nov. 20	20° S	21° S	21° S	23° S	26° S	31° S	42° S	Jan. 23
Dec. 1	22° S	23° S	23° S	25° S	29° S	35° S	48° S	Jan. 13
Dec. 10	23° S	24° S	24° S	27° S	30° S	37° S	51° S	Jan. 4
Dec. 21	23½° S	25° S	25° S	27° S	31° S	38° S	53° S	Dec. 21

Figure 4-14: A table from the *Old Farmers Almanac* that allows you to find where the sun will rise & set, at any time of the year and at any location in the northern hemisphere

approach is refreshing in an age where information is provided to us through the latest technologies, and in a world where digital and wireless devices are the norm. Almanacs have a certain *je ne sais quoi* if you will.

Figure 4-14 shows a page scanned from the *Old Farmer's Almanac* showing where the sun will rise and set from 0 to 60 degrees of latitude north, which is literally the whole of the northern hemisphere. To use this table, find out the date and the latitude for which you want to know when the sun will rise and set, then adjust each azimuth for your exact location by adding or subtracting the magnetic declination for your location using, as an example, the table shown in figure 4-13.

The *Old Farmer's Almanac* also features charts showing when to expect the major meteor showers as well as a wealth of information, some more relevant to our needs than others, about the weather and the natural world. It also offers charts showing the phases of the moon, the place where the moon will rise and set, the moon's age, the horoscope, and much more. I consider it a must, both for its usefulness and for its entertaining aspects.

GPS

A global positioning system is another way to find out when the sun will rise and set. Shown here are the sunrise/sunset and moonrise/moonset information screens for the Garmin eTrex. Newer models will no-doubt be available by the time this book is published, but the information displayed on new units should be comparable. A GPS offers a simple and convenient source of information. This information is readily available since a GPS is carried in your bag or in your car. If you do not have a GPS yet you should get one because

weather, they need information about the seasons and the weather, as well as predictions about such things as how cold or warm the next year is expected to be and when and where to expect frost or drought. And yes, they also need to know when and where the sun and the moon will rise and set, which is where their needs coincide with ours. Almanacs provide all this information in an accurate and practical manner. Furthermore, they are usually presented in a way that is reminiscent of past centuries. This slightly antiquated

Figure 4-15: Garmin eTrex

Figure 4-16: Sun & Moon Screen

Figure 4-17: Mark location screen

they are a great complement to maps and in some instances are more practical than maps.

Having a GPS will also prevent you from getting lost when you photograph in remote locations or in locations where finding your way is challenging, such as in a forested area or in sand dunes. The simplest approach to avoid getting lost is to take your GPS with you when you photograph. Before leaving your vehicle, mark the location of your car on your GPS. You can save this location as a "favorite" by naming it "Car + your specific location + the date or the number of your hike". Because GPS only allows you to use a few letters, you will have to use a shortened form of writing. A writing style inspired by custom license plates works well. For example, to indicate the location of my car at white sands on my 4th hike, I would use the sentence "Car White Sands 4" which would be entered as *CARWHTSDS4*.

At the end of my hike, if I need to know where my car is, all I have to do is set the GPS to *Go to CARWHTSDS4* and it will show me the way to my car. Figure 4-17 shows the "Mark Waypoint" screen for the Garmin eTrex Vista. I blurred the *location* data since it would only be useful if you were parked exactly where I was. In the field, selecting *CARWHTSDS4* and clicking on the *GoTo* button at the bottom left of the screen will instruct the GPS to indicate the route back to this location.

You can also keep your GPS turned on during a hike to enter the locations that you photograph. Finally, you can set the GPS to mark your trail as you hike and then follow this trail backwards when you are ready to leave. I prefer the *Mark Waypoint* approach because it is the simplest and it shows me the shortest route back to my car.

Figure 4-18: Compass type 1

Figure 4-19: Compass type 2

Whenever you take your GPS with you, make sure to take a set of new spare batteries with you as well. GPS are "battery hungry" and will go through a set of alkaline batteries in a couple of hours. Having a GPS with dead batteries and no spares won't do you much good!

A Sylva Compass

A compass is another very useful tool. Certainly, just about every handheld GPS unit comes with a digital compass, but I personally prefer using an analog compass. For one thing, I find that it gives me a more precise reading when I need to find an exact azimuth because I can sight more accurately with a handheld compass. I also find it easier to

dial-in the magnetic north correction. Eventually, this is more a matter of personal preference than anything else. What matters most is that you have a compass, digital or analog, to locate the azimuth on the horizon.

The thing to note here is that knowing how to find the azimuth, and knowing how to find where the sun rises and sets, also teaches you how to find where the moon rises and sets because the process is the same. However, the moon has different astronomical characteristics than the sun in regards to photography. First, while the sun has a one-year cycle, the moon has a 29-year cycle. This means that the moon may rise or set at a specific location only once in 29 years, giving us more of a challenge in regard to getting the moon in a precise location for a photograph.

If you want to photograph the moon rising or setting in a given position, within an arch for example, the process of finding when and if this will happen is simple. As I mentioned above, this process is the same as for the sun. First, go to the location and, using a compass, measure the azimuth where you would like the moon (or the sun) to rise and set. Second, using a chart or astronomical software (see below), run the numbers to see if and when the sun, or the moon, will rise at this azimuth.

Websites

Websites are another very useful source of information. Given the nature of the Internet, the number of websites providing information about sunrise/sunset and moonrise/moonset is increasing exponentially each day, month, and year. Since there is no way to track them all, all I can do here is to list some of the websites I have used recently and mention what they have to offer.

aa.usno.navy.mil

This is the website for the Astronomical Department of the US Naval Observatory. There you can find the sun and moon data for any given day.

Of particular interest is the separate listing for astronomical, nautical, and civil twilight. Twilight refers to the time between dawn and sunrise and between sunset and dusk. The three different types of twilight refer to the position of the sun below the horizon. Astronomical twilight is when the sun is more than 18 degrees below the horizon. Nautical twilight is when the sun is between 12 and 18 degrees below the horizon. Civil twilight is when the sun is less than 6 degrees below the horizon.

For photography we only need to know the time of civil twilight. The other two twilights—astronomical and nautical—occur when the sky is still too dark for regular photography. However, they are useful when doing star photography because they tell you when the sky starts to get brighter. With star trail photographs you want to close the shutter before astronomical twilight because this is when the night sky starts to get brighter. Leaving your shutter open after that time will cause your photographs to be overexposed.

www.locationworks.com

This site does what drawing a line around the globe at a specific latitude would do: it allows you to find all the main cities on a given latitude. It also gives you the times of sunrise and sunset for that latitude at any time of the year. Remember that sunrise and sunset times do not vary for a specific latitude regardless of where you are on earth. What changes with latitude is, first, the magnetic declination, which you have to adjust for your location

when you use a compass, second, the specific time zone, and third, the identification of daylight saving time or standard time.

www.timeanddate.com

For a given city on a given date, this website provides the times of sunrise and sunset, the azimuth for sunrise and sunset, and the length of the day. It also provides many other types of information about the sun, the moon, and the planets.

www.sunrisesunset.com

This website features a table with a selection of cities arranged by country. For each city it shows sunrise and sunset times for a specific date.

Astronomical Software

Astronomical software has its place in the photographer's digital toolbox. For one, it allows you to calculate the times of sunrise/sunset and moonrise/moonset. It also makes it easy to find when the sun or the moon will be at a given azimuth.

If you do nighttime photography, especially star trails, astronomical software also facilitates finding where Polaris will be located on any given night. Finding where Polaris will be in the night sky is important because Polaris, also called the North Star, is the only star that does not move during the night. Polaris stays in the same place all night long while all the other stars rotate around it. Centering your photograph on Polaris will create a pinwheel effect on the photograph. An example of this effect is provided in the "Examples" section of this chapter.

Astronomical software can be very simple, offering just the time and location of sunrise/sunset and moonrise/moonset, or very

Figure 4-20: Focalware #1

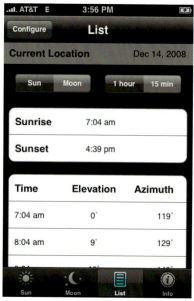

Figure 4-21: Focalware #2

is studying astronomy. We don't always think about it that way, but it is. The sun is a star and the moon is a natural satellite orbiting earth. Furthermore, the sun and the moon, in their journey across the sky, follow an ecliptic path; the same path that the other planets in the solar system follow.

All these astronomical bodies are related, and even if we need information only about the moon and the sun, it doesn't hurt to learn more about the entire solar system and about the universe, the stars, the galaxies, and so on. The sense of wonder that this knowledge gives you when you realize how small and insignificant we really are, is similar to the sense of wonder I feel when I realize how vast the landscape is and how small I am. There is a symbiosis, a parallel understanding, and a direct comparison between how I feel towards nature and how I feel about the universe.

Looking at the night sky while at a remote location that is far away from cities and without any light pollution is an unforgettable experience. Next time you are out there on a moonless night, driving back from a shoot in a distant location, stop the car in the middle of nowhere, turn off the engine and the headlights, and look at the Milky Way. As your eyes adjust to the darkness, you will see more and more stars until the Milky Way looks like a bright band of white stars streaming across the sky. As you do this, keep in mind that it takes time for your eyes to adjust to total darkness. If you have been looking at a bright light source, it can take up to 20 minutes. As your eyes adjust to the darkness, you will see more and more stars until the night sky is filled with millions of stars above you.

Shown here are several screens shots from the various display options offered in Equinox 6.

complex, offering the location of all the planets and stars in the universe. Following, I give examples for two types of astronomical software.

FocalWare

FocalWare is an iPhone application that calculates sunrise/sunset and moonrise/moonset times and position for any location in the world. Because the iPhone is a wireless portable device, iPhone applications are always available and easy to use in the field.

Equinox 6

Equinox 6 is a full-fledged astronomical software package. In a way, it offers far more than photographers need. However, I have always liked astronomical software for what it teaches about the planets, the stars, and the universe. After all, studying sunrise/sunset and moonrise/moonset times and azimuths

Figure 4-22: Program icon Equinox 6

Figure 4-23: The entire sky, Milky Way and Ecliptic
on June 12th, 2008

Figure 4-24: The names of constellations
on February 12th, 2008

Figure 4-25: Looking North on June 12th, 2008

Figure 4-26: Mythological formations

Figure 4-27 + Figure 4-28:
Gossen Luna-Pro

Figure 4-29 + Figure 4-30:
Gossen StarLite

Gossen and Pentax Spot Meters

I am often asked if we still need a spot meter or a light meter, now that we have digital cameras with built in histograms and sophisticated metering systems. If you use a digital camera with a built-in light meter and histogram, you don't need a separate light meter. In fact, if you have just a histogram and no built in meter (as with some digital backs mounted on mechanical cameras with no built in light meters) you still don't need a light meter. The histogram is all you need. To find the proper exposure, start with your best guess (which can be pretty accurate with experience), take a photograph, look at the histogram of the resulting photograph, and make corrections if necessary. Increase the exposure if the image is too dark (histogram too far to the left) and decrease the exposure if the image is too light (histogram too far to the right). Usually, two or three exposures using this approach will give you a perfectly exposed photograph.

The reason why you might need a separate light meter, preferably a spot meter, when using a digital camera is to study the light. It is not to calculate the exposure (the histogram will give you more information in that regard); rather it is to learn about the luminance of the various objects and elements in the scene you are photographing.

Certainly, if your camera has a built-in spot meter you can use that. However, I find that a standalone spot meter is better. First, it is designed to measure the light and nothing else. Second, the best models feature several ways to compare readings from different areas of the scene. They can also store several readings and compare them in different ways.

Shown here are several light meters I currently own. In all fairness (and because I am frequently asked this question), my favorite is

Figure 4-31 + Figure 4-32:
Pentax 1 Degree spot meter

the Pentax 1 Degree spot meter because it is simple, gives extremely accurate readings, and is easy to use. I don't like to fumble around with my spot meter. I want it to tell me what I want to know and move on. What is important is capturing the image, not endlessly trying to locate the controls in order to calculate the exposure.

Reflectors – Creating Reflected Light

Reflectors are the last type of tool I want to mention. A reflector consists of a shiny surface that reflects light. The most practical types of reflectors are folding reflectors that are easy to carry due to their compact size. You can find extremely small reflectors that, when folded, are no more than five or ten inches in diameter, making them easy to carry with you in the field in a regular camera bag.

Using a reflector is simple. All you need is a direct light source such as the sun. For the maximum effect, you need to reflect direct sunlight. To use the reflector simply point the reflective surface towards the sunlight, then orient the reflector in such a way that the light reflects towards the area you want to light. The reflective surface of the reflector is powerful enough to make the reflected light appear like direct light to the untrained eye, as you can see in the photographs shown here (figures 4-33 through 4-36).

Reflectors come with reflecting surfaces of various colors, but they are usually gold, silver, or white. Because light takes on the color of the surface it is reflected off, you need to carefully select the color of the reflector. I like a gold surface because it gives a warm color to the light, much like the color of sunset light.

Figure 4-33: Small reflector in its bag

Figure 4-34: Small reflector gold side shown (the other side is silver)

However, you may prefer the cooler light of a silver reflector or the more neutral color of a white reflector. Some reflectors are reversible and come with two different reflecting colors, such as gold and silver, one on each side of the reflector.

Adding reflected light to a scene is most effective when the subject is in the shade. By bouncing reflected light to a shaded area, you can effectively add a highlight to the scene. Another technique is to bounce reflected light onto part of the subject, rather than on the whole subject, making the area stand out. It also makes the lighted area look more important by focusing the attention of the viewer to that one area.

Still another technique is to use bounced light to show the texture of a subject. When used that way, the reflector is positioned so as to project the reflected light horizontally. This

technique mimics the effect of sunrise and sunset light by creating horizontal light that grazes the surface of the object and makes the texture of that object stand out. It works particularly well with objects that have an interesting texture. This technique is commonly used when photographing petroglyphs, which are designs carved on rock surfaces by prehistoric cultures. These carvings are often hard to see because the carvings are very shallow. By using the reflector in the manner I just described, it is possible to increase the contrast of the designs and make them stand out more. Of course this technique requires that direct sunlight be available nearby. Since this is not always the case, it is sometimes necessary to return to a location when the sun shines next to the petroglyphs.

For maximum light intensity, direct sunlight cannot be bounced from far away. The amount of light that reaches an object is

reduced by four each time you double the distance between the light source and the subject, therefore it doesn't take long until the light is too weak to light the subject. This rule is called the *inverse square law* and it is an important rule to keep in mind when working with reflected light. When working with direct sunlight this rule does not apply since we cannot significantly increase or decrease the distance between the sun and us! However, you need to keep it in mind when working with flash or other artificial light sources since it is easy to change the distance between the light source and the subject. Again, this rule is simple: doubling or halving the distance between the subject and the light source, will reduce or increase the power of the light by a factor of four.

Figure 4-35: Natalie holding the reflector

Using Natural Light

A painter works with color as the medium, a photographer works with light.

Carlotta M. Corpron

As we previously saw, in order to learn how to find good light and how to compose with natural light, one has to study light and become an expert in knowing the movement of the sun in the sky over the course of the year. One also needs to learn to use the tools that are available to us. However, there is another aspect of learning how to compose with light, and that is learning as much as possible about weather events such as clouds, haze, lightning, rain, rainbows, snow and snowstorms, reflections, sun stars, star trails, halos, light shafts, rims of light, comets and other astronomical events, as well as a myriad of other lighting conditions.

Figure 4-36: Reflector used on a rock art panel in Southern Utah

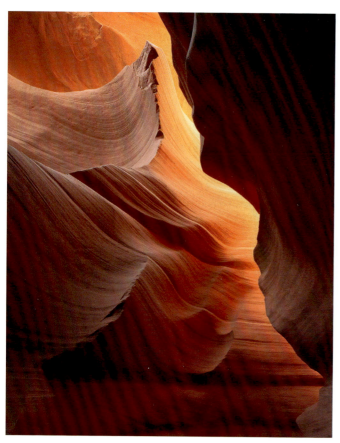

Figure 4-37: Example 1 – Natural reflected light

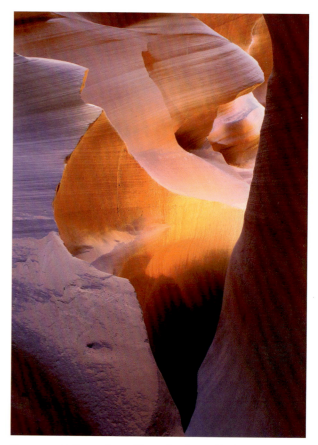

Figure 4-38: Example 2 – Natural reflected light

In this section I will show diverse examples of photographs taken in a variety of natural lighting conditions. My goal while doing so is not to cover each and every natural lighting situation possible. Instead, my goal is to show a selected number of specific natural lighting situations for which I can make the case that using a specific type of light helps create a successful photograph. Where possible, I will show the same scene both under good light and under lighting conditions that are not propitious to the creation of successful photographs.

Natural Reflected Light

The first example consists of two photographs taken in a slot canyon in Northern Arizona. What is distinctive about these photographs is the type of light that was used: the only light in these images is reflected light—there is no direct light. Reflected light is direct sunlight that bounces off a surface before striking the elements—in this instance the canyon walls—shown in the photograph. We talked about reflected light when I discussed how to use a reflector. This is the same type of light, except that the reflector is the canyon wall, not a

hand-held reflector. Reflected light is also called bounced light or diffused light.

Reflected light has several important qualities. First, it is very saturated and colorful because it takes on the color of the surface from which it is reflected. Since the refective surface here is red sandstone, the light becomes very red, and when it strikes another sandstone surface in the photograph, which is also red, the red color of the light is added to the red color of the canyon wall, thus increasing the intensity of the red canyon wall.

In other words, the canyon wall is more saturated when lit with reflected light than when lit with direct light; as the light bounces off one red canyon wall onto the other red canyon wall, the light becomes redder, and in turn, the reds become more saturated. The more surfaces the light bounces off and onto, back and forth, the less intense the reflected light becomes. However, maximum saturation in reds is reached with medium-density reds. This means that the light needs to lose quite a bit of intensity for the reds to reach maximum saturation. In narrow canyons, you have to look in the lower areas of the canyon, or in the darker areas, to find maximum saturation reds. In some particularly striking situations, I have seen reflected light become a dark, saturated red as it reaches low in a canyon.

The second quality of reflected light is that when it is very intense, as in these images, it appears to glow. The glow comes from the light reflecting off a surface that is very close to the surface it bounces onto. In these photographs, the reflective surface is only a few feet away from the surface the light hits after being reflected, causing the reflected light to glow. This glow comes from the high brightness level of the reflected light.

The third quality of reflected light is softness. Even though the light is strong and colorful, it is still not so strong as to cast deep shadows and create a high contrast scene. There is contrast in these images, but the contrast is far lower than what it would be if these photographs had been taken in direct light instead of reflected light. In fact, I had to slightly increase the contrast of these images in order to make them more dramatic and colorful. Still, even with this increased contrast, there are details in both the highlights and shadows. With direct light I would have had to reduce the contrast and even then it is most likely that I would have lost detail in the highlights, the shadows, or both. Images taken in slot canyons with direct light almost always have burned highlights, blocked shadows, or both.

Air Light

Our second example shows a unique type of light commonly called *air light*. The name air light comes from the source of this light, which is the open blue sky or the "air".

Air light is found in a scene whenever the only source of light for the whole scene or for part of the scene is the open blue sky. Understandably, this is not very common since whenever the sky is blue and without clouds the sun is also shining upon the scene. Therefore we have to look for situations in which, for some reason, the sun is not lighting the scene or the sun is only lighting part of the scene. This happens on a number of occasions.

First, it happens at sunrise and sunset when the sun is either not above or below the horizon yet or when it has just come up or is just about to go down. At these times the scene is partially lit by sunlight and, if the sky is blue, partially lit by the blue sky hence creating air

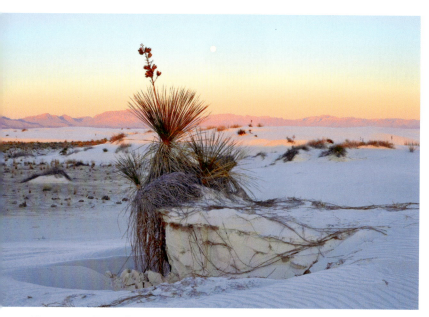

Figure 4-39: Example 1 – White Sands Moonset at Sunrise

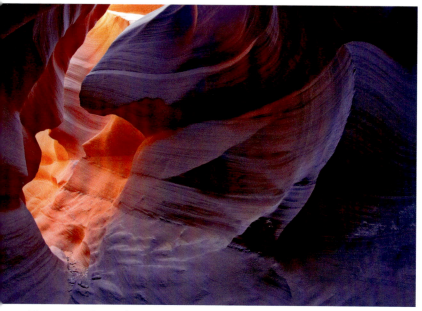

Figure 4-40: Example 2 – Antelope Canyon

light. This is the situation depicted in the first example photograph (figure 4-39), "White Sands Moonset at Sunrise". In this scene the sun had been up for just a few minutes. The background, i.e., the mountains and the dunes in the distance, are lit by direct sunlight. The color of the rising sun is orange and pink, causing the mountains and the white dunes to be orange and pink. The areas that are not yet lit by sunrise are blue because they are lit by the blue sky only, by air light.

A similar situation can happen at sunset if the sky is blue. It can also happen just before sunrise or just after sunset, if the sky is blue. At sunrise, for about 5 to 10 minutes, as the landscape emerges from the darkness of the night, the sky gets lighter and lighter until it turns a dark shade of blue and then progressively turns lighter shades of blue until the sun rises. During the time the sky gets brighter, the landscape becomes progressively bathed in pure air light, giving a blue color to the land. The process is the same, but in reverse order, at sunset, provided of course that the sky is blue and cloudless.

We also find air light in narrow canyons that are just a few feet wide. These canyons are commonly called slot canyons because from above they look like a slot in the earth. When you are inside one of the canyons you are, in effect, in a subterranean chamber in which light *percolates*, rather than reaching the bottom directly. Because these canyons twist and turn, and because they are often wider at the top than at the bottom, sunlight is blocked in certain areas while it is able to reach into the canyon in other areas.

If the sky is blue, the areas where the sun does not reach all the way to the bottom of the canyon are good candidates for finding air light. I say *candidates* because there is another

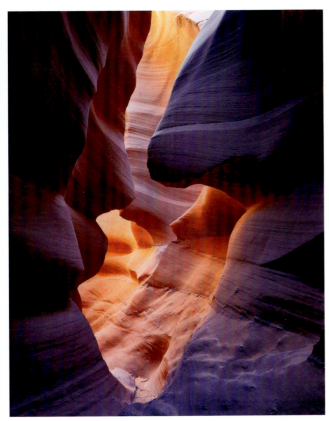

Figure 4-41: Tungsten color balance setting (cool colors)

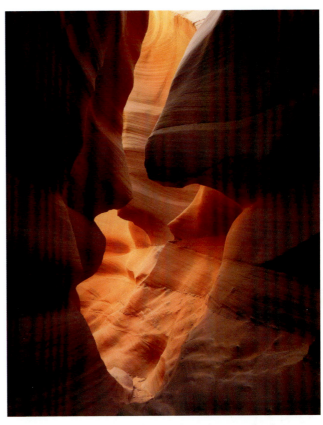

Figure 4-42: Shade color balance setting (warm colors)

condition required besides not having direct sunlight. This other condition is that nothing blocks the light of the blue sky from reaching the bottom of the canyon. In other words, finding air light in tight canyons is not as easy as it may seem: first, the sky must be blue, second, you must find an area where direct sunlight is blocked, and third, light from the blue sky must be able to reach all the way to the bottom of the canyon. In other words, the walls of the canyon must block direct sunlight but not air light. Not a very common situation. Furthermore, you must be able to recognize air light—something that takes some training as well.

How do you recognize air light? To the naked eye, air light looks gray on canyon walls and on bare ground. This is because our eyes neutralize color casts. In other words, our eyes and brain do not see color in areas that we expect to be neutral in color. At White Sands National Monument at dawn and dusk, if the sky is blue, the dunes will be blue in color. This is because the white color of the dunes takes on the color of the sky 100%. It is like shining a blue light on a white piece of paper. However, when walking in the dunes, our eyes neutralize this blue color and we see the dunes as they are during daytime under sunlight, which is pure white. This is essentially because

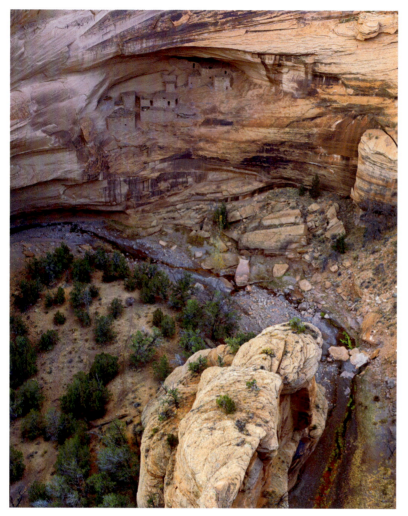

Figure 4-43: Daytime

when you underexpose you make the color richer and more saturated, thereby showing the blue better.

Finally, seeing air light on a photograph is also function of the color balance settings you are using on your camera and in your RAW converter. Shown here are two versions of the same image. The first photograph (figure 4-41) was converted with tungsten color balance settings, while the second photograph (figure 4-42) was converted with shade color balance settings.

These two different color balance settings create two entirely different color palettes in the converted photographs. While the tungsten color balanced image shows air light very clearly, the shade color balanced image shows no air light whatsoever. This is because the shade setting warms up the colors considerably and removes blues and purples, while the tungsten setting gives a much cooler color palette to the image and retains blues and purples.

Also note, in the previous examples, both the "White Sands" and the "Antelope Canyon" photographs have two different types of light in the scenes. One is air light, which is blue, and the other is reflected light, which is red and purple. The reflected light appears in the background of both examples while the air light is in the foreground. The inverse situation is possible as well. Finally, notice how this difference in the color of these two types of light disappears when the shade color balance setting is applied to the "Antelope Canyon" photograph. Because the shade color balance adds a lot of yellow to the image, it takes out the blue altogether. This is because blue and yellow are opposite colors, therefore when you add yellow you remove blue and vice versa.

the blue color is a pale tint. If the dunes were bathed in deep, oversaturated blue light then we would see it, probably not as blue as it really is, but blue nevertheless. This fact creates another problem when you take a photograph of air light. The fact that the blue color is pale and somewhat subdued means that it will not be visible on a normally exposed photograph. You have to underexpose the photograph to see the blue color of air light because

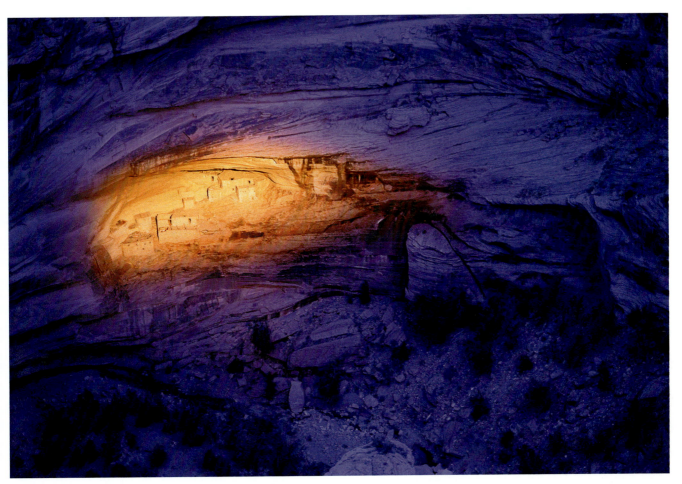

Figure 4-44: Nighttime lit with million-candle spotlight

Artificial Light at Night

Somewhat similar results (i.e., having two opposite colors of light; blue and yellow in this instance) can be achieved by lighting a night scene with artificial light. In the grand landscape this is best achieved by using a multi-million candle portable spotlight, such as the one shown in figure 4-45. There are many different models of this type of spotlight, with more or less lighting power. The one shown here is a 20 million candles portable spotlight.

Figure 4-45: Vector 20 million candles portable spotlight

Figure 4-43 shows the scene during daytime, in open shade, meaning without direct sunlight. While I like this daytime photograph, I wondered how the scene would look if photographed at night with artificial light added to it. I thought adding artificial light selectively would give a sense of mystery to the image as well as create an uncommon lighting situation.

The second image is the result of this experiment (figure 4-44). I used a multi-million candle portable flashlight that I powered off my car battery using the cigarette-lighter adaptor. I had to park my truck as close as possible to the overlook from where I took this photograph, because the extension cord for the flashlight was not very long. This created a somewhat hazardous situation because my truck was parked precariously close to the edge of the canyon and because there was nothing to stop it from falling into the canyon if the parking brake were to fail.

I worried about that the whole time, but I was able to successfully complete the shoot without seeing my worst fears become a reality. Most of what we fear never happens, and while this has little to do with light quality, it is worth keeping in mind because knowing this allows you to take a more objective look at risk versus rewards in many situations.

In the resulting image, the artificial light is orange while the shadows are blue. This is due in part to the color balance that I chose for this image and in part to the color of the light itself. The flashlight color was warm, and I did not have to do much to make it the color that you see in the photograph. The shadows were bluish, and I intensified the blue and cleaned up the color to make it what you see in the image. In short, the colors were there in the photograph, I simply made them stand out more.

This type of lighting can be used on a variety of subjects and in many different locations. A super-powerful spotlight is only necessary when you photograph distant or large subjects. In this instance, I was about a quarter mile from the ruin and I needed a very powerful light source to reach it. In fact, even with such a powerful spotlight, I still needed a 10 to 20 minute exposure time. With smaller subjects, a less powerful spotlight would work and a shorter exposure time would most likely be adequate.

This image was created with film therefore I had to get the film developed before I could see if the shoot was successful or not. Today I would use a digital camera. The great thing with digital photography is that we can see the results immediately on the LCD screen and we can check if the exposure is optimal by looking at the histogram. This not only gives us instant feedback about whether or not we captured the image properly, it also speeds up learning time. In the days of film, we had to wait until the film came back from the lab to know all of this. This meant that if we had been unsuccessful, we had to schedule a new trip to the location, try a second time, and again wait for the film to be developed to know how we did. This could go on for a long time with challenging locations such as Antelope Canyon. Today, digital makes this learning process faster because we can see the results immediately, literally in real time, and therefore make the necessary corrections while we are still at the location instead of having to schedule another trip.

Changing Light Quality

In the following examples, we will study how the light changes from night to dawn, to sunrise, to morning, to evening, to sunset, and finally to dusk. These changes are the most significant light quality changes that take place during the day. Certainly, the light quality changes between morning and evening, but not as dramatically as it does at sunrise and sunset. Essentially, during daytime the sun changes position in the sky and this affects the direction and size of shadows and lit areas. However, the color of the light stays relatively constant, while at sunrise and sunset the color of the sunlight changes dramatically.

The biggest changes in light quality take place during the hour before and after sunrise, and during the hour before and after sunset. This is also when the light is the most propitious for photography, when using direct sunlight. Of course, there are other types of light that are propitious to photography during daytime, and we will look at those later on. For now we are going to focus on what happens early and late in the day.

From Night to Dawn — Navajoland Commuting

Night: In this first example we are looking at Monument Valley from an overlook on the north side of the valley. The mesa is located south of the overlook. The first photograph shows night starting to turn to dawn. The sky is still dark, but the earth shadow (the band of bright blue along the horizon) is starting to be visible in the sky. The moon is setting over the mesa on the right side of the image. The colors on the mesa and on the ground exhibit a low saturation level. The moon and the sky along the horizon are the two most saturated colors. The colors for the most part are still quite dark and have a low saturation level. This is a night scene, with the mystery that comes from looking into shadows without having enough light to be able to reveal everything that we see.

Dawn: The next photograph was taken at dawn when the sky, no longer dark, turns purple and pink. The mesa also gets a purple-pink glow. The greens and the reds in the land on the foreground are more saturated already. The entire scene is bathed in the soft, colorful light that characterizes dawn.

Sunrise: In the third photograph, the sun just came out and the first rays of sunlight were reaching the top of the mesa on the horizon. The purple color of this mesa at dawn is giving way to a pink color that is quickly turning to red. In fact, the hill under the mesa is already deep red. The colors are still dark for the most part. The sky is now light blue at the top of the image and soft pink along the horizon, a significant change from the colors of the sky in the second photograph.

Morning: The fourth and last photograph in this series shows the scene bathed in morning light. Between the third and fourth photographs only a few minutes had elapsed, yet major changes had taken place. Now, direct sunlight bathed the entire scene except for the immediate foreground that is shaded by the hill from where I took this series of photographs. The sky was quickly turning blue but still showed a hint of pink color along the horizon. The light was still spectacular for photography, yet in a few minutes the best light was be gone.

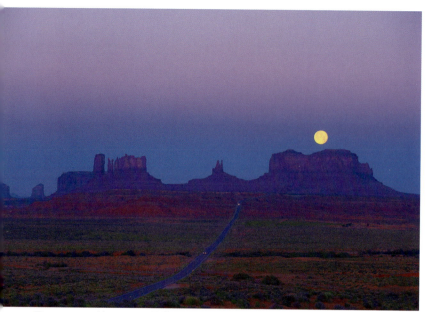

Figure 4-46: *Monument Valley* – Night

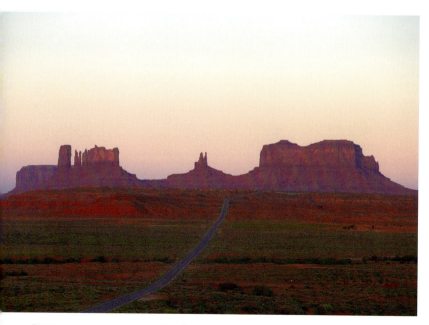

Figure 4-47: *Monument Valley* – Dawn

Image Selection

When I show these four photographs I am often asked which image I would choose if I had to select a single image from this series. In other words, which one is my favorite? It is difficult to make a selection based on the light quality since all four images exhibit very nice light. Instead, I prefer to make a selection on the basis of the contents of the image.

While I was there, several cars drove down the road that bisects the photograph and creates a leading line through the image. While it was still dark, their headlights created pinpoints of light in the image. As I was watching these cars go down this remote road, I realized that the drivers, though in the middle of a wilderness, were most likely commuting to work. Why else would they be on the road this early in the day? This was an unlikely commuting scene, one that contrasted sharply with our traditional, city-based view of commuters struck in early morning traffic on the freeways of large cities. To play up this contrast, I thought it would be fun to call this photograph "Navajoland Commuting", thereby pointing out both the location and the metaphorical meaning of the image.

I selected Monument Valley Night (figure 4-46) as my first choice, and I did later title it "Navajoland Commuting". I also converted and optimized the other three photographs, but my selection remained the same after I converted these other photographs, and it remains my favorite to this day. Light quality in a great location is fantastic, however visual metaphors with great light in a fantastic location is an even better combination. Plus, this was the only photograph with the moon in it. By the time I took the three other photographs the moon had set, removing one of the main elements from the scene.

Photographing a scene as the light changes from night to morning (or from evening to night) is not something I do every time I photograph at sunrise or at sunset. I did this in the example of Monument Valley (figures 4-46 through 4-49), essentially because the moon was setting while the sun was rising, and because the colors remained uncommonly vibrant after the sun had been up for some time.

Dawn to Sunrise at Bryce Canyon

Usually, I find there is not enough light to photograph before dawn. I also find the most propitious light for dramatic photography is when the sun first breaks over the horizon at sunrise, or when the sun is just about to dip below the horizon at sunset. In the next two sets of examples, dawn and sunrise at Bryce Canyon and in the Escalante, this is exactly what happened. I photographed before sunrise, as dawn was starting, but while the colors in the dawn photographs are soft, colorful and attractive, it is the direct light contrasting with the shaded areas of the sunrise photographs that I find the most compulsive and dramatic. The direct light helps give both scenes a three dimensional quality, which also provides another level of visual interest by outlining details of the foreground rocks in the Bryce Canyon image, as well as the shapes of the hoodoos in the Bryce Canyon photograph.

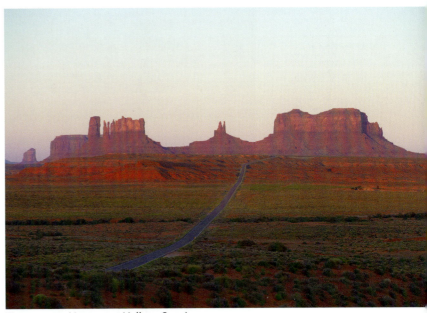

Figure 4-48: *Monument Valley* – Sunrise

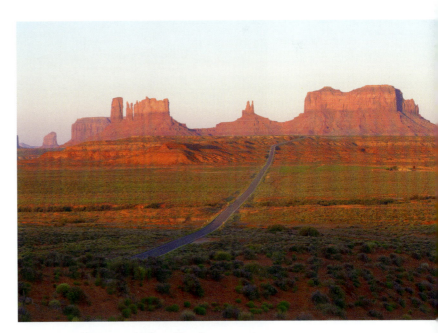

Figure 4-49: *Monument Valley* – Morning

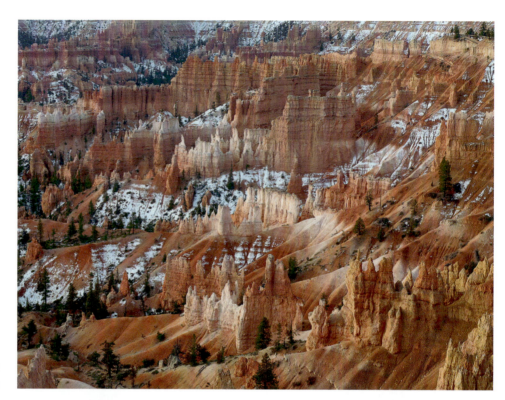

Figure 4-50: *Bryce Canyon* – Dawn

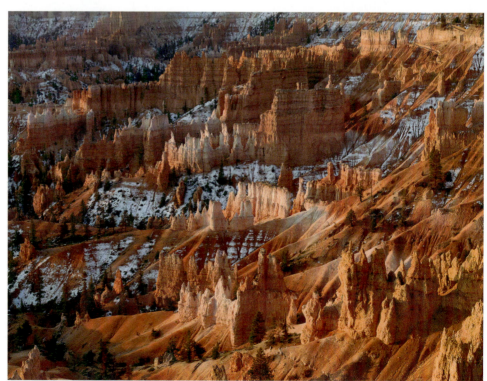

Figure 4-51: *Bryce Canyon* – Sunrise

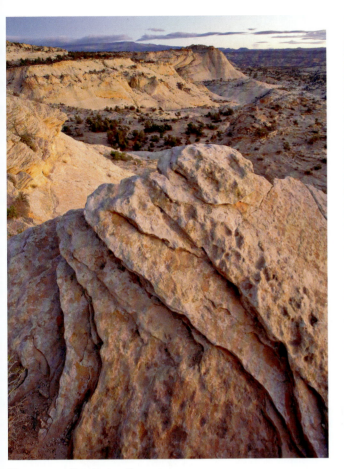

Figure 4-52: *Escalante – Dawn*

Figure 4-53: *Escalante – Sunrise*

Dawn to Sunrise in the Escalante

In a sense, even though the shadows are not very dark in these next examples (figures 4-52 and 4-53), the contrast between lit and shaded areas create a chiaroscuro effect. I also like the warm colors of sunrise light better than the cooler colors of dawn. All these choices are, of course, personal preferences. One can achieve superb images at dawn, before the sun is up, just as well as after sunrise. In many ways, these choices influence your personal style more than the advantages of one type of light versus another. When we discuss personal style, I will explain how personal style is the result of many decisions made by you about what you like and dislike. As we will see, the type of light that you prefer is one of the cornerstones of your personal style.

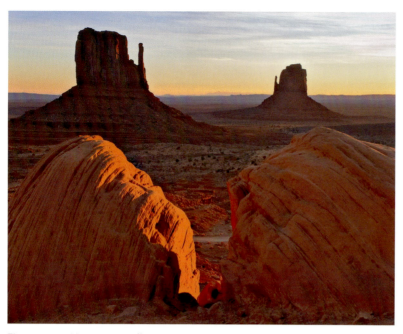

Figure 4-54: *Monument Valley – Sunset*

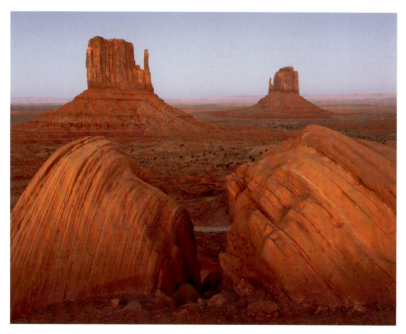

Figure 4-55: *Monument Valley – Dusk*

Sunset to Dusk at Monument Valley and Lake Powell

Sometimes, when having to select between dawn and sunrise or between sunset and dusk, the choice of which image I like best is quick and straightforward. Often, a particular image clearly stands out as being more powerful and attractive than all the others, and the image I choose communicates how I feel about the scene more effectively than all the others. It is a no contest situation, and the matter is resolved nearly instantly.

At other times, the choice is far more difficult because, as often happens, I like several images equally, each for different reasons. This is what happened with the images in figures 4-54 through 4-57, taken at Monument Valley and on top of a mesa overlooking Lake Powell. In each set of two photographs, I liked both images equally, each for a different reason.

In each of these sets of images, one image was taken before sunset and the other one after the sun had set. In a way these groupings are similar to the groupings of photographs from Escalante and Bryce Canyon that we just discussed. However, the difference here is that I found making a selection far more difficult because I liked both images and because each one expressed a different portrait of the scene.

A landscape can have, metaphorically speaking, different appearances. In fact, all landscapes do, and this is something that makes returning to the same locations over and over again, in all different types of weather and seasons, fun and creatively motivating. However, selecting your favorite photograph among those taken during a shoot can be quite difficult.

In this instance the images taken at sunset (the ones with direct sunlight) were attractive

because of their bold and dynamic quality. The warm, direct light contrasting against the shadowed areas gave these images a high level of visual energy. However, the images taken at dusk, the ones with the soft light and the saturated colors were also very attractive. The photograph of Lake Powell at dusk was particularly compelling. At dusk, Lake Powell was bathed in soft, even, enveloping light that gave a peaceful and introspective quality to the scene that the images taken during sunset did not have.

The same remarks holds true for the two photographs of Monument Valley. While the sunset photograph is attractive because of the energy and dynamism that it expresses, the dusk photograph features a peaceful quality that is just as compelling.

In the end the final choice must be made on the basis of which aspect of the scene you want to share with your audience. When thinking about your audience, what you need to consider are the visual metaphors present in each image. Images taken at dusk metaphorically present both landscapes, Monument Valley and Lake Powell, as quiet and peaceful places where one can rest and meditate.

On the other hand, the images taken at sunset present each landscape as dynamic and energetic, as places where one may find renewed strength or engage in physically challenging activities. Therefore, who your audience is significantly comes into play here, and so does whether you want to cater to a specific audience or share your own vision regardless of your audienc—two positions that we will discuss when we consider the concept of audience later in this book.

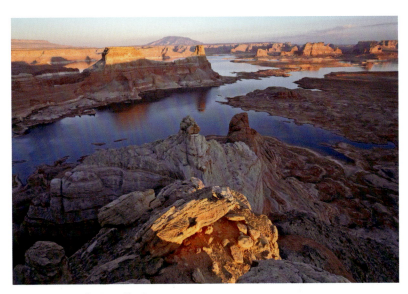

Figure 4-56: *Lake Powell – Sunset*

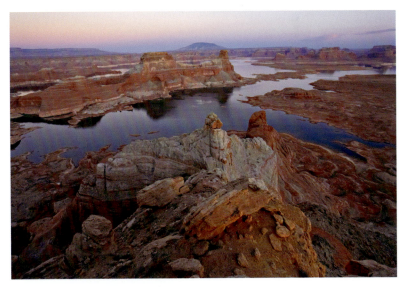

Figure 4-57: *Lake Powell – Dusk*

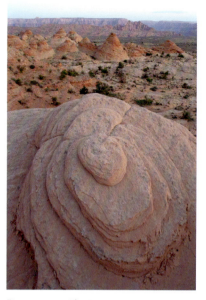

Figure 4-58: *The Teepees* – Dawn

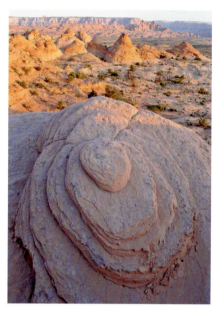

Figure 4-59: *The Teepees* – Sunrise

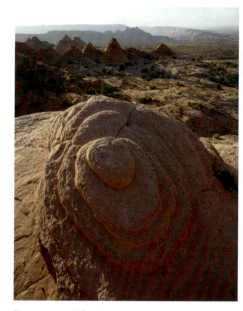

Figure 4-60: *The Teepees* – Sunset

Dawn to Sunrise to Sunset at the Teepees

This example shows how a specific composition can be transformed by photographing the scene under various types of light. In this instance, I went to this location at dawn and photographed this scene with dawn and sunrise light (figures 4-58 and 4-59). I then returned at sunset and photographed it with sunset light (figure 4-60). At the time I shot these photographs, none of them were meant to be examples for this book. They were all meant to be fine art photographs and they were created toward that goal. It was only in retrospect, while researching examples for this book, that I found these three images to be particularly interesting. I could have taken one more photograph, at dusk, after sunset, however, at the time this did not appeal to me. On the day I created these photographs,

dusk light was dull and colorless and I was not inspired to photograph past sunset.

These three images allow us to study the changes that a specific landscape goes through from dawn to sunrise to sunset. As we would expect, the light of dawn is soft and even. How bright the sky appears at dawn depends on which direction you are looking. Here, I was looking west, meaning that the sun was rising to the right and behind me, and setting to the left and in front of me. In the Escalante example (figures 4-52 and 4-53) I was looking north, meaning the sun rose immediately to my right, and the sun was closer to the direction I was viewing, hence the sky was brighter. Here, the sun was further away from the direction I was viewing and thus the sky appears slightly darker.

The sunrise image is the most pleasing to me. The rocks in the foreground have not lost

the soft pink hue they had at dawn, but the scene now appears far more three-dimensional due to the direct sunlight on the middle ground buttes. The mesa in the background is also in direct sunlight, however the light is still very soft and is not yet casting dark shadows. The contrast between the pastel pink foreground rocks and the soft orange buttes in the background creates an inviting photograph with a dynamic quality.

The sunset photograph is the one with the highest level of contrast. Most of the scene is in deep shadow and some of the buttes in the background appear as silhouettes. The areas in direct sunlight do not have the colorful quality they had at sunrise. One of the reasons for this change is because the sun was setting behind the buttes and the mesa in the background, which was blocking much of the sunlight, whereas at sunrise the sunlight was able to reach much more of the scene. Another reason for this change is that due to the height of the mesa in the background the sun was setting early, before it could take on the subtle colors it had at sunrise. At sunrise the sun rose over a flat plain, and therefore reached the buttes while the sunlight color was still warm. The warm color of the sun disappears within minutes of the sun breaking over the horizon at sunrise, and starts just minutes before the sun dips below the horizon at sunset. Since the sun was setting earlier during sunset, it did not have the opportunity to take on the same warm colors it had at sunrise.

A final difference is that at sunset there was quite a bit of sand in the air, due to a sandstorm, and this sand further weakened the sunlight reaching the buttes. This also created a brownish hue to the light and removed the warm tones that the sun had at sunrise. As you can see, the factors affecting sunlight color and intensity are many and they vary greatly from one location to the next. Sunrise and sunset, although they take place everyday, are rarely the same from one day to the next.

One important thing to notice about this composition is that it is a near/far composition. The near element is the sandstone formation with the concentric circles, the middle ground elements are the teepee-shaped buttes, and the background element is the mesa at the top of the image as well as the sky.

Notice also the size of the foreground element. It is very large, or rather I made it look very large. In reality it is only 3-feet in diameter. However, I used a wide-angle lens and positioned the camera close enough to the sandstone formation to make it extend from the right to the left side of the image, nearly touching the borders of the image on both sides. When composing a foreground/background image, you want to make sure that you make the foreground large enough. A large foreground is one of the key aspects of a successful foreground/background photograph. Many foreground/background compositions fail because the foreground is far too small and therefore not noticeable enough.

Star Trails

Night photography can literally transform a landscape. In these example photographs you can see the power of this transformation first hand. The first image shows a one-hour exposure taken on a moonless night, while the second image shows the same exact scene photographed during daytime.

While the daytime photograph qualifies as a snapshot, the night photograph captures our attention. The image was composed so that Polaris is at the center of the frame, creating a pinwheel effect over the one-hour exposure.

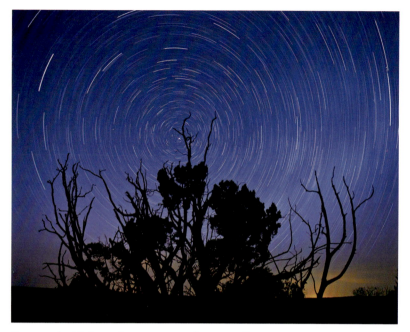

Figure 4-61: Night – 1 hour exposure for star trails

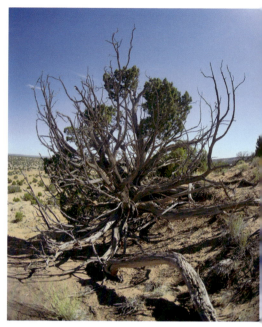

Figure 4-62: The same tree during daytime

The resulting circular star pattern becomes the most visually attractive element of this photograph, an element that could not be had during daytime.

In this image the trees are reduced to silhouettes. The tallest tree is at the center of the image, while the other trees and branches spread out to the left and right. After looking at many trees along the ridge where this photograph was taken, I chose this tree because of its graphic quality. The dead branches work better for this photograph than a full canopy would, because at night dead branches have a far more graphic quality than leaves.

The color of the sky is equally important. Deciding on a color for the night sky is not easy because we see colors at night mostly in shades of gray. The low light level causes the cones in our eyes (our color sensors) to stop working, leaving the rods (the brightness sensors in our eyes) to function alone. The result is that we see mostly in black and white at night, something that becomes a challenge when it comes to deciding what color things should be in night photographs.

I could have just as easily made the sky yellowish, or gray. I decided on a dark deep blue, vignetted around the edges, first because to me this is the color of night and second because I love the rich, velvet feel of this color. Dark blue also works very well with black, another reason for using this color in a night photograph.

During long exposures digital cameras create a dark frame after the exposure is complete. While not an absolute requirement (most cameras can be set to turn dark frame exposure on or off), this is a big plus in regards to image quality. What the camera does when it creates a dark frame is compare a pure black

frame to the one hour exposure, looking for "hot pixels" which are pixels that are just noise instead of photographic information. The camera then removes these hot pixels, leaving areas of pure color (such as the blacks and blues in this image) free of white pixels. Without calculating the dark frame, chances are that the image would have a number of hot pixels and that these would have to be removed manually with the cloning or healing brush. With the dark frame this is done automatically, and the resulting image is free of defects.

The important thing to keep in mind is that the dark frame takes as long to calculate as the exposure time set for the image. So, if you set the camera for a one-hour exposure like I did here, you have to plan for a two-hour exposure between taking the photograph and calculating the dark frame. What this means is that you have to have enough battery power to last for two hours. Otherwise, if the camera runs out of power, you will lose the photograph. In this case, two hours was the maximum time I could get out of the Canon 1DsMk2 battery, which is why I decided to do a one-hour exposure.

The other device you need to use is a timing remote control. This is the only way to set the camera to such a long exposure. With this remote you can trigger the shutter and set it to close after a set period of time.

Finally, I used a wide opening on a wide-angle lens (f/4 on a 17 mm lens I believe) and set the ISO to 100. There was no need for a high ISO since I was not trying to shorten the exposure time. Over the course of an hour, all the areas that are lit will show detail in the image. The low ISO is therefore used to guarantee a noise-free photograph.

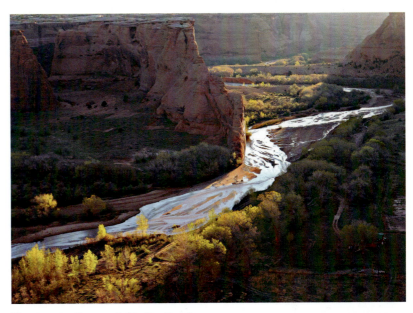

Figure 4-63: *Canyon de Chelly* – Sunrise

Backlight

Backlight, or backlighting, is one of the most dramatic types of natural light. If you want to create dynamic images, then you need to consider backlighting.

For backlight to work the sun must be in a low position. While it is possible to create a backlight effect with the sun high in the sky, most foreground objects are simply not tall enough to be backlit when the sun is high.

A low sun means photographing at sunrise or sunset. This means that you not only get backlight, you also get the color and drama of sunrise and sunset. As I said, if you want dynamic lighting, this is it.

Backlighting a subject basically means placing this subject right in front of the sun. The light therefore comes from behind the subject, highlighting the contours of the object or of the entire scene.

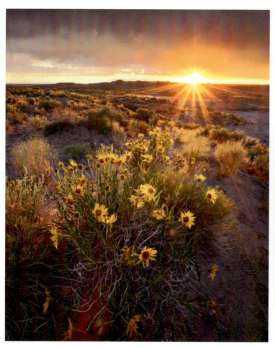

Figure 4-64: *Sunflower* – Sunset

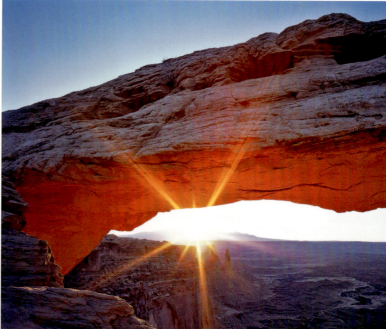

Figure 4-65: *Mesa Arch* – Sunrise

You can choose whether or not to have the sun itself visible in a backlight situation. In the example "Sunrise at Canyon de Chelly", the scene is backlit but the sun is not visible. The sun is located in the middle of the image and above the canyon, but was not included in the photograph. What we have is backlight without seeing the light source itself.

In the other examples, the light source—the sun—is shown in the photographs. We therefore have the backlit subject plus the light source making for an image as dynamic as possible, especially when combined with a wide-angle view, since wide angles by nature create dynamic compositions.

The sun in these examples shows up as a star. The star-effect is created by using a small f-stop such as f22 or smaller. What creates the star is the diffraction of the light onto the blades of the diaphragm in the lens. The diaphragm is the mechanical device located in the lens that controls the lens aperture, also called the f-stop. The design of the diaphragm, together with the number of blades in the diaphragm, has a direct effect on the shape and the visual quality of the star. Some lenses create better sun stars than others, so if you like this effect you may want to experiment with different lenses to find out which ones create the best sun stars in backlight photographs.

Open Shade

I often say that open shade is one of the best-kept secrets in photography, because in terms of light quality and in terms of how well open shade light works for photography, it certainly is. I also say that because, besides professional landscape photographers, not many people know how valuable open shade is when your goal is to take superb photographs.

Open shade is a type of lighting that occurs in one of two situations: on a cloudy day, when the sky is uniformly filled with clouds, or on a sunny day, when you photograph in the shade while being careful not to include any direct light in your photograph.

Because open shade does not have any direct light, there are no shadows in scenes that are lit by open shade. And, because there is no direct light and no shadows, contrast is reduced to a minimum. Therefore, open shade light is one of the lowest-contrast lights you can find in nature.

Open shade is so named because you photograph in the shade—either shade created by clouds or shade created by elements in the scene that block direct sunlight. Shade looks dark to our eyes, but when exposing the image you "open" the shade by overexposing the image. Our eyes perceive shadows and overcast days as dark because of the way our eyes and brain work. We perceive something as being dark by comparing it with something that we know as being light. Therefore, for us, shadows are dark in comparison to areas lit by direct sunlight, and cloudy days are dark in comparison to sunny days. However, cameras do not see things that way. For a camera, having a dark or a light photograph is relative to the amount of exposure given to this photograph. Take a photograph in a dark shadow or on a dark, cloudy day, overexpose it slightly,

Figure 4-66: *Trees* – Northern Utah

Figure 4-67: *Indian Paintbrush*

and you end up with a photograph that is bright or looks as if it had been taken on a bright day. On the other hand, take a bright sunny day, underexpose it, and you have a dark photograph.

Because open shade looks dark to the eye, many people think it is not good light for photography. They think that if the scene looks dark, the photograph will be dark. As photographers we know better than that. We know that how something looks in reality and how something looks on a photograph can be totally different. It is this knowledge that enables us to use open shade for what it does best: create photographs with soft contrast and saturated colors.

Saturated colors? Yes, indeed. This is another quality of open shade in addition to its soft contrast and lack of shadows. Colors are saturated in open shade because they are not lit by direct sunlight. Direct sunlight, except at sunrise and at sunset, bleaches out colors. Because of its intensity and lack of color, direct sunlight desaturates colors in photographs just like bleach desaturates colors on clothes.

I am often met with incredulous looks when I present this information, so if you doubt the veracity of what you just read I recommend you do this simple test. Take your camera out on a sunny day, set it to RAW capture, and photograph the same element—a flower, a rock, a patch of grass, etc.,—in direct light and in open shade. Then, convert the photographs on your computer and compare the colors. You will have to add a little bit of saturation to both images because RAW photographs are desaturated by nature, so make sure to add the same amount of saturation to both images to insure that the test is consistent.

You will find that the colors in the open shade photograph are more saturated than the colors in the direct light photograph. The only time when this is not true is when you photograph at sunrise or sunset. At that time colors are far more saturated because the sunlight is filtered by the atmosphere. At sunrise and sunset the sun is low on the horizon and the light of the sun must go through all the layers of haze and dust that hover over the earth. These layers of haze and dust filter the light by removing most of the colors of the sunlight, leaving mostly yellows, pinks, and reds. This is why sunrise and sunset light has such a warm color. At the same time, the intensity of the sunlight is also reduced by having to go through these layers of dust and haze, and as a result the light is softer. Soft, warm light is great light for photography, which is why photographing at sunrise and sunset works so well for us.

As the sun rises in the sky, the amount of dust and haze the sunlight has to go through is reduced, until, when at the zenith (the highest point the sun will be in the sky on any given day) the sun has to go through a minimum amount of dust and haze. As the sun rises, the intensity of the sunlight reaching earth increases and the colors of the sunlight becomes more and more neutral. In other words, as the sun gets higher in the sky, it casts deeper and deeper shadows while the color of the sunlight becomes less colorful, less red.

Open shade removes all these variables. Since there is no direct light there are no shadows and saturation is higher.

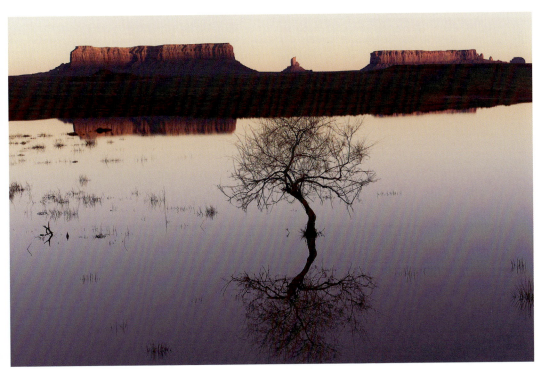

Figure 4-68: *Monument Valley Reflections*

Reflections

Reflections in nature need two things to occur: first, a body of water, small or large; second, an element reflected in the water. This element can be as simple as clouds or as complex as a mountain range overlooking a body of water. Without water there can be no reflections in nature, and without an element to reflect in the water, there can be no reflections either.

Reflections are a purely visual phenomena, and for this reason they are extremely effective in photography. I often say "Always photograph reflections", because you are working with a purely visual effect and there is a high probability that you will be creating interesting photographs.

I say that reflections are purely visual because not everything that we want to photograph is 100% visual. As I discussed in chapter 3, "The Eye and the Camera", much of what makes us want to photograph a natural scene is not visual. We may be attracted to a scene because of the way it *feels* rather than because of the way it *looks*. How something feels is invisible in a photograph. Only how something looks, provided it is photographed adequately, will be visible in the image. The warmth of a summer day, the call of a raven flying below the rim of a canyon, the smell of pinion pine sap, the feeling of solitude generated by being alone in a location far away from everything, none of that will be present in your photograph unless you somehow find a way to turn these other-than-visual feelings into a visual reality, into something that your audience can see in the image.

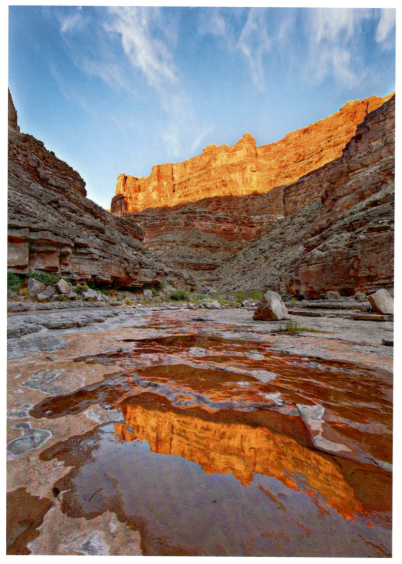

Figure 4-69: *Slickhorn Reflections* – San Juan River, Utah

Communicating something beyond the visual is not necessary with reflections because reflections are 100% visual. They are not about sound, smell, warmth or cold, experiencing solitude, or any other feelings. They are about an object reflecting its image into a body of water. Therefore, by not needing any sense other than our sight, reflections can be a photographer's best friend! If you photograph reflections, there won't be any bad surprises. However, there are a few essentials to keep in mind in order to create outstanding reflection photographs.

First, reflections often need polarization to look their best. Together with rainbows, reflections are one of the main reasons you should carry a polarizing filter with you. While the effect of polarization can be mimicked to some extent in Photoshop, it cannot be 100% duplicated. This is one instance in which using a filter in the field is still necessary. A polarizer will allow you to darken reflections. It will also help you make reflections stand out more by removing unwanted glare on the water or by darkening the water so that objects below the water are not visible.

Second, a reflection is always darker than the object it reflects. This is because water absorbs a certain amount of light. This means that during processing you will have to selectively brighten the reflection area of the photograph to make it match the density of the object reflected in the water. If you do not do that you will have a reflection that is darker than the reflected object. While this is okay if this is the effect you are after, it can be a problem if you are expecting the mirror image to mirror the density as well!

Third, a reflection will often take on the color of the reflecting surface. Reflections in water are often bluish, because most bodies

of water appear blue. However, when the water appears green, then the reflection will be greenish. With shallow bodies of water on a sandy background, the reflection will take on the color of the sand, which may be yellow, brown, or red. This is particularly true when the reflecting element has a neutral color, in which case the color cast created by the background is particularly noticeable. Clouds may be the instance in which this is most noticeable.

In "Playa Reflections", the cover image of my book *Mastering Landscape Photography,* I had to remove a significant amount of yellow from the clouds reflected in the shallow waters of the Death Valley Playa. Without this modification, I would not have achieved a perfect balance of density, tone, and color balance between the sky and the reflections. I also had to brighten the reflections because, as I mentioned, the reflections were darker than the clouds and the sky. This was also the case with the example of "Slickhorn Reflections" (figure 4-69). Plus, I was dealing with a high contrast scene. The top of the canyon was receiving direct light from the setting sun, while the bottom of the canyon, where the reflections were, was in deep shade. I had to combine several bracketed exposures to get details throughout the scene, in addition to brightening the reflections and removing the color cast. In this instance, the shadows were bluish because they were lit by the blue sky (see the section on air light earlier in this chapter) and I wanted them to have a warm tone so that they would be in harmony with the warm colors of sunset at the top of the canyon.

In figure 4-68, "Monument Valley Reflections", the problems were far fewer because only a small amount of sky was visible. Furthermore, the area of sky that was visible

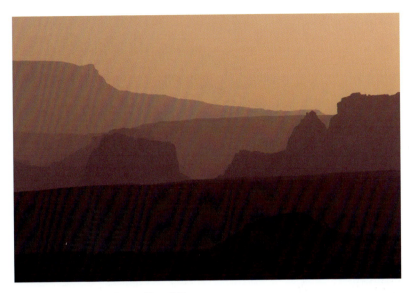

Figure 4-70: *Brown Haze* – Grand Canyon

was not very bright. I therefore had hardly anything to do to correct this image besides brightening the reflections slightly and making sure that the color balance was correct. I did not have to worry about having a color cast on the reflection since the object reflected in the water was pure black. The reflection was going to be pure black—colorless—no matter what. Sometimes things are hard, and sometimes things are easy. With these two photographs we have an example of each.

Silhouettes

Using silhouettes is a very effective way of composing strong photographs. A silhouette is an object reduced to the shape of its outline. When rendered as a silhouette, a complex subject becomes a simple shape. The body of a silhouette is usually of a solid color. Many photographers like to use black silhouettes, however silhouettes can be any color you want. When non-black silhouettes are used,

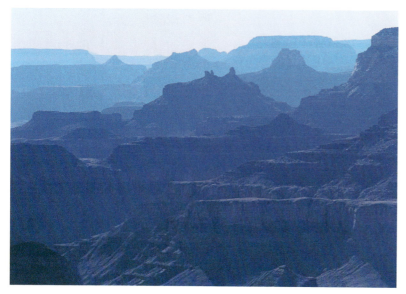

Figure 4-71: *Blue Haze* – Grand Canyon

several silhouettes of different colors can be superimposed onto each other. This superimposition creates a series of shapes that differ from one another by their outlines and by their colors.

Silhouettes are by definition flat. Therefore, depth can be created by placing several silhouettes in front of each other. The closest silhouettes have dark colors and the farthest silhouettes have light colors. Usually this darkening and lightening occurs naturally. Objects in the distance become lighter the further away they are, thereby creating the impression of depth.

A color silhouette photograph, such as the examples in figures 4-70 and 4-71, is comparable to a paper collage. In a silhouette collage, shapes are cut out of paper of different colors and then superimposed onto each other. The darkest shapes are placed in the foreground and the lightest shapes in the background. The change from dark to light colors is what gives depth to the image. The different shapes of the silhouettes are what create variety and interest in the image.

Because silhouettes have a strong visual presence, they are very effective in photography. Silhouettes simplify complex subjects. Very often less is more in art and in photography. When using silhouettes, we show less of the subject and by showing less we create images that are simpler and, if done well, stronger as well.

Silhouettes also lend themselves to a simplification of the color palette. Often, hazy conditions will naturally create silhouettes. This is what happened in the first and second photographs shown here. These silhouettes are often monochromatic in color, meaning they have only one color. The natural color of the silhouettes can be kept or can be changed

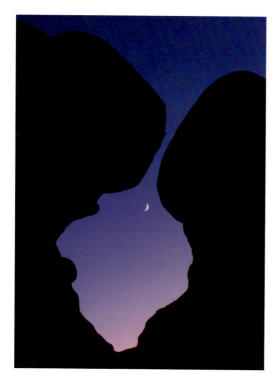

Figure 4-72: *Silhouettes after Sunset* – Escalante

to a different color. For example, in figure 4-70 I kept the natural beige color of the silhouette. However, in figure 4-71 I changed the natural beige color to a light blue.

In both examples, the simplified monochromatic color palettes of these two scenes are in harmony with the simplified shapes of the subject. The result is an image that is reduced to its main components of shapes and color.

Silhouettes can also be created at sunrise and sunset by placing an element in front of the sky and reducing this element to pure black. This treatment was made popular with color transparency film that had a very small dynamic range and which therefore dramatically increased contrast, which made creating black silhouettes easy.

With digital, if you want black silhouettes you may have to force the foreground elements to black since they may retain details and colors that you do not wish to show. This is what I did with figure 4-72. This photograph was taken at sunset as the moon was rising. The two black rock formations create an arrowhead shape and appear to be a single rock. However, in reality these are two separate rock formations with one located in front of the another, but reducing them to black silhouettes makes them appear to be on the same plane. The rising moon adds another level of interest to the image while the sky color, transitioning from purple to dark blue, adds a dash of color that sharply contrasts with the black foreground. The image is powerful and memorable, in large part due to its simplicity, both in terms of the elements and of the colors present in it.

Sunrise and Sunset Light

I am going revisit the topic of sunrise and sunset light, as there are some additional things I have to share. There is no *predictable* light that is as dramatic and colorful as the light of sunrise and sunset. I say "predictable" because other lighting conditions may be as dramatic as sunrise and sunset, however they are not predictable because they cannot be expected to occur every day the way sunrise and sunset

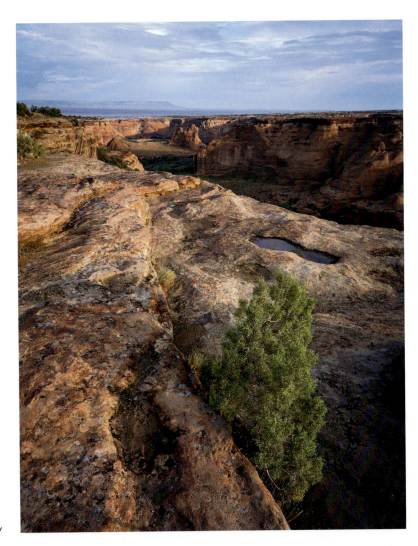

Figure 4-73: *Sunrise at Canyon de Chelly*

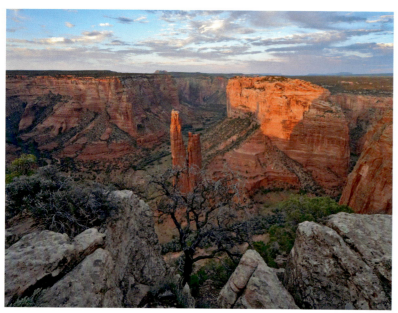

Figure 4-74: *Sunset at Canyon de Chelly*

horizontal light. Horizontal light grazes the objects in the scene, revealing every detail of their texture in ways no other type of light could match.

The examples shown in figures 4-75 and 4-76 show particularly well how grazing light reveals texture. I took these two photographs at my house, in the stairway to be specific, using the wall texture as my subject. I took the first photograph in late afternoon when the sun grazed the surface of the wall, revealing the texture in ways that surprised me. The light made it look as if the wall texture was a half-inch deep, or even deeper, while in reality it is barely 1/16 of an inch. If you pass your hand on the texture you can barely feel it, yet in grazing light it appears as if we are looking at a very rough texture.

I then took a second photograph when the same surface was in open shade, without any direct light. This is the same exact wall, facing in the same exact direction as the first photograph. The color balance and the conversion settings are also the same for both photographs. The only difference is the light: grazing light in the first photograph and open shade in the second photograph.

Snow

Snow has a significant impact on the lighting of a scene. On a sunny day, snow on the ground reflects direct sunlight. In doing so, snow acts as a giant reflector, bouncing light into the shadows and reducing contrast. A snow scene takes on a high brightness level that the same scene without snow would never have. On overcast days, snow provides a white background on which dark objects can be outlined. This white background also provides a neutral-color backdrop.

do. Rainbows, storms, and lightening are three examples of extremely dramatic lighting situations, however they happen unexpectedly and one cannot plan when to photograph them.

Because the sun rises and sets on the horizon (except when mountains block the sunlight), the light of sunrise and sunset is often referred to as *horizontal* light. Sunrise and sunset light are horizontal because the light shines in a horizontal direction. The horizontal quality of the light is what causes this light to outline the texture of objects so well.

In figure 4-73, "Sunrise at Canyon de Chelly", the foreground rock which is at the rim of Canyon de Chelly would be far from interesting had it been photographed at midday. However, when photographed at sunrise it displays a wealth of details, textures, and colors that are all created and outlined by the

Figure 4-75: Grazing light

Figure 4-76: Open shade

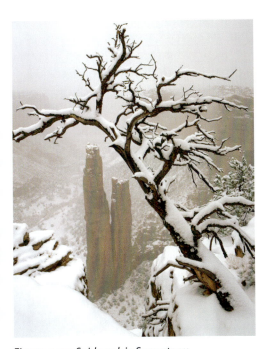

Figure 4-77: *Spiderock in Snowstorm –*
Canyon de Chelly

Figure 4-78: *Trees with Fresh Snow –*
North-Eastern Arizona

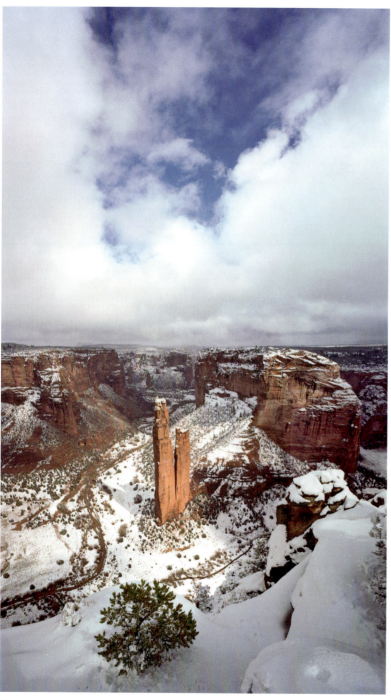

Figure 4-79: *Sunset with Snow* – Monument Valley

Snow simplifies compositions by hiding elements. After a snowstorm, a lot of details and features that would normally be visually distracting are hidden under the snow. Snow also softens the contour of objects, making harsh edges and sharp lines look soft and rounded.

Snow can create unusual visual patterns. For example, in figures 4-77 and 4-78 the snow is an integral component of the compositions. Both images were taken on overcast days: Figure 4-77 was actually taken during a snowstorm, while figure 4-78 was taken the morning after a snowstorm. If there had been no snow when I created these photographs, I would have composed them very differently. The presence of snow offered opportunities that a snowless landscape would not offer.

In figure 4-78 the snow gave a lace-like quality to the tree branches. The contrast between the tree trunks, which had no snow, and the branches, which were covered with snow, was also visually striking. I decided not to include any sky in this image because the photograph is about what is happening within the world of the snow-covered trees. I also decided to keep the photograph in color rather than make it black and white, even though it naturally appears very close to black and white. I made this choice because I wanted to preserve the little bit of yellow in the grasses and the faint red-brown hue of the tree trunks. The presence of these two colors adds a dimension to the image that a purely black and white image would not have. In short, the subtle colors add another layer of interest to the image. Having multiple layers of interest in a composition makes the photograph more dynamic and more sophisticated.

The next two examples (figures 4-79 and 4-80) were taken when the sun was out and shining on parts of the scene. Both

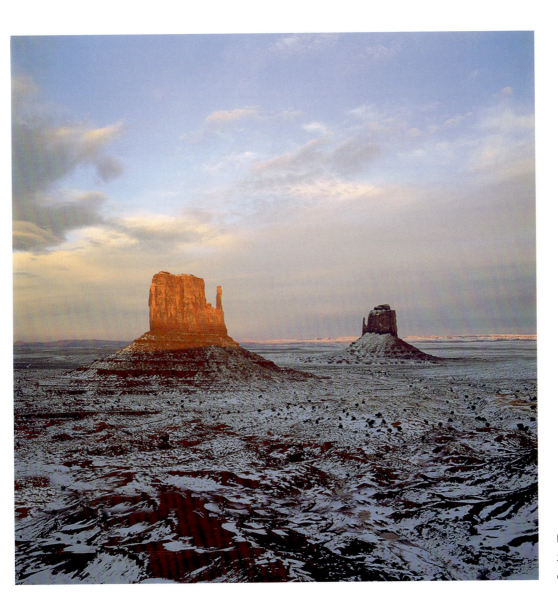

Figure 4-80: *Clearing Snowstorm* – Canyon de Chelly

photographs offer interesting opportunities for remarks about snow and light.

Figure 4-79 was taken at sunset, close to the time of the winter solstice, and it depicts one of the many unique lighting situations found at Monument Valley. In the winter, just before and just after the winter solstice, the sun sets behind the mesa to the right of the main Monument Valley overlook. Just before sunset the shadow of that mesa blocks the sun, preventing it from reaching the Right Mitten. At that time only the Left Mitten is in direct sunlight, making for an interesting visual contrast with one mitten in the light and the other in the shade. Instead of making the snow totally white in this image, I left a hint of blue in it. I could have made the snow pure white, thereby further reinforcing the color contrast, but I

wanted to create a color relationship between the blue sky and the blue snow.

Figure 4-80 was taken around noon, and demonstrates that in winter it is possible to take good photographs during the daytime, even several hours after sunrise and before sunset. This is because in winter the sun stays low in the sky all day long, providing us with good light throughout the day. The snow on the ground acts as a giant natural reflector that bounces light into the shadows, filling these shadows with additional light. This makes the shadows much brighter and more colorful than on a snowless day. It also lowers the contrast of the entire scene by brightening the shadows. A photograph of the same scene taken at noon in the summer would be far less attractive and colorful, because in the summer the sun would be high in the sky, shining straight down.

In these photographs the presence of snow on the ground provides a neutral color that further emphasizes the contrast of light and color. When you have a neutral color in the landscape, the other colors seem much more saturated than if they were surrounded by other saturated colors. The white snow provides a neutral color for us to look at, providing an opportunity to compare areas in the image with and without color.

In snow scenes, white becomes the dominant color. Remember that no two whites are exactly the same color. If you doubt this, pick up two pieces of white paper. Make sure they each come from a different source (not from the same ream of paper). Lay these two pieces of white paper on top of each other. You will see a difference of color between them. Each piece of white paper has a slightly different shade of white. Some whites are yellowish while others are bluish and some may even have a magenta cast.

Rainbows

Rainbows offer unique opportunities for photography. However, these opportunities are fleeting and unpredictable. Photographing a rainbow cannot be planned because the occurrence of a rainbow depends on the combined presence of two elusive elements: rain and sunshine. If you want a truly impressive rainbow photograph, you also need a third element: sunset light. I could also say sunrise light, but I have yet to see a rainbow at sunrise. I have no doubt it can happen, it's just not something I have witnessed myself.

In Arizona, where these three example photographs were taken, we have a season called the Monsoons that takes place in August and September. Some years, the monsoons occur like clockwork, everyday at the same time, seemingly following a natural schedule. During the Monsoon season, storm clouds build during the day, starting around midday to early afternoon. In late afternoon, the cloud-building process reaches its peak and it starts to rain. The rain quickly gets heavy and sometimes lightning strikes occur. Then, just as suddenly as it started the rain stops, the clouds open up, and the sun shines again.

This brief, transitory time between the time the sun comes out and the rain stops is when rainbows are apt to appear. If you are lucky, the clouds part just before sunset to let the sunset light shine through, creating a rainbow with sunset colors in the clouds and on the landscape. Those rainbows are the best! igures 4-81 and 4-83 were both created at sunset when the clouds opened just long enough to let the sun shine through in the west while a rainbow formed in the east, and for a brief

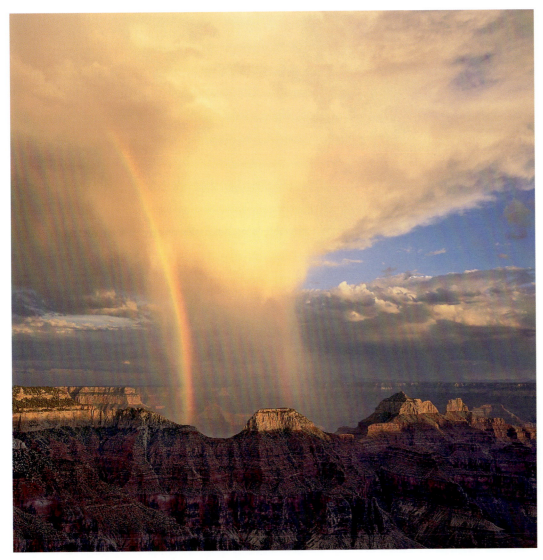

Figure 4-81: *Rainbow over Zoroaster Temple* – Grand Canyon

moment sunset colors filled the canyon with warm saturated light.

These unique photographic opportunities last only an instant—a few minutes at most—and one must be ready to photograph when they occur. This is not the time to fumble with your camera settings, or to hesitate about which lens to use. This is the time to shoot now and sort it all out later. These fantastic scenes may seem eternal but they will be gone in an instant, never to come back in quite the same way again.

Rainbows are formed by the sunlight shining on droplets of water in the air, which act as optical prisms, splitting the light into all the colors of the visible spectrum. Rene Descartes

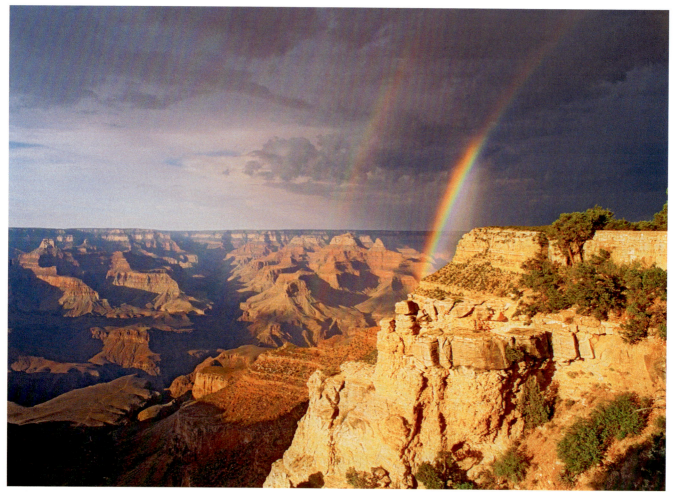

Figure 4-82: *Rainbow over Brahma Temple* – Grand Canyon

offered the first scientific explanation of this phenomenon in the *Discours de la Methode,* which was published in 1637. Prior to Descartes it was believed that rainbows were magical events, and their occurrence was the source of numerous myths and stories.

Rainbows are always located in the exact opposite direction of the sun. That is, if the sun is in the west, at sunset for example, rainbows will form in the east. Elevation-wise, rainbows will also be located at the opposite

elevation of the sun. So, for example, if the sun is low on the horizon, as it is at sunset, the rainbow will be high up in the sky; and if the sun is high above the horizon, then the rainbow will be low in the sky. Figures 4-81 and 4-83 were both taken at sunset, when the sun was just above the horizon, and as a result the rainbows were high up in the sky.

These photographs were all taken with medium telephoto lenses and show only part of the rainbow. Rainbows are circular, but

because they occur in the opposite direction of the sun, only the upper half of the rainbow circle is visible, that is unless you can see below the horizon. How can you do that? By standing on top of a mountain and looking down into a valley, for example, or by standing on the rim of the Grand Canyon and looking down into the abyss. The Grand Canyon is a mile deep, therefore rainbows can form below the horizon if they extend to the bottom of the canyon, which happens regularly when the sun shines around midday during a rainstorm. In fact, all three rainbow photographs show part of the rainbow extending down into the Grand Canyon. They do not show the whole rainbow because at sunset the sun was not shining deep enough in the gorge to show the entire rainbow.

The photographs in figures 4-81 through 4-83 show very vivid colors in the rainbows. Polarizing filters darken the sky and also darken the colors of the rainbow. In fact, besides being there when a rainbow occurs and having your camera ready, a polarizing filter is the most important ithout a polarizing filter most rainbow photographs will have weak and washed out colors. Simply rotate this filter until you get the maximum polarization, and all of a sudden the colors will become bright and vivid and the rainbow will be sharply visible. This is because natural light is scattered means that natural light shines in every direction. When you use a polarizing filter you polarize the light, you the light shine in a single direction the colors. It works particularly well with rainbows.

The last thing to keep in mind in regard to rainbows is that a full rainbow is circular and is therefore 180 degrees wide. Because of this extreme width, the only way to photograph a full rainbow in a single frame is by having

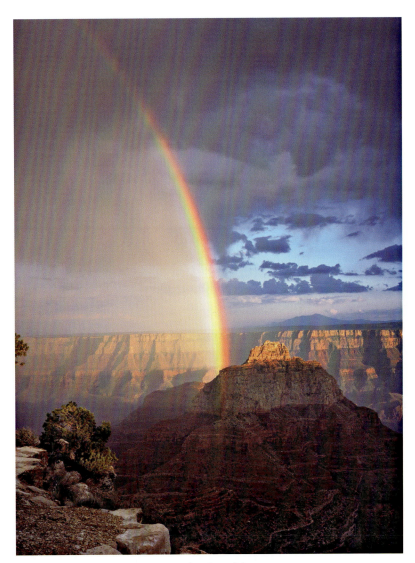

Figure 4-83: *Rainbow over Isis Temple* – Grand Canyon

a lens able to a 180 degree field of view. Such lenses are called fish eyes and unless you have one you will be limited to photographing only part of rainbow, or you will have to several photographs together to show entire rainbow in a single photograph.

However, most of the time you do want the full rainbow. In fact, at the Grand Canyon it

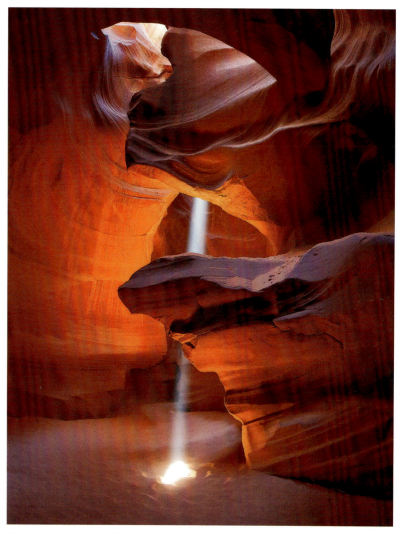

Figure 4-84: *Light shaft – #1*

is because the photograph I was on the south rim of Grand Canyon looking north, the two other photographs I was on the north rim of Grand Canyon looking south. Since all three photographs were taken at sunset, I captured a different side of the rainbow.

Rainbows are dynamic compositional elements. Their shape, color, direction and height, as well as the shape and size of the clouds around them, offer unique creative possibilities for the composition of a photograph. For example, with a tall rainbow you will have to include more sky than you would with a short rainbow. If the clouds are particularly interesting, you may want to include above the rainbow as well. These are just two possibilities among many offered by rainbows.

The curve of a rainbow is a very dynamic element. This curve forms a C-shape, one of the most dynamic shapes d in nature. It is almost as dynamic as an curve. Always photograph C-shapes and S-curves. Always photograph rainbows as well!

Light Shafts

I talked about light shafts earlier in this chapter when I discussed chiaroscuro. However, because I photograph light shafts regularly, and because light shafts are often found in slot canyons and in other dark locations, I thought it was important to devote a section to this type of light.

Light shafts provide unique photographic opportunities because they occur in places that are by definition dark. Even though they may look very bright, light shafts are actually not all that bright. It is the darkness that surrounds them that makes them stand out.

Light shafts can occur in a variety of locations. However, for a light shaft to be visible three conditions are necessary. First, direct

is rare that a full rainbow is located over the canyon. Usually, one half or so is over the canyon and the other half is over the rim. In the photographs I chose to show only the part of the rainbow located over the canyon. If you look carefully at the photographs, you will see that in figure 4-82 I captured the left side of the rainbow, while the other two photographs I captured the right side of the rainbow. This

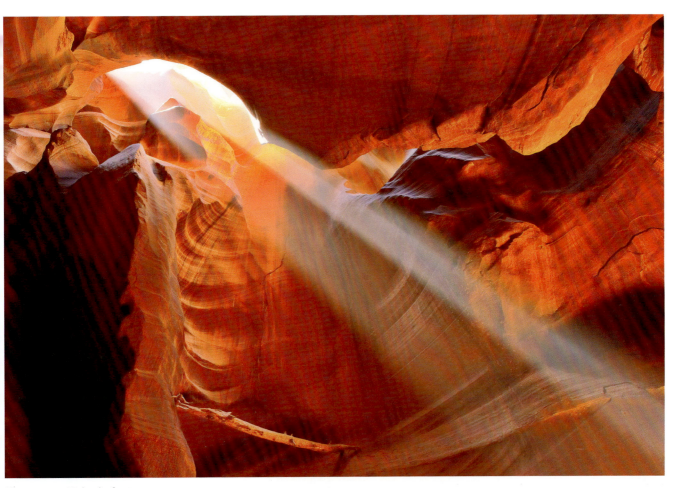

Figure 4-85: *Light shaft – #2*

sunlight must reach that location. Second, the ambient light must be dark enough for the light shaft to be visible. Third, and most important, dust, sand, smoke or other particulates must be suspended in the air. This third condition is an absolute requirement, because without it the light shaft will not be visible. If there are no particulates in the air, all you will see is a spot of light on the floor showing where the light shaft ends.

In slot canyons light shafts can occur naturally on a windy day if sand is floating in the air, carried upwards by the wind. But how do you make a light shaft appear in a slot canyon when no dust or sand is floating in the air? Simple! Take a handful of sand and throw it up in the air into the location of the light shaft. As soon as the sand or the dust is in the air, the light strikes the particles and as if by magic a light shaft appears in front of your eyes. With practice you will learn exactly how much sand you need to throw, as well as how high you need to throw it, to create the perfect light shaft.

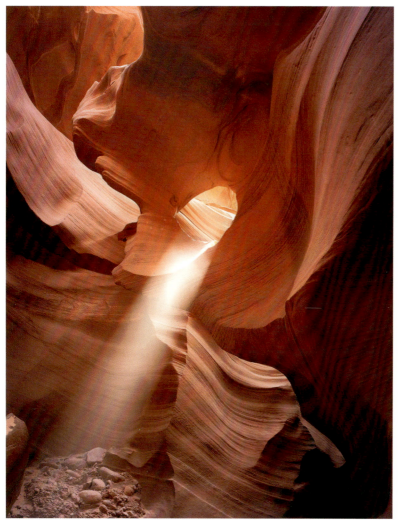

Figure 4-86: *Light shaft – #3*

If there is an upward air draft in the location of the light shaft, you can kick sand with your feet to make it rise towards the light shaft. The air current will carry the sand into the light shaft and you won't need to throw it. This works only when the air is blowing upwards, which is not always the case. The rest of the time you need to rely on the tried and true "sand throwing" method.

Light shafts add an exciting visual element to your compositions. They are dynamic elements that are both intangible and ever changing. Because they form straight lines, they can be used as compositiontional leading lines or as diagonal lines. They can even be used to show perspective since the far end of the light shaft is narrower than the end nearby.

Skill Enhancement Exercises

Transforming a Subject with Light

While you are photographing a landscape, pay attention to the way light plays on the rocks, the trees, the water, and all the other elements around you. As you look at this play of light, think about how light can transform the appearance of these elements. Think about how the light is making these elements look right now. Then think about how a different type of light would make the same elements look. How would sunrise, sunset, mid-day, overcast, open shade, reflected, or diffused light change the appearance of these elements?

As you study the effects the different types of light will have on different natural elements around you, write down or record your observations. Take notes about what you are learning as well as the things you are wondering.

Do you understand all that the light is doing, or do you have questions about how light works, about how it transforms things around you? If you have questions, write them down and look for answers later on.

As you continue to study light, start to study the lack of light as well. Shadows are areas without direct light. What kind of light are the shadows receiving? What is the color of the shadows? Which objects are casting the shadows you are studying? What are the shapes of these shadows? Would you photograph both the lit and the shadowed areas in the same image, or would you just photograph one or the other? Write down or record your conclusions and any questions you may have.

The Relationship between Color and Light
Look at the color of the objects around you. This color is a combination of the light and the natural color of the objects. How different would the color of these objects be if they were lit with a different type of light? What color would they be at sunrise, sunset, midday, in the shade, with reflected or diffused light, etc.?

Light Preferences
As you continue your study of light, ask yourself which type of light you prefer. Write down your answer and explain why you prefer a particular type of light. What qualities in this light appeal to you? What attracts you to it? What do you find beautiful about it? Again, write down or record your answers as well as any questions you may have.

Observing Changing Light
Photograph the same location throughout the day, from before sunrise to after sunset. Back in your studio, convert the photographs and then compare them to visualize the dramatic light changes that take place between sunrise and sunset.

Conclusion

One of the biggest mistakes a photographer can make is to look at the real world and cling to the vain hope that next time his film will somehow bear a closer resemblance to it... If we limit our vision to the real world, we will forever be fighting on the minus side of things, working only to make our photographs equal to what we see out there, but no better.

GALEN ROWELL IN MOUNTAIN LIGHT

In this chapter we looked at many different types of light and we explored which tools can help us in our search for exceptional light. What remains is finding light that we like and creating exciting photographs with it. The exercises listed above can be most helpful in getting you started down this path. There is, after all, nothing better than practice to fully learn how to compose with light.

5 Composing with Color

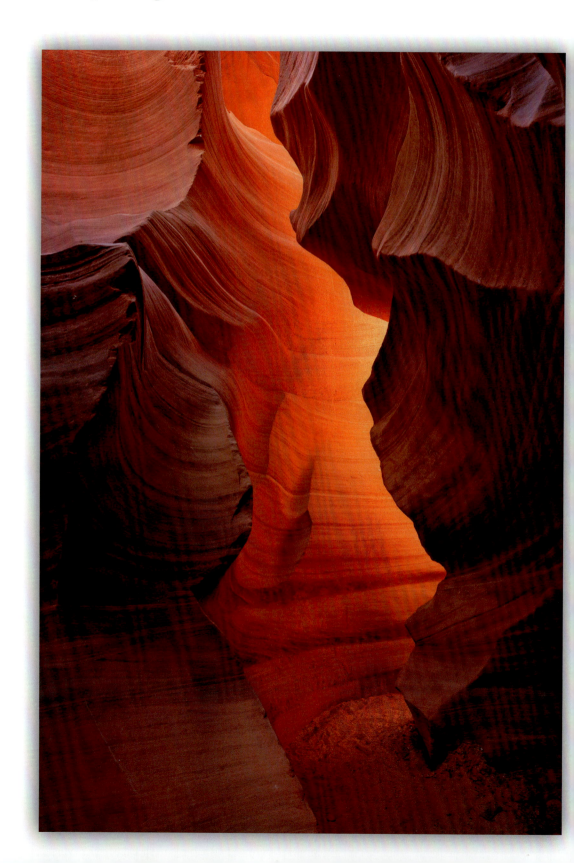

Color Vision

The prejudice many photographers have against colour photography comes from not thinking of colour as form. You can say things with colour that can't be said in black and white... Those who say that colour will eventually replace black and white are talking nonsense. The two do not compete with each other. They are different means to different ends.

EDWARD WESTON

Color is all around us. And yet when we photograph in color we rarely consider color as an element of composition. Certainly, we do see the color in the scenes, the objects, and the elements that we include in our images. However, we do not (at least not without training) see color as an element that changes the composition of our photographs depending on how we use it.

This attitude regarding color sharply contrasts with the attitude of photographers who work in black and white. Photographers working in black and white make a significant effort toward developing an awareness of black and white tones. They want to know how specific colors will appear in black and white and which shades of gray these colors will be. They want to know which areas of the image will be the darkest and the lightest. In short, they want to visualize the image in black and white prior to taking the photograph. To this end, they use black and white viewing filters and they meter specific areas of the scene with the goal of learning how different brightness areas will translate into shades of gray and how these different areas will relate to each other in terms of black and white.

Certainly, there isn't just one approach and methodology to photography but as many approaches and methodologies as there are photographers. However, what I am talking about here is what could be called "commonly used practices" that most people follow when photographing in black and white and in color.

It has been said that there is more need for visualization in black and white than there is in color photography, because we do not see the world in black and white. Therefore, to achieve successful black and white photographs one must first find out how the colors in the scene will translate into black, gray, and white tones. Good point. However, the same point can be made, in reverse, about color photography. While we do see in color, there are significant differences between what we see and what the camera sees, which affect how color is represented in photographs.

We see in color, yet, if we gave everyone a camera, not everyone would create great color photographs. In fact, we don't really need to conduct this experiment. All we have to do is look at the photographs taken by friends, relatives, and other photographers. The fact that we see in color is not enough to give us the ability to create stunning color photographs.

The same could be said about any natural ability. The fact that we can run does not qualify us to be Olympic athletes. The fact that we can talk, does not qualify us to be professional singers or orators. The fact that we can crack jokes does not qualify us to be comedians. Clearly, education and training are required in order to turn a natural ability into a profession. Athletes, singers, and comedians must train and study in order to develop their natural abilities. And color photographers must also train and study in order to develop their natural abilities.

In short, just because we have a natural ability does not make us an expert in that

Figure 5-1: *Antelope Canyon Glow*

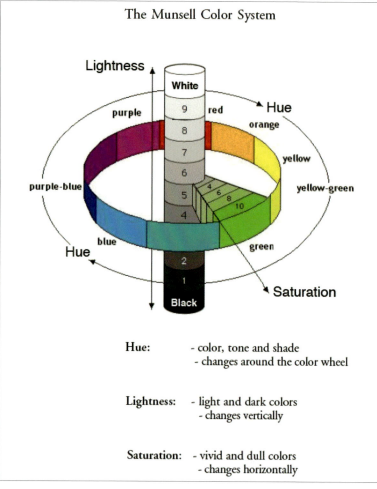

The Munsell Color System

Hue: - color, tone and shade
 - changes around the color wheel

Lightness: - light and dark colors
 - changes vertically

Saturation: - vivid and dull colors
 - changes horizontally

Figure 5-2: The Munsell Color System

Figure 5-3: Munsell's
A Grammar of Color

field. Training, study, practice, and especially perseverance are required. This is something easy to forget when talking about something that is all around us, such as color. Therefore, it is important to remind ourselves of this fact every once in a while.

If our goal is to create stunning color images, we must become experts in color. Knowledge of color is necessary in order to get color to do what we want it to do; to control color instead of being controlled by it.

The Three Variables of Color

A good color image is a good black and white image.
BILL BURT

Controlling color in photography means controlling the three variables of color: hue, saturation, and lightness.

- **Hue** represents all the colors we can see: red, yellow, green, blue, magenta, etc.
- **Saturation** represents how intense each individual color is. Saturation goes from total desaturation (grayscale) to full saturation (maximum color intensity).
- **Lightness** represents how light or dark each individual color is.

The Munsell Color System

The person who first described the three variables of color is cause for debate. My goal is not to enter this debate here. Instead, my goal is to describe how we can understand and control color in our photographs.

I like to think that Albert Munsell first described these three variables around 1920. At least, it is by reading his books that I first

learned about these variables in a way that made sense to me. Munsell presents this information in a way that is both simple and coherent. Our eyes perceive three values: hue, saturation, and lightness. The Munsell color system is designed to graphically represent how our eyes see color. It is a visual representation of these three values.

Figure 5-2 shows a diagram representing the Munsell Color System. This diagram shows the three variables of color in a simple and effective manner.

Also shown here is the cover of *A Grammar of Color*, the book in which Munsell presents his theory of color. This is the cover of my personal copy of this book, published in 1921 by the Strathmore Paper Company. Besides presenting Munsell's theory of color, the book explains how to harmonize the different shades of colored paper produced by Strathmore. In fact, Munsell's text and illustrations about his color system occupies only half of the book. The other half consists of actual Strathmore paper samples of various colors.

One of the most interesting aspects of the Munsell Color System is that it closely duplicates the way in which color spaces are currently represented. Figures 5-4 through 5-6 show several three-dimensional graphs of a large color space widely used in digital photography: ProPhoto RGB. These graphs were created in Chromix ColorThink and show the color space from the top, the side, and the bottom respectively.

In these 3D graphs the center represents the lightness values, which is white on top and black at the bottom. Around the center are the hues—all the various colors—found in this color space. Finally, as we move away from the center and toward the outside of the

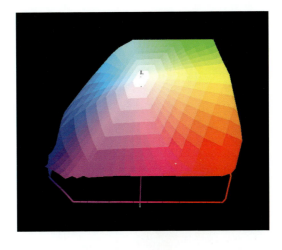

Figure 5-4: Top view – ProPhoto RGB color space

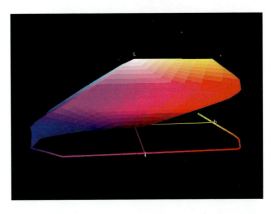

Figure 5-5: Side view – ProPhoto RGB color space

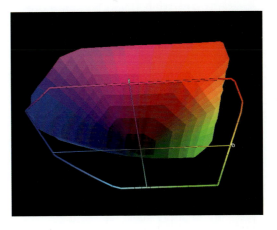

Figure 5-6: Bottom view – ProPhoto RGB color space

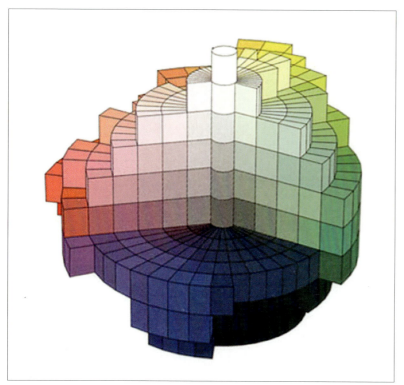

Figure 5-7: The Munsell Color System

So far we have been discussing color and color spaces. To contrast with these, figure 5-8 shows a visual representation of a black and white color space, also done in Chromix ColorThink. Black and white is color but without hue and saturation. Therefore, in a black and white color space only lightness is left, as shown in the next three figures.

In these diagrams, the vertical L axis represents lightness. The four horizontal colored lines indicate the directions in which yellow, magenta, blue, and cyan would be found if hues and saturation were present. However, since they are not present only the lightness values are being displayed on the graph. These lightness values are being represented as a vertical, tube-shaped color space. There is nothing else to display because black and white is color without hue and saturation. Therefore, in a black and white color space, the only variable that is represented is lightness.

To make visualizing a black and white color space easier, the second image in figure 5-8 is a close up of the central tube that forms a black and white color space. As you can see this tube is comparable to the black and white tube in the Munsell color system representations that we saw previously. The third image is another projection of a black and white color space superimposed onto a regular color space, in this case sRGB. The black and white color space is the vertical tube in the middle of the sRGB color space. This shows how small a black and white color space is. The solid line toward the bottom of the graph is the projection of the sRGB color space. The projection of the black and white space is also present but is hardly visible since it is no larger than the diameter of the central tube that represents the black and white color space.

color space, the colors become more vivid. This represents saturation. Colors become more saturated as they move away from the center and toward the outside of a color space.

Figure 5-2 shows a representation of what can be considered a "skeletal" representation. However, in the same book, Munsell also provided a solid, "full bodied" representation of his color system as shown in figure 5-7.

Again, we can see how closely this representation resembles a contemporary color space representation. In fact, if we were to map the Munsell Color System with Chromix ColorThink instead of using the historical drawing above, we could not distinguish it from other color space representations used in digital photography today.

Figure 5-8: Black and white color space #1

Black and white color space #2

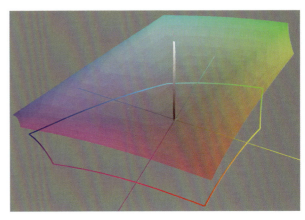

Black and white color space #3

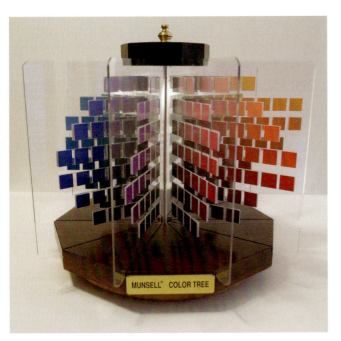

Figure 5-9: The Munsell Color Tree is a 3D model of the Munsell Color System

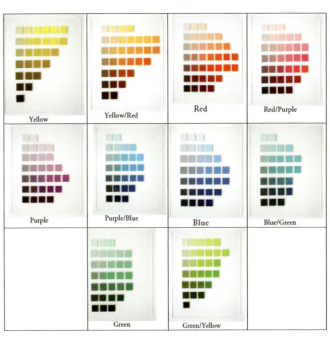

Figure 5-10: All ten color sets of the Munsell Color System

Another representation of the Munsell Color System is shown in figure 5-9, this time using a physical, three-dimensional model called the Munsell Color Tree. This model is made and sold by Gretag Macbeth, and this is the particular model I own. It consists of ten transparent panes of acrylic on which squares of color are glued. These squares represent the range of colors found in the Munsell Color System. Figure 5-10 shows all ten panes individually. Each pane shows a different color together with the variations in saturation and lightness within that color. It is made of wood and is mounted on a rotating base, making it possible to rotate the model to see each pane. The empty space between the panes allows the user to see the colors in each pane from the center to the edge of the color space.

The design of the Munsell Color Tree was chosen for practical purposes. In reality, there is no space between the colors. Instead, there are solid colors all around the model, from the center to the edges. Figure 5-7 shows a three-dimensional drawing of the Munsell Color System as it actually is. This illustration is open in the front, meaning some of the colors were removed, so we can see all the way

to the core. One of the problems of representing color spaces is showing the inside of the color space. Since color spaces are continuous, meaning the colors touch each other, the only way to show the inside is to do a crosscut, remove some of the colors, create a wire frame model, or create a semi-transparent model.

Controlling Color in Photoshop

It is not the form that dictates the color, but the color that brings out the form.

HANS HOFMAN

The model described by Munsell is present in another way in digital photography. In Photoshop we can control color by using the *Hue/Saturation* dialog box. The *Hue/Saturation* dialog box gives us access to the three variables of color independently: hue, saturation, and lightness, just as Munsell described them over 80 years ago.

These three Photoshop adjustments work exactly the way I previously described them: The *Hue* slider controls color, the *Saturation* slider controls the intensity of the color, and the *Lightness* slider controls how light or dark the color is. These Photoshop controls duplicate Munsell's description of color precisely.

In practice, I primarily use this dialog box to adjust the saturation level, and only occasionally I will adjust the lightness level, but I rarely use this tool to adjust the hue setting. This approach is based on my personal preferences regarding image adjustments. Since I adjust these variables using methods other than the *Hue/Saturation* tool, I will discuss this further in chapter 16, "Image Maladies and Remedies".

Figure 5-11: Hue, Saturation, and Lightness controls in Photoshop

Color Balance

The difficulty with color is to go beyond the fact that it is color – to have it be not just a colorful picture but really be a picture about something. It's difficult. So often color gets caught up in color, and it becomes merely decorative. Some photographers use it brilliantly to make visual statements combining color and content; otherwise it is empty.

MARY ELLEN MARK

One of the most important aspects of color photography is color balance. Color balancing a photograph means adjusting the overall color of the image so that neutral colors are correctly rendered. Color balance is sometimes called gray balance or white balance.

From a technical perspective, the goal of color balancing is to achieve a neutral color within the image to be truly neutral, that is without a color cast. From an artistic perspective, the goal of color balancing is to get colors to appear pleasing to the eye. Either approach is correct. I personally use a combination of both, working toward getting neutral colors to be truly neutral and working toward creating a color balance that is pleasing to me.

Color balance can be set in your digital camera by selecting one of the options in the color balance menu (auto, shade, daylight, flash, etc.). This will change the appearance of the image on the camera's LCD screen. However, when you capture the photograph in RAW format, the color balance information is only "tagged" to the image data and can be changed later on during RAW conversion. In other words, the color balance setting used in your camera does not alter the RAW file permanently.

I set my camera to Auto white balance most of the time, and then I adjust the white balance to the settings of my choice during RAW conversion. It is important to set the proper white balance at the time you convert the image, because a RAW file is a single-channel file. Adjusting the color balance during conversion is easier and more accurate than adjusting the color after the image has been converted. After conversion, the image becomes a tri-color image—red, green, and blue—and color correction must be done on three channels instead of one. Furthermore, a RAW file is not a photograph but is instead a set of numbers and data that will be transformed into a photograph by the RAW converter. Modifications made at that stage are applied not to a photograph but to RAW data. You are affecting the way the photograph is created, which is a much more reliable approach than modifying the photograph itself after conversion.

Both digital cameras and RAW converters offer a variety of color balance settings. The following series of examples show the color balance settings offered by Adobe Lightroom 2.0. These various settings were all applied to the same photograph. No other changes were made to this photograph other than changing the color balance. The color balance settings used are indicated under each version of the photograph.

Color balance is adjusted by changing two values: the color temperature (*Temp* in the screenshots) and the tint (*Tint* in the screenshots). The color temperature allows us to adjust the image from blue to yellow, while the tint allows us to adjust the image from green to magenta. Green and magenta are opposites (adding green removes magenta and vice versa) as are blue and yellow (adding blue removes yellow and vice versa).

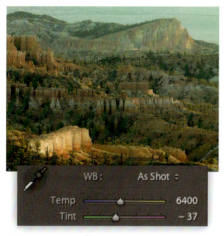

Figure 5-12: As shot

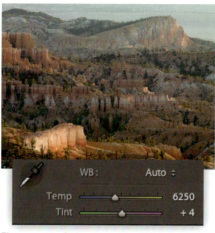

Figure 5-13: Auto

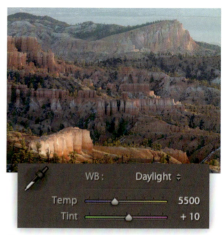

Figure 5-14: Daylight

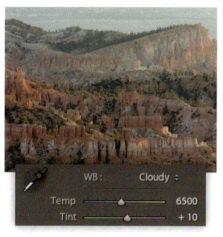

Figure 5-15: Cloudy

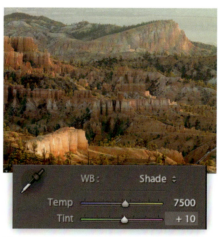

Figure 5-16: Shade

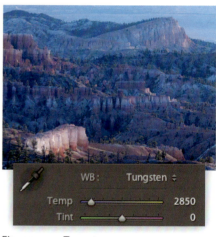

Figure 5-17: Tungsten

The proper color balance is achieved by adjusting both temperature and tint. The tint value indicates how much or how little magenta or green is added or removed. The temperature value indicates a value in Kelvin degrees.

Kelvin degrees are used to measure the temperature of a light source. Cold light (blue) has a high Kelvin number while warm light (yellow-orange) has a low Kelvin value. For example, tungsten light, which is warm, has a value around 2,800 Kelvin degrees while overcast northern light, which is cold, can have a value has high as 10,000 Kelvin degrees.

Each setting shown indicates the Kelvin degree value for the type of light source that

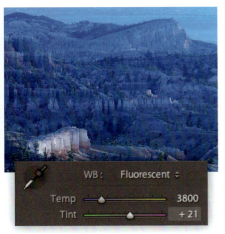

Figure 5-18: Fluorescent

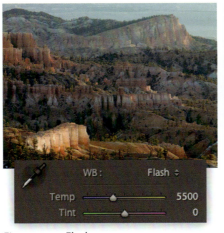

Figure 5-19: Flash

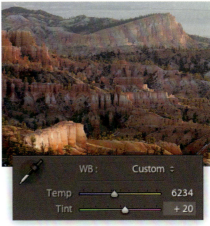

Figure 5-20: Custom

was selected. For example, the daylight preset indicates a temperature of 5,500, which is the Kelvin temperature of sunlight at noon; while the tungsten preset indicates a temperature of 2,850, which is the average light temperature of a tungsten light bulb.

Color Palette

I've been forty years discovering that the queen of all colors is black.

<div align="right">Henri Matisse</div>

Color palette is another important concept to take into account when working with color.

Color palette is different than color balance. As we just saw, color balance is about balancing the color of the light so that neutral tones are truly neutral or so that colors are pleasing overall. Color palette, on the other hand, is about selecting a range of colors that are going to be used in the photograph.

Color palette is a painting term. In painting, you start with a blank canvas. Therefore,

defining the color palette lets you choose the colors that will be placed on the canvas. We can think of painting, for the sake of argument and learning, as an *additive* process. When painting, colors are *added* to the blank canvas.

In photography, you start with a frame filled with elements and colors. Therefore, defining the color palette is often a matter of modifying, or in some instances removing colors from the photograph. We can think of photography, also for the sake of argument and learning, as a *subtractive* process. When photographing we *subtract*, or remove, colors and elements from the original scene.

Considering the color palette as part of the act of creating a fine art photograph is a novel concept. It demands that you give yourself the freedom of altering, modifying, enhancing, or manipulating your photographs. This is an important step that you have to take as an artist in order to develop a personal style (remember that we are talking about art here, not about forensic, scientific, or other literal photographic representations). Nobody forces

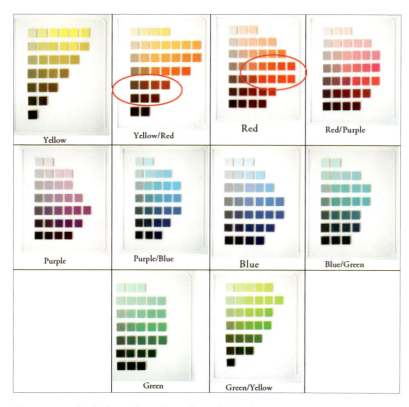

Figure 5-21: Circled in red are the colors I defined
as warm red and brown hues

When defining a color palette all three variables of color are used: hue, saturation, and lightness. For example, when defining the warm palette I just mentioned, you might decide to use saturated light reds and low saturation dark browns. Just by writing this short description we have precisely defined the two main colors of your palette.

Two important things need to be said about what I did in figure 5-21. First, I used the Munsell Color System, and more specifically, I used the photograph of the ten color panes from the Munsell Color System that we discussed previously. Second, I circled not a single color, but a group of colors. I did that for the two colors I previously defined.

I used the Munsell Color System because I want to tie the concept of color palette with what we studied previously in regard to color. It makes sense to do this since we are still talking about color in the terms that Munsell introduced: hue, saturation, and lightness.

Using the Munsell Color System to define a color palette has another important advantage. Because Munsell's description of color is used in Photoshop and other image processing software, there is a direct relationship between Munsell and digital image processing. In other words, if we define a color with the Munsell Color System we can very easily create this color in Photoshop by using the *Hue/Saturation* tool, or some of the other tools we will study later on in this book.

Why did I circle more than one color? After all, I talked about single colors rather than groups of colors, therefore I should have circled a single color. I did so because when talking about a color palette we are not referring to a single color. Instead, we are referring to a group of colors. The expression "color palette" is not a scientific term. Instead, it is an artistic

you to manipulate your work, however, it is necessary that you take a stand for or against manipulation, as it is a significant step.

For now we are considering color palette for what it does best: the selection of a range of colors used in a specific photograph. Color palettes are defined for a single photograph or for an entire project (if you are working on a project and wish this project to have a color continuum). For example, you could work on a project in which the color palette makes use of a variety of blues and whites. Or, you might work on a project in which warm hues such as reds and browns are used.

expression that is used to indicate a range of colors rather than a single, specific color.

What is great about the Munsell Color System is that it works both as a scientific approach and a definition of color, as well as an artistic approach and practice of color. It can do both because this system can be used in a very specific manner or it can be used in a more general manner. Using the Munsell Color System within a specific color space, one can define a color using RGB values. Using the Munsell Color System in a more general manner, as we do in this section on color palettes, one can define a color in general terms of hue, saturation, and brightness.

When defining a color palette for artistic purposes, as we are doing here, saying that we want high saturation light reds and low saturation dark browns is all we need. Circling the range that these two colors encompass on the Munsell Color Charts is specific enough for our purposes, because a photograph, even when its color palette is restricted to two colors, will have a certain variation of tones within these two colors. In other words, the photograph will have more than two colors in reality. A photograph composed of leaves, for example, which are desaturated dark brown in the fall, photographed in front of a sandstone canyon wall, which could be light saturated red if in full sunlight, will have many variations of reds and many shades of brown. Yet, its color palette would be light saturated reds and dark desaturated browns.

In other words, the color palette is defined in simpler terms than the actual colors used in the artwork, be it a photograph or a painting. This is the beauty and the power of a color palette. Because it is somewhat vague and unspecific, it gives the artist the freedom to interpret the color palette according to their own style and inspiration. In practice, it gives them the freedom to invent the actual colors. The outcome is that two different artists working with the same color palette would most likely not create the exact same colors. And this is the beauty of art: the lack of specific values results in endless variations in the creations by each individual artist.

Defining a Color Palette Using Chromix ColorThink

Another way to define a color palette besides using the Munsell Color Tree is by using Chromix's ColorThink software tool to map the colors of the photograph to a color space. This mapping can be done by itself, or it can be superimposed onto a specific color space to see how much of that particular color space is used by the photograph, which is exactly what I did with the photograph titled "Indian Paintbrush" (figure 5-22). I opened the photograph in Chromix ColorThink and graphed its colors in 3D, and in this case to a LAB color space. The resulting graph is comparable to the graph of any color space, such as those we saw previously in this chapter.

Figure 5-23 shows the colors that are present in the photograph looking at the color space from the side, and figure 5-24 shows the same color space looking from the top down. Each color in the photograph is represented by a small dot of color on the graph.

When looking at the colors from the side we see the Lightness axis running vertically at the center of the graph and we see the Color axis going in four different directions toward the corners of the graph. We learn a number of things from looking at this graph.

First, there are only a few colors in this photograph. Second, the color that is dominant in quantity and in saturation is red, as shown

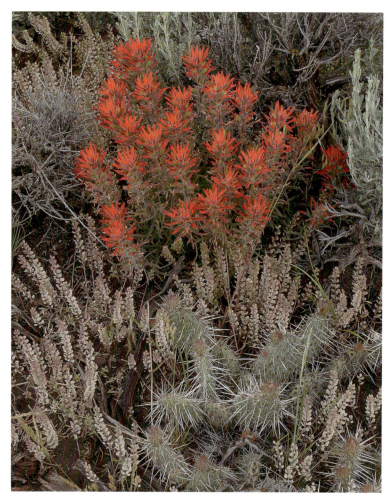

Figure 5-22: *Indian Paintbrush*

Figure 5-23: Color space side view

Figure 5-24: Color space top-down view

by the large amount of space taken by the red dots. These dots extend far to the right, meaning that the reds are very saturated. Remember that the visual representation of the colors in this photograph follows Munsell's System. Saturation goes from the center outward, lightness goes up and down, and hues go in a circular way around the color space. Third, we can see that there are no extreme bright or dark areas in the image, therefore the contrast

of this photograph will be low. This is shown by the dots in the center of the graph, along the vertical Lightness axis. These dots do not go all the way to the top or the bottom of the color space, showing that there is little to no pure white or pure black in the image.

The top down view shows the same information but provides a better view of the colors found in this photograph. It confirms what we previously saw: reds dominate and are the

Figure 5-25: The image inspector dialog box from which you create a 3D graph of the photograph

Figure 5-26: *Indian Paintbrush* image in sRGB color spaces side view

most saturated color, while the rest of the colors consist essentially of soft mauves, greens, and blue-greens. None of these colors are very saturated, as shown by the dots being close to the center axis.

The two graphs in figures 5-26 and 5-27 show the same information as discussed earlier, but now I added the graph of the sRGB color space on top of the photograph color space. I chose the sRGB color space for this example, however any color space can be used. The color space is in full color, while the photograph is graphed as it was in the previous graphs, with dots of color. The photograph is now located within the sRGB color space and is seen by looking through the sRGB color space which is shown as semi-transparent for the purpose of this illustration.

The first thing we notice is that the colors in the photograph occupy only a small area of the sRGB color space. While there are many

Figure 5-27: *Indian Paintbrush* image in sRGB top-down view

Figure 5-28: ColorThink Logo

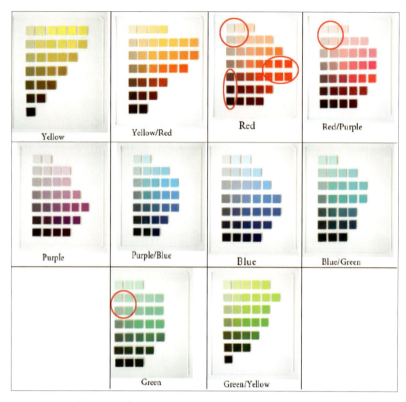

Figure 5-29: The colors found in *Indian Paintbrush* circled on the Munsell Color Tree panes

colors reach the top or bottom of the sRGB color space.

All this information is very useful in helping us define the color palette used in this photograph. This is a more technical approach than finding the colors on the Munsell Color Tree but it works just as well. My recommendation is that you use both approaches since, as we just saw, they complement each other very well.

Saturation

To see in color is a delight for the eye but to see in black and white is a delight for the soul.

ANDRI CAULDWELL

Saturation is an important yet overused aspect of color. In short, it is just too easy to oversaturate a photograph, either globally or locally, in an attempt to make it more colorful or more interesting.

Certainly, it can be said that overusing the two other variables of color is just as bad: making a photograph too light or too dark is not good, and having too many different hues in an image is a sure recipe to make it look gaudy. Similarly, reducing the hues to a minimum may remove interest in the image altogether. But right now, I want to specifically address the issue of saturation because I believe this subject needs a little discourse now followed by a few remedies later in chapter 16 on "Image Maladies".

The problem with saturation starts with RAW files. RAW files are by nature desaturated. This is simply one of the aspects of capturing photographs in RAW format. Therefore, in order to make them look normal (whatever "normal" might mean to each of us) we have

nuances of color in the photograph, there are not that many different colors, meaning the color palette used in this photograph is small. If we circle the colors found in this photograph on the Munsell Color Tree panes, we have the representation shown in figure 5-29.

We also see that the colors do not exceed the color space boundaries. In fact, even the reds, which are the most saturated colors in this photograph, are well within the boundaries of the sRGB color space. This is good news since it means none of the colors are clipped, therefore giving us detail in every area of the image.

Seeing the color space also confirms that the brightness range is small since none of the

to increase their saturation level. This is often the source of problems with color photographs.

There is nothing easier than oversaturating an image. I believe the simple reason is that saturation is addictive. More is better, or so it seems. Since I started teaching digital photography in 1995, I have seen very few photographs that lacked saturation. However, I have seen countless photographs that were oversaturated. Some were slightly oversaturated and many were greatly oversaturated. In just about all instances, the photographers were not aware that their images were oversaturated.

Oversaturating an image is easy. Just drag the slider to the right and there you have it: instant interest! And certainly, the majority of the public likes saturated color images. In fact, if you want to quickly create a popular image, simply oversaturate the colors and increase the contrast. While you may not achieve a sophisticated image, you will achieve an image that will please a less demanding audience.

Finding the right balance of saturation is a little like cooking. If you can't achieve a dish that has enough flavor, just add salt. If that doesn't work, add pepper. Salt and pepper are, to unrefined cooks, what oversaturation and high contrast are to unrefined photographers. They work, but they do so superficially. Furthermore, go one step too far and the dish is inedible or the photograph gives you a headache when you look at it. The line is easily crossed. Finally, twenty years of overly salted and peppered food, or of overly saturated and contrasty images, will cause you to lose your appreciation for properly seasoned cuisine and properly processed fine art images. This risk is very real, therefore I mention it here so if you decide to take this route you know what you are getting into.

So how do you prevent oversaturation? Simple. The first thing is to be aware of the risk. The second thing is to acquire a taste for how much saturation is enough. This is best achieved by comparing your work to photographs that you consider to be properly saturated. These are photographs that you like, that you admire, and that you want to use as models for your own work.

You can do this by comparing your images on-screen to images found on the Internet. Or, you can do this by comparing your prints to reproductions in books or magazines. However, the best approach is to compare your fine art prints to original fine art prints of the images you want to use as models. Anything other than an original print is a reproduction, which is never as good as an original. Something is always missing in a reproduction, thus the quality is lower than that of an original. And that is precisely why reproductions cost less than originals.

The following series of photographs shows the same image subjected to a range of saturation increases and decreases. In these examples I chose to divide saturation into five categories: none, lower than normal, normal, higher than normal, and maximum. It is possible to create finer differences between each category, and you may want to do so.

These examples are provided as a study guide. You may want to create your own examples using your own photographs. Finally, keep in mind as you look at these images that the only change made to the photograph was an increase or decrease in saturation. No other modifications were made.

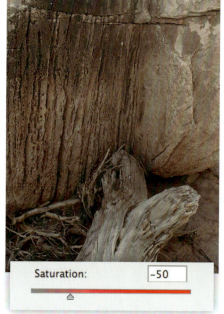

Figure 5-30: No saturation

Figure 5-31: Lower than normal saturation

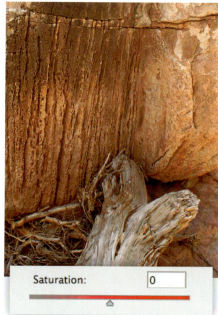

Figure 5-32: Normal saturation

Global and Local Saturation

The next step in learning how to not over-saturate your photographs is learning to differentiate between global saturation and local saturation. Global saturation is an increase or decrease of saturation that is applied to the entire image or to all the colors in the photograph. Local saturation is an increase or decrease of saturation that is applied to only part of the image or to some of the colors in the photograph.

Usually, when converting a RAW file you will start by increasing global saturation, which means modifying the saturation of all the colors in the image. When doing this, it is important to be careful not to oversaturate colors. As I mentioned, you can use another photograph as a guide to determine whether or not you are going too far.

As you study the results of this saturation increase you may notice that one or several colors have increased in saturation more than the other colors. In other words, some colors may have become oversaturated. If this is the case, you will need to do a local desaturation by adjusting only some of the colors in the image.

Local oversaturation often occurs with distant objects or features in the landscape. Objects that are far away in a landscape are by nature less saturated than objects that are close to us. This is because atmospheric haze, as well as dust, vapor, or other particulates in the air, reduce saturation. This means that the further an element is from us, the less saturated it will be.

If, in a photograph, a distant element is more saturated than a nearby element, the photograph will not be believable to the

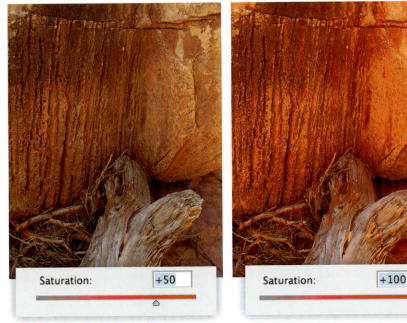

Figure 5-33: Above normal saturation

Figure 5-34: Maximum saturation

viewer. That may be fine if such is the intent, but if it is unintentional it will cause the viewer to lose interest in the image. Of course, viewers will not come to you and say, "I really enjoyed looking at your photograph until I realized that the mountains on the horizon were more saturated than the flowers in the foreground at which time I lost interest in the image because I found it to no longer be credible while your attempt is clearly to create believable representations of the landscape". This will never happen, or I should say hardly ever (never say never, there's always someone to prove you wrong when you do!). It won't happen because you are supposed to know all of that. You are expected to have control over your medium and you are expected to be aware of the effect you intend to create with your work.

The solution to local oversaturation is to lower the saturation of the afflicted color. Usually, blue is the color that oversaturates the most in landscape photography. To cure this problem, simply lower the saturation of the blues and the problem will be resolved.

Color Seeing Aides

In my photography, color and composition are inseparable. I see in color.

WILLIAM ALBERT ALLARD

There are a number of tools that can specifically help you see and compose with color. In this section we are going to take a look at these tools, in no particular order.

Figure 5-35: Zone VI

Figure 5-36: Zone VI filter in use – #1

Figure 5-37: Zone VI filter in use – #2

Filters for Analog Photography

The first tool is a color-viewing filter from Zone VI, which was made to be used with analog photography. Zone VI is no longer in business, and I purchased mine long ago. Zone VI also made a black and white viewing filter that I describe in the next chapter, "Composing in Black and White".

The goal of a color-viewing filter is to show the contrast and color balance of a specific film. I am not sure which film the Zone VI filter was designed to emulate but it does increase the contrast of the scene and it does make it look bluer. Maybe it was designed to emulate Ektachrome since this film had a color balance shifted towards blue.

I have always had mixed feelings about color viewing filters. We see in color, so why use a color-viewing filter? After all, it will show us the world in color, something we can see without the filter! The contrast increase and color shift are helpful to a point, but the filter also makes things darker, which makes composing more difficult than without the filter. I never used this filter much, certainly far less than the black and white viewing filter.

In film days the goal of a color filter was to duplicate the contrast and color of a specific

film. With digital capture, color viewing filters have become far less useful since contrast and color can be adjusted at will. Since the filter can only show one contrast and color combination, one is better off looking at the LCD screen on the digital camera.

LCD Screen

With digital capture, using your LCD screen to visualize the color in your photographs is much more effective than using a color viewing filter. Color viewing filters were all we had prior to digital. Today they are passé to say the least. However, there are a few things to keep in mind when you use your LCD screen as a visualization tool.

First, colors on the LCD screen are based on the color balance setting you selected on your camera. Changing this setting will change the color balance of the photographs displayed on the LCD screen.

Second, this color balance can be changed in the RAW converter later with no loss of quality (see color balance in section 5.5 of this chapter and in chapter 16, "Image Maladies"). Therefore, the choice of color balance in-camera is not final.

Third, the image on the LCD screen is generated from a JPEG that is generated from the RAW file. The conversion settings used to create this JPEG are based on the settings on your camera. This means that the quality of the image on the LCD screen may not reflect the full potential of the RAW file.

Fourth, your LCD screen can only exhibit some of the colors in the RAW file. This of course is dependent on the quality of your LCD screen, which is not as good as a calibrated, large-gamut monitor, for example, and definitely not as good as a fine art print.

Fifth, if exposed correctly, the image on the LCD screen will appear too bright. This is due to an approach called *exposing to the right*, which calls for overexposing digital captures to record more bits of data. Inversely, in instances where you wish to preserve extremely bright highlights, the image on the LCD screen may appear too dark. In either case, images that are overly bright or dark make for poor color evaluation. In these instances, which are common with digital capture, I recommend that you take a photograph for the sole purpose of viewing it on the LCD screen. When the capture was exposed to the right, this viewing image will have to be underexposed, and when the capture was exposed to preserve highlights it will have to be overexposed.

Finally, keep in mind the goal is not to do "LCD art". This means that the image on the LCD screen is only an evaluation image and not the final artwork. Don't go too far in trying to make it look good! You'll waste valuable time better spent capturing other photographs while the light is great. Instead, do only what is absolutely necessary to have an LCD image that you can evaluate properly,

Figure 5-38: Nigrometer

Figure 5-39: Nigrometer in use

then use what you learned from looking at the LCD screen to refine your composition.

Using a Nigrometer

Another useful tool used to study color is a Nigrometer. This tool is very simple in design. It consists of a tube with a 1/4-inch hole at each end. You use it by looking at a specific area of color through the tube.

No light reaches inside the tube, making the inside black. When you look at a specific

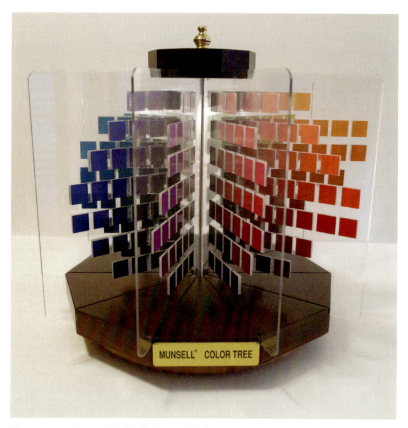

Figure 5-40: GretagMacbeth Munsell Color Tree

area through the Nigrometer, the color of that area is isolated from other surrounding colors. This allows you to study a single area of color, which is something we cannot normally do because we cannot narrow our field of view without using some sort of device; our eyes alone see several areas of color at once and we cannot isolate a single area of color.

A good exercise to conduct with the Nigrometer is to look at the same object under different lighting conditions. For example, if you look at a patch of grass both in direct sunlight and in the shade, you will see the grass take on two very different colors. The grass will be a low saturation light yellow-green when it is

in the sunlight and a high saturation darker green when it is in the shade. Doing this exercise with a variety of subjects and lighting conditions will teach you a lot about color and light.

I am not sure if you can buy a ready-made Nigrometer. I have always made mine from simple supplies. All you need is a narrow poster tube with a plastic cover at each end. Make a hole with a hole punch in both plastic covers, and paint the caps as well as the inside and outside of the tube with black spray paint (the black color is necessary to neutralize colors). Finally, glue or staple the caps to each end and you are ready to go.

Munsell Color Tree

The Munsell Color Tree is a 3D model of the Munsell Color System. I previously discussed it at length in the section on the Munsell Color System, so I will only mention it briefly here. This device is sold by GretagMacbeth and I bought mine from their website. A slightly different version is available from www.munsellstore.com.

Priced at around $300, this is not a cheap tool. However, I find it to be extremely valuable to study how the Munsell Color System works, and to study how hue, saturation, and lightness work together in changing specific colors. I use it when I want to visualize how a specific color will look if I make it darker, lighter, or more or less saturated. I also use it to determine the color palette of a specific image.

One of the nicest aspects of this tool is that the color patches are actual prints and not reproductions. In fact, each patch is glued by hand to the sheets of Plexiglas. This means that short of printing these patches yourself on your own printer, these colors are as close

Figure 5-41: Minolta IIIF color meter

Figure 5-42: Gossen Sixticolor color meter (front)

Figure 5-43: Gossen Sixticolor color meter (back)

as they can be to the actual color. As I mentioned before, the only original is a fine art print and everything else is a reproduction. These patches are originals, not reproductions, and this most likely accounts for the high cost of this tool.

Color Meters

A color meter is an instrument that measures the color of the light. Because light color is measured in Kelvin degrees, which I described previously, a color meter uses this type of measurement.

Shown here are two types of color meters. Figure 5-41 shows a Minolta IIIF, and figures 5-42 and 5-43 show a Gossen Sixticolor. The Minolta IIIF is one of the most sophisticated color meters, not only giving the temperature of a light source but also indicating which filtration is necessary to correct this light source for a specific film type.

The Gossen Sixticolor is a much simpler type of color meter that also gives the temperature of a specific light source. The Sixticolor uses a galvanometer instead of a battery and is much less costly than the Minolta IIIF. Both of

these meters are no longer produced but may be found on eBay or in used camera stores or websites.

Today, with digital capture being the norm, we no longer need to filter the light to color balance a specific film type. However, knowing the temperature of the light is still useful when making an assessment about the quality of the light and when considering which color the image will be.

This is also something we can determine by looking at the image on the LCD screen. Changing the color balance setting on your camera will change the color of the photograph. By playing with the color balance settings, and by comparing how the color of the photograph changes with different settings, you can estimate the temperature and the color of a specific light source.

Gray Cards and WhiBal

Balancing color is a challenging endeavor, as we saw earlier and as we will see again later on in chapter 16 titled "Image Maladies". However, there are a number of tools designed to help you. Figures 5-44 and 45 show one of

Figure 5-44: Small WhiBal

Figure 5-45: Large WhiBal

them, called *WhiBal*, which is designed and produced by my friend Michael Tapes.

The predecessor of the *WhiBal* was the Kodak gray card which was designed to be used with film. The Kodak gray card was middle gray and to use it, you took a photograph with the card in it prior to taking the actual photographs. By using the same lighting conditions on the gray card and in the actual photographs, you could use the gray card to color balance the prints.

The same approach is used with the WhiBal except that WhiBal includes black and white surfaces in addition to the middle gray surface. In addition to that, the middle gray surface is optimized for digital (don't ask me how this is done, ask Michael) making it ideal for color balancing digital captures.

Use the WhiBal just like you would use a gray card: by taking a photograph with the WhiBal in it followed by the actual photographs, all under the same lighting conditions. Later, in the RAW converter, you use the color balance eyedropper and click on the gray WhiBal to set the color balance. If you also

want to use the WhiBal to set the black and white points, you can use the black and white eyedroppers in Photoshop to click on the WhiBal black and white patches. This will let you set the color balance for the photograph, and alternatively the black and white points. Personally, I set the white balance in the RAW converter and I adjust the black and white points in Photoshop using separate curve adjustment layers for the black and the white points.

Keep in mind that while setting a neutral point is very important, when doing creative photography it is not always necessary to have a pure neutral gray point in the image. For example, if you photograph at sunset or sunrise, the sunlight has a warm color that you should keep in the final image. This means that color balancing the image to a pure neutral gray will not work since doing so would remove the warm glow of sunrise or sunset.

Similarly, you may want to purposely add a color cast to a photograph, for example to express a particular feeling or emotion. A snow scene with a bluish color balance will

Figure 5-46: Macbeth Color Chart – Front

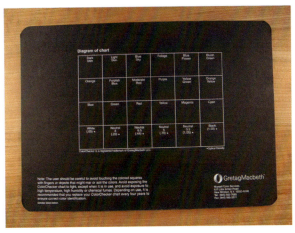

Figure 5-47: Macbeth Color Chart – Back

look colder than with a neutral color balance. And a slightly magenta color balance will make the image look warmer than a neutral color balance. Other situations may call for different color shifts, based on your personal ideas, goals, inspiration, and style.

Macbeth Color Chart

Another way to study color is to use a Gretag-Macbeth color chart. This chart was designed to be photographed or scanned, either by itself or by including it in a photograph, very much like you would use a gray card or a WhiBal.

Photographing a Macbeth color chart gives you more information about the color of the light than photographing a gray card alone. This is because the color chart gives you 16 color patches and three shades of gray in addition to black, white, and middle gray. Photographing these color patches allows you to see how different colors react to different light temperatures.

On the back of the chart are the names of each color, and on the accompanying values chart are the RGB values for these colors.

values for each patch

No.	Name	R	G	B
1.	dark skin	94	28	13
2.	light skin	241	149	108
3.	blue sky	97	119	171
4.	foliage	90	103	39
5.	blue flower	164	131	196
6.	bluish green	140	253	153
7.	orange	255	116	21
8.	purplish blue	7	47	122
9.	moderate red	222	29	42
10.	purple	69	0	68
11.	yellow green	187	255	19
12.	orange yellow	255	142	0
13.	blue	0	0	142
14.	green	64	173	38
15.	red	203	0	0
16.	yellow	255	217	0
17.	magenta	207	3	124
18.	cyan	0	148	189
19.	white (.05*)	255	255	255
20.	neutral 8 (.23*)	249	249	249
21.	neutral 6.5 (.44*)	180	180	180
22.	neutral 5 (.70*)	117	117	117
23.	neutral 3.5 (.1.05*)	53	53	53
24.	black (1.50*)	0	0	0

*Optical Density

Figure 5-48: Macbeth Color Chart – Patch values

This chart is very useful to test how colors change with exposure. The way to conduct a test that will show how color changes with over- and underexposure is described in the exercises section of this chapter.

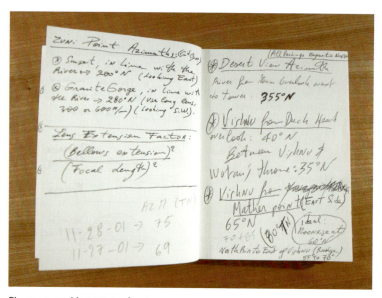

Figure 5-49: My personal notes

Figure 5-50: Notebook and pen

Figure 5-51:
Sony PCM-D1 Digital
Voice Recorder

Taking Notes in the Field

The act of painting is not a duplication of experience but the extension of experience on the place of formal invention.

STUART DAVIS

The tools I covered in the previous section are all useful in helping you to visualize color and compose with color. However, there is one more approach—one significant enough to have its own section. This is taking notes in the field when you are photographing, which is a very important practice. At no other time will you have better access to the colors in the scene you are photographing than when you are viewing it with your own eyes.

You might say, "But I have the photographs and in them are all the colors of the scene as they were when I photographed it". Well, not exactly. A photograph is indeed the most accurate representation of a scene that we have

available today. However, a photograph is not a completely accurate record of the colors in the scene. First, as we previously saw, getting an accurate color balance is not easy. Second, films and sensors introduce their own color and contrast bias. There are other issues, all affecting how a photograph differs from the way we perceive the world with our eyes. I covered all of these in chapter 3, "The Eye and the Camera", so I won't go over them again here.

All this to say that ultimately the most accurate record of the scene is what you see with your own eyes and what you remember. But memory is fleeting and therefore taking notes about what you see guarantees that you will not forget what you saw.

You can take notes mentally, but as I said memory is fleeting. However, if you can reliably record what you have seen this way, then go for it. Otherwise, I recommend that you either take notes in writing or record spoken notes. I have done all three, and personally I

find that written notes work best. With audio notes I have to transcribe them before I can use them, and that ends up taking longer than if I write them down directly.

So what do I take notes about? I take notes on the color of the light, on the color of objects in the scene, and on the contrast of various areas of the landscape. I may, for example, describe the differences between the colors of different trees. While trees are green when they have leaves and fall is yet to come, no two trees are the same exact shade of green. Juniper leaves for example are a dark bluish-green which has a low to normal saturation level. Aspen leaves, on the other hand, are a moderately saturated light green. Pine trees, such as ponderosas, tend to have medium saturation, dark green needles. Grasses have many other shades of green. No two plants that have chlorophyll—the substance that produces the green color in nature—are the same green color. The variations are incredibly large, and yet, to the untrained eye, all these plants are green.

For each scene that I want to remember, I take notes to record the three variables of color—hue, saturation, and lightness—for the different objects in the scenes. These notes do not have to be complicated. Often, they simply read as follows:

Aspens: light green with high saturation. Pure white trunks.
Medium contrast overall. Medium lightness in shaded areas. Bright light in open areas.

I may take notes on how I will process the image later on, such as:
Reduce overall contrast so that transition from light to shade is soft and progressive, not harsh and sudden.

I don't take notes on everything. I know I will remember certain things, while with others I want to make sure I can go back to my notes in case I have a question. I know I am the only source of reliable information about the light, contrast, and color in the scene I photographed. Going back to the location to check contrast, light, and colors is not a viable solution. While certain elements do not change—for example, junipers in the Southwest stay pretty much the same green year round—the light would be different and, unless I time my visit precisely, the time of year would not be the same.

Plus, going back to all the locations I photograph just to check the color of things would be a wasteful use of my time. Taking notes about these things is much more efficient. I know I will need this information, so I gather it while I am there. By making information gathering and note taking an inherent aspect of my photographic work, I save myself time and I increase the amount of data I bring back from a shoot.

We live in the information age, and we have all learned that reliable data acquisition and processing is a fundamental aspect of success. Taking notes in the field about light, contrast, color, etc. is nothing more than data acquisition, and use of this information in the studio while processing my images is nothing else but data processing. Doing so is certainly more work, but this extra work provides me with information that photographers who are not willing to do this extra work do not have, and this gives me a competitive advantage. Following this approach will give you the same advantage.

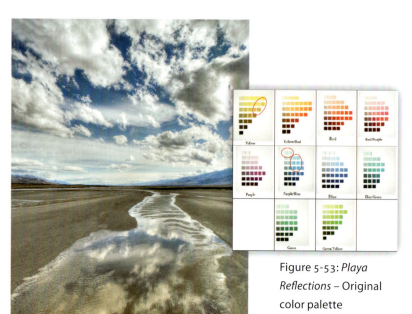

Figure 5-53: *Playa
Reflections* – Original
color palette

Figure 5-52: *Playa Reflections* – Original RAW
conversion

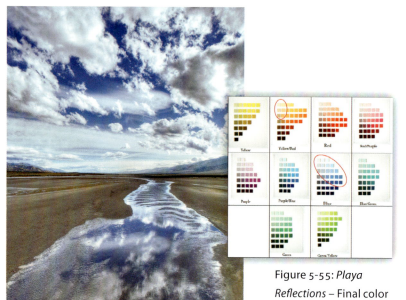

Figure 5-55: *Playa
Reflections* – Final color
palette

Figure 5-54: *Playa Reflections* – Final version

Composing with Color: Examples

*A work of art is a world in itself, reflecting senses
and emotions of the artist's world.*

HANS HOFMAN

Controlling the Color Palette:
Playa Reflections

Defining a color palette for a photograph can
seem a daunting task. However, there are ways
to make it easy. I let my inspiration guide me.
I am inspired by the scenes I photograph and
draw from this when I process and optimize
the photographs in my studio and when I
define the color palette for a specific photo-
graph. To me, defining a color palette is an
artistic process, not a technical endeavor.

There is little you can do to define a color
palette in the field. Certainly, you can choose
to photograph in a certain type of light and
you can choose to include or not include
certain objects or certain colors. All this can
help, however, the real work in defining the
color palette for an image starts in the studio.
I work on the colors of the photograph to
emphasize certain colors and de-emphasize,
or remove, other colors.

The way I do this is through the use of the
Hue/Saturation, Curves, and *Selective Color* con-
trols in Photoshop. Desaturating a color will
turn it to gray, or to a very pale hue, effectively
neutralizing this color. Changing the color
balance can also be helpful. Finally, I use both
Curves and *Selective Color* on adjustment layers
to accurately modify individual colors.

For my "Playa Reflections" image I decided
to create a color palette that consists of three
colors: blue, white, and a light, desaturated
yellow. In figure 5-52 you can see the original
RAW conversion. This conversion has a lot

of yellow in the whites and in the blues. The blues are pale and either oversaturated, as with the mountain in the background on the right side, or too light, as in the sky at the top of the image and also in the reflections at the bottom of the image.

In the final version I removed the yellow from the whites (figure 5-54). By doing so, I made the white clouds the neutral color in the image. It is always nice to have a neutral color in an image, when possible, because it gives a point of reference to the viewer against which all the other colors are compared to. Neutral tones make colors seem brighter, cleaner, and more saturated, even if the saturation level is actually fairly low.

I also darkened the blues and shifted them from light cyan to a dark cerulean blue. Finally, I warmed up the yellows, changing them from a pure yellow to a yellow-orange-brown, which I find to be more suited to this image. Blue and yellow are opposite colors, and balancing the colors of an image with two opposite colors has to be done carefully. In this instance I decided to saturate one of the two opposite colors, the blues, and desaturate the other color, the yellows. The result is a photograph in which these two colors co-exist happily instead of clashing with each other, as would be the case if both were equally saturated. The fact that the area of yellow sand is quite large and continuous helps balance it with the smaller and discontinuous areas of blue sky and reflections.

On the Munsell Color Tree panes shown in figure 5-53, I circled in red the patches of color that make up, respectively, the color palette of the original RAW conversion and the color palette of the final image. Doing this allowed me to precisely visualize which colors are present in these two images, as well as how these

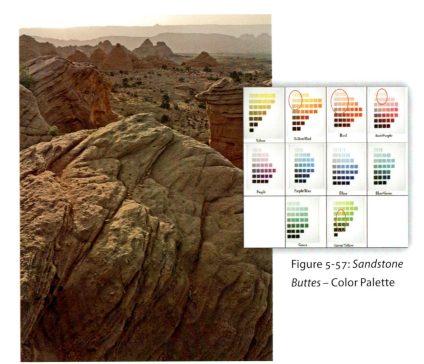

Figure 5-57: *Sandstone Buttes* – Color Palette

Figure 5-56: *Sandstone Buttes*

colors were modified when I went from the original conversion to the final version.

Working with a Specific Color Palette: *Sandstone Buttes*

In the "Sandstone Buttes" photograph (figure 5-56) I used a color palette that was very different from the palette of "Playa Reflections". The color palette in this image is the result of both the type of light present on the day I took the photograph and the color balance settings I used when converting the photograph. Therefore, I only needed to slightly modify the colors of this image.

This photograph was taken during a series of sandstorms on the Colorado Plateau, in Northern Arizona. The storms caused sand to be suspended in the air. This airborne sand

filtered the sunlight and gave it a light brown-yellow color. This photograph was taken at sunset, and because the sun was setting in front and to the left in the photograph, the buttes are backlit. This means that most of the image is lit by open shade, and therefore has a very low contrast. The mesa in the background is rendered as a smooth silhouette and its appearance contrasts sharply with the detailed foreground buttes. Some of the backlit buttes have moderately saturated orange light coming from the light bouncing off the buttes in front of them. However, besides these, most of the colors in the scene have a medium saturation.

Again, I circled the colors present in this image on the Munsell Color Tree panes (figure 5-57). Notice the presence of medium-saturation and medium-lightness greens. These greens are found in small trees located in the middle ground of the image. These trees are easy to miss on a small version of the image, so I wanted to point them out. At first, it seems that greens would not fit within this warm yellows and soft red-purples color palette. However, after consideration, the low saturation reds and greens look good together. This is because reds and greens are opposite colors, just like blues and yellows as we saw in the previous example.

Reds and greens would clash if they were both highly saturated and made to compete with one another. However, here we have small patches of green and large areas of reds, and neither color is very saturated. Therefore, instead of competing with each other, these two colors complement each other. The small areas of green provide just enough color contrast to create an opportunity for a visual comparison of reds and greens. Sometimes, having two opposite colors in one image makes each color appear more colorful than if it was shown by itself.

Global Desaturation: *Antelope Light Shaft*
Saturation is one of the most challenging aspects of composing with color. Adjusting saturation is necessary with just about every photograph captured in RAW format. However, increasing saturation is not always the best choice. Sometimes, decreasing saturation is what the image needs.

In the image "Antelope Light Shaft" the original was naturally saturated (figure 5-58). I tried increasing saturation, but when I did the colors veered toward a yellowish-red that I found unpleasant. I visualized this image as having delicate tones and the increased saturation made it look gaudy rather than sophisticated.

An alternate approach would have been to make the image black and white by desaturating it completely. However, this was not the direction I wanted to go in.

I wanted to retain some color, therefore reducing saturation was the solution. It achieved the goal of retaining some color while giving the image delicate tones. It also made the light shaft the dominant feature in the image. When the colors were highly saturated, color competed for attention with the light shaft. After the saturation was reduced the composition of the image changed, as color took a secondary role and the light shaft took center stage.

Naturally, the eye goes first to the area of highest contrast as well as to the brightest area. However, the eye also goes to the colors that are the most saturated. When a photograph has both a bright area and saturated color, the eye jumps back and forth between these two areas, not sure which one to look

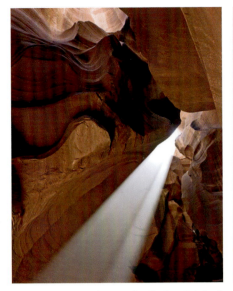

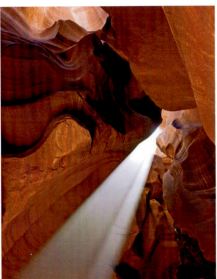

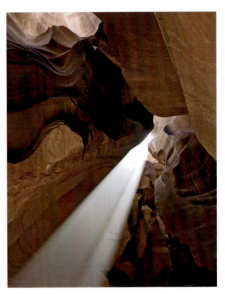

Figure 5-58: *Antelope Light Shaft* – Original image

Figure 5-59: *Antelope Light Shaft* – Saturated image

Figure 5-60: *Antelope Light Shaft* – Desaturated image

at. By desaturating the image I rearranged the order in which the eye explores the image and created a well-balanced composition.

Global Saturation: *Zabriskie Point*

Sometimes increasing saturation is necessary. This is exactly what happened in figure 5-61. The color in the original conversion was extremely flat and uninteresting. Therefore, increasing the global saturation of the image was necessary. However, in this instance I decided to saturate the image more than I normally would because I wanted to compose an image with color as the primary source of interest.

The resulting photograph is a departure from reality. While the original scene did not look as colorless as the original conversion, it did not look as colorful as the final version either. The color of the "real" scene, if there is such a thing, lies somewhere in-between the two photographs shown here.

Extreme saturation increases do not always work, but two factors made this extreme saturation increase work with this photograph. The first factor was the light in which this image was made. The photograph was taken at sunrise, and only the background—the mountain on the other side of the valley—was in direct sunlight. The rest of the scene—the foreground and the middle ground—were in the shade. Shaded areas saturate far better than directly lit areas due to their soft contrast characteristics. However, because this was taken at sunrise, the direct light was still soft and warm in color, making a global saturation increase possible.

The second factor was the semi-abstract nature of the location. Death Valley has unique features, terrain, and colors that are not found anywhere else. This uniqueness means that we are unlikely to compare photographs of Death Valley with photographs of other places. Death Valley has its own reality,

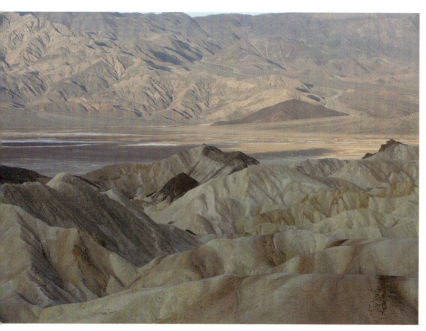

Figure 5-61: *Zabriskie Point* – Original RAW conversion

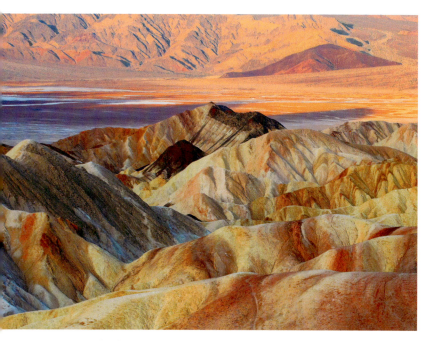

Figure 5-62: *Zabriskie Point* – Global saturation, final version

and even when you have been there it is difficult to remember the exact color of each location. The lack of a reference point means that we look at the landscape of Death Valley as it is, without trying to compare it to other places. While the colors in this image may be considered over-the-top, they are still acceptable because we are not comparing them to other places we are familiar with. If I had applied the same saturation increase to a scene that is familiar to most people, a beach photograph for example, the image would have lost its believability. Here, while some may question whether the image is real or not, it does retain a high level of believability.

I often say that my goal is to create believable images and not "real" images. Believability is different from reality. Something can be believable while being a departure from reality. Most fiction writing is that way. Things in fictional stories may not be real—indeed they are often made up either in whole or in part—but to be successful with the readers they have to be believable. One has to believe that these things can happen, even if one knows that they did not happen.

My favorite definition of fiction, given to me by Alan Woodman, my creative writing teacher at Northern Arizona University, is: "Is it real? No. Did it happen? Yes". I like this definition because it points to the fact that in fiction writing believability is more important than reality. For fiction to be successful the reader needs to believe that something can happen. However, the reader does not need to believe that something is real. A photograph meant as a departure from reality can be seen as a work of fiction, a work in which believability is more important than reality.

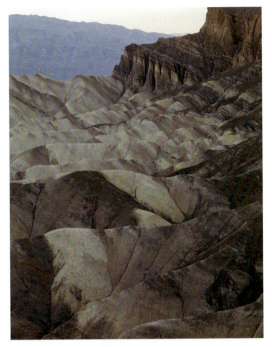

Figure 5-63: *Zabriskie Point Sunset –*
Original conversion

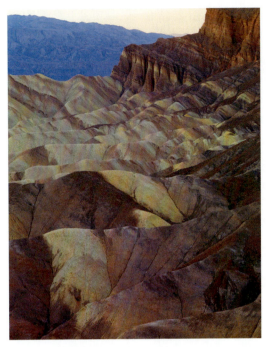

Figure 5-64: *Zabriskie Point Sunset –*
Saturated image

Local Desaturation: *Zabriskie Point Sunset*
In some instances global saturation is not the perfect answer. While it may be necessary to saturate the image globally, doing so sometimes results in some areas of the image being oversaturated while other areas of the image are properly saturated.

This is exactly what happened with the photograph in figure 5-63. While the image did need global saturation, one area of the image—the mountains in the background at top-middle—became overly saturated. The deep blue color of the mountains simply does not work with the color palette of this image. The composition of this image is based on a low-saturation, brown-red-yellow color palette. Not only is blue not part of this color palette, the high saturation level of the blue

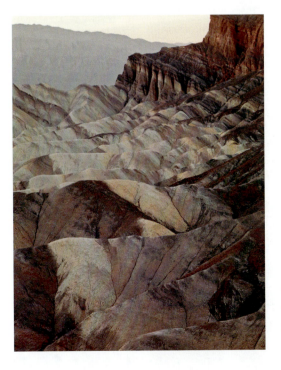

Figure 5-65: *Zabriskie Point Sunset –*
Saturated image +
local desaturation

mountain causes it to become the focus point of the image.

The solution is to desaturate the blues as shown in figure 5-65. Notice that I desaturated this area further than it was in the original. I did so to remove all the blue color so that the color palette is exactly what I wanted it to be.

To desaturate the blue area I selected only the blues in Photoshop's *Hue/Saturation* dialog box and lowered the saturation significantly. I also adjusted the hue to make the mountain brown instead of blue.

Changing Color Balance Settings:
Antelope Canyon

These examples of my "Antelope Canyon" image show how various color balance settings can transform the colors of a photograph (figures 5-66 through 5-68). The only difference between these three images is the color balance settings. A different color balance preset was used for each image: respectively tungsten, fluorescent, and shade. All the other conversion settings are similar for the three images.

The results are three photographs that, to the untrained eye, look as if the colors had been modified in Photoshop using *Hue/Saturation*, *Curves*, or *Selective Color*, to name a few of the many ways color can be altered digitally.

Which of these three images you like best is a matter of personal taste. I like the first one (the tungsten color balance) the most because of the contrast between warm and cool colors. The blues are very beautiful and the presence of yellows and pinks create a stunning color contrast.

The blues are created by air light and are particularly visible when a cool color balance setting is used. Because the *tungsten* preset favors

cool colors, I often use it when I want to show air light in a photograph. The air light color is partly visible in the image where the *fluorescent* preset was applied. However, air light disappears totally when the *shade* preset is used because this preset warms up the image so much that the blues are no longer visible.

On the composition side, the *shade* preset creates an image that is more uniform in tone and in composition. Warm colors dominate, with yellows, oranges, and blacks composing nearly the entire color palette of the image. The *tungsten* preset, on the other hand, creates an image in which different zones of color—blues, pinks, blacks, purples, and yellows—contrast with each other and create a rich color environment. There is a lot of differentiation between colors in the tungsten image. However, the color palette is coherent, meaning the colors are harmonious and do not clash with one another.

Photographing Color in Open Shade:
Indian Paintbrush

Open shade is one of the finest lights for photography, so much so that a number of photographers use open shade exclusively for their work.

Open shade is characterized by low contrast, absence of shadows, and saturated colors. The colors are so saturated in open shade that, depending on the subject, they sometimes require very little additional saturation to look good.

Such was the case with the image in figure 5-69, "Indian Paintbrush", taken in Northern Utah with a Canon 1DsMk2 and a Canon 50mm f1.8. I saturated the image about 10% and this was all that the image needed. Besides careful color balancing, hardly

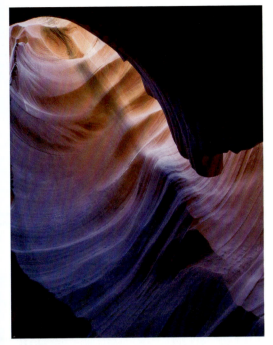

Figure 5-66: *Antelope Canyon* – Tungsten

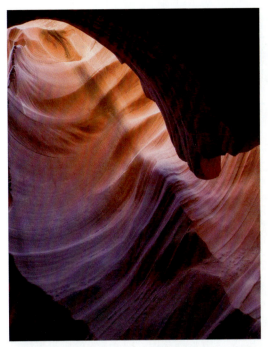

Figure 5-67: *Antelope Canyon* – Fluorescent

anything else was done to the image besides sharpening it prior to printing.

The reason for the very low level of saturation was two fold. First, the most colorful part of the image, the Indian Paintbrush flowers, was naturally very saturated. Even with a low level of saturation added, the flowers were just about ready to clip the color space. They were so saturated that any further increase in saturation would have caused the reds to exceed the boundaries of the color space, which would have clipped the color. The clipped areas lose all detail and may look as if the color is *bleeding*, meaning the color looks as if it is spreading onto neighboring areas of the image. Bleeding is particularly visible on fine art prints because a fine art print is where the largest number of colors is reproduced. Bleeding is less visible on the web or in a printed

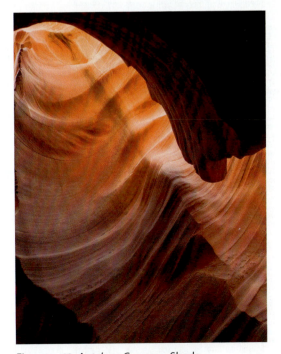

Figure 5-68: *Antelope Canyon* – Shade

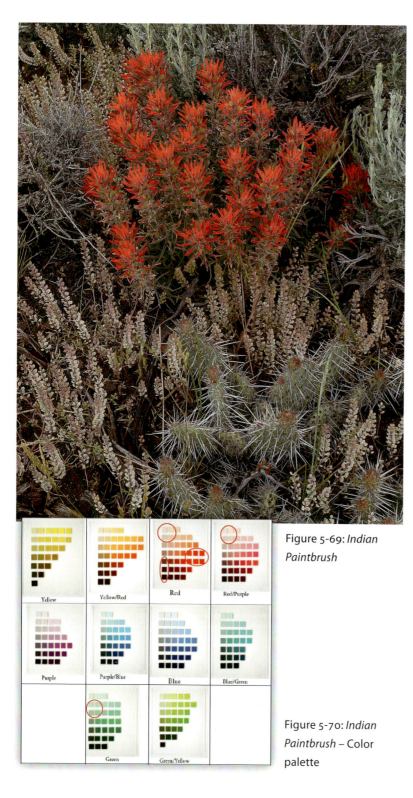

Figure 5-69: *Indian Paintbrush*

Figure 5-70: *Indian Paintbrush – Color palette*

book because a smaller number of colors are reproduced.

The second reason why a low saturation increase was used is because I wanted to maintain a soft color quality in the other areas of the image. The composition of this image is based on a visual relationship between low saturation and high saturation elements. The red paintbrush flowers are the high saturation element while all the other plants in the image, as well as the soil, are the low saturation elements. Pushing the saturation of the image any further would have caused this relationship to fail by oversaturating all the elements, including the ones that I wanted to keep at a low saturation level.

Composing with Colors: *San Juan River*

We have seen many examples in which color plays a role in the composition. In figure 5-71 we are looking at an image in which color was the reason for the image to be created. In other words, this image was not composed *with* color; it was composed *for* color.

I saw the color of these four rocks first and then I saw the composition of the image. The rocks were naturally arranged this way. When I first saw them, walking along the river's edge, they were facing me sideways. I stepped into the water to face them the way I wanted to compose them. I liked the composition with three rocks on top and one at the bottom. If they hadn't already been arranged this way, I may have arranged them like this, although I don't know if I would have thought of it.

The four different colors of the rocks were natural, however, I did significantly increase the color saturation in Photoshop. I also increased the saturation of some colors more than others. The yellow saturated the most immediately, the red was next, and I had to

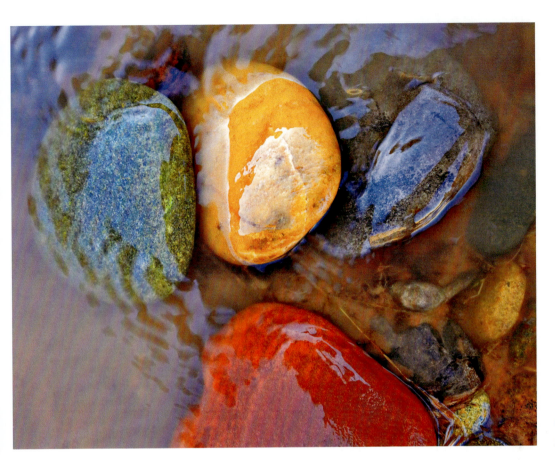

Figure 5-71: *Four River Rocks*

apply extra saturation to the blues and greens individually. It was important for the composition of the image that the saturation level of all four rocks appeared to be equal. Since this rarely happens in nature, I had to make it happen in Photoshop. The appearance of equal saturation was necessary so that the rocks had equal importance in the image. The composition is based on the four rocks sharing "center stage" so to speak, without one taking precedence over the other.

Skills Enhancement Exercises

I found I could say things with color that I couldn't say any other way. Things I had no words for.
<div align="right">GEORGIA O'KEEFE</div>

Build a Nigrometer

Following the description earlier in this chapter, build a Nigrometer.

Use the Nigrometer to study the color of objects in direct light and in shaded areas. When you have found an object whose color you are interested in, take photographs of this object in the shade and in direct light. Convert the shade and direct light photographs using the same color balance preset.

After conversion, open the photographs in Photoshop and compare the colors in the two photographs. Study how the colors of the objects change according to the lighting conditions.

Compare Color Variances with Under- and Overexposure

Perform the following steps:

- Get a GretagMacbeth Color Chart
- Photograph this chart with over, under, and normal exposure settings. Go 5 stops in both directions (5 stops underexposed and 5 stops overexposed).
- Convert the images
- See how the colors are transformed by under- and overexposure
- Using the Munsell Color Tree as reference, find out where the normally exposed, the underexposed, and the overexposed images fall on the Munsell Color Tree.

If you conducted this test correctly, you will notice that:

- Underexposure often increases saturation
- Overexposure often decreases saturation
- Extreme overexposure washes out color and color goes toward white
- Extreme underexposure muddies colors and color goes toward black

On the Munsell Color Tree, overexposed images are lighter and higher on the tree. On the other hand, underexposed images are darker and lower on tree. Finally, normally exposed images are located in the middle of the color tree.

Determine Your Color Preferences

Knowing which colors you like and which colors you don't like is important. To find out which ones you like and dislike, start by looking for color photographs that are pleasing to you and for photographs that are not pleasing to you. Looking at the photographs you like, note which colors are in the photographs. Describe each color as specifically as you can, using hue, saturation, and lightness values. Looking at the photographs you do not like, note which colors are in the photographs. Again, describe these colors as specifically as you can by using hue, saturation, and lightness values.

The next time you photograph in the field, look for scenes that feature the colors you like, and avoid photographing scenes or objects that feature colors you do not like.

Practice Taking Notes in the Field

Go out and photograph a landscape that you like. In addition to your camera gear, take a pen and paper, or a voice recorder, or both.

While you are at the scene, describe to yourself the colors in the landscape in front of you. Then record this description either in writing or through an audio recording. Describe the colors of all the objects, plants, rocks, etc. in your photograph and be as specific as you can when describing these colors. Use hue, saturation, and lightness values in your description of each color.

Once you are back in your studio, read or listen to your field notes as you convert and optimize your photographs. Adjust the colors during processing and optimization so that the colors in your image match the colors that you have described in your notes.

Compare the resulting images with images you processed previously without taking notes about color in the field. In your opinion, which photographs do you like the best? Which photographs match your experience of the scene the most?

Practice Using Hue/Saturation in Photoshop

The *Hue/Saturation* image adjustment in Photoshop gives you control over the three variables of color: hue, saturation, and lightness.

Open a color photograph in Photoshop and then open the *Hue/Saturation* dialog box. Practice moving the three sliders right and left to see how each slider modifies the colors in the image.

As you move these sliders, keep in mind that moving the hue slider is equivalent to changing colors on a color wheel; that moving the saturation slider is equivalent to moving inward or outward from the center of the color space (full desaturation) to the outer edge of the color space (maximum saturation); and that moving the lightness slider is equivalent to moving up and down the central, black and white column of the color space.

Refer to the Munsell Color System diagram if you need to visualize how these variables relate to each other.

Don't be afraid to move the sliders to the extreme right and left (plus or minus 100%). You cannot ruin anything. Doing so will allow you to visualize how the image looks when extreme settings are used. From there you can modify the settings until you find those that are the most pleasing to you.

Conclusion

The stuff of thoughts is the seed of the artist.
Dreams form the bristles of the artist's brush.
ARSHILE GORKY

Color is an important element of composition, one that you need to carefully consider when you are creating color photographs. Color is a powerful element and a judicious use of color can significantly improve your compositions, as we learned with the examples in this chapter. Therefore, it is important to learn not only how color works, but also how to adjust the color of the elements in your composition, which is done during RAW conversion and during image optimization.

Composing in Black and White

Black and white are the colors of photography. To me they symbolize the alternatives of hope and despair to which mankind is forever subjected.

<div style="text-align:right">ROBERT FRANK</div>

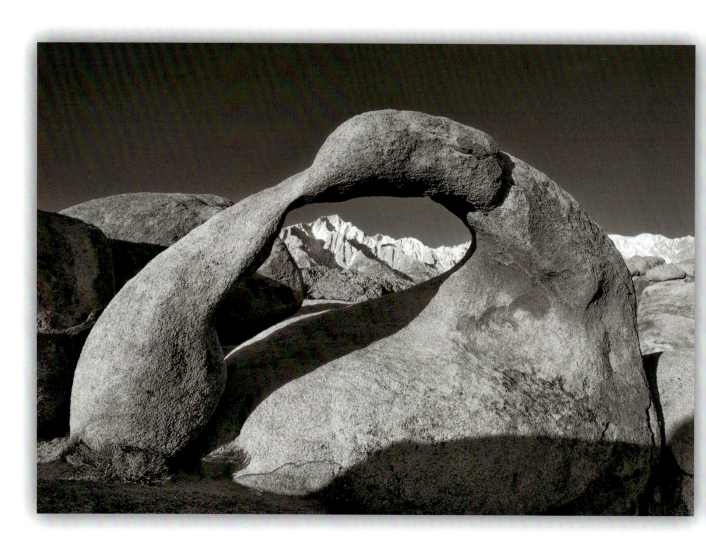

Introduction

I am often asked which is more difficult: color or black and white photography. The answer is that one is not more difficult than the other. They are simply difficult in different ways.

In the film days, color or black and white was a choice that had to be made in the field, before taking the photograph. Today, with digital photography, this decision can be made after image capture. All digital cameras capture images in color, and if you want a black and white image, you can convert it to black and white during RAW conversion or during image optimization. This means that you can always go from color to black and white and, inversely, that you can plan to make an image black and white then later change your mind and keep it in color.

With digital, the decision to do color or black and white is reversible and can be made at any time, with one exception. The only time that you have to make a non-reversible decision regarding photographing in black and white is when you photograph with an infrared camera. Infrared digital cameras are designed to capture only infrared photographs, and in that case the resulting image will not be reversible to a full-color image.

Black and White Is Color with One Variable

As we saw in the previous chapter, "Composing with Color", black and white is color with only one variable: lightness. Black and white has no hue and no saturation. The only variable that photographers working in black and white have at their disposal is lightness. They have to do everything with one variable that color photographers do with three. In a sense, it is easier because you only have one variable to control. On the other hand, it is more difficult because you must do everything with fewer tools. Black, white, and shades of gray are all you have to work with.

Seeing the World without Color

Why would anyone want to photograph an indisputably colourful world in monochrome? If colour film had been invented first, would anybody even contemplate photographing in black and white?

RUSSELL MILLER

Besides giving you only one variable to work with, black and white offers another big challenge: you have to see the world in black and white values, which means in shades of gray. Since we naturally see the world in color, seeing the world in black and white means being able to change reality from color to black and white. Black and white is a departure from reality, one that the photographer has to learn to perform. Black and white is an abstraction, an alteration of reality, a manipulation if you will. It involves seeing the world without color.

Composing in black and white is also quite different from composing with color. Clearly, what I said about composing in color in the previous chapter no longer applies here since there are no colors in black and white. Instead of composing with color we have to compose with tone and contrast, which I will talk about how to do later on in this chapter.

Figure 6-1: *Sierra Arch*

Black and White and Art

Colour is everything, black and white is more.

DOMINIC ROUSE

The emergence of black and white photography was due to the technical limitations of early cameras. Quite simply, creating color photographs was not something that was technically possible in the early days of photography. Taking monochrome photographs, either black and white or sepia, was therefore the norm.

Many people think that black and white art came about because of photography, but the fact is that black and white art existed long before photography. It was not called black and white though, it was called pencil (or charcoal) drawing. Only one of the three variables of color—lightness—is used in a pencil drawing. Hue and saturation are not present, therefore all that the artist has to work with are black, white, and shades of gray. Black and white drawings were commonly done in preparation for a color painting in order to study how light would be used in a specific composition.

Because black and white uses only lightness, it is perfectly suited to the study of light. Using black and white to study light reduces the composition to areas of lightness and darkness. If the final piece is to be done in color, color is added afterwards, when the composition has been defined in terms of light and dark areas. When I studied painting at the Beaux Arts in Paris, we often did a black and white drawing to study how light was going to be arranged in a painting. The color painting was done afterwards, building upon the lighting arrangement we had defined in the drawing.

It is often thought that the purpose of a pencil sketch on canvas is to mark the areas where objects are to be painted. Certainly, that is one of the purposes we could describe as making the best use of the canvas-space. Making effective use of this space and defining where objects and elements will be placed are definitely important. However there is another, and just as important purpose behind doing a pencil sketch prior to creating the color painting, and that is to define areas of lightness and darkness.

We could say that one of the purposes of a pencil sketch is to define the location of objects in the painting. In that respect the pencil sketch follows the traditional rules of composition. We could also say that another purpose of a pencil sketch is to compose with light. In that respect the pencil sketch follows a far less traditional approach to composition. In fact, by making a pencil sketch the artist composes with black and white.

If we embrace this second premise, the use of black and white in art is nothing new. In fact, it goes back as far as we can find pencil and charcoal drawings, which is basically as far back as the first man-made representations on the walls of caves and canyons. Photography continues this tradition.

Black and White and Manipulation

A very fine photographer asked me, "What did it feel like the first time you manipulated an image?", and I said "Do you mean the first time I shot black and white instead of color, do you mean the first time I burned the corner of a print down, do you mean the first time I 'spotted' a dust speck on my print, do you mean the first time I shot with a wide angle instead of a normal lens, I mean what are you referring to? Where does it stop?"

<div align="right">DAN BURKHOLDER</div>

Black and white photography is often considered *art* while color photography is often considered *reality*. Here I am defining a popular view of photography and not my own view. My view, as you most likely know by now, is that fine art photography is not reality, whether it is black and white, color, or something else altogether. My view is that fine art photography, as I practice and teach it, is the expression of the artist's emotions and not a straightforward representation of the world as it "really" is.

The question to tackle here is why such a large number of people consider black and white photography as art and color photography as real. Do keep in mind that in discussing this point I am referring solely to fine art photography, not to photography as used in forensics, scientific research, medicine, law, or other disciplines in which the feelings of the photographer are not supposed to be part of the photograph.

I believe the reason black and white fine art photography is considered art is because black and white is, by nature, a departure from reality. We see in color, therefore representing the world in black and white is unnatural—a manipulation if you will, depending on what term you prefer to use. At any rate it is a *modification* of reality. When looking at a black and white photograph, the audience is asked to enter a world they do not normally see around them. A world in which color is gone and only shades of gray are left. If, on the other hand, the photographer creates an image in color, then this image must be a depiction of reality since the world around us is in color.

In other words, with black and white photography the audience is asked to believe in something that they were never asked to believe in when looking at drawings and paintings. Drawings were not, and still are not, considered more artistic than paintings because they are in black and white. In fact, color oil paintings are often more valuable than drawings. They are also considered more "high art" than drawings. Therefore, in the world of painting, drawings are often considered less artistic than paintings. The logic is therefore reversed, showing that there truly is no logic at all, that there is simply a set of arbitrary beliefs laid down because of the specific use of the two mediums and because of how the development of these two mediums occurred.

In photography, black and white photography came first and color photography came later. The concept that black and white is more artistic than color did not surface before color photography came about. Until then, photographs were all black and white (or sepia, which is color monochrome) and therefore the issue of whether a photograph was art or not was made on the basis of content, not on the basis of tone.

Once color came about, color photographs started to be considered more realistic than black and white photographs, essentially because no matter how different the colors in the photograph were compared to the "real"

colors, they were closer to the world we saw with our eyes since we see in color. In other words, even a little color in an image was more realistic than a pure black and white image.

The first color photographs did not have very realistic colors. As color quality improved, and as colors became more realistic, black and white was slowly abandoned as a form of objective (i.e., forensic, legal, medical, etc.) representation, and for these purposes color took the place of black and white. Eventually, black and white came to be used only by artists who wanted to depart from reality. Why else would you use black and white since you could just as well use color? It must be because you have no interest in representing things in a realistic manner. It must be because you are an artist, and it must be because black and white photography has become art, or so the argument would go.

This argument continues to this day even though it no longer holds true (provided it ever did). Why did it hold true and no longer does? Because for a long time altering the colors of a color photograph was very difficult while altering the tones of a black and white image was easily achieved. With chemical color photography, as soon as you try to change the colors during the printing of a color photograph, you change the color balance of the whole image. The result is a photograph with poor color, rather than a photograph that better expresses your feelings.

With chemical photography, color could only be adjusted globally. What the photographer did was balance the image globally to get good color, meaning realistic color: pure blues, reds, yellows, greens, etc. The color was adjusted so that the color balance of the print matched the color balance of the transparency, or, if printing from a color negative, matched a reference color in the negative (usually a gray card).

Local color adjustments were virtually impossible without extremely sophisticated equipment. Certainly, they could be done. But one needed to create local color masks, a complex and expensive process that required extensive training and specialized equipment. Or, one could build a modified enlarger so that different colors of light could be used, preferably in specific areas of the image, which meant using multiple light bulbs and wiring them so that they could be turned on and off individually—not exactly an easy project to complete and one that only a handful of practitioners engaged in.

There were a couple of other color printing methods that allowed local color enhancements, but none of them were easy or affordable. For example, the Fresson and the Dye Transfer processes allowed local changes to the color, however, both processes were expensive and required specialized knowledge and equipment, something that was accessible only to a small number of photographers. These processes were so esoteric that the practitioners became known as much for their use of these processes as for the subjects they photographed.

On the other hand, black and white photographs could be modified "at will" during printing, so to speak. Not only that, but the amateur could easily process both films and prints with a minimum amount of expense and equipment. While color films required sophisticated development processes and were best developed and printed by a professional lab, black and white films could be developed and printed in a closet or a bathroom with a

minimum amount of expense, training, and equipment.

Furthermore, both at the film development and at the printing stages, significant contrast and tonality changes could be made to a black and white photograph with relatively simple techniques. Developing a black and white film a little more or a little less gave you images with more or less contrast. Exposing the negative a little more or a little less resulted in images that were lighter or darker. Dodging and burning specific areas of the image during exposure under the enlarger allowed the photographer to brighten or darken specific areas. Furthermore, black and white processing could be done under red lighting, meaning you were able to see what you were doing; as opposed to color processing, which had to be done in complete darkness where you could not see what you were doing until all processing was completed.

In short, and to bring this point to a close, black and white film development and printing gave a lot of creative freedom to photographers, while color film development and printing severely limited creativity. Black and white photography offered multiple ways for the photographer to express himself, while color photography limited the photographer's creativity.

Plus, there was the issue of cost. Black and white processing was far less expensive than color processing. This directly influenced who could have access to the medium and how much trial and error could be done. Black and white, because of its lower cost and freer approach, allowed photographers to produce a lot more prints, and therefore gave them the freedom to try different things and experiment with various techniques. Color photography on the other hand, because of its higher

cost and more rigid approach, reduced the amount of experimentation and creativity that most photographers could engage in.

Black and white printing became the medium of choice of photographers who were looking for a creative outlet and who wanted to express themselves, and eventually, black and white photography became accepted as art. This acceptance sealed the deal and made working in black and white a logical choice for photographers who wanted to express an artistic intent.

Digital photography made altering color photographs just as easy as altering black and white photographs. In fact, it made both color and black and white easier because we no longer had to work in the darkroom, we could take all the time we wanted to process our images, and we could save our efforts instead of being limited by exposure and development times. With digital, once a master file has been created, we can print this file without having to rework the "printing recipe" all over again the way we had to each time we made a print in the darkroom.

With digital, access to colors, both globally and locally, became possible. Suddenly we were able to change any color in any way we wanted. We could change the hue, the saturation, and the lightness of any color any way we pleased. We could not have more control over color than we have now. Certainly, we may further refine this technical control and we may make it easier to use. However, we cannot make it more extensive because we already have control over every aspect of color.

In other words, altering the tonality and the color of a digital color photograph has become just as easy as altering the tonality and the contrast of a black and white digital or film photograph. Enhancing, manipulating, and

changing the tones of a photograph can be done with equal ease on a color and on a black and white photograph. The two mediums—color and black and white—are now equal, and the choice of one versus the other has to be done on the basis of the photographer's preferences, not on the basis of the medium's creative capabilities.

Yet the belief remains that black and white is more artistic than color. This belief needs to be challenged and the only way to do so is to create artistic color photographs. Only by demonstrating that color has the same artistic and creative potential as black and white can we move away from an antiquated view of these two mediums.

Color vs. Black and White

Now to consult the rules of composition before making a picture is a little like consulting the law of gravitation before going for a walk. Such rules and laws are deduced from the accomplished fact; they are the products of reflection...

EDWARD WESTON

The fact that color has more variables than black and white—three instead of one—had been the limiting factor when photographs were developed and printed chemically. The chemical process allowed us to control only one of the three variables of color: lightness. Controlling hue and saturation remained elusive and was achieved only by a few dedicated individuals working with expensive and complex equipment and processes.

Today, what these few dedicated individuals were able to do at great cost of time and money can be done by anyone with a computer and a copy of Photoshop, Lightroom, or other image processing software.

Yet, and this is the point I want to make here, the belief remains that black and white is more *artistic* or more *creative* than color.

When digital photography was introduced we should have changed how we approach black and white and color photography. However, old habits die hard and we did not quite do that. I think this is the main reason behind the belief that black and white is more artistic than color. However, I believe that there is another reason. This reason is that black and white makes use of light as its main component. When you compose with black and white, you compose with light and dark tones. In effect, you compose with light since light without color is lightness and darkness.

Chiaroscuro, which we discussed previously when we studied composing with light, is a visual relationship between lightness and darkness. If we convert a color photograph that is composed essentially with light to black and white, the loss of color will not cause a total collapse of the image.

Figure 6-2 shows the same photograph that I used as an example of chiaroscuro in chapter 4, "Composing with Light". Next to it is a black and white conversion of this image. This conversion was done by desaturating the image 100%. Nothing else was done to this image except for a slight increase in brightness through curves, because desaturation made the image look darker than it did in color.

The lack of color did not cause the interest of this image to wane. While I do prefer the color image, I also like the black and white photograph, because the interest of this image is not just the color. The interest is mainly the light. And light is something that works very well with black and white because light, and

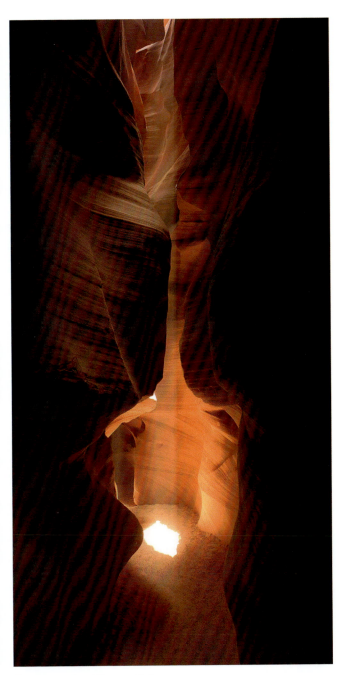

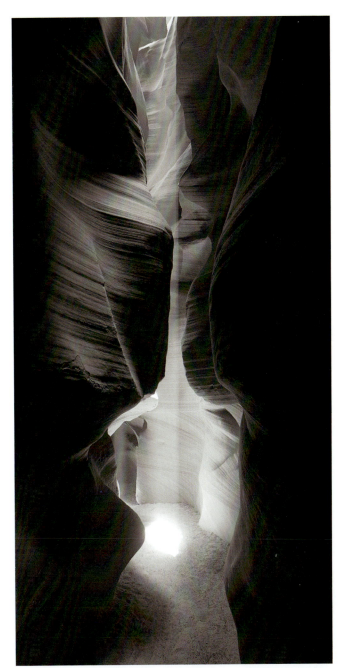

Figure 6-2: *Sand Caves* – Color

Figure 6-3: *Sand Caves* – Black and white

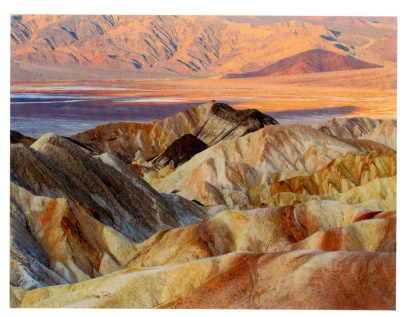

Figure 6-4: *Zabriskie Point* – Color

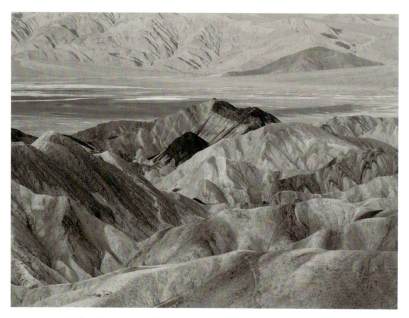

Figure 6-5: *Zabriskie Point* – Black and white

especially chiaroscuro, is about light and dark, and therefore about black and white.

Let's take another example, this time using a photograph composed with color rather than with light (figures 6-4 and 6-5). Again, as with the previous example, the color original was converted to black and white through 100% desaturation. No other adjustments were made besides resetting the black and the white points. This resetting was necessary because the black and white points had disappeared after saturation was dropped to 0, due to the color space being so drastically modified.

This image loses most of its interest when converted to black and white, because the main interest of this image is color. Therefore, when converted to black and white the interest disappears together with the color. Even after the black and the white points were reset, most of the tones remained a medium gray, and most of these tones run into each other, which makes looking at the image slightly confusing since it is no longer clear what is in front of what. Certainly, it would be possible to darken certain shades of gray and brighten others, something that I have not done here. However, I doubt that doing so would bring back the interest this image has in the color version. This image simply does not work in black and white. The fact remains that this is an image composed with color, and that therefore it has to be seen in color.

Certainly, I am using examples here that are very clear-cut. "Sand Caves" is primarily composed with light while "Zabriskie Point" is primarily composed with color, but things are not always so clearly defined. Many photographs are composed of say 50% color and 50% light, or some variation of these ratios, for example 40:60, 30:70, etc. The next image,

"Yavapai Dusk", features a composition that relies on both light and color (figure 6-6).

Unlike the two previous examples, "Sand Caves" and "Zabriskie Point", which respectively retained most of their interest or lost most of their interest when converted to black and white, "Yavapai Dusk" falls somewhere inbetween in regard to loss of interest. When converted to black and white this photograph loses some interest, but it retains some interest as well. I'm not sure if the mix of light and color is a ratio of 50:50 or 60:40, but it is somewhere close to that.

In other words, when this color image is converted to black and white the interest disappears in areas where the composition relies essentially on color, while the interest remains in areas where the composition relies essentially on light. The distant canyon, whose interest comes from the saturated purples, pinks, and reds, loses interest in black and white. However, the trees along the rim, which rely on the difference in lighting between the foreground and the background, remain interesting.

Does the image work better in black and white? No, because it is an image composed around color and light and therefore it needs color and light to work and to be enjoyable. However, the interest is not completely lost when converted to black and white, as it was with "Zabriskie Point", and this is the main point I want to make with this example.

What we are learning here is that an image composed with color does not do well when converted to black and white. However, what we are also learning is that an image composed with light can do well when converted to black and white. Therefore, we can say that composing with light is part of composing with black

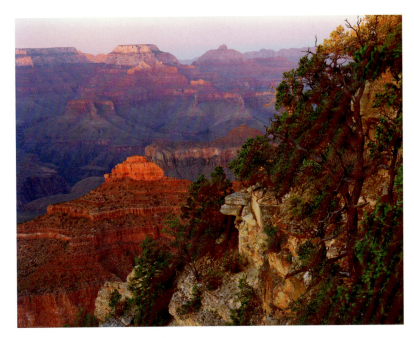

Figure 6-6: *Yavapai Dusk* – Color

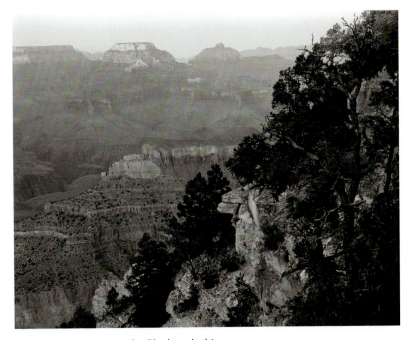

Figure 6-7: *Yavapai Dusk* – Black and white

and white, while composing with color is not part of composing with black and white.

In other words, when we compose with black and white we can rely on some of the compositional techniques used when composing with light. However, when we compose with black and white we cannot rely on the techniques used when composing with color.

This all seems very straightforward and in practice it is. The most important information here is that light is part of composing with black and white, which brings me to consider that the relationship between light and black and white may be what caused black and white photography to be considered more *artistic* than color photography. It may be that this reliance on the fundamental aspect of photography—light—(and remember that the word "photography" etymologically means *writing with light*) gives black and white photography a claim to a more direct connection with the *essence* of photography.

However, as I write this I cannot help but think of the beautiful color images that I have seen or that I have created myself. And, as I consider these images, I do not see any reason why these images should be considered less artistic than if they had been done in black and white, or why they should be converted to black and white to bring them to a higher level of artistic achievement.

So I may be wrong, or I may be right, or I may be right in some instances and wrong in other instances. I know this is not much of a conclusion to reach, but it shows the inherent difficulty of answering some of these questions. In the end, what matters is how *you* feel about this issue.

Seeing in Black and White

The world is in color, you have to work at black and white.

Andrew Maclean

We see in color. Therefore, when we compose a black and white photograph we have to, somehow, ignore color and visualize a scene in black and white. This is more easily said than done! Some photographers have an easier time doing this than others, however, the majority of photographers have a difficult time seeing in black and white. It simply does not come naturally.

For those of us who need help seeing in black and white, there are a number of seeing tools and techniques that can help us see the world in black and white values, a significant help in learning to convert the world from color to shades of gray. In this section we are going to look at what these different seeing aides are.

Squinting

The first technique is simply to squint while you look at the scene. When you squint you reduce the amount of light that reaches your eye. The result is that if you squint hard and long enough, you may see in black and white instead of color. How successful you are depends on the light level in the scene you are looking at. This technique does not always work with extremely bright scenes.

Why does squinting help us see in black and white? Simply because by reducing the amount of light that reaches our eyes, we effectively cause one of the two light-gathering devices in our eyes to stop working. Our eyes are equipped with two light gathering devices: the rods and the cones. The rods see

lightness and darkness (black and white) while the cones see color. In dark conditions the cones stop working and only the rods gather light. When this takes place we effectively see in black and white since we are no longer able to perceive colors.

Normally this happens at night or when we are in a dark place during daytime, such as a dimly lit room or a dark canyon. However, by squinting we can make this happen anytime, although as I mentioned this might not work in extremely bright light since even squinting hard may let too much light reach our eyes.

Working in Dark Places

Photographing in dark places can have the same effect as squinting. Here too, the cones in our eyes stop working and only the rods gather light. The result is that we see in black and white. This can happen in dark canyons, for example. In fact, for a long time photographers working in slot canyons (narrow and dark canyons) photographed exclusively in black and white. For some time I believed that this was due to the fact that black and white film offered a larger dynamic range than color film. However, after creating successful color photographs in slot canyons using color negative film, I came to the realization that this was not the main reason.

I now believe that the use of black and white film in these dark canyons was due to photographers seeing these canyons in black and white, literally, because the darkness caused the cones in their eyes to stop working and made them see only lightness values. This is still true today, however the advent of LCD screens allows us to see color on the photograph even though we may not see color in the canyon. LCD screens have a much higher brightness level than slot canyons, causing the

cones to work when looking at the LCD screen while only the rods work when looking at the actual canyon scene. The nice thing is once you learn which colors are present in the canyon, your brain can fill in the blanks, so to speak, and you can learn to "see" this color in the canyon even though your eyes alone cannot see it.

Black and White Filters

One of the most useful tools that can help us see in black and white is a black and white filter. This is a filter that removes all colors from the scene and that lets you see only brightness values. There are a variety of black and white filters, however all of them use variants of the Kodak Wratten #90 filter.

This filter converts color scenes to shades of black and white. It allows you to "see" the scene in black and white. The filter actually has a low-saturation orange color, but after a short time your eyes adapt to the color cast and you progressively stop seeing the orange color and start seeing the world in black and white. The filter works by removing all the color from the scene so that you only see contrast. It is very helpful both in learning to see in black and white and in visualizing how a scene will look in black and white, even if you have been photographing in black and white for a long time.

Kodak Wratten #90 Filter

The first black and white filter I ever used was an original Kodak Wratten #90 filter. This is a gelatin filter, not a glass filter, and as such it is very fragile. It can be easily scratched, dented, or cut. To prevent this from happening I mounted the filter in a slide mount. This made it easier to use and provided a frame to isolate the composition, making it both a viewfinder and a viewing filter.

Figure 6-8: Kodak #90 filter in original pouch

Figure 6-9: Filter mounted in slide mount

Figure 6-10: Photograph taken through the filter

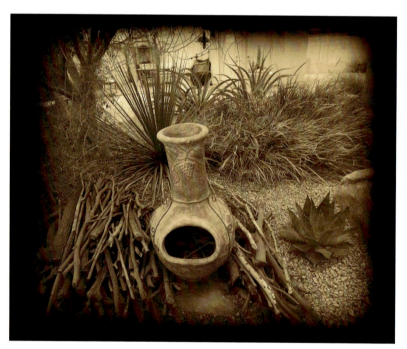

Figure 6-11: Image taken through Kodak #90 filter

Figure 6-10 shows a landscape (actually a *gardenscape*) as seen through the Kodak #90 filter. No modifications were made to the original photograph. The area of the landscape seen through the filter is black and white (actually sepia on the photograph), while the area around the filter is in color. Figure 6-11 shows a full-frame photograph of the same scene, taken by placing the filter right in front of the lens and taking the photograph through the filter. The slide mount being right in front of the lens created the diffused black border around the image. The mount is blurred because it is placed so close to the lens. I created this image to demonstrate how you see the world when looking through a Kodak #90 filter. However, I liked this effect so much that I ended up creating an entire series of images all taken through the filter and all having blurred black borders.

To say that this filter reduces the scene to shades of gray is inaccurate. What it does is remove all colors by reducing the scene to lightness and darkness values. It does not make the scene neutrally black and white. Rather, it gives a low saturation orange or sepia color to the scene. However, as I said

Figure 6-12: Zone 6 black and white filter – #1 black

Figure 6-13: Zone 6 black and white filter – #2 yellow

Figure 6-14: Zone 6 black and white filter – #3 sky

earlier, after a few minutes of looking through this filter your brain adjusts by neutralizing the color and you no longer see the orange-sepia color. You only see brightness values and eventually you have the impression of seeing in black and white.

In my series of images taken through the Kodak #90 filter, I decided to keep part of the filter color instead of making the images pure black and white. I ended up giving them a desaturated sepia tone because I found it pleasing and because it worked well with the blurred border. I also liked the antique quality that this toning gives to the images.

A number of other companies offer black and white viewing filters. Most, if not all, use Kodak #90 Gelatin filters in these filters. The only difference from the original Kodak filter is that the gelatin filter is sandwiched between two pieces of optical glass. These filters are also mounted into devices that make carrying them more practical.

Peak and Tiffen both offer mounted, portable versions of the Kodak #90 filter. Using these instead of the original Kodak filter is nice because you won't damage the filter. However, these filters are smaller than the

Figure 6-15: Peak black and white viewing filter

Kodak version, making them less useful in my opinion.

The only company I know of who made a large mounted black and white viewing filter was Zone VI. Now out of business, Zone VI was bought by Calumet, who may continue to offer the Zone VI filter under their name (I haven't checked if they do or not). The Zone VI filter was nice because it was large, was mounted in a sturdy frame, and came with a lanyard so you could carry it around your neck when photographing. Photographers like to carry things around their necks. Therefore, if you do, you are a real photographer!

Figure 6-16: Tiffen black and white viewing filter

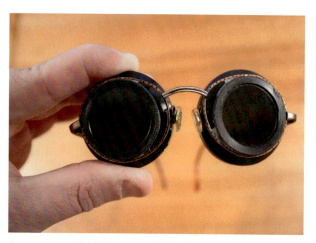

Figure 6-17: Alain's homemade black and white glasses

Figure 6-18: How do I look in these?

Black and White Glasses

These two photographs show a device that I made myself; namely a pair of black and white viewing glasses (figures 6-17 and 6-18). These were made by taking two Tiffen black and white viewing filters, removing the little handle located on the Tiffen filters, and then gluing the two filters into a pair of viewing glasses rims. I used superglue and I had to bend the rims to accommodate the filters. The result is a pair of black and white viewing glasses, something that I dreamed of having for years until I finally got down to making them. To my knowledge, glasses like these are not available for sale ready-made. You have to make your own, and when you are done you have a pair of glasses that are guaranteed to give you this sought-after, mad-scientist look. I may very well have the only such pair of glasses in the world!

The only drawback of these glasses is their weight. The Tiffen filters are glass with metal mounts and are therefore heavy. Putting two of them together makes for a very heavy pair of viewing glasses, so much so that I had to bend the temples so they would hook behind my ears and not fall off my face.

The nice thing about this contraption (I hesitate to call them glasses) is that it shows you the world in black and white all the time, not just part of the time. This means you look at the world through black and white filters constantly, not just when you think you see something that may look good in black and white. This difference is important because when you see something you think would look good in black and white, and pull out your filter to check it out, you have already made a conscious decision about what may look good and what may not look good in black white.

How do you know what will and will not look good in black and white before you use the filter? Unless you have extensive experience viewing and photographing the world in black and white, you probably won't. And if you do, chances are that you no longer need to use a viewing filter. Black and white viewing glasses solve this problem by allowing you to see the world in black and white 100% of the time, for as long as you wear them.

Figure 6-19: Original color photograph

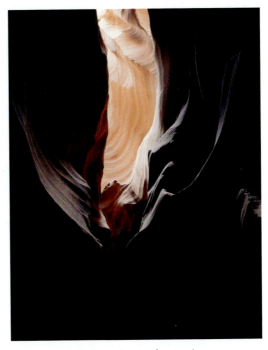

Figure 6-20: High contrast color version

Examples of Composing in Black and White

One very important difference between color and monochromatic photography is this: in black and white you suggest; in color you state. Much can be implied by suggestion, but statement demands certainty... absolute certainty.

PAUL OUTERBRIDGE

Color to Black and White: *Sandstone Swirls*

For me, creating a black and white image is frequently a decision I make in the studio, when I see that the color version is not satisfying. Most often, the problem is that I do not like the color, or I realize that the color simply is not necessary, that it takes away from the photograph rather than adding something to it. In other words, for me, converting a

Figure 6-21: Black and white conversion

photograph to black and white is a post-visu-alization decision, rather than a decision made in the field, except in a few rare instances.

In figures 6-19 through 6-21, taken on transparency film with a 4 x 5 camera, I struggled to adjust the color until I realized that the image was not about color. Instead, it was about the lines and the shapes of the image; it was about the contrast between the deep shadows and the subtle highlights. Color had nothing to do with all of that. In fact, color created a distraction rather than adding another level of interest. It took the attention of the audience away from the photograph instead of furthering the audience's interest in the photograph.

In composition, if something does not add interest to the image, then that something takes away interest from the image. In other words, nothing is innocuous. Everything in the composition matters and every element of the image has consequences.

When I understood this, I decided to remove the color and make the image black and white. Doing so transformed the image into a much more interesting photograph. It also allowed me to increase the contrast between blacks and whites (between highlights and shad-ows) much more than when the image was in color. With a color image, increasing contrast and making certain areas very dark or very bright means removing or drastically altering the color of these areas. With highlights, the color is either extremely washed out or nearly white. With shadows, the color can get muddy or nearly black. In either instance the color is often lost. With black and white this is not the case. One can push an area to pure white or to pure black and not lose color because there is no color!

One also does not have to worry about hues shifting, another problem when increasing the contrast of a color image, since there are no hues either! Finally, by increasing contrast one takes advantage of the only variable present in black and white: lightness. When doing so, one works fully within the confines of black and white, using the black and white medium for what it can do best: expressing luminos-ity values and creating relationships between areas of various lightness levels.

After creating the black and white version, and out of curiosity, I created a high contrast color version of this image. I wanted to see what level of highlight luminosity I could achieve while retaining some color, meaning without making the highlights pure white. The resulting image can be seen in figure 6-21. While this image goes in the direction that I want the image to go, it does not achieve what the black and white image expresses. The problem is that the color gets clipped because we are working with three variables instead of just one. With color images clipping can occur with color and with lightness, meaning that we can get clipping when the saturation or the lightness is increased. With black and white, clipping can only occur with lightness since there is no saturation.

In black and white the availability of one variable instead of three can be a hindrance. However, in situations like the one in this example, it is an advantage. It makes it pos-sible to push the lightness of the highlights further than can be done in color, without clipping the highlights, meaning without los-ing data in the image due to saturation levels exceeding the range of the color space.

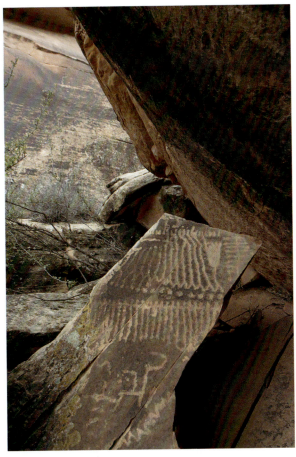

Figure 6-22: *Hardscrabble Wash –*
Original color version

Figure 6-23: *Hardscrabble Wash – Triangles #1*

Color to Black and White:
Hardscrabble Wash

The desire for lightness levels higher than can be safely achieved with color is one reason to convert an image to black and white. However, there are instances when the reason for converting an image from color to black and white is simply that color is not important. The image might actually look fine in color, but color may not add much to the photograph. In other words, the image is about something other than color. It may be about the shapes in the image, about the relationship between elements, or about the graphic quality of the image.

In the next example are photos taken at Hardscrabble Wash in Arizona (figures 6-22 through 6-25). I saw this image as being about the composition of several triangular shapes. I drew these triangles over the image to clearly show how I composed this photograph. The presence of these triangles, which I see as being the foundation of this image, was not helped by color. Color did bring new elements to the image—hue and saturation—but these elements did not help the composition. In

Figure 6-24: *Hardscrabble Wash – Triangles #2*

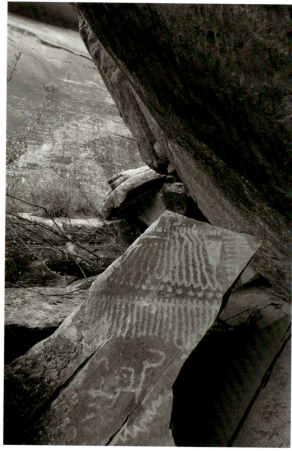

Figure 6-25: *Hardscrabble Wash –*
Black and white version

fact, removing color simplified the composition and placed more emphasis on the shapes in the image. Again, in this instance less was more.

An interesting note is that I first drew the triangles on the color version, but when drawing on the black and white version I found different triangles. My eye perceived the organization of the space differently in the color and in the black and white versions. I could see the triangles more clearly in the black and white version, maybe because the lack of color

simplified the image and made it easier to perceive these geometrical shapes.

Color to Black and White to Sepia:
Montezuma's Castle** and **Death Valley Dunes
A third alternative available in addition to color and black and white is color monochrome. A color monochrome photograph is an image in which a single hue is used, most often with a low saturation level. The most popular choice for color monochromatic

images is sepia, but blue, green, or any other color can be used.

Color monochrome images are used because sometimes the look of pure black and white does not work for some photographs. When such is the case, I like to give the image a sepia tint because it gives a warm tone to the image. Sepia also has, metaphorically speaking, the connotation of something older, something with a historical quality. Giving a sepia tone to a photograph gives the image a timeless look that I like.

This is what I did with figures 6-26 through 6-31. I didn't like the color image, and doing a pure black and white conversion didn't work for me either. So I tried sepia toning which gave the image the look I was after. Of course, these are personal choices. Your choices may be different.

When converting a black and white image to a color monochromatic image, regardless of hue, it's important to remember that we are adding the two other elements of color to that image. A black and white image has only lightness. A color monochromatic image has lightness, hue, and saturation. When making an image sepia, for example, we are adding hue, which for sepia is red, and we are adding saturation, which for sepia is a low saturation level.

However, because we are using only one color, and because we are keeping the saturation at a low level, there is little we can do with that color. We can tone highlights and shadows differently, which means double toning the image, either with two different shades of red, or with two different colors such as red and blue, and that's about it.

Using a single color throughout the image means that while there is color in the image, the viewer will percieve the image as

Figure 6-26: *Montezuma's Castle* – Original color version

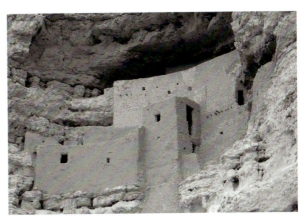

Figure 6-27: *Montezuma's Castle* – Black and white version

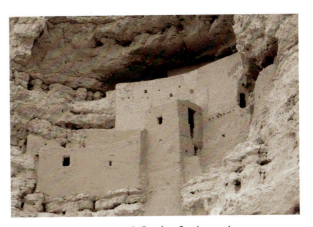

Figure 6-28: *Montezuma's Castle* – Sepia version

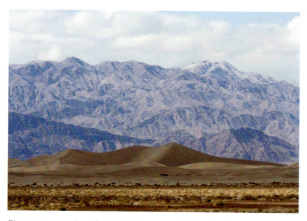

Figure 6-29: *Death Valley Dunes* – Original color version

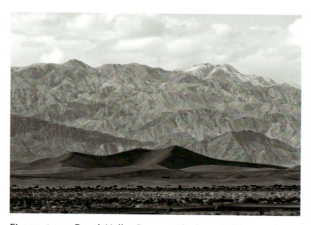

Figure 6-30: *Death Valley Dunes* – Black and white version

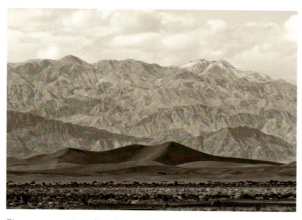

Figure 6-31: *Death Valley Dunes* – Sepia version

black and white. Remember the Kodak #90 black and white viewing filter? This filter is orange but after a few times looking through it you see the world in black and white, not in orange. The same effect occurs when you look at a sepia photograph. You are aware it is sepia, but after looking at the image for a few minutes you forget it is sepia and you see only a monochromatic photograph. Your eyes neutralize the sepia color, and only when comparing the image to a pure black and white image are you reminded of the sepia color. This makes for a sophisticated effect whose presence is both seen and not seen, or seen and forgotten, alternatively. It makes for an unobtrusive presence of color in the image and can create a refined look when used well.

Color, Saturated Color, Black and White, and Sepia: *San Juan River Ruin*

With some images, deciding between color, black and white, or sepia is simple, not to say obvious at times. This was the case with the two earlier examples, "Sandstone Swirls" and "Hardscrabble Wash".

However, sometimes deciding between color, black and white, and sepia is very difficult. Figures 6-32 through 6-35, "San Juan River Ruin", show an instance in which deciding between color, black and white, or color monochromatic was very difficult.

Shown are four different versions of this image: normal saturation color, high saturation color, black and white, and sepia. Each of these options offers a unique look and I like them all for different reasons. Making a choice between these four possibilities was therefore very challenging.

Looking at these images from a metaphorical perspective offered the best approach in terms of deciding what I wanted to express

Figure 6-32: *San Juan River Ruin –* Original RAW conversion

Figure 6-33: *San Juan River Ruin –* Saturated

Figure 6-34: *San Juan River Ruin –* Black and white

Figure 6-35: *San Juan River Ruin –* Sepia

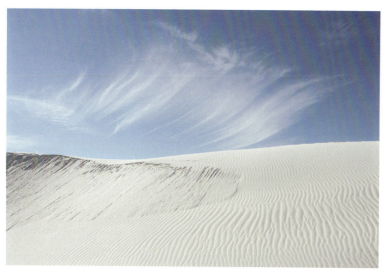

Figure 6-36: *White Sands Dune and Clouds* – Original color version

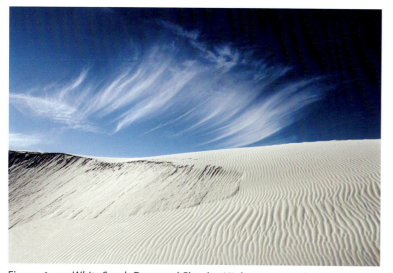

Figure 6-37: *White Sands Dune and Clouds* – High contrast color version

ruin a classic look, maybe the look we would expect to see in the work of a master black and white photographer displayed in a gallery or a museum. Finally, the sepia version gave the ruin a timeless look and reminded me of historical photographs made by archaeologists. It presented the ruin as being something from the past and played up its prehistorical aspect.

When looking at these four images this way, the sepia tone image became the most attractive. I had no interest in showing this ruin as a "normal" photograph, so this eliminated the regular color photograph immediately. The super-saturated look, while dynamic and attractive, took the image in a direction that was both overly contemporary and too easy to duplicate. The black and white look placed the image in a tradition of photography that was removed from my style. The sepia version was the one I liked the most because it played upon the ruin's current appearance, its prehistoric origins, and the history of archaeological research in the American Southwest.

Color to Black and White:
White Sands Dune and Clouds
Figure 6-36 called "White Sands Dune and Clouds" also gave me problems when I converted it from color to black and white. It simply did not work as a color image, so I had to go back to what attracted me to this scene in the first place to find out how to best express my feelings in this image.

My initial attraction to this scene, and the reason why I took this photograph, were the patterns in the sky and on the dune. I saw a similarity between the flowing pattern of the clouds and the flowing ripples in the dune.

However, the straight conversion image did not emphasize this visual relationship between the dune and the clouds. Instead, it

with this photograph. The normally saturated image came across as being a "normal" photograph. The high saturation version expressed a more contemporary approach, a "current" representation of a prehistorical site, so to speak. The black and white version gave the

played it down by making the cloud difficult to see and the dune pattern hardly noticeable.

The solution was to increase the contrast of the dune and the clouds. However, when I did that the blue became extremely distracting (figure 6-37). The super saturated blue sky became the focal point of the image and took attention away from the relationship between the dune and the cloud.

It was then that I realized that this image was not about color. In fact, there was only one color in the image besides black and white and that was blue. Converting the image to black and white would remove the blue, something that would help the composition of the image since having the sky blue was not necessary.

Converting the image to black and white also allowed me to push the contrast of the sky and the clouds to a maximum by making the sky pure black in the top right hand corner of the image, where the sky is the darkest. It also allowed me to drastically increase the contrast in the dune and emphasize the dune patterns. This allowed me to create the visual relationship between the dune and the clouds that I had visualized and that initially attracted me to this scene.

The final image has a graphic quality that I could not achieve in color. The image is also a lot simpler and, as is often the case when you simplify a photographic composition, much stronger as well.

Color to Black and White: *Monument Valley*

Again, converting the image in the example "Monument Valley" from color to black and white significantly improved the rendition of the sky by giving far more importance to the clouds.

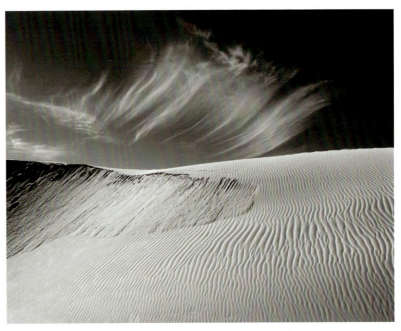

Figure 6-38: *White Sands Dune and Clouds* – Black and white version

The color image is nice (figure 6-39) but because it was taken in the mid-afternoon, the colors are nothing spectacular. Increasing their saturation level would have only made the colors more noticeable.

A far better option was to remove the color by making the image black and white. With the color gone, the attraction became the graphic quality of the image. The viewer's eye goes where the contrast is highest and where the brightness is the greatest: the clouds. This is exactly what I wanted since the focal point of this image are the fantastic clouds that were hovering over the valley that afternoon. The land and the monuments act as a metaphorical stage where the clouds can play. However, enough image-space is given to the rock formations to make them important elements of the image.

In the black and white version, the gray tones of the rock formations work much

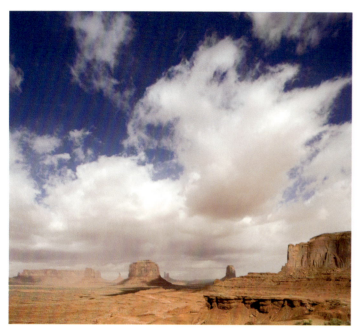

Figure 6-39: *Monument Valley* – Original color version

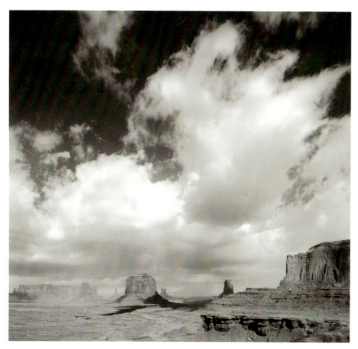

Figure 6-40: *Monument Valley* – Black and white version

better than the reddish-yellow tones these formations had in the color image. The quality of the light is far less of a problem because the main issue with the quality of the light was its lack of color, not its lack of contrast. Removing color took care of this problem by making it possible to have high-contrast black and white clouds.

Skills Enhancement Exercises

Ask Yourself Some Questions
- Think about some of your color images and ask yourself if some of them may look better as black and white images
- Find several color images that you are not satisfied with and convert them to black and white
- Compare the color and the black and white versions and decide which one you like best

Convert Your Image
- Choose an image and then convert it to color, high saturation color, black and white, and sepia
- Compare the four different versions
- Which one do you like best and why? Feel free to use the comments I made when discussing the "San Juan River Ruin" example as a guideline.

Reflect and Ask More Questions
- Reflect on the issue of black and white being more artistic than color
- Do you think that black and white photographs are more artistic, just as artistic, or less artistic than color photographs?
- What would you say if you were asked this question by someone during a show of your work?

Take time to think about this question then write down your answer. Explain where you stand in regard to this issue. Also, justify your position with facts. Explain not only *what* you believe but also *why* you believe it.

Conclusion

Black and White Photography does more to evoke an emotion and freeze a moment in time than any other medium. Looking back over the decades at such famous photographers as Steiglitz, Weston, Adams, and others has helped elevate Black and White Photography to a Fine Art form. The subtle tones of grays, the strong emphasis of the Blacks, and the softness of the Whites makes one look much closer at the subject and composition due to the lack of natural color. Emotions are always much easier to portray with Black and White, because of the stark contrasts and the sharp focus on the subject.

BOB SNELL

When making the decision to convert an image to black and white or to color, you must take into account the intention of the image. You have to decide which option—color or black and white—will best serve the image in regard to achieving the strongest composition for that image.

This decision can be easy or it can be difficult, as we saw in the examples that we studied. When weighing your options, keep in mind that you cannot permanently ruin anything by converting a color photograph to black and white only to find that you really don't like the black and white version. With digital processing you never lose anything if you are careful to save your originals, and then work on copies, always saving your work at each step of the process. Therefore, do not hesitate to try different things. By experimenting you will know far more about what can be done and what works the best for a specific image.

Very often, when working on my photographs, I end up having 10 to 20 different versions of the same image, each version being saved at a different time in the process of finding what works best. As I work toward a final image that expresses how I felt when I took the photograph, I save the image multiple times, thereby buying myself insurance in case I decide that I have gone too far in one direction, or that I have taken a direction that I do not like, or in case I want to compare different versions.

With digital these changes are free. The only cost is bytes of data stored on hard drives or DVDs. At the time I am writing this book, this cost is roughly a penny per megabyte and it is getting lower every day. In comparison to the other expenses we incur when doing landscape photography—such as food, travel, and lodging during field trips, upgrading software and hardware, purchasing consumables such as ink and paper, and more—this is inconsequential. The low cost of storing digital photographs should definitely encourage you to experiment with many different looks for your images. Try it all: color, super-saturated color, sepia, and black and white. Only by going too far and finding what you don't like will you eventually discover what you really like. And, as you do this, you will take another step toward the development of a unique, personal style.

7 Important Elements of a Strong Composition

Composition is the strongest way of seeing.
EDWARD WESTON

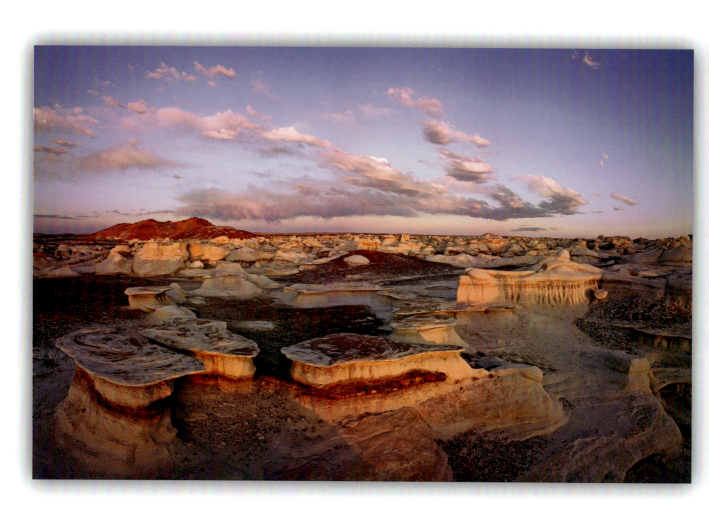

Introduction

Certain aspects of composition are what I call "foundational". That is, they form the foundation of good compositions. These are the aspects you have to consider each time you create a new composition. Rather than devote a chapter to each of these aspects, which would have made this book unnecessarily lengthy, I decided to bring them together in a single chapter and present them as a checklist. I also added short remarks after each item on this list. This list is designed to be used both at home, as a formal study of photography, and in the field, during the creation of new photographs. I like to refer to it as a checklist designed to guide you toward the creation of strong compositions.

Edward Weston said that "composition is the strongest way of seeing". This was his definition of composition. While this definition is helpful, it does not give you any details about what makes a strong composition. My goal when writing this checklist was to fill in the details about the things that make a strong composition.

This chapter has two parts. Part 1 is the checklist itself and in Part 2 are examples that expand on the checklist by providing you with insights on how I composed seven specific photographs. In the example section I talk about what inspired me and what I was thinking about as I created each photograph.

Part 1 – The Checklist

Strong Compositions Checklist

Composition Is a Machine
- To work efficiently this machine cannot have broken, misplaced, or unnecessary parts
- The machine must be designed to be simple and efficient

Keep it Simple
- Often less is more in art and in photography
- Making something simple is often more difficult than making something complicated
- The ability to simplify is a quality
- Remove distracting and unnecessary elements from the image until only what matters most remains
- What doesn't add detracts. A strong image is one in which nothing detracts. Remove all the elements that are distracting to the viewer's eye.

All Areas of the Image Are Important
- Each area of the image—corners, center, borders, etc.—is equally important
- There is no area that is not important

Figure 7-1: *Bisti Badlands Panorama*

Borders and Corners

- Borders are very important but are hard to see in small viewfinders
- Larger cameras have larger viewfinders that indirectly lead to the creation of more carefully composed images
- Use your cardboard viewfinder if your camera viewfinder is too small to see small details along the borders and in the corners
- Image borders have to be clean
- Objects along the borders must not be cut off, or must be cut appropriately
- Be careful that nothing intrudes into the image from the borders without your awareness
- You must exert control over the edges of the image and not let them control you

Light Quality

- Be aware of the light quality at all times
- Light is part of composition
- What type of light do you like?
- Is the light in the scene to your liking?
- Should you photograph now or wait until the light is different?
- Could the light be better at a different time of the day or year?
- Could the light be better in different weather conditions?
- Could the light be better in different astronomical conditions?
- "My first thought is always of light" (*Galen Rowell*). Is it yours?
- We photograph the light first and the subject second
- The best subject in the wrong light will not be interesting
- We want great light on a great subject
- We don't want a great subject in poor light!
- Changing the light changes the composition

Look for Color

- Color is part of composition
- Color has three parts: hue, saturation, and lightness
- Changing the hue, saturation, or lightness of a color changes the composition
- Studying colors in the field and taking notes about what you see is the most reliable way of creating these colors later in the studio
- It is important to precisely color balance your photographs
- Always photograph reds, because red is the rarest color you will find in landscapes. The color red is most noticeable; it stands out and adds dynamism to an image.
- Look for contrasting colors
- Red advances
- Blue recedes
- Look for cool and warm colors
- Think of the color palette you want to use
- Changing the color palette changes the composition

Create Vertical and Horizontal Compositions

- Horizontal compositions come more naturally because we see horizontally (we turn our head on a horizontal axis, from side to side, we do not normally turn our head on a vertical axis, up and down)
- 35mm DSLR cameras, which are the most popular type of cameras, have viewfinders that are oriented horizontally, making us create horizontal composition unless we purposefully turn the camera sideways
- Looking and composing vertically is a learned skill
- There are advantages to both vertical and horizontal compositions
- The goal is to find which works best for each specific composition

Create Visual Rhythm in Your Photographs

- Visual rhythm is created by using patterns in your photographs
- Patterns can be created by using straight and curved lines, or by using geometrical shapes such as triangles, squares, circles, etc.
- Or by using repetition of a line or shape such as several triangular shapes or several S-curves in the same image
- S-curves are extremely dynamic elements when you want to create a visual rhythm
- Look for S-curve patterns in the landscape and photograph them
- Another pattern that is very effective in creating visual rhythm is a C-curve
- Look for C-curves and photograph them

Threes Rule!

- Repetitions in amounts of three are aesthetically pleasing
- Look for elements in groups of three, such as three triangles, three circles, three S-curves, etc.
- Look for colors in groups of three:
 - Three elements of the same color
 - Three different colors next to each other
- Use the rule of thirds:
 - Divide the image in thirds horizontally or vertically
 - Place important elements in these three zones
 - Create emphasis by using 1/3 and 2/3 for element placement

Repeat Yourself

- Try the same composition over and over again with various subjects
- Use repeating patterns throughout the image
- Use repeating colors (in the foreground and in the background for example)
- Use repeating elements (trees, telephone poles, rocks, etc.)

Use Contrasting Elements

Visually contrasting elements work great in photographs. They add tension and interest to the image. Here is a short list of contrasting elements. Feel free to add your own to this list:

- Young/old
- Dry/wet
- Reflections/no reflections
- Red/green and blue/yellow (maximum color contrast because these are opposite colors)
- Light/dark
- Smooth/rough
- Moving/still (works well with water and rocks)
- Fast/slow
- Male/female
- Rough/smooth
- Saturated/desaturated
- High contrast/low contrast
- Big/little

Use Leading Lines

- Leading lines guide and lead the eye into the photograph
- They are part of the traditional rules of composition (See *Mastering Landscape Photography* for a presentation of the traditional rules of composition)
- They are one of the most effective traditional composition techniques
- They can be found in most locations (look for them and you will find them)
- You can create leading lines by using elements not related to each other
- Leading lines are one of the strongest ways of creating depth in a photograph

Stitching Images Together

- Stitched photographs are different than photographs taken with a super wide lens. The area seen may be similar but the image geometry is different
- Different types of stitching and various stitching software packages will give you different final images even though the individual frames are the same
- Experiment with different stitching methods

Use Visual Aides

- Use a cardboard or optical viewfinder (see *Mastering Landscape Photography* for a discussion of viewfinders)
- Use a black and white viewing filter to remove color if you shoot in black and white
- Practice previsualization (seeing the final print in your mind before taking the photograph)
- Draw your composition on paper using simple lines to see how strong your composition is

Passion In, Passion Out

- You must be passionate about your work to make your audience passionate about your photographs. If you find your work uninteresting, your audience will find your work uninteresting.
- On the other hand, if you are passionate about your photography, your audience will be passionate about it
- Love what you do!

The Rules of Composition Are Meant to be Broken

- First learn the rules, and then break the rules . You cannot break rules you don't know.
- It is okay to break the rules after you've learned them
- It is okay to make your own rules
- Always following the rules often results in repetitiveness and lack of creativity
- The best time to break the rules is after you have mastered them
- Use several rules in one image. Rules are more interesting when combined with other rules.

Have Fun!

- Don't get overwhelmed by this list
- Work on one part of this checklist at a time
- Set goals and deadlines for the completion of each part
- Make it fun and keep it fun

Part 2 - Seven Examples

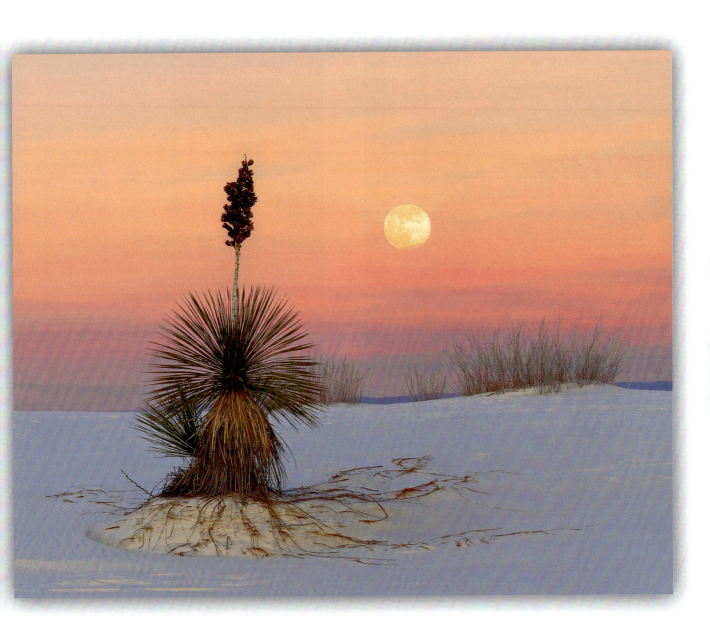

Figure 7-2: *White Sands Moonrise*

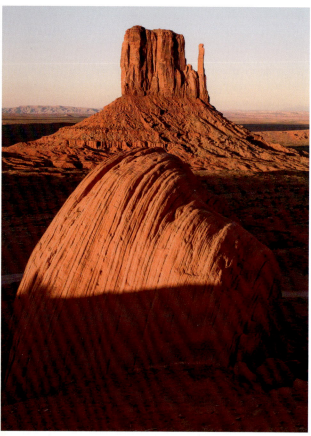

Figure 7-3: *Rock* over the Mitten

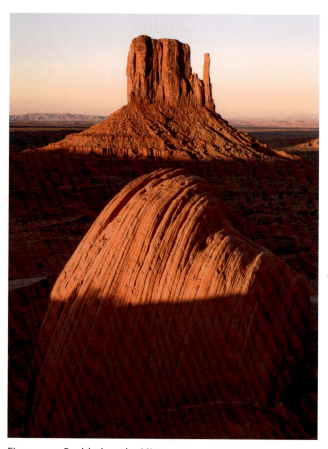

Figure 7-4: *Rock* below the Mitten

Example 1—Superimposing Objects: *Monument Valley*

Rules are useful, but without examples to show how to use them, rules can seem very abstract. In this second section I will discuss a number of photographs to demonstrate how I used some of the rules I presented. Note that I said, "some of the rules" and not, "all of the rules". To demonstrate all the rules would require an entire book, something that would be fantastic but is not my goal here. As I talk about these photographs I will also branch out into other image creation considerations that I did not include in the previous section.

One of these considerations is how elements in an image relate to each other. In the three photographs taken at Monument Valley (figures 7-3 through 7-5), we have two main elements: the Left Mitten Butte (named this way because it looks like a mitten) and the Ansel Adams Rock in the foreground, named this way because, arguably, it was first photographed by Ansel Adams (I wasn't there so I can't swear to this but it makes for a nice story and it has become part of photographic lore).

Example 1—Superimposing Objects: Monument Valley 173

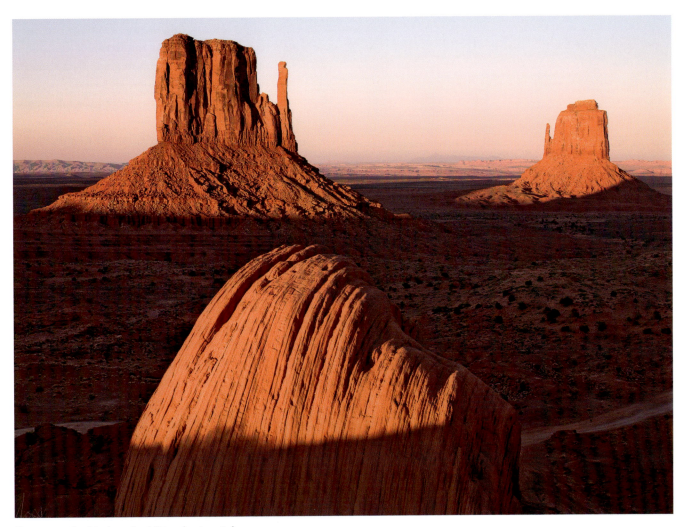

Figure 7-5: *Rock* below the Mitten horizontal

The whole point of this example is how the Left Mitten and the Ansel Adams Rock are positioned in relationship to each other. There are two possibilities: the rock can be placed over the Mitten, or the rock can be placed below the Mitten. If the rock is placed over the Mitten, then the shapes of these two elements merge and become visually confusing. It is difficult to tell where one ends and where the other begins. This is especially confusing because both the foreground rock and the Mitten are in direct light. When the rock is placed below the Mitten, it becomes easy to tell them apart. This is made easier by the fact that the rock is in direct sunlight while the area below the mitten is in the shade. The contrast between the shaded area and the directly lit areas is what makes this second composition effective.

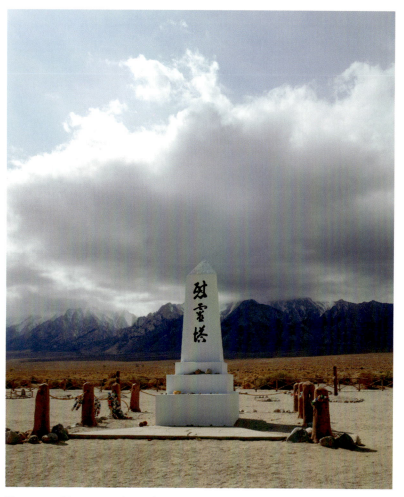

Figure 7-6: *Monument* above the mountain

Right Mitten. This was an advantageous trad-eoff because showing the second Mitten added more interest to the photograph than showing the bottom of the foreground rock.

Tradeoffs and choices often have to be made when working in the field. The decision you make should be based on the option that will result in the strongest composition. Remember that, as Edward Weston said, "Composition is the strongest way of seeing". In this instance I decided that the strongest way of seeing this scene was to not superimpose the foreground rock and the Left Mitten. Instead, the strongest way of composing this scene was to position the foreground rock below the Left Mitten, use a horizontal composition, and show both the Right and the Left Mittens. Your decision may be different, and that is not a problem, as long as you can support it in terms of compositional strength.

Example 2—Creating Visual Metaphors: *Manzanar Monument*

I often say that creating images that feature visual metaphors is the ultimate goal of composition. A metaphor is something that stands for something else. A commonplace example is a rose, which in Western culture stands for love. In itself, a rose is a flower. But through metaphorical association it stands for something other than a flower. When people who are familiar with this metaphor see a rose they see both a flower and a symbol of love. Therefore, a photograph of a red rose can be used in a photograph as a visual metaphor for love. Using soft focus, dewdrops, and glowing light to create a romantic image can further strengthen this visual metaphor. I am sure you can visualize such an image since they are

After trying both compositions and reviewing them on my LCD screen as I photographed, my choice was to use this second option for my final images. I started by creating the vertical version because the vertical composition allowed me to show more of the foreground rock. However, I realized that if I used a horizontal composition instead I would be able to show both the Right Mitten and the Left Mitten. Of course, I would have to show less of the foreground rock but this loss would be compensated for by being able to show the

Example 2—Creating Visual Metaphors: Manzanar Monument 175

quite commonplace. For this reason I am not featuring a photograph of a soft-focus rose with dewdrops and romantic lighting here. A variety of other objects can be used as visual metaphors, as long as these objects are not used in a literal manner. To be used as visual metaphors, these objects must be used for what they stand for.

In this example we have a monument located in Manzanar, near Lone Pine, California, in the Eastern Sierra Nevada (figures 7-6 and 7-7). Manzanar was a relocation camp for Japanese-Americans during World War II. This camp was called Manzanar because the location was originally an apple orchard and Manzanar means *apple orchard* in Spanish. The monument is located in the Manzanar cemetery and is a memorial to the camp residents who died at the camp and were buried there.

There is only one difference between these two photographs: the first photograph shows the top of the monument rising above the mountain, while the second photograph shows the top of the monument located below the mountain. These two images were created one after the other. The first image was with a normal lens, then I backed up a couple hundred feet to create the second image. I used a short telephoto for the second photograph to keep the monument the same size as in the first photograph. However, the longer lens caused the mountains to be larger than in the first photograph. It also caused part of the clouds to be cropped out. Finally, I changed the angle of view slightly to locate the monument under the tallest peak.

So why did I create these two images and why am I talking about them in the context of a discussion about visual metaphors? Because, for me, the location of the top of the monument in relationship to the mountain has a

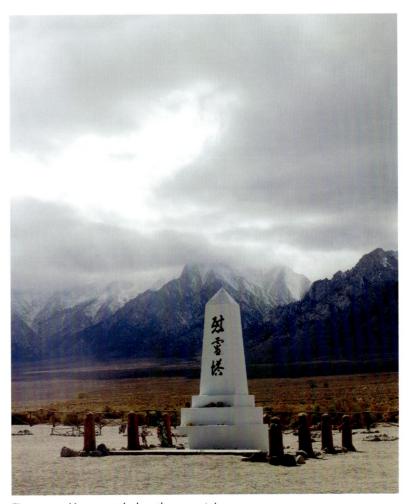

Figure 7-7: *Monument* below the mountain

metaphorical meaning. If the top of the monument is above the mountain, metaphorically, I interpret this as meaning that the monument rises above the mountain. Since the monument stands for those who are buried at Manzanar, metaphorically, it can be said that their souls rise above the mountain, carried by the monument since its top is located above the mountain. The monument rising above the mountain can also be said to represent man towering over nature. By extension, it can be seen as meaning that man dominates,

or is greater than nature. On the other hand, if the top of the monument is located below the top of the mountain, then it can be said that the mountain shelters and protects the monument, the cemetery and those who are resting there. It can also be said, always from a metaphorical perspective, that the mountain is the larger entity, and that the monument is a path, or a vehicle, through which the souls of those who are resting there can travel to the top of the mountain and to the skies above. Finally, it can be said that the monument being positioned lower than the mountain represents nature towering over man. By extension, this can be seen as meaning that nature dominates man, that nature is greater than man, or that man is part of nature.

The image with the monument located below the mountain is my favorite. To me, this image, metaphorically speaking, represents what I consider to be the proper order of things. The monument is smaller than the mountain and it is contained, visually, within the shape of the mountain. This monument stands for those who are resting there, but it also stands for us all. When we find ourselves in the immensity of nature, of the wilderness and in the mountains, we realize how infinitely small we are in relationship to the enormous size of nature and of the mountains. We do not dominate nature; nature dominates us. We do not stand over nature; nature stands over us. Finally, we are part of nature, for better or worse. I find it fitting to create an image that represents this metaphorical worldview, and that is why my favorite image is the one in which the mountain is higher than the monument.

The beauty of visual metaphors is that they can be continuously reinvented and reinterpreted. Not only can we create endless

variations on the same metaphorical theme, we can also interpret the same image in different metaphorical ways. I am sure that while some will agree with my interpretations of these two photographs, others will disagree or will have entirely different ideas in regard to what these images mean to them metaphorically. There is no right or wrong. There are simply images that offer a rich context for personal interpretation and for discussion. If you create metaphorical images, and if they generate discussion or controversy, do not feel badly about it. Instead, rejoice! You have managed to reach a metaphorical level with your work, something that I believe to be the ultimate goal of composition.

Example 3—Leading Lines: *Sand Dunes at Sunrise*

Leading lines are one of the most powerful forms of composition. A traditional approach to composition, leading lines are so effective as to be timeless. Leading lines can take many forms. I consider an S-curve to be another type of leading line. S-curves are curves with an "S" shape. If you see an S-curve somewhere, photograph it, because it is so effective and so powerful that it often leads to fantastic compositions. Just be there with the right light, make sure that the rest of the image is interesting, and you will discover that an S-curve can become the foundation of a strong composition.

I chose the image "Sand Dunes at Sunrise" (figure 7-8) as an example of leading lines because it has so many lines in it. Instead of a single line, a pair of lines, or even an S-curve, this image is structured around complex patterns that feature many different types of

Example 3—Leading Lines: Sand Dunes at Sunrise 177

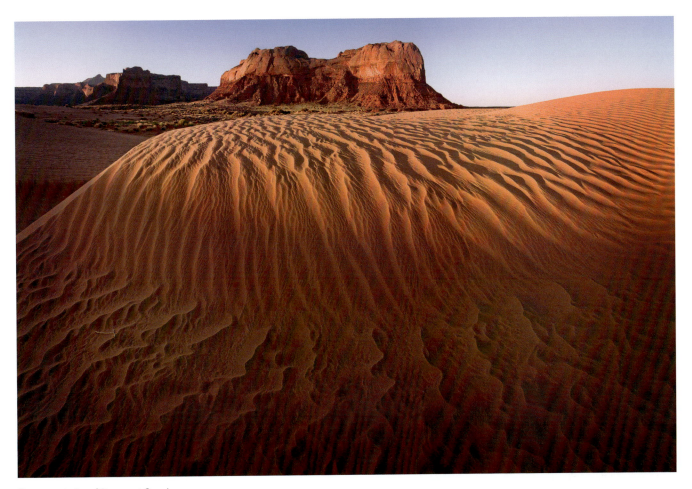

Figure 7-8: *Sand Dunes at Sunrise*

lines. We have straight and curved lines in this image. We have serpentine lines (snake-like lines) in the foreground. We have a semi-horizontal curved line that forms a separation at the top of the image between the foreground (the dune) and the background (the mesa). We have many other lines in the foreground that converge towards the mesa in the background, giving a sense of depth to the image and directing the eye towards the rock formation at the top and center of the photograph.

The light also plays an important role in this photograph. I created this image at sunrise, as the sun was breaking over the eastern horizon, and I waited until the sunlight reached the top of the dune in front of me to release the shutter. The shape of the dune, and the wide-angle lens that I used, created a semi circular pattern where the sunlit area stops and the shadows start.

When I processed and optimized the image, I opened the shadow areas significantly so that the areas in the light and the areas in the

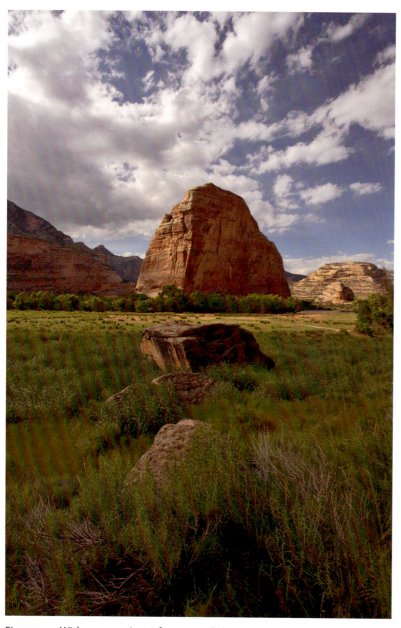

Figure 7-9: Without prominent foreground element

shade would merge together and give a feeling of light permeating throughout the scene. I did not want a sudden break between sunlit and shadow areas. I am not fond of creating high contrast scenes, at least not for most of my work.

Example 4—Near-Far Compositions: *Brown's Hole, Dinosaur National Monument*

Foreground-background compositions are one of the most powerful types of compositions. Captured with wide-angle lenses, these photographs create a relationship between the foreground and the background of the image, thereby creating interest throughout the photograph.

Having an interesting foreground is the key to a successful foreground-background composition. In this example (figures 7-9 and 7-10), the same background is used with two different foregrounds. I created the first image while looking for an interesting foreground element, and I found some possible elements: the grass, the rock, and some small twigs, but nothing that really stood out. These elements were too small and merged with each other too much, which created visual chaos rather than a well-organized composition.

In the second photograph (figure 7-10) I included part of a dead tree in the foreground. This new element was much larger than the elements I first used and it stood out clearly in front of the grass and the rock. This tree also acted as a leading line. I positioned it diagonally in the image, starting in the bottom left corner of the image and pointing towards the top right hand corner of the image. This created a diagonal line across the lower half of

Example 5—Near-Far Compositions: Vertical and Horizontal 179

image. Even though this diagonal line is not going through the entire photograph, our eye completes this diagonal line when we look at the image. In other words, the tree suggests a diagonal line and the eye completes it.

The composition of this second photograph is much stronger than that of the first image. The difference is subtle yet important. Without the tree in the foreground, the image has far less interest. Since the background and the middle ground are the same in both photographs, it is easy to see that it is the use of the tree in the foreground that makes this second image successful.

Example 5—Near-Far Compositions: Vertical and Horizontal

In the previous example we saw how important the foreground is in a foreground-background composition. Here, we will look at three more examples of foreground-background compositions. These types of compositions are also called near-far compositions because they bring together elements that are near and elements that are far. Wide-angle lenses are the lenses most commonly used to create near-far compositions.

The first example is the image I called "Hoodoos" (figure 7-11), which is a horizontal near-far composition. I tend to create few horizontal near-far compositions because it is easier to include a prominent foreground in a vertical image. This is because a wide-angle lens offers a wider angle of view in the long direction of the frame. And, since most foregrounds are at our feet, vertical images lend themselves better to near-far compositions. However, in some instances a horizontal near-far composition can work great, especially

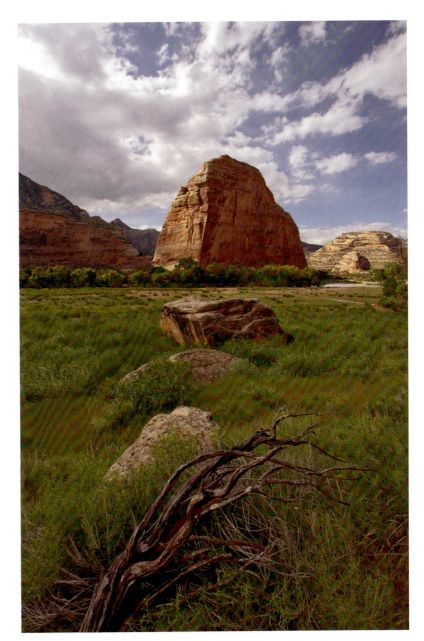

Figure 7-10: With prominent foreground element

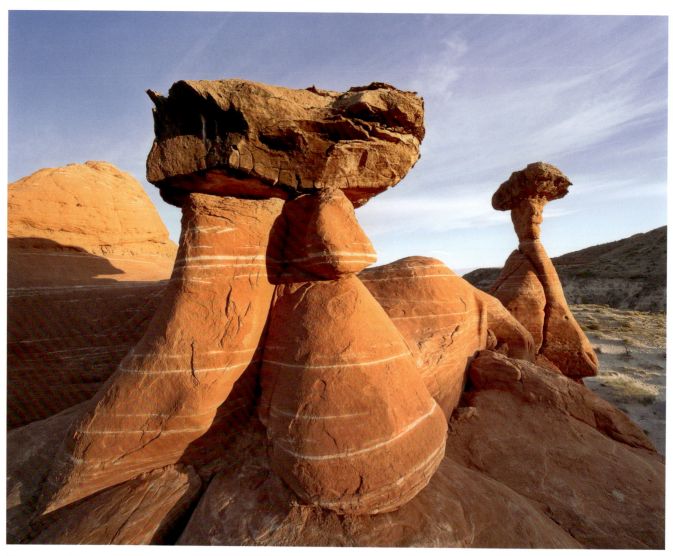

Figure 7-11: *Hoodoos*

if you have a close object on one side of the frame, as was the case in this instance. The hoodoo (rock spire) at left was very close to my lens while the hoodoo on the right was further away. This allowed me to create a horizontal near-far composition that exaggerated the relative proportions of both hoodoos as well as the distance between them. In reality both are the same height. They are also located much closer to each other than it appears in

the photograph. Wide-angles are great when you want to emphasize space and exaggerate the size of nearby objects.

The two other examples (figures 7-12 and 7-13) are vertical near-far compositions. In each of them the foreground elements were carefully chosen. When looking for foreground elements, I look for patterns, shapes, or details that have a fascinating visual quality. This is the case with the flowers in "Horseshoe

Example 5—Near-Far Compositions: Vertical and Horizontal 181

Bend with Flowers" and of the petroglyphs (Native American carvings) in "Petroglyphs in Dead End Canyon". Both elements have a beautiful visual quality and both hold interest for a long time due to their intriguing quality.

In "Horseshoe Bend with Flowers", created near Page, Arizona, the perfectly circular pattern of the yellow flowers is hard to believe, and so is their presence at the perfect location in the perfect light, outlined in front of a sandstone slab that provides a backdrop free of distracting elements while dawn brings a soft and colorful light to the landscape. The circular shape of the butte in the background provides a visual echo to the shape of the flowers. The visual resemblance of the flowers and the butte, which are both circular, was the initial motivating factor in my decision to create this image. The blues, greens, yellows, mauves, and oranges form a pleasing color palette. The most saturated color is the yellow flowers, a fitting decision since they are one of the most important elements. Finally, the soft enveloping predawn light that bathes the scene creates open shadows and a soft contrast that complements particularly well the pastel colors of this landscape.

In "Petroglyphs in Dead End Canyon", created in the Coso Range of California, it is the presence of the petroglyphs in a landscape otherwise devoid of human presence that is intriguing. The relationship of the man-made carvings in the foreground and of the otherwise forbidding landscape in the background, causes us to pause and reflect upon the ancient cultures that once inhabited this area. We ask ourselves questions: Why did people choose to live here, why did they leave, and where did they go? The fact that the petroglyphs are full of movement, being carved in multiple directions on the foreground

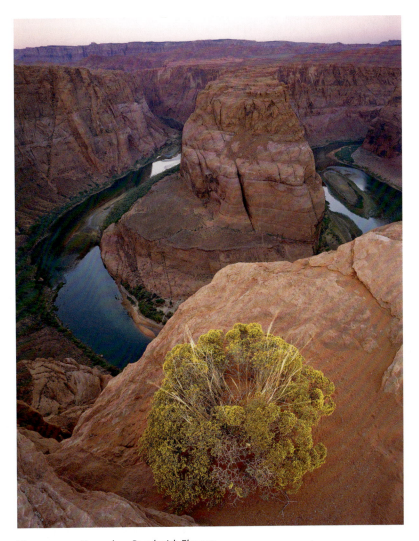

Figure 7-12: *Horseshoe Bend with Flowers*

sandstone slab, and the fact that these petroglyphs represent animals and shapes that are full of life, adds another level of intrigue to this scene and brings up more questions: Why is there so much life in these images and so little in the landscape, were there more animals living here before, and if so why are they gone now? Creating images that cause viewers to ask themselves questions about the content

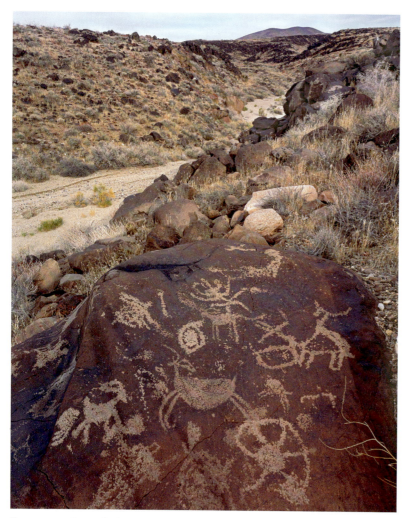

Figure 7-13: *Petroglyphs in Dead End Canyon*

grows and where it appears that little or no life can be sustained. Creating images that intrigue the viewer is another way of generating interest and of making the audience carefully look at a photograph. Something intriguing is something that surprises the audience while not revealing the source of this surprise. Something intriguing is something that causes us to ask questions that have no satisfying answers. A second look is necessary in order to find out the cause of this intrigue. We are puzzled, then curious, and our curiosity causes us to come back to the image for another look, another attempt at finding out why this image surprises us.

The color palette of "Petroglyphs in Dead End Canyon" is consistent throughout the image. This palette supports the foreground-background relationship because the colors of the foreground are found in the middle ground and in the background of the photograph. This creates a consistency of color throughout the image. Finally, the size of the sky, which is devoid of clouds, is minimized in this image thereby providing more space for the foreground. When the sky offers little or no interest, I prefer to give less space to the sky and more space to the foreground elements. *What does not add detracts*, therefore it is important to use the space available in the image (the image space) as wisely as possible. Following this key concept goes a long way toward creating strong images; images in which all areas of the image are important.

of a photograph generates continued interest in the image. It also causes the viewer to look at the photograph in depth and to scan the image visually in search of clues that may provide answers to these questions.

For me, the visually intriguing aspect of this image is the contrast between the life emanating from the petroglyphs and the otherwise forbidding landscape in which little vegetation

Example 6—Careful Cropping Between Objects: Navajoland Cloudscape 183

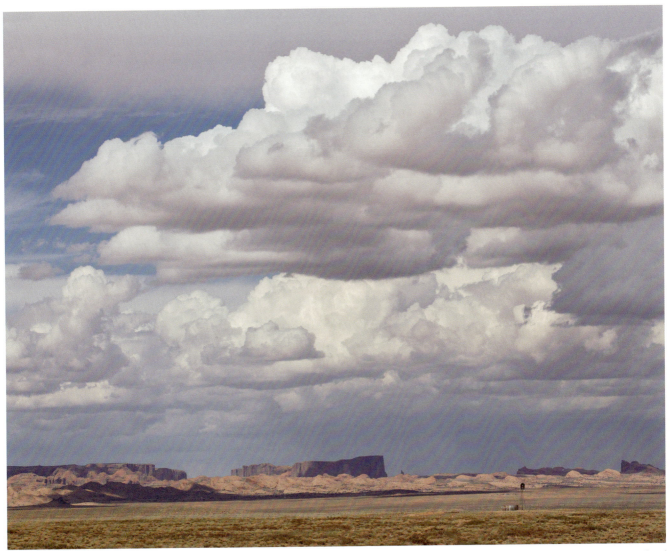

Figure 7-14: *Navajoland Cloudscape*

Example 6—Careful Cropping Between Objects: *Navajoland Cloudscape*

A photograph is by definition a section of reality. I use the word "section" intentionally. It sounds harsh but it accurately describes what a photograph does.

Regardless of how wide our lenses might be, we cannot photograph the entire scene in front of us. Certainly, we can create circular panoramas that capture a 360 degree view of a scene as it unfolds all around us, but to see such a view we would have to look at it one section at a time. We could not see it all at once. Furthermore, it would be difficult to display such a photograph in your home. It would have to wrap around the room in order

to be displayed! This is why rectangular format photographs are the norm, and why paintings follow the same approach. These formats allow us to see the entire artwork at once, without having to turn our heads right and left. Panoramic photographs can work as well, as long as the format is not made to be overly long, unlike the example I just mentioned.

What does all this mean to you, the photographer? It means that you have to decide where to crop your photographs, where to end them, because you cannot photograph the entire scene or the entire world. Therefore, where to end the image, where to *section* the landscape, becomes an important decision. This decision will affect the contents of the entire image as well as the visual impression this image will give to the viewer.

Deciding where to end an image is never easy. However, it is particularly difficult when you photograph a cloudscape—a scene in which clouds are the dominant feature. Clouds are by nature fluffy and apparently endless. Therefore, we have to put an end to them arbitrarily for the purpose of the image. Where to crop the clouds, where to end the cloudscape, is a crucial decision. My guiding principle when doing so, my rule if you will, is to crop *between* the clouds. In other words, I do not crop the clouds themselves. Instead, I crop between the clouds. Or, I cut the photograph in front of or behind a cloud.

This is what I did in the image, "Navajoland Cloudscape" (figure 7-14). Looking at the left side of the image, I cropped the photograph to the left of the cloud that is at the top of the image. I left a little bit of blue sky to the left of the cloud to give it space to travel to, metaphorically speaking. When you leave empty space next to a moving object, this empty space indicates the direction in which the

object is traveling. Since a photograph is static and since what it shows is frozen in time, this space is metaphorically representative of motion. This empty space stands for something, and this something is the movement of the cloud, the journey that the cloud is taking through the sky, and the destination where it will be in a few moments.

It is often tempting to think that cropping an image only involves the right and left sides of the image and that this is where we have to pay attention. This is inaccurate. Cropping an image also involves making decisions about where the top and the bottom of the image will be cropped.

In this instance I cropped the cloudscape above the large cloud that is the dominant feature of this image. Here too I left a little bit of space above the cloud. This time, this space is not metaphorically representative of where the cloud is travelling to because the cloud is moving horizontally, not vertically. Instead, this space is representative of the larger space that is present above the cloud. In other words, the space above the cloud metaphorically stands for the sky above the cloud, for more clouds. It says that even though the image ends here, the sky does not end here. Instead, the sky continues above the cloud and this little bit of space above the cloud indicates just that. If I had cropped into the cloud at the top of the image, or on the left side of the image, I would have removed these two visual metaphors and the image would have lost a lot of its meaning. By leaving these two open spaces I gave the cloud room to breathe. I created a photograph that shows a cloud and yet shows more than a cloud.

I did have to crop the cloud somewhere and did so on the right side. There was no place to leave room for anything there, because the

Example 7—Cropping and Borders: Escalante Canyon 185

cloud went on forever without breaks in one massive billowing pile of water vapor. But this cut, if we want to continue with metaphorical associations one step further, represents the massiveness of this cloud. This cloud could not be shown in its entirety because it was so large. Therefore it had to be cut, and this cut was done not because the photographer was careless, but because the photographer had no other choice.

The cropped cloud on the right also creates a nice visual variation when compared to the left side of the image. While the left side is open and the cloud free to move forward, the right side is closed and static. This impression is reinforced by the brighter tones of the left side compared to the darker tones of the right side.

Example 7—Cropping and Borders: *Escalante Canyon*

The last example in this chapter is a photograph taken in a small canyon in the Escalante, Utah area. A tributary of Deer Creek, this canyon does not actually have a name, so I simply titled the photograph "Escalante Canyon". In this title the word Escalante is the general location rather than the name of this specific canyon. The beauty of this canyon comes largely from the chaotic nature of its features and layout.

I photographed there for an hour or so, covering a distance of less than a mile, using a super wide-angle lens exclusively (a Sigma 18-24 mm on a Canon 1DsMk2). I handheld the camera, using a small f-stop to guarantee maximum depth of field. This was during midday, so I had plenty of light and did not need to use a high ISO setting. However, because

I was in a relatively deep canyon, I benefited from open shade, which gave me soft lighting and saturated colors. None of the images I captured in this location have direct light in them, except when the sky was included in the photograph.

The sky was included this image (figure 7-15), which could not be avoided if I wanted to get this composition. However, I did not want the sky in the final image because it was featureless and because the white sky did not work with the color palette of this image. This meant that I had to crop the photograph to cut the sky out. I knew that I would crop this image when I was taking the photograph.

There was another reason I wanted to crop this photograph, and that was to get a 4 x 5 format instead of a 35mm format image. I personally find the 35mm format too tall or too wide, depending on whether I create a horizontal or a vertical composition. Often, a full-frame 35mm image gives me the impression of a small panorama rather than of a rectangular image. There are exceptions of course, instances in which the 35mm format is the ideal format for a specific image, but in general, I find the 35mm format too tall or too wide. I find the 4 x 5 format to be far more pleasing to the eye. The 4 x 5 format is a narrower; close to a square, yet still rectangular. The fact that I have worked with 4 x 5 cameras extensively certainly plays a roll in this preference. In terms of enlargement and paper sizes, it is interesting to note that 4 x 5 enlarges directly to 8 x 10, 16 x 20, 20 x 30, etc., and that photographic paper formats were standardized around this format. For this reason, when you print a full-frame 35mm photograph on a standard size sheet of photographic paper, (either darkroom or digital), there is empty space left in the height of the

Figure 7-15: *Escalante Canyon* – Original conversion

the factory-installed focusing screen of the 1DsMk2 with a Canon focusing screen that shows the crop lines for 4 x 5. I can then compose the image with the intent of cropping it later to the 4 x 5 format.

Image format considerations play an important role in this photograph since I cropped the sky off in the final version. As I mentioned above, this was not an afterthought, but a decision I made prior to taking the photograph. If I had used a 4 x 5 format camera I would have composed the image without the sky in the field. In addition to the sky being cropped off, it is the color that catches my eye when I compare the original conversion to the final image. The color in the final image is more saturated, warmer, and more prominently red. This is due to adjusting the color balance and the saturation, something that we studied previously.

This photograph offers other compositional aspects worth considering, especially in regard to the borders of the image. In a chaotic scene like this one, keeping the borders of the image clean is a real challenge, because there are things coming into the frame from every direction. I had to be particularly careful to keep elements from entering the image from the sides. In this type of situation it is often necessary to move things out of the way, or to cut or bend small branches that would otherwise intrude into the image. Elements that come into the image from the sides are often visually distracting and are best left out. Because cloning them later on can be difficult, it is easier to carefully check the borders of the image in the viewfinder and on the LCD screen, remove distracting elements, and then take another photograph without them.

The visual appearance of this scene is due to geological forces, erosion, weathering, and

paper. However, when you print a 4 x 5 format image on a standard size sheet of paper, the image fills the page perfectly.

Cropping an image to a format other than the camera format is easier if you visualize the final format when you compose the image. To make this possible, I replaced

Example 7—Cropping and Borders: Escalante Canyon 187

vegetation growth. This scene is neither a studio set nor a still life arrangement! Nothing was created here for the purpose of taking fine art photographs. Nothing was arranged for our visit. Instead, everything happened because of natural forces. Thus, it is up to us to find a pleasing composition and to organize the chaos that nature offers us. Creating visual order from the chaos of nature is really what this image is all about. In fact, this is what creating images in natural locations is about. Some locations offer more visual order than others, but all present a certain level of chaos. Successful landscape photographs are images in which the photographer arranged the natural chaos into a pleasing composition.

Here, I used the bush in the foreground as a central element and organized the composition of the image around it. The bush separates the riverbed from the canyon wall. The riverbed is filled with loose rocks and sandstone slabs, while the canyon wall has a horizontal structure to it. The canyon wall is also more orange and more saturated than the riverbed, further defining the difference between the two.

As I mentioned earlier, I was careful to avoid placing elements along the borders of the image. However, in the field I could not do this perfectly so I had to clone out a few twigs and rocks in Photoshop to perfect the composition. This is fine because, as we know, this image is not intended for forensic analysis or scientific study. Instead, this image will be used to decorate homes, to illustrate my essays and books, to be published on my website, and to be used in other places where my work is featured. Most importantly, this image represents my vision of the location and reflects how it inspired me and how I

Figure 7-16: *Escalante Canyon* – Optimized final image

responded to this inspiration through my personal style.

Ultimately, this image is about me as much as it is about the location I photographed. I am not saying, "This is how the canyons of the Escalante look". Instead, I am saying, "This is how Alain Briot represents the canyons of the Escalante". This difference is central, not only to my work, but also to my marketing.

Section C:

The Creative Process

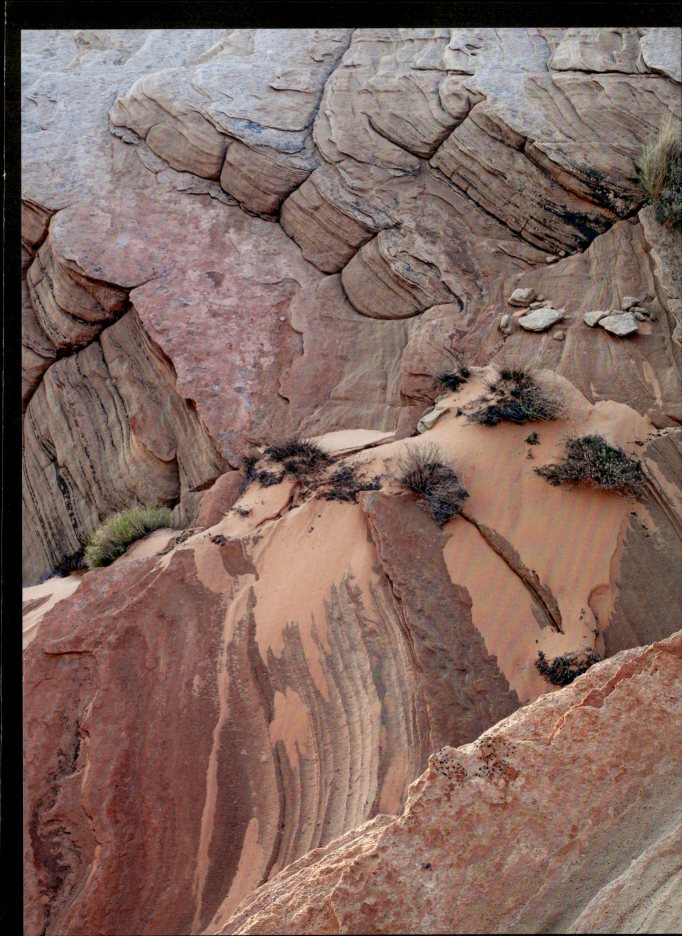

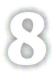

Finding Inspiration

I learned... that inspiration does not come like a bolt, nor is it kinetic, energetic striving, but it comes into us slowly and quietly and all the time, though we must regularly and every day give it a little chance to start flowing, prime it with a little solitude and idleness.

BRENDA UELAND

Introduction

How do you find inspiration? This question, which may seem benign at first, is important because inspiration is at the origin of any work of art. As we will see in this chapter, inspiration is the spark that motivates an artist to create new work. It is the spark that, in turn, will lead this artist to formulate a vision for his work, a vision that will eventually define his personal style.

When I started writing about inspiration for this book, I believed that inspiration encompassed the entire creative process. However, as I reflected further upon the subject of inspiration, I realized that inspiration is only one aspect of the creative process, and this process includes other equally important aspects. Furthermore, I realized the different aspects of the creative process are all interconnected and each part of the process depends upon the other parts to work.

At the time of this writing I have defined four parts to the creative process. They are as follows: inspiration, creativity, vision, and personal style. I have decided to devote one section to each of these four parts. In these sections I will be exploring what each of these four parts consists of and how they interact with each other.

This book is intended to work as a whole, with each chapter being a different part of a single metaphorical machine. I like to call this machine, for simplicity's sake, *the artistic process*.

Inspiration, Creativity, Vision, and Personal Style

Inspiration lights the spark of creativity. Together, if well integrated, they result in a personal vision for our work. In turn, personal style allows us to express our vision in a unique manner.

ALAIN BRIOT

When I started reflecting and writing about inspiration and all that it entails, I thought I was addressing only the act of being inspired. However, I realized I was also writing about the act of being creative, about the discovery of a personal vision, and also about the development of a personal style.

Why make things more complicated you may ask? Why not keep things under one name—inspiration—and write about all of this at once? Because breaking it up is really the only way to make this subject easier to understand. Separating what is usually considered a single subject into four parts allows me to study this subject in greater detail and this approach allows me to share better insights upon the artistic process and upon how each part of this process dovetails into the other parts. In the end, I believe this is the only way to truly address this important subject with the depth of thinking it requires. I will start by explaining the differences between inspiration, creativity, vision, and personal style.

Inspiration without Creativity

One can find a wonderful source of inspiration and be motivated to create art without knowing how to physically translate the ideas generated by this inspiration into a work of art. In photography, one can be inspired by a beautiful landscape or a stunning sunset without seeing a specific composition and without

Figure 8-1: *Hoodoos Panorama*

feeling the urge to create a specific image from this landscape. For example, one can stand on the edge of the Grand Canyon and be inspired to create artwork that expresses one's personal experience of the Grand Canyon. This inspiration may stem from the personal experience of admiring the beauty of Grand Canyon, or it may also come from the realization that none of the artwork currently available expresses in a satisfying manner what it feels like to be there. In this situation the artist feels inspired to go beyond what other artists have previously created. However, for this to happen the artist needs to transform inspiration into images, a process that takes place through creativity.

Creativity without Inspiration

Wanting to be creative without feeling inspired is common, and is often the case when first trying new equipment. For example, I can think of many times when a new camera or new equipment made me feel very creative and motivated me to try all sorts of things, without the outcome being particularly inspired. The images resulting from this creative urge were different and new to me. However, my inspiration was derived from the new equipment and not from a personal desire to fulfill a previous idea. In other words, my inspiration did not come from the subject that I normally photograph, in my case the natural landscape. My inspiration came solely from the equipment I just acquired. Also, this equipment being new to me, I did not have time to develop the necessary craftsmanship required to create fine art quality images.

Inspiration and Creativity without Personal Vision

One can be inspired and have an idea, be very creative in making this idea into a work of art, and have developed the required level of craftsmanship, all without the desire to follow a vision. Vision is an overriding envelope that encompasses both inspiration and creativity. It is a blanket that covers the entire artist's work, a blanket that often comes later in the life of an artist, after one has perfected one's art and moved beyond the commonplace outcome that most artists have to go through. For this reason I placed vision as the third step of this process. I placed it there not because it comes necessarily at the end of the process but because it is often something that artists discover later in life.

Personal Vision without a Personal Style

One can have vision without having found a personal style through which this vision will be effectively expressed. Without a style, a vision remains an unfulfilled dream. Without a style, vision remains just that: vision. It remains something that is seen by the artist but which has not yet taken a physical reality. Without a style, vision remains something that exists only in the artist's mind. Vision cannot be effectively expressed through a commonplace style, a mundane style we may say, or a style used by many other artists. When vision is expressed through a commonplace style, this vision does not have the ability to impact the viewer in a meaningful way. This vision does not have a chance to stand out as being different and unique. Rather, this vision blends with the general artistic landscape and becomes relatively unnoticeable. It becomes akin to *déjà vu;* to a vision that has already been seen and a style that has already

been done. To truly stand out, to be noticed, to become meaningful to an audience, a personal vision needs to be expressed through a personal style. To be effective, this style must be new to the audience. To be new to the audience, this style needs to have been created by the artist.

Example 1:
Location as a Source of Inspiration

During a visit to Death Valley in 2006 I felt inspired to represent this location in a way that I had not thought of before. Until then, I saw Death Valley as a place that was primarily dry and inhospitable. The presence of water on the playa—the dry lakebed that is at the heart of Death Valley—and the presence of clouds, were instrumental in bringing about this change in my perception of this location.

After working the scene for over an hour, I found that the composition which most effectively expressed my inspiration was one in which clouds and reflections shared the space evenly; a composition in which land and sky mirrored each other. As I worked the scene, I kept thinking of the poem by Robert Frost, *The Road Not Taken*. In a way, this poem was the inspiration for this image as much as the clouds and their reflections. While the image is not a direct visual metaphor for the poem, in the sense that it shows only one stream of water and not two diverging ones, it does represent a departure from my previous work, a step towards an artistic path onto which I had not previously traveled.

Figure 8-2: *Playa Reflections 1* – Death Valley National Park

The Muses

Having completed this description of the creative process as I see it, let us now look at the first part of this process in detail: inspiration. I believe it is important to start with a discussion of the Muses who are the classical reference to inspiration in Western culture. The original concept of the Muses is found in

Greek mythology. In ancient Greece the nine Muses were the daughters of Zeus, the king of the Greek gods, and of Mnemosyne, the goddess of memory. The word "Muses" itself is derived from the Greek "mousai" from which the word mind is derived. The root of the word "Muses" has a direct connection to the human mind and to the activity of the mind.

There were three original muses: Aoede, the muse of singing, Mneme, the muse of memory, and Melete, the muse of practice. The choice of these three muses shows that the Greeks placed emphasis on medium, memory, and practice. Those were the three most important categories. If we replace singing with another medium, say photography, the two other Muses, or emphases, remain the same: memory and practice. In other words, one must know his medium, must remember the knowledge he previously acquired, and must practice regularly. The combination of these three areas will guarantee success in the arts.

In later times the three original muses became nine, each of them being associated with a particular art. The emphasis shifted from medium, memory, and practice, which can be considered a system for success in the arts, towards the choice of a specific medium. The original connection of the muses with practice disappeared and was replaced by the connection with a specific art form: Calliope was the chief of the muses and the muse of epic songs, Euterpe was the muse of lyric songs, Clio was the muse of history, Erato was the muse of erotic poetry, Melpomene the muse of tragedy, Polyhymnia the muse of sacred songs, Terpsichore the muse of dance, Thalia the muse of comedy and poetry, and Urania the muse of astronomy.

Each artist or scientist sought guidance, help, and inspiration from the muse most closely associated with his medium. I believe that if the Muses had continued to be used as a metaphorical representation for inspiration in Western culture, other mediums would have been added to the list, and new muses would have been chosen to represent them.

This description of the Muses, and the change from approaching the arts from the perspective of a system designed to insure success to approaching the arts as separate mediums, teaches us an important lesson. After this change, the arts were approached as medium rather than as profession. One chose a medium, and this choice was the most important. Previously, in Ancient Greece, one chose not so much a medium as a systematic approach designed to guarantee success in the profession of artist. After this change, being an artist stopped being a profession and became the exercise of a particular skill.

What I propose in this chapter, and in my teaching approach in general, is a return to approaching the arts as a system designed to guarantee success in a profession rather than approaching the arts as simply the choice of a specific medium. Applied to photography, this means that the choice of *doing photography* is not the only choice one needs to make in regard to guaranteeing success as an artist. Certainly, choosing a medium is a meaningful and important choice. However, the most important and the most meaningful choice is the choice of approaching this medium as a profession, or if it is a hobby, of approaching it as a serious endeavor that requires training, practice, personal involvement, and accountability.

A Lifestyle

I am ruthless about my own pictures or they would never get as good as they tend to. There's very little that's automatic about it. It's mostly just a ton of learning and dedication and work, but built around an idea and a vision and when the pictures look really right, they make me happy.

JOSEPH HOLMES

The Greeks believed that the Muses visit you whenever they please. In a way they believed you are not fully in control of inspiration. Instead, the Muses are in control, because it is their visit that brings you inspiration. What is within your control is your openness to taking advantage of the inspiration brought by the Muses when they visit you. You must be able to make room so that you are available when these visits occur.

Today few people believe in the Muses being the source of inspiration. In turn, you may or may not believe in the Muses. This doesn't matter all that much because the fact remains that inspiration is unpredictable. You cannot pinpoint when or where it will happen. All you can do is be ready when it happens.

Being ready means being able to dedicate time to being inspired, something that in today's society, and in the life of a majority of people, is rarely the case. In other words, if you hear yourself saying, "Yeah, right. Like I can really drop everything just because all of a sudden I feel inspired!", you are actually expressing how most people feel. There is little room for inspiration today in most people's lives. However, if your goal is to create artistic photographs, if your goal is to be an artist, in short if your goal is to create art, you must make room for the Muses to visit you, or for when inspiration strikes, whenever that may be.

Some may say that they do not have time for inspiration. When someone says, "I don't have the time", what they are really saying is "this is not one of my priorities". If something is not one of your priorities, you will not make room for it in your life, and as a result you won't have time for it. It is simply not part of your life. You don't need it, won't have it, and couldn't care less about it. However, as an artist you do need inspiration. You have to make room for it in your life, which means that you must make it one of your priorities, even though it may not be the most important priority. You simply cannot leave inspiration out of your life entirely.

This may imply, at the least, allowing space for inspiration in your life; and it may imply, at the most, a lifestyle change. How you live your life—your lifestyle—is something that you have control over. Your lifestyle can be conducive to welcoming inspiration, or it can be conducive to pushing inspiration away. You can make room for inspiration in your life or you can close that space and have no opportunities for inspiration to visit and no time for inspiration when it does visit you. I understand that creating a lifestyle conducive to inspiration can be difficult. Indeed, our lives are full of duties, responsibilities, and demands placed on our time. Our time itself has become our most valuable commodity, and we never seem to have enough of it. Furthermore, no matter who we are, we all have 24 hours in a day and not a second more.

So how do you do it? How do you make room for inspiration when you barely have enough time to do all that you had to do before reading this chapter? Simple: *prioritize*. Prioritizing is nothing more than deciding that certain things are more important than others. Implementing prioritizing is nothing more than

placing the things you consider most important at the top of your "to do" list. Most of us, if not all of us, prioritize. For some of us prioritizing is a very involved process. For others it is a more casual process. Nevertheless we all know that to be successful we have to prioritize, otherwise the important things in our lives will never get done.

So the question then becomes: how important is inspiration to you? Where does it fit on your priorities list? Clearly, I cannot answer this question for you because the answer to this question is personal. However, I can answer it for myself. My answer is that inspiration is very high on my priorities list. I won't give you a detailed list of my priorities, because doing so is beyond the scope of this book, but I can say that inspiration is definitely among my top five, and possibly among the top three priorities. Why? Simply because inspiration is what allows me to do what I do. Inspiration is what allows me to remain creative, to continue searching for new answers to age-old questions. It keeps me in motion. It keeps my mind active. Above all, it keeps me curious and eager to discover new ideas. Finally, inspiration is the metaphorical key that opens the door to vision. Therefore, having a substantial place for this "key" to develop and grow is crucially important.

So how do I do it; how do I implement inspiration in my life? For me inspiration is a lifestyle. I find inspiration in the way I live, in the décor of my home, the landscaping of my garden, the cars I drive, the clothes I wear, the artwork I surround myself with, the people I socialize with, the places I visit, the books I read, and much more. Inspiration is a way of life, a way of being, a way of existing. In a sense, it is somewhat close to existentialism. I like to be in a beautiful setting, doing pleasurable activities, and always with the presence of art in one form or another.

I found a long time ago that it is while doing activities that are very different from photography that the Muses visit me the most frequently. I therefore regularly engage in activities that have nothing to do with photography, and yet they are activities that are related to photography in the sense that conducting these activities relaxes my mind so that it becomes open to ideas for new images.

For some, inspiration occurs when taking time off from work, or when visiting places away from home. For others, visiting a place that is special to them, or a place they have never been to before, or again a place they always wanted to go, is a way to invite inspiration in their lives. For yet others, meeting other professionals or attending a workshop or a seminar, opens the door to new ways of seeing and to new inspiration.

Example 2:
Remoteness as Source of Inspiration

The location where I created "Playa Reflections 1" (figure 8-2) can be reached by parking along the road and walking less than a mile. In comparison, getting to the side canyon of the San Juan River featured in this second example (figure 8-3) requires a multi-day hike or a multi-day river trip. It is one of the most remote locations on the Colorado Plateau of Southern Utah.

Sometimes remoteness is a source of inspiration. The fact that a place is rarely if ever visited, means that images of this location are either few or non-existent. As a result, it is possible to approach these places free of preconceptions, our mind unencumbered by

images from other photographers, images that visually described the place to us before we ever saw it with our own eyes. The outcome is images inspired by a direct experience of the place rather than by the work of other artists; images that represent a personal vision of these remote locations.

New Equipment, Supplies, and Software: New Possibilities

Just as appetite comes by eating, so work brings inspiration, if inspiration is not discernible at the beginning.

IGOR STRAVINSKY

Inspiration is also brought about by the acquisition and ownership of new equipment. This can be a new camera, printer, computer, software, or any other new tool that we use in creating our images. This is not limited to hardware. It extends into software and supplies: a new version of Photoshop (or other software) with added features that have to be explored in order to discover what they can do and how they can allow us to reach a new level of image quality. This is extremely inspirational because it offers the promise of opening new doors, or of providing a solution to age-old problems. Similarly, new supplies such as a new type of paper or mat board, to name a few, also offer the promise of an enhanced image or presentation quality.

With a new piece of equipment, new software, or new supplies, the artist sees more than the physical objects in front of him. The artist also sees the possibilities offered by these objects. In turn, these possibilities become the source of new inspiration. With new equipment comes the promise of new

Figure 8-3: *Canyons of the San Juan*

doors to open, and with this promise the spark of energy that motivates us to create is brought back to the forefront. In a way, to remain creative we need new tools, new supplies, and new software. We are blessed to live in a world in which our tools are constantly being improved, our supplies are constantly getting better and our software is constantly offering new options and more effective

solutions. Take advantage of them, not only for what they can effectively do, be it offer higher resolution images, a better print quality, or enhanced optimization options, but also for what they inspire us to do.

The only thing to watch out for in regard to equipment becoming the source of creativity, is to make sure that this creativity is placed at the service of a personal idea or vision. As I mentioned in section 8.2 of this chapter, it is easy to be inspired by new equipment solely because of what this equipment can do. While this may be fun, it will not work toward completing the creative process as a whole and working towards achieving a personal style. To work toward achieving a personal style, one needs to use this new equipment to further one's vision by pushing the technical envelope to achieve one's creative goals better than was previously possible.

Example 3:
Mood as a Source of Inspiration

I had visited this location in Monument Valley several times prior to creating this image. However, each time the light was flat, the sky cloudless, and I did not feel inspired to create a photograph. This particular time things were vastly different. A sandstorm was blowing through the valley and storm clouds were moving rapidly in the sky. When I arrived at the spot where I took this photograph, the light had taken a soft and almost golden quality, a consequence of the clouds acting as a giant diffuser for the sunlight and of the red sand flying in the air giving a warm color to the light.

Because I knew this location well, I was immediately able to recognize the uniqueness of this lighting situation. I also knew that it would not last long. The minute the clouds cleared up, or the minute the sand stopped blowing, this unique light would be gone.

I immediately set to work, inspired by the light, the cloud formations, and the constantly changing patterns of light and shade that were cast on the sandstone spires in the distance. Because I did not have much time to narrow down the exact final composition, I created images using several lenses, slightly varying how much of the landscape I was including in each image. I also created images with different clouds and shadow patterns. Later, in my studio, I selected the image in figure 8-4 from all the ones I created that day because it best expressed how the scene felt to me when I experienced it.

Become an Expert

Without craftsmanship, inspiration is a mere reed shaken in the wind.

—Johannes Brahms

Sometimes, finding inspiration in the work of another photographer is intentional, in the sense that you are looking at books, visiting exhibitions, or browsing online with the purpose of seeing new work and finding fresh ideas. However there is a second situation— one that is just as important to know about. This situation occurs when you discover, or when someone else points out to you, that, unknown to you, your work closely resembles the work of another artist. This may be an artist that you are aware of, or it may be an artist that you have never heard about.

This situation presents itself frequently, especially if you are just starting in

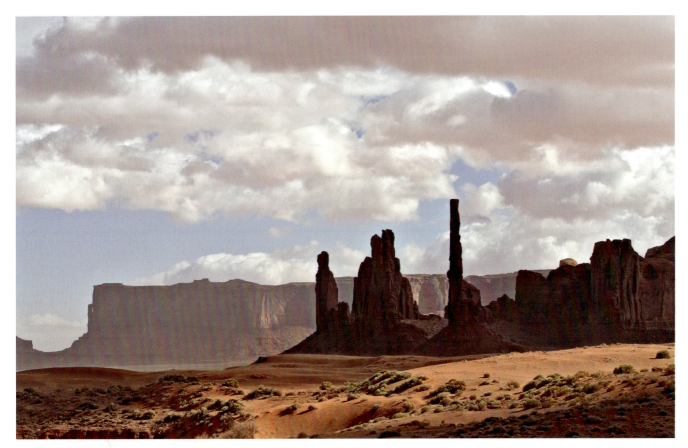

Figure 8-4: *Totem Pole,* Monument Valley

photography (or in any art for that matter) because at such a time you are less likely to be familiar with all the artists that have worked in the same medium and have addressed the same subjects in the same stylistic approach as yours. It also occurs because originality is something difficult to come by at the beginning of a career, regardless of one's age. Finally, it happens because all artists work with the same types of subjects—be it landscape, still life, portraiture, architecture, etc.,—and because eventually we are going to create one or several pieces, usually accidentally, in a style comparable to that of another

artist who came before us and who spent his lifetime refining this style.

What do you do if and when that happens? Simple: you become an expert in that artist's work. You become an expert in their work so that not only are you familiar with their work, but you know more than most people about their work. You study and master the techniques this other artist used. You understand where their inspiration came from and how their vision evolved throughout their career. You find out how far they have gone in the specific style they chose and with the specific subject they worked with.

Finally, when all this is done—and it may take years to do all of this—you try to go further than they have. You pick up where they left off and you go beyond what they have achieved. This may or may not be possible. Some artists leave room for others and some artists push the boundaries of their approach so far that their work is an end in itself, a final statement in a way, a total exploration of a particular artistic possibility. If it turns out you cannot exceed their achievements, that the road they started has come to an end, it will then be time to reassess what to do next. However, you will not know this until you familiarize yourself with their work, their technique, and the source of their inspiration.

External and Internal Inspiration

In study, theory, or practice, knowledge is undoubtedly the keynote to individual thought and originality in painting.

EDGAR PAYNE

For many years I found immense inspiration in the work of other photographers whose work I admired and wanted to emulate. I was inspired by their images and I sought to find the source of their inspiration. I wanted to find out how they translated this inspiration into a powerful vision and personal style.

I thought inspiration was solely something external to myself. I thought it was something I could go out and find. I believed that once I found it everything else would progress from there. On one level, inspiration is something external, at least at first. Inspiration is a spark that lights up when we are confronted with something truly inspirational, something that makes us look at the world in a new way,

something that opens a window onto a new landscape, one we had never imagined before.

However, back then I did not realize there is a second level of inspiration. This second level of inspiration is our own work, the work we create when following the spark of inspiration I just described. At that time, when new work is being created, this work in turn becomes the source of inspiration, of new ideas. This work starts to generate ideas for more work. It becomes the motivation for going further into a specific direction and for continuing to explore a specific subject.

I vividly remember the day I found my work more inspiring than the work of the masters that had thus far guided my steps. It came as a shock and at first it felt sacrilegious. But the feeling persisted and proved to be a lasting fact rather than a passing impression.

As time went by and as my work progressed I became more and more inspired by *my work* and less and less inspired by other photographers' work. Today, I continue to find inspiration in the work of artists, but this inspiration increasingly comes from artistic mediums other than photography. I find inspiration in writing, painting, music, architecture, and in the design of functional and beautiful objects, be it cars, ceramics, tableware, light fixtures, or a multitude of other things. I love to discover objects that demonstrate a seamless relationship between form and function. In turn, I like to collect and own such superb examples of artistic design to which practicality and art have been given equal attention.

Inspiration Is Asking Why not How

Of course, there will always be those who look only at technique, who ask "how", while others of a more curious nature will ask "why". Personally, I have always preferred inspiration to information.

MAN RAY

Inspiration comes out of a personal curiosity accompanied by being able to wait for the answers to come to you. Asking why something is done, or why something happens, or again why something is the way it is, is very different from asking how something is done, how something works, or how something came to be.

The answers we receive are closely related to the questions we ask. In a sense, the question contains the answer. Ask, "Why am I fat?" and if you are indeed overweight you will find many answers as to why this is the case. On the other hand ask, "How can I lose weight?" and if you do indeed need to lose weight you will get answers pointing to how you can regain a svelte figure. The first question leads to finding the cause of the problem. The second question leads to finding solutions to the problem.

When you are aware of the power of questions, it becomes easier to find out which question is best to ask in order to find the specific answers you are looking for. In the example above all you have to do is ask yourself, "Do I want to find out why I am overweight, or do I want to find out how to lose weight?" The answer to this question immediately tells you which question you need to ask yourself.

The same is true in photography. Asking *how* leads to answers that point to technique, to a series of steps, or to an itemized list of operations. Asking how is asking to learn how to do what someone else knows how to do. It is asking to learn the technical knowledge required to achieve a specific result. How do you do this? How can I achieve this result? How does this software, camera, or other tool work? The person who asks how usually has an end product in mind and usually a very specific idea of what this end product is going to be.

Asking *why* leads to answers that have to do with motivation instead of technique. Asking why leads to answers that are about the reasons people do what they do. Asking why points to what inspires people, because inspiration is the motivating force behind any creative endeavor. Why is this artist painting only people dressed in black? Why is this photographer so in love with color? Why not use a more subdued palette? Why not work in black and white? The answers to these questions, when asked about a specific artist and a specific body of work, immediately generate answers that address where this artist's inspiration comes from. They lead to answers about what inspires this artist.

Why artists do what they do, why they make the choices that they make, and why they create the specific style of art they create is rooted in the source of their inspiration. And the source of this inspiration can only be found by asking why they do what they do.

Example 4: Repeat Visits to Favorite Places for Inspiration

I visit the same places over and over again. I do so because I don't tire of visiting these places and because I continue to find new inspiration in these locations.

This approach works for me because these places hold special meaning for me. These are places that I continue to see in a new light each time I visit. These are places that are both complex and challenging to capture in photographs, and each new visit gives me a better understanding of how to approach these challenges. Some of these locations are popular and are photographed extensively by other photographers, therefore creating new images there is difficult because so many images of these locations exist already. By becoming intimately familiar with these places I can move past the superficial images and create images that represent a personal vision.

I find inspiration in the challenge of creating a new image from a place that has been extensively photographed. I also find inspiration in revisiting a place I have been to many times. It is like visiting an old friend. I am reminded of why this place means so much to me while at the same time I am surprised by aspects of it I had not seen before.

One cannot see the entire scope of a location in one visit. One can only see certain aspects of it. Furthermore, there is renewed inspiration associated with visiting a favorite place over and over again, just like there is renewed inspiration associated with listening to a favorite musical piece over and over again, or admiring a favorite painting or artwork regularly, or reading a book several times. Repetition brings a deeper understanding of a specific location or artwork. One develops a personal relationship with it, a relationship that becomes more intimate as time goes by.

While it is possible to create original art after a single visit to a location, I often find that it is after several visits that I am best able to distance myself from the representations I previously saw and start creating my own images.

Memories of What I Have Seen and Experienced

The real voyage of discovery consists not in seeking new landscapes but in having new eyes.

MARCEL PROUST

Our minds store an amazing amount of memories. These memories are not just about facts and events. They are also about the feelings and emotions our mind recorded at the time the specific events took place. These memories are about sounds and scents, about how specific objects feel to the touch, and about the feelings we experienced.

In *The Bourne Identity*, Jason Bourne, played by Matt Damon, suffers from amnesia and seeks to find his identity. A trained secret agent, his skills automatically reaffirm themselves whenever the situation calls for them. The problem is he has no control over how this happens.

Although it is unlikely any of us will find ourselves in Bourne's situation, I believe our minds retain memories unknown to us and these memories are brought back when specific situations occur. I also believe many of us have far more skills than we make use of, and some of these skills are hidden away in our minds, waiting to surface. When it comes to art, many of these skills were acquired when we were children or adolescents, and then buried under new obligations as we engaged in various activities later in life.

Within these memories priceless information has been stored about how we see the world and, indirectly, about how we can represent the world in photographic images. The further back we go into these memories, the closer we get to remembering our initial reactions to things we have seen and experienced:

Figure 8-5: *Antelope Swirls*

our first snowstorm, walk into a forest, glimpse of a desert landscape, sight of towering sandstone cliffs, hike into a canyon, or our first experience of spring to name but a few. Within these memories are countless pieces of information recorded with the vividness of a first experience. If we can tap into these memories we will have access to valuable data about how to represent similar events that we more recently photographed.

How the mind records information is both a surprise and a revelation. A surprise because what triggers a specific memory is rarely, if ever, the event itself. Rather, it is almost always an object or an event associated with the memory I seek to recall.

For example, I vividly remember wearing a new leather jacket for the first time one early spring day when I was about nine years old. Today, when I think of this jacket I experience the feeling of that spring day all over again. However, if I try to remember the spring day alone, nothing comes to me. I have to go back to the jacket laying on my bed, and me picking it up and putting it on, in front of the open French-window which swung outwards toward the yard with the cherry trees in bloom, to experience again the warming weather of

spring, the birds singing in the trees, the new grass emerging from the darkness of winter, the strollers pushed by young mothers, my friends playing outside, and me eager to wear this new jacket, hoping they would notice.

Memories are complex. I have similar memories of walking down the two-lane street in the city where we lived at the time, on our way to hike into the forest where we were going to pick blue flowers. To this day I have no idea what the botanical name for these flowers is, all I know is that hearing the words "blue flowers" brings back to me the entire reality I experienced when I first picked these flowers: their soft and pleasant fragrance, their blue-purple blooms with white stems, the tall grass under the trees near where they grew, the bog-like terrain where they were often found, the Noces et Banquets restaurant in front of which we walked on the way to the forest but never stopped to have a drink or a meal at, the cars in the street and the noise associated with them, the intersection we had to cross, the quietness and peacefulness of the forest once we reached the walking path that led us through it, the birds singing, the definite feeling of quietness I experienced once we had entered the forest and found ourselves in another world separated from the noise and bustle of the city by little more than a mile of trails.

In these memories I find inspiration for the photographs I create today. My memories go back nearly forty years, yet they are as fresh as if the events they recall occurred yesterday. The question is how do you recall these memories at will? For me the key to recalling distant memories is seeing objects that somehow bring me back to a past time. Which objects bring which memory is not possible to deter-mine *a priori because it varies greatly. However, there are some general rules.*

Objects that are somehow related to my childhood are most efficient in this endeavor. At first I thought I had to have the exact same objects I owned and used in my childhood. However, this has proven not to be necessary. When I hold an object from times past, I often find that while memories come flooding back, they come to me unsorted, so to speak, with both good and bad memories rushing in at once. I have also found that some of these memories block the way to others, making me think of certain things that I would rather not remember.

What I found to work much better is to use new objects or new experiences that somehow trigger a positive memory of things past. In other words, and perhaps to follow Marcel Proust's approach, I use pleasant experiences to bring back memories of things past [1]. For example, the leather seats in my car remind me of the leather jacket I wore on that spring morning I described previously. The car itself, being of European make, is far more efficient at generating memories of things past than an American car, simply because I grew up in Europe and rode in European cars when I was little. Certainly, today's European cars are different from the cars I rode in when I was nine, but the make of the car, the layout of the controls, the way the vehicle *feels* has not

1 As an aside, I do love Proust's writings, though I am usually unable to read more than short passages at any given time. I found that his books are best approached the way leftover cake is approached, by eating the most appetizing piece first and seeing what happens next. Sometimes, just a bite is enough. Sometimes, more is necessary.

changed, or at least has not changed in certain cars. Those are the ones I seek.

Similarly, food can be used for the same purposes. The specific taste of a dish I first had as a young boy can trigger the memories associated with the place where I was at when I first ate it, which in turn can trigger memories about the specific time of year, the little village I was in at the time, the wood pile that my father split before dinner, the wood smoke from the chimney permeating the atmosphere of the room we were in, the mixing of the fragrance from the food cooking and the wood smoke, the large buffet in which the plates and dishes were kept, the armoire in the basement where the confitures resided and to which I did not have access unless accompanied by an adult.

I could go on and on, but to keep this to a reasonable length let me say that when it comes to finding inspiration, I delve into these memories the way a starved man goes after food. You may say I live in the past, but nothing could be further from the truth. I live today, right now. I live as I type these words. But I know that my most powerful memories are of those things that happened to me for the first time . These memories, at least the memories I seek to remember, are about feelings and emotions and are triggers that lead to inspiration.

Skills Enhancement Exercises: How to Invite the Muses and Bring Out Your Creativity

Genius is one percent inspiration and ninety-nine percent perspiration.

Thomas A. Edison

Take Time Off for Inspiration

Take time off from your regular routine and during that time, ask yourself where your inspiration comes from. Try to pinpoint previous times when you felt inspired to create. Work toward remembering exactly when that happened, where you were at that time, and which other memories are attached to this event. Try to relive these events in order to recapture the source of your inspiration.

Did you act upon the inspiration you received back then? Did you create new photographs that expressed this inspiration? If you did not, do you intend to create such photographs in the future? If you did, were these photographs successful in sharing your inspiration with your audience? If not, what else could you do to bring these images closer to your inspiration?

Listen to the Landscape

Visit your favorite photographic location, or go to a location that you have always wanted to visit. When there, relax and take your time. Don't rush and photograph right away. "Listen" to the place, meaning, listen to what it is telling you from an emotional and sensory perspective. Nature talks in its own ways, through the moods it evokes, the memories it brings back, and the ideas it generates. Inspiration is, in part, the desire to express through your work what nature is telling you. You may or may not photograph that day, but if you

listen carefully you may return home inspired and with new ideas for your work.

Listen to Your Favorite Music

Music conveys feelings and emotions in a very different way than photography or the visual arts. By listening to music you are opening yourself to new emotions and ideas, and a new perception of the world. Music is a way to open your mind to ideas and to welcome inspiration.

Music is also relaxing and will help take your mind away from your current preoccupations. Listen to nothing else but the music. Put all other thoughts out of your mind. Focus on the notes, on the rhythm, on the melody. Try to isolate each instrument, each note, try to understand what the composer, or the musicians are trying to say through their music. What message do they want to share? What is this musical piece about? What emotions does it convey? It there something in it that inspires you to create a photograph?

Try Mediums You Have Not Tried Before

Try mediums that are not visual art mediums, or that are not two dimensional visual art mediums. Try making a sculpture or playing a musical instrument for example. Do it for the fun of it or do it to see what happens when you work with these mediums. Don't worry about the result or about making mistakes. Just let yourself be inspired by the possibilities offered by the medium you chose to explore.

Work With and Learn From Other Artists

Watch how other artists do what they do, and find out how they think about what they do. How different is their approach to yours? What is it they do that you could do too?

What inspires you in their work and in their approach? What could you borrow from their approach and use effectively in your own work?

Describe the Kind of Photographs You Want to Create

Do not describe the photographs you are currently creating, instead describe the photographs you have always wanted to create but haven't created so far. Compare these to the photographs you are currently creating. What are the differences? Make a list of these differences. What do you need to do, or change, to make your current work into this ideal work you have always wanted to create? What inspires you in the work you would like to create but which so far exists only in your mind?

Conclusion

Inspiration is an awakening, a quickening of all man's faculties, and it is manifested in all high artistic achievements.

GIACOMO PUCCINI

Finding inspiration is an engaging subject, and as we just saw there are many ways to find it. Yet there is one more way I have not discussed, and that is where your own internal inspiration, your "secret flame", resides. This flame, this spark of energy, this initial internal combustion burst, resides within you. It has been there for a long time, most likely since the day you were born, and it is for you to discover if you do not know about it yet.

In this regard, I cannot speak for anyone except myself. For me this internal source of energy lies in my childhood that was spent in the company of artists in Paris. I was born in the 14th Arrondissement of Paris, where at

the time many artists lived because rent was affordable and the area was conducive to the arts with places to meet and galleries nearby. My parents visited small cafes in their leisure time, where artists met and socialized, and on one such occasion Salvadore Dali made a sketch of me as a baby. I have no recollection of it, just like I have no recollections of anything that happened to me before the age of five. This story was passed on to me by my mother and I have always found it to be enlightening.

Similarly, I grew up among circus performers because my mother was a trapeze artist. I was, in a way, part of show business, because the circus is a performance art, one in which the artists are only as good as their last show, and one in which one can either shine or kill oneself on any given soiree. I grew up with memorabilia of my mother's days as a solo trapeze artist, playing with her sequin-covered costumes and spending hours looking at photographs of her in flight as well as at Chepperfield, Bouglione, and Rancy Circus posters.

I grew up going to galleries and museums and studying art in a city known for being one of the world's art capitals. I attended a private drawing school—the Atelier Baudry in the Passage Denfert near Denfert Rochereau in Paris. I continued by studying painting and drawing at the Academie des Beaux Arts. Art supply stores and museums were my daily hangouts as well as painting and drawing ateliers (artists' studios) in which I practiced my craft. The smell of turpentine, linseed oil, and drying oil paint was with me on a daily basis. I can still remember the smell today, and whenever I think about it a surge of inspiration comes over me.

I discovered photography in Paris, first through Le Mois de la Photographie, a yearly Paris event during which, for a full month, galleries, museums, and countless other locations offer one-time photography shows of artists ranging from world-famous to virtually unknown. I was motivated to study photography at the American Center in Paris where, in the early 1980's, some of the world's most prestigious photographers offered year-round workshops organized around a weekly meeting format.

This unique experience will remain with me forever. It shaped my life in a way that is unique to me and it represents an essential source of inspiration, a grounding if you will, that I return to frequently. I of course cannot change any of it because I fell into it more than I chose to experience it. As the saying goes, it chose me more than I chose it. However, I wouldn't change any of it if I could because I do not see a better way to start a career in the arts.

Your inner source of inspiration is most likely very different from mine. If it is not known to you, I strongly recommend that you try and find it. Doing so may take some time or may be a rather simple process—it all depends on how close you are to it. For some of us, these origins are buried under years of accumulated responsibilities and concerns that took us miles away from it. Going back to our "artistic roots" as we may call it, can be challenging, time consuming, or both. However, it is an important aspect of becoming artists, of finding our true source of inspiration and of creating work that is unique to us.

How your work becomes unique is in many ways rooted in how you turn your inspiration into creativity. How this takes place, and how creativity works as a whole, is the subject of the next chapter.

Exercising Creativity

Creativity grows out of two things: curiosity & imagination.

BENNY GOODMAN

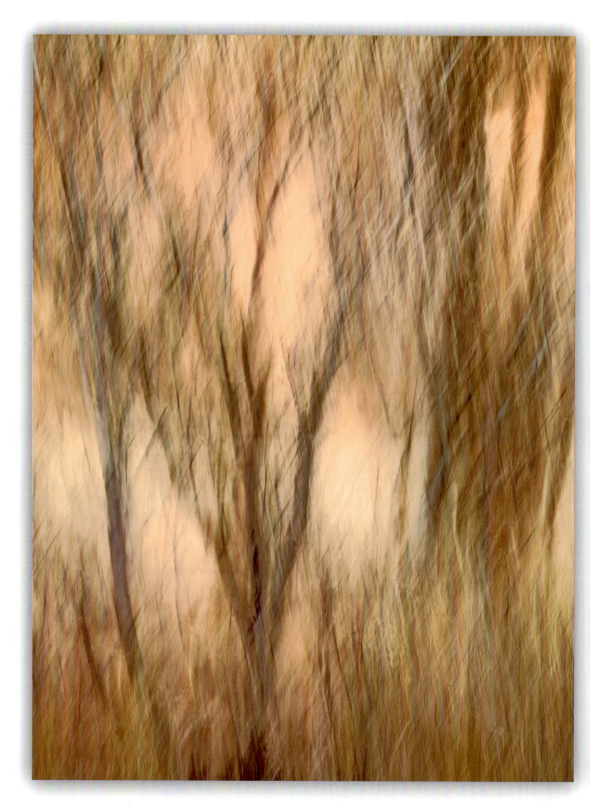

Introduction

You may wonder why a chapter on creativity follows a chapter on inspiration. After all, is there really a difference between the two? I wondered about this as well while I was working on this chapter.

In fact, I originally titled the chapter on inspiration "Creativity and Inspiration". However, while I was writing, I found it increasingly difficult to write about both inspiration and creativity at the same time. I found that although these two subjects are usually presented together, there are many things that separate them.

First, being creative is not the same as being inspired. On the one hand, one can be inspired and not exercise his or her creativity. On the other hand, one can be creative without being able to find inspiration. The first situation is comparable to staring at a blank canvas. The desire is there but the implementation is lacking. The second situation results in unsatisfying output, in artwork that goes into all sorts of different directions but lacks a specific and unifying source of inspiration.

Second, inspiration by itself does not necessarily result in the creation of new work. Inspiration is a spark that can potentially lead to a creative fire. However, for the fire to be lit one has to nurse the ember generated by creativity until it becomes a raging fire. If not, this amber may die a quick death, carrying with it the hopes of our newborn inspiration.

Third, creativity carries with it certain risks. The most notable is being creative for creativity's sake, without following a specific inspiration and without catering to the needs of a specific vision.

In other words, those two terms, inspiration and creativity, are not identical. Although they are commonly used interchangeably, they really address two separate parts of the artistic process. It is for this reason I decided to devote a separate section to each of them.

The Difference Between Inspiration and Creativity

The aim of creative photography is to make a visual interpretation of an experience, not just to record an image.

MONTE NAGLER

Inspiration is the flame that lights our creative fire. How that flame is born is the purpose of my previous chapter, "Finding Inspiration". What to do once the flame is lit is the purpose of this chapter, "Exercising Creativity".

Inspiration is the motivating factor that makes an artist want to create new work. However, by itself inspiration is just that: a motivating factor, a thought, and a desire. It may be a burning desire, but it is not a physical reality.

What makes inspiration a reality, what turns inspiration into a work of art, is creativity. Creativity in this regard is the logical outcome of inspiration. Creativity is what makes inspiration a physical reality. It is therefore through creativity that you will make your inspiration come to life into a work of art.

Creativity may be described as focused freedom. On the one hand you are free to create, on the other hand you are focused upon your work and your vision. It is a mix of two opposite directional forces in a way. In that respect it is a challenging state to find, to experience, and to make happen. However, once you are in this state, magical things can take place that would not otherwise happen to you.

Figure 9-1: Trees in Capitol Reef

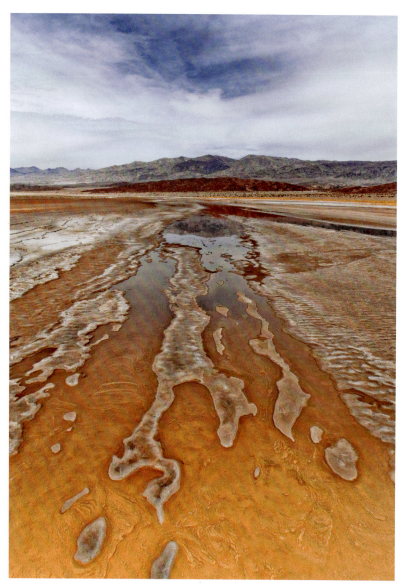

Figure 9-2: *Playa Reflections 2*

Do Not Delay Creativity

How do you find this state of focused creativity? It is hard to say for sure because we are not fully in control of creativity. In fact, we may not be in control at all. What we are in control of is our openness to taking advantage of the inspiration brought by the Muses when they visit us, and the creative urge that follows this visit. The sooner we can give way to this creative urge, the better. It is best to give way to this urge immediately when it takes a hold of us.

Don't plan to do this on a later trip. Don't try to think about it too much. Just get to work right there and then and create the images that you have in mind at that moment. Don't postpone it until a later and uncertain date. The fact is that there may not be a later time. You may not be able to come back for a long time, or maybe not at all, and if you do return the inspiration you feel today may no longer be there. Exercise your creativity now, today, on the spot. Don't delay. Don't wait for a "better" time. There won't be a better time. Now is the time!

This image was created almost exactly one year after "Playa Reflections 1", which is featured in chapter 8, "Finding Inspiration".

When I created "Playa Reflections 1" I thought I had gone a little too far in terms of creativity. However, the response to this image proved that I was on to something. The first image quickly became a best seller and was used as the cover image for my first book. (It was also widely hot-linked on MySpace, although this is both good and bad.)

This motivated me to go further, and one year later I created "Playa Reflections 2" as a result. The inspiration for this image is quite similar to "Playa Reflections 1". However, I did

not want to do a copy of my first image, and thus sought to be creative in different ways. My use of a yellow tone for the foreground sand caused me to, once again, wonder if I had gone too far. However, once again this image became a best seller proving that continued creativity as well as going further into my vision was the proper thing to do.

We All Have the Potential to Be Creative

Eventually I discovered for myself the utterly simple prescription for creativity: be intensely yourself. Don't try to be outstanding; don't try to be a success; don't try to do pictures for others to look at—just please yourself.

RALPH STEINER

All of us have within ourselves the resources we need to be creative. Being human means being creative. Why? Because being creative is being able to solve problems in new and unique ways, in creative ways. From the beginning of mankind the ability to solve problems is one of the things that has given man an advantage over other species. I should add the ability to solve problems effectively, so that the problems do not come back. Doing so means finding new solutions to old problems. How do you find new solutions? You find new solutions by being creative and imaginative.

In other words, being creative is not something that is specific to artists or to photographers. It is not something that is used only to create original art. Being creative is something that is used in all walks of life and in all professions whenever a new solution is necessary. Being creative is being able to bring new solutions to both old and new problems.

Being creative is also being imaginative. It is being able to think ahead, to think into the future, to brainstorm, to imagine what may happen down the road. Scientists, mathematicians, engineers, and all other professions need imagination and creativity to continue growing, to push the envelope further, to create new things, to be and to remain competitive, to visualize something that does not yet exist, to imagine this new "thing" from conception to construction and finally to implementation.

Creativity and its sibling, imagination, are all around us. As soon as we seek to create something new, no matter how insignificant it may seem, as soon as we seek to solve a problem effectively and pro-actively, we become creative by using our imagination to find new and effective ways to complete the task we set out to achieve.

From there we only need to take a small step to apply our creative abilities toward the arts and toward photography in particular. We only need to make minor adjustments in order to use our imagination toward creating photographs that are ours only, images that are new, images that we constructed in our mind and that are the result of our unique personal creative abilities.

Liberating Our Creativity

One does not think during creative work, any more than one thinks when driving a car. But one has a background of years—learning, unlearning, success, failure, dreaming, thinking, experience, all this—then the moment of creation, the focusing of all into the moment. So I can make ‚without thought,' fifteen carefully considered negatives, one every fifteen minutes, given material with as many possibilities. But there is all the eyes have seen in this life to influence me.

EDWARD WESTON

Creativity is turning the ember that was lit by inspiration into fire. As such, creativity is fragile and delicate because if handled improperly this ember can turn into ashes rather than into a blazing fire.

A number of things can stifle our creativity and turn this ember into ashes. When this happens creativity becomes captive of our beliefs, or of what we have been told to believe. To use the full potential of our imaginative skills we must liberate our creativity. In fact, liberating creativity is one of the most important aspects of the creative process. It is the key to being able to exercise our creativity. Why? Because our creativity is too often held back, or "chained" to put it in a more dramatic fashion, for a number of various reasons.

This situation may not be the case for everyone. However I have found it to be the case for a large majority of people in one way or another. It was definitely the case for me, so much so that I had to spend years liberating my own creativity. Today I credit my personal style to the time I spent and the efforts I made working toward being free to do my own work rather than copy the work of the other photographers who influenced me.

In the next six sections we are going to explore the reasons why creativity can be held back, and ways to liberate our creativity.

Fear of Failure

One is not really a photographer until preoccupation with learning has been outgrown and the camera in his hands is an extension of himself. This is where creativity begins.

CARL MYDANS

To be creative, to use our imagination toward creating original art, we must do something new, something that we have most likely never done before. Doing something we have not done before carries with it the risk of failure, essentially because we have to learn how to do this new thing from scratch. For many of us, whenever there is risk there is fear, in this case fear of failure. Fear of failure is one of the main things that can stifle our creativity.

It is important to understand that there is no such thing as a failure. There are failed attempts. However, a failed attempt does not mean absolute failure. It only means that this one time things did not work.

For example, Thomas Edison failed over 400 times before he found the right way to build a light bulb. When asked about all these apparent failures, Edison said that he had discovered over 400 ways to not create a light bulb. To him, these attempts were not failures. They were successes in the sense that each attempt allowed him to narrow the field of possibilities.

Success, ultimately, is a state of mind. So is failure, which can be seen as success when you look at it the way Thomas Edison looked at it. You can become depressed because of

your failures or you can get energized by them if you look at them not as failures but as attempts that are paving the road to success.

As an artist you will rarely succeed on your first try. This is especially true if you are trying new ways to represent the world and to express your vision. A certain amount of trial and error is necessary, and a certain amount of failure is to be expected. If you let your failures discourage you, you will not maintain your creativity. Instead, you will be creative for a short time, and then fall into depression when you fail to be successful at your first attempts.

Success is the result of not giving way to failure. Success is continuing to try in the midst of repeated failures because we believe that there is a solution to the problem we are working on and that it is only a matter of time until we find this solution. In this respect, failures are nothing more than valid attempts that did not materialize into the outcome we expected.

A failure is certainly a setback; one that shows the limits of our knowledge. We failed not because we are inept, or lack talent, or are incapable of success. We failed because we lack the proper knowledge to succeed. The solution is not to fall into depression or self-pity. The solution is to find ways to acquire the knowledge we need to succeed. The process of acquiring this knowledge is what will enable us to expand our current boundaries. Knowledge is what will make us go beyond our actual limitations.

There are two options when we are faced with a lack of knowledge: first, self pity, which leads nowhere but to a circular pattern of depression and blame, and second, seeking new knowledge that will allow us to exceed our current limitations and place us on the road to success. The first solution leads to failure; the second leads to success, be it in regard to liberating our creativity or in regard to any other endeavor.

When looking at failure this way you soon realize that failure is a door one can decide whether or not to push open. One can look at the door and say, "This door will never open for me". Or one can say, "I can open this door. I just need to learn how to do that". Failure, when viewed this way, is the opportunity to open new doors. These doors lead to a greater version of us, a version we currently ignore but whose potential is there.

The fear associated with deciding whether or not to open this door lies in the fact that what is beyond the door is unknown. In other words, there is a risk, and this risk is that we will step into something unfamiliar, something beyond our comfort zone. By staying in front of the door in self-pity we are actually staying within our comfort zone. By deciding to learn how to open the door we are stepping into the unknown and leaving our comfort zone.

Taking the risk of stepping into the unknown carries with it the possibility that a reward awaits us once the door is opened. It carries with it the elation of new possibilities that will present themselves later on. In my experience this reward far exceeds the risks that creative endeavors bring with them.

I rarely change colors to the point that they look unlike anything that would be found in a natural setting, but that is what I did in this image (figure 9-3). I often make a photograph black and white when the natural colors just do not work or do not look good at all.

This is what I thought of doing here, when I realized that giving a blue tone to the image would be more interesting. I also thought that the blue tone would suggest that the image

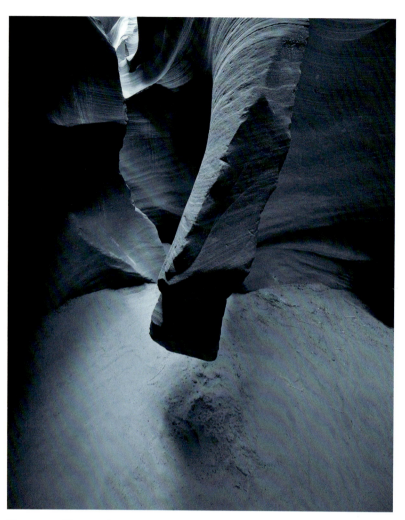

Figure 9-3: *Blue Antelope*

Moving Out of Your Comfort Zone

A dream is your creative vision for your life in the future. You must break out of your current comfort zone and become comfortable with the unfamiliar and the unknown.

Denis Waitley

Your comfort zone is represented by everything that you have achieved so far and by everything that you are comfortable doing. This is your safe zone, a place where you are at ease, where you are not taking a chance, and where you are not exposed to the risk of failure, ridicule, or error. All that you have achieved so far, all that you are comfortable doing, is located within this comfort zone. Your comfort zone is your safety zone.

Anything else you want to achieve, or are not currently comfortable doing, anything else you do not know how to do, is located outside of this comfort zone. To learn how to do these things comfortably you must first step out of your comfort zone. You must be willing to take a risk to learn these things in order to reach a higher level of experience, success, and achievement.

If you continue to stay within your current comfort zone you will remain at the level of experience, achievement, and knowledge that you are currently at. To expand both your knowledge and your achievements, you must leave your comfort zone and take a risk. The size of this risk is to some extent within your control. However, the size of the reward is proportional to the size of the risk. The larger the risk the larger the reward!

Liberating your creativity and making images you have not created so far requires leaving your comfort zone. It requires doing things that are new to you, things whose

depicts a night scene, since we associate night with blue tones, although in reality colors at night are rarely blue. This is a strong departure from reality, but I found it to be appropriate for this location because the shapes of the canyon lend themselves to a semi-abstract rendering.

outcome is unknown to you. Because you have no previous experience creating or showing these new images, you cannot predict the exact outcome of your creative work nor can you predict people's reactions to this new work. As we will soon see, the most efficient way of addressing this issue is to focus on your work and push all other concerns aside.

Overcoming Creative Fear

Thinking should be done before and after, not during photographing. Success depends on the extent of one's general culture, one's set of values, one's clarity of mind, one's vivacity. The thing to be feared most is the artificially contrived, the contrary to life.

HENRI CARTIER-BRESSON

Being overly focused on an artistic goal can be so frightening as to paralyze the artist. This is what happens when an artist stares at a blank canvas, unable to put paint onto it. This is also what happens when a writer experiences writer's block and is unable to put words onto paper. In either instance creative fear, which is another term for fear of failure, is dominating these artists to the point that they cannot be creative in any way.

In photography, one doesn't stare at a blank canvas. Rather, one stares at a viewfinder filled with a scene. In photography, taking a photograph can be as simple as pressing the shutter release button. However, it is still necessary to go out there in the landscape to create photographs if you are a landscape photographer, or to go into the studio if you are a studio photographer. Sometimes, creative fear is so powerful that it prevents the artist even from doing that.

Because photography is a multi-step process, creative fear in photography also takes place after the photograph is taken. For example, I know a photographer who is unable to print any of his work. He is able to create new images in the field, he is able to develop his film (if you shoot digital you can compare this to converting digital captures from RAW), but when it comes to printing he draws a blank and cannot do it.

Other photographers may print their work only to find that they are unable to show it or exhibit it. This is something I witness during workshop print reviews where a number of photographers who bring prints find themselves unable to show their work to the group.

How do you fix this problem? How do you stop creative fear? How do you put an end to being unable to create, print, or show your work? A very effective solution is to focus on the positive rather than the negative aspects of the process. Focus on what you are going to learn from a print review rather than on the criticisms that may come your way. Focus on the print quality you may be able to achieve rather than on the lack of it. Focus on the exciting new photographs you may end up with rather than on the ones you will have to discard.

In short, stop focusing on negative aspects of the art. All endeavors can potentially result in a negative outcome. However, if we focus on this negative aspect, we will get discouraged and give up even before we try.

Instead, focus on the positive aspects of the process. If you are a painter, focus on the beauty of a single brushstroke on a white canvas. If you are a photographer, focus on the beauty of a single capture or exposure. Focus on a certain color that you love and that you want to apply to the canvas before any other

color is put down, or that you want to capture in your photograph more than any other color in the scene in front of you.

Focus on the parts rather than on the whole, and definitely don't focus on the finished product. Focus on the individual steps you need to follow to complete the artwork. Focus on what inspires you. Focus on anything, but do not focus on what the finished artwork will look like or on what others will say when they see it.

Also, be playful with your medium. Give yourself the freedom to play with your subject. Playfulness may be the most effective way to remove fear. When being playful one is not thinking about creating a masterpiece or a work on which one's success or failure is dependent upon. Playfulness does not carry a success or failure implication. Playfulness only means that we are having fun; we are enjoying what we are doing while at the same time exploring what can be done and what can happen when we experiment with new approaches or techniques. While playing, one's focus is on the here and now, not on what may happen tomorrow. This approach removes the fear that comes from focusing on the future implications of one's actions. The only implication of having fun is that we are having fun. Playing is not serious, it is not considered to be "for real". In fact, this is the very definition of playing: that it is a fantasy and not a real-life situation.

So make art a game, make it playful, and have fun with it. Rather than think about the future implications of your actions enjoy these actions at the present time. Focus on what you like in the scene you want to photograph. Do not focus on whether or not others will like your images. Focus on what you like to do. Do not focus on what others may say about

your work or on what they may expect you to do. Focus on your inspiration and make it a point to express this inspiration freely and creatively.

Fear of Critique

Critique is important but there is a time and a place for it. The creative stage is definitely neither the time nor the place. Therefore, do not seek critical feedback or commentary on your work during the creative stage of the artistic process. Your goal at this stage should be to let your creativity run free and to create new images unencumbered by critical considerations.

Do not worry whether others will like or dislike the new work that you are creating. This is not the time or the place for that either. Focus on creating this work, on having fun, on enjoying yourself, and above all on expressing your inspiration through the creation of new images. Feedback and criticism, if you want them, will come later. At this time it is far too early for critique to take place.

It is best to wait until after your work is completed to ask for feedback and criticism. During the creative phase of your work, do the very best you can do. Once your work is completed, you will have the opportunity to show your work to others and to let them say whatever they think about your work if you so desire.

Similarly, do not worry whether you are creating a masterpiece or not. Just like criticism, this is neither the time nor place. Furthermore, this is not for you to say. It is for your audience, for the critics, and for the reviewers to decide. Your responsibility at this point is

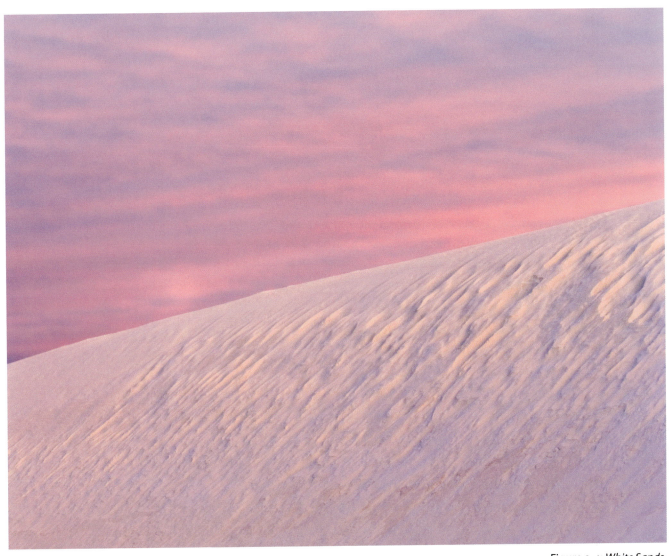

Figure 9-4: *White Sands*

liberating your creativity and producing new work.

To liberate your creativity you need to take a chance; you need to get out of your comfort zone. For this to happen it is best to push aside any thoughts concerning what others might think of your new work. To give consideration to future criticism is to stifle your creativity and make you fear the outcome of your work won't be pleasing to your audience.

This is the exact inverse goal of what you are trying to achieve. You want to liberate your creativity, not stifle it. So let it go and don't give it any thoughts. Just focus on your work and create.

I was photographing the moon rising over White Sands National Monument in New Mexico when I turned to my right and noticed this scene unfolding next to me. The colors of the sky and the dune were very similar, and

the ripples in the sand mimicked the cloud formation in the sky.

I had a 300 mm lense with a 1.4 tele-extender on my 1DsMk2 at the time. Aware that the light quality was about to disappear, I decided to not change anything to my lens setup. I had concerns that this lens combination was way too long for this image, but I did as I recommend you to do to foster creativity, turn off your inner filter. Just create an image, without editing anything, without wondering if this is right or wrong, and without asking yourself what others might think. After all, if your idea doesn't work, you can always delete the RAW file and move on. Nobody needs to know what you did unless you decide to talk about it, which is what I am doing now.

The light and the colors vanished after I took about three frames, and my desire to change to a shorter lens remained unfulfilled. Back in my studio, it took me some time to convince myself that I should convert, optimize, and even print this image because it was unlike anything else I had done that day, or even before that day for that matter. I also wondered what title to give it, until I decided that simply calling it "White Sands" was the way to go. After all, for me this is what White Sands was like on that day. This is my emotional response to this scene, an unfiltered and purely creative response. I do like the final image and have since included it in one of my portfolios.

Everything Has Already Been Done

One painter ought never to imitate the manner of any other; because in that case he cannot be called the child of nature, but the grandchild. It is always best to have recourse to nature, which is replete with such abundance of objects, than to the productions of other masters, who learnt everything from her.

LEONARDO DA VINCI

Another cause for lost creativity is the feeling that whatever you want to do has already been done before, feeling that you are, in effect, doing nothing else but redoing what others have done before you. In short, you feel as if your work is redundant and you are wasting your time. But not everything has been done before. In fact, your vision is yours and yours alone. You are unlike anyone else. Certainly, at first, your steps toward expressing your vision are most likely to be the same steps that other artists have taken before you. We all have to start somewhere, and we all start pretty much from the same place: a blank canvas for a painter and a camera viewfinder for a photographer. Those are the same. What is different for all of us is what happens afterward.

The logic of the "it has already been done" approach is a false logic. The best way I can prove it is by pointing to the contradictions that follow those who embrace it. Usually, when you hear someone say, "everything has already been done" what you hear him or her say next is "all art looks the same". Well, if indeed everything has already been done, then we should be surrounded by the widest variety of art that we will ever see. We should not be surrounded by art that is "all the same".

Nobody Cares About Your Work

Believing that nobody cares about your work is another common source of discouragement for budding artists and another cause for not feeling creative. The best way to address this issue is to look at the potential audience for your work. The number of people who inhabit the Earth is growing exponentially. At the time this book was written there were close to seven billion people on the Earth. If you think of this number as your potential audience, it is clear that it is larger than it has ever been for any artist who preceded you. Even if you reach only a small fraction of this audience, let's say less than 1%, the numbers are still staggeringly high.

There is an audience for you out there. It may be a buying audience or it may be an audience that simply enjoys looking at your work. It may be an audience of only a few people, or it may be an audience of thousands or more. It may be an audience of people who like your work or it may be an audience who criticizes it. It may be a lot of other things as well. All that matters is that there is a huge number of people out there to whom you can show your work. Some of those who see your work will start to follow what you do, and those that do follow your work will become your dedicated audience.

You cannot control the size and the nature of your audience. They choose you rather than you choosing them. However, you can control what part of your audience you address. You have control over who in your audience you give your time to, who you favor, who you talk to, and who you choose as your friends.

My recommendation, modeled after my own approach, is to favor that part of your audience who loves your work. This is where encouragement comes from. This is the audience that will encourage you to go further, to continue your work, to grow, to improve, and to reach the next step with your art. This is the audience who likes you and your work. It is also the audience who is willing to support you in order for you to continue your work. This audience focuses on the positive aspects of your work. They like what you do, they want you to continue, and they are willing to help you do that. This is the audience to listen to and give your attention, and it will foster your creativity.

You want an audience who pushes you toward being more creative, more daring, and more yourself. The only way to guarantee this will happen is to focus on the part of your audience who is on your side, who likes your work, who sends positive reinforcement and encouragement your way, and wants to see more of what you have to offer.

Negative feedback, disillusioned audience members, or overly critical art patrons do not generate creativity. Although these and other negatively oriented individuals may be part of your audience, it is definitely not the part of the audience you want to focus on. Certainly, they will approach you and tell you whatever it is they want to tell you. That you cannot control. What you can control however is your response to their remarks. And the response I recommend is to let them speak then move on politely without engaging in an argument or a detailed explanation, which will be futile (I expand on this point in chapter 12, "Just say Yes").

I do not photograph in black & white. I photograph in color then I convert a small number of my color photographs to black and white when the colors do not add anything to the scene, or when the colors take away from

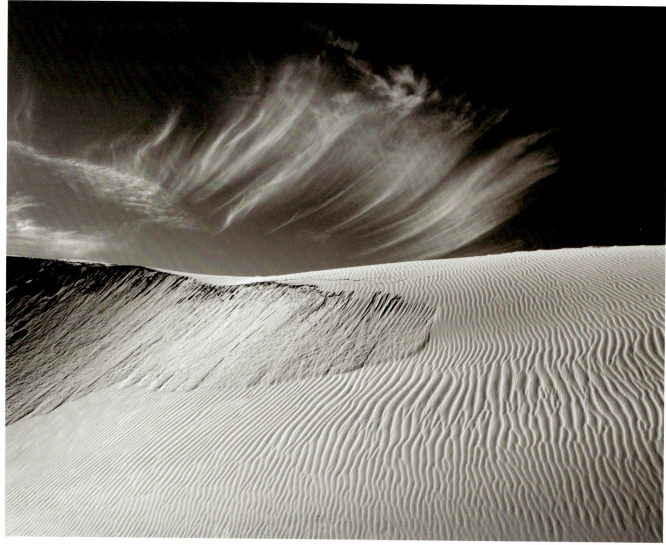

Figure 9-5: *White Sands* – Black & White

the scene. A black and white image is successful, for me, only when it would never have worked in color. At that time I do not miss the color and I am able to find enjoyment in the arrangement of black, white, and gray tones.

This image was challenging because I saw it as an opposition of forces (figure 9-5). On the one hand, there is the strong graphic quality of the dunes and the clouds. The pattern in the sand and the clouds are reminiscent of each other while at the same time they point away from each other, the sand waves pointing downward and the cloud wisps pointing upward.

The compositional strength of the image as well as the movement of the dune and

cloud patterns asked for an equal amount of strength in the treatment of the image contrast. In other words, the contrast had to be comparable to the composition in terms of strength. A weak contrast would have clashed with the strength of my composition.

On the other hand, I did not want this contrast to be overwhelming because this often results in images that are overdone and turn into clichés rather than into engaging works of art. For this reason I refrained from making the sky pure black and from overexaggerating the contrast between the clouds and the sky and between the dune ripples. I let my creativity guide me more than my rational interpretation of what was right and wrong. I ended up, after several days of work, with a plethora of files from this one image, among which I eventually selected this rendition as the one that best represents my emotional response to this specific scene.

Skills Enhancement Exercises

Nothing will give permanent success in any enterprise in life, except native ability cultivated by honest and persevering effort. Genius is often but the capacity for receiving and improving by discipline.

GEORGE ELLIOTT

The best way to explore and liberate your creativity is to perform exercises designed to achieve exactly that. There is little about this process that is intellectual. Therefore, at this stage it is necessary to go out and photograph.

Following are three sets of exercises I have found to be most effective.

Breaking the Rules

My first photography teacher, Scott McLeay, had a great exercise aimed at developing creativity. When I first practiced this exercise I found it opened the doors to ideas and images I would not have thought about otherwise. Today, after many years, I continue to think it is one of the best exercises to develop your creativity. This is a two-part exercise:

- List all the rules of photography you believe you should follow, the rules that have been taught to you by others, the rules you made for yourself, the rules your parents told you about and so on. You may even want to get together with other photographers to help you make this list, or to create a list not only of the rules you believe in but also the rules other photographers believe in.

- Go out and photograph with the goal of breaking each of the rules you listed. You can either do this in one day, working on all the rules, or you can do it in several days or over a longer period of time.

A few important notes about this exercise:

I recommend you do this exercise over several days or longer. This will allow you to break a rule each day, or to break a specific rule over several days by creating a number of photographs that each represent a different way of breaking a specific rule.

For example, let's say you decide to break the following rule: "always photograph with your camera on a tripod", and to break this rule you decide to always photograph with your camera handheld during a five day shooting trip to one of your favorite locations.

What will happen as a result? For one, if you are a nature photographer, you will soon find yourself at sunrise or at sunset at a great location during your multi-day trip. This means that you will have to raise the ISO to

compensate for the low light, and that you will have to cope with the increased grain or digital noise and the resulting loss of sharpness in your images. If you had been breaking the rule over a single day, or a single shot, chances are you would have worked handheld during the middle of the day and would not have had to confront the technical issue of noise or grain.

In short, breaking the rules over several days as opposed to a single shoot or a single image makes the process more realistic. Over a multi-day shoot in one of your favorite locations, you will become aware that you are walking away from creating images that you know would be successful should you have followed the rules you normally follow. However, because you have decided to break the rules and you are not doing what you think you should be doing, you will not get the shot you think you should get. As a result, you may be strongly tempted to do away with the rule-breaking exercise and return to your regular practice "just for this one shot". I strongly urge you not to do that for several reasons. First, if you return to your previous approach and decide not to break the rules for the one shot you feel you must have, you will invalidate your entire attempt at breaking the rules. The time at which this exercise is the most valuable is when it means the most to you; when it costs you something you don't want to give up. In the case of the example above (photographing without a tripod while your rule says always use a tripod), it means giving up a photograph you know would be successful for a photograph that may not have any value at all.

What you really need to do to make the exercise valuable is do the things you could not do with your camera on a tripod. For example, try multiple angles, change the camera height, vary the camera position and location in such

a way that it would not have been possible to set up your tripod in those ways because you would never have had the time necessary to do so in the short amount of time you had available before the sun set. Or photograph from a position or a location where setting up a tripod is virtually impossible. Or photograph with the desire to have movement, or noise, or grain be positive attributes of your photographs rather than defects. Work with the goal of making these effects an advantage, an element that you wanted to feature in your images. Only then will you make the process of breaking the rules work for you. (This approach will work for any rule, not just for the "no tripod" rule.)

Second, if you refuse to break the rules because one photo is too important, you forget that each shoot is unique and that any photograph can be done again. Granted, we cannot return to all the locations we ever visited, nor will the light, the specific plants, cloud patterns, and all the other elements be exactly the same as they were on our first visit. However, we can return and we can pretty much compose a similar image on a different day. This means that we are not really missing anything. What we are doing is trading one approach (an approach with known results) for another approach (an approach with unknown results). That is all we are doing. Furthermore, we do not have evidence that the new, rule breaking approach we are using will not generate good results. All we know is that the results will be different.

Third, we must not forget the reason we are breaking the rules. We are breaking the rules either because we do not like our current results and want to try something new, or because we want to go further than we have gone so far, or again because we want

to develop a unique way of seeing, a way of seeing that is different from other photographers. Most photographers follow similar rules. Therefore, by breaking these rules we have a good chance of discovering something new, something that no one else is doing. It is also possible that this discovery will, in turn, lead to a new way of seeing the world, to a new vision, and eventually to the development of a personal style.

In other words, rather than focusing on what we are giving up, we need to focus on what we are gaining, which is a new way of seeing, a new vision, and a personal style. There is the risk and the reward. In my estimation this is worth it, especially if we believe that following the rules does not always give satisfying results.

Using Different Equipment

This exercise will allow you to take a different direction with your work, to see things differently, to take chances, and to step out of your comfort zone. It is also a lot of fun.

The list of equipment you can use for this exercise is virtually endless. Below are two possibilities that I have found to be effective both for my own work and for my students' work:

- Use a Holga Medium Format Polaroid camera. This is an imperfect camera. It is a camera known for its defects more than for its image quality. To use it to your advantage you will have to learn how to make these defects part of your work, how to turn them into a quality rather than a defect.
- Use a Lensbaby on a DSLR. This will allow you to combine the most sophisticated digital cameras with one of the simplest—if not *the simplest*—lens. The distortion capabilities offered by the Lensbaby, as well as the

selective focus area that can be controlled to some extent, offer further opportunities for creative work.

Doing Creative Things on a Regular Basis

This practice will ensure that creativity becomes a routine part of your life and not just on occasion.

Each time you create new images, either in the field or in the studio, take a chance by trying something you have never done before. This can be a very different type of composition, or it can be using a new filter in the computer, or it can be something else altogether. No matter what you do, the idea is to try something you have not done before and to take a chance with a couple of photographs. If you don't like the results, you don't have to show them to anyone. However, you might surprise yourself and end up with images you really like!

I practiced this exercise when I found these four rocks while looking for photographic possibilities along the shore of the San Juan River in Southern Utah. (Although I used this same image earlier in the book, I am featuring it here for a second time because it provides a good example of the concept of practicing creativity.) I was not looking for rocks in particular, or for details specifically. In fact, I rarely photograph details, preferring to focus on the grand landscape rather than on closeups.

What attracted me to the rocks were their colors as well as their arrangement. Certainly, I isolated this grouping among countless other rocks along the shore. However, I did not rearrange them. I rarely if ever rearrange anything in my images. It just takes too long and I never manage to make it look right. Nature makes it look right: I make it look contrived. If I rearrange, what I photograph is my arrangement,

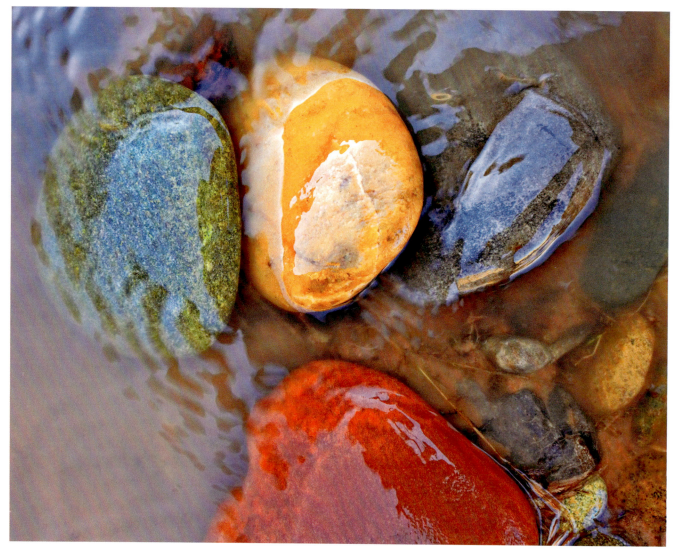

Figure 9-6: *Four River Rocks*

while if nature arranges it, I photograph nature's arrangement.

I let my creativity take over and guide me toward this image. It stands as one of the few detail shots I have created and shown. Many of these either never get shown, or they receive a less than maximum exposure. In this instance what I liked the most was the color of the rocks and the arrangement of the stones. They look as if they formed a small community along the shore, each bringing its uniqueness to the group, until a wave comes along and pushes them away, down the river and into the current.

Conclusion

The preceding exercises may have given you the impression that anything goes when it comes to exercising your creativity and that the goal is to be creative first and generate good photographs second. This is not exactly true and for this reason I must add this remark immediately following the Skills Enhancement Exercises section.

Certainly, you need to liberate your creativity and the previous exercises were designed with this goal in mind. If you practice them regularly, you will become more creative and less fearful of unanticipated results. However, the goal is not to be creative for creativity's sake. The goal is to be creative in order to materialize your personal vision. Eventually your creativity needs to be placed at the service of this vision. For this to happen you must have an awareness of what your vision is.

Describing the process of developing and expressing your vision is the goal of the next chapter. Your vision must follow your inspiration and be served by your creativity. When these three pieces fall into place the outcome is the achievement of a creative style.

Don't be alarmed if this four part process seems overly complex or if this description is a little too succinct. At this point we have only covered half of this process and we still have two chapters to go before we cover the topic entirely.

Creativity is exploration and imagination. On the one hand, it is looking for something without knowing exactly what this thing is. If you already know precisely what you are looking for, you are not being creative. You are simply trying to find something that you know exists, something that most likely others have found before you. Creativity must be channeled, otherwise it runs wild without following a specific direction, without seeking to reach a specific goal. This direction, this goal, is your personal vision. It is vision that brings inspiration and creativity together.

10 Developing Your Vision

Vision is the art of seeing what is invisible to others.
JONATHAN SWIFT

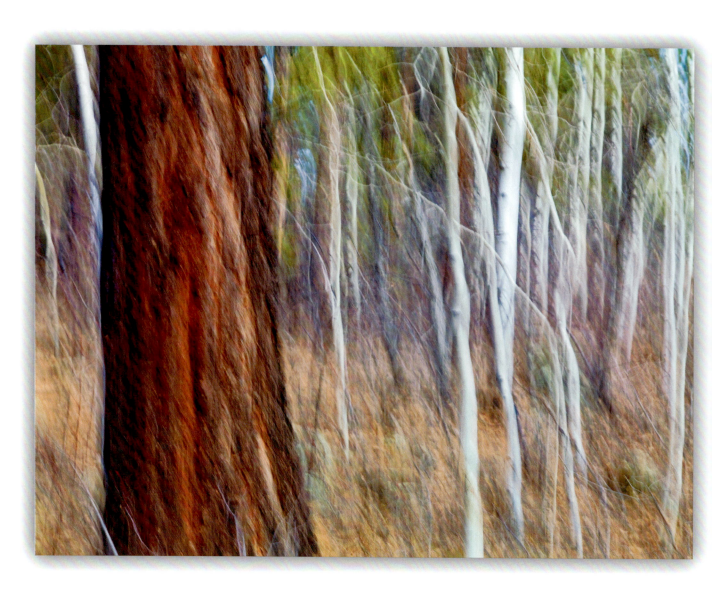

Introduction

Inspiration lights the spark of creativity. Together, if well integrated, inspiration and creativity result in a personal vision for your work. Your vision, when expressed successfully, results in the achievement of your personal style.

This is a four part process. In the previous chapters we looked at the first two parts: inspiration and creativity. It is now time to look at the third part: vision.

Vision is a subject that is rarely discussed in photography, yet, as we are going to see, it is a very important subject because without vision an artist will create commonplace photographs; they may be the most technically perfect photographs one can take, but they will still be commonplace. With vision your photographs go beyond being just commonplace images. They become the conveyors of ideas. How this process takes place and what is involved when it happens is the subject of this chapter.

What Is Vision?

It is a terrible thing to see and have no vision.
HELEN KELLER

Vision is the art of seeing the invisible. In this respect, vision is not just seeing; it is not just "sight". Instead, vision is *insight*. It is the ability to see something that only you can see, something that others do not see because this something does not have a physical reality. It is something you see in your mind's eye, something that exists in your imagination, something that is within yourself.

A vision is something abstract: an idea or a concept. Vision is made real through creative work. In photography it is made real through the creation of photographs that express your vision. The goal of these photographs is to share your ideas, your concepts, your *vision* with your audience.

A vision can come about in any field of human endeavor. In regard to photography, vision is made real through the photographs you create. How clear your vision is, and how closely your photographs follow this vision, defines how successful you will be in conveying your vision to others.

Vision is inspiration made into reality. Vision is using photography to express something otherwise invisible. Vision is making poetry with photographs. It is going beyond the technical knowledge of the medium and reaching the artistic level. It is going beyond mastery of the medium and reaching improvisation and self-expression.

Finding and expressing your vision can be a challenging process. Because your vision is something that is invisible to others, it is a process you have to go through essentially by yourself.

Vision demands an unwavering commitment to your art. It also demands that you back up this commitment with work, because only through work will you be able to share your vision with others and thereby prove you are truly committed to this vision.

Vision is message. It is not just creating an image but creating a story through the image. This message can be about sharing an emotion, a feeling, a belief, or a particular way of looking at the world. It is not just about sharing an image with your audience. It is also about sharing the meaning of this image with your audience. This image means something

Figure 10-1: *Boulder Mountain Trees*

to you. This image contains more than just objects, people, and features. It also contains ideas that represent your vision. Without vision an image is just an image. With vision an image becomes the vehicle that carries your ideas to your audience.

Making Your Vision Reality

New images surround us everywhere. They are invisible only because of sterile routine convention and fear.

LISETTE MODEL

Creating a photograph that is faithful to your vision is similar to creating a product based on an idea, on an image in your mind. This product can be anything: software, mechanical devices, services, etc. This product will represent the outcome of your vision as long as it started as an idea that you turned into a physical reality. Ideas cannot be shared as ideas; they have to be translated into something else first. This "something" is the vehicle used to deliver your idea—your vision—to your audience.

The simplest way of translating your vision is to put your idea into words in order to explain to others, either orally or in writing, what this idea consists of. This is what a description, an essay, a short story, a novel, or any other piece of writing is. A photograph can also be used as the vehicle for an idea if the photograph is used to describe this idea. In the same way, anything created on the basis of an idea and turned into a physical reality qualifies as being a vision made into reality. If this process doesn't take place, your vision will remain an abstract concept, a dream that exists only in your head.

So what do you need to do this? For one, you must have an idea, which is something only you can do. For some, this comes naturally. For others, it is something that requires work, and sometimes, soul-searching. I can't give you this idea. No one can! It is something that you have to come up with. What I can do is help you find the way to this vision and then help you to turn your vision into reality. This is what we are going to explore in the following sections.

I consider the light quality in this photograph, "White House Storm" (figure 10-2), to be part of my personal vision. I also consider this light quality to have helped define my personal style.

I have seen this type of light and have been able to photograph it on three separate occasions. This image represents the third of these three occasions. This is a very uncommon type of lighting because it only occurs when a storm is clearing in the late afternoon. There has to be clouds in the sky, both in the eastern and western directions, as well as openings in the clouds in the west so that the sun can shine through.

Critical Thinking

The only thing an artist has to remember is to never lose faith in his vision.

JAMES LEE BURKE

Vision is the stage at which *thinking* about your work is just as important as *creating* your work. In other words, you need to spend time reflecting about your photographs. Just creating and printing new photographs will not allow you to express your vision. Reflection has to take place. Thinking has to take place.

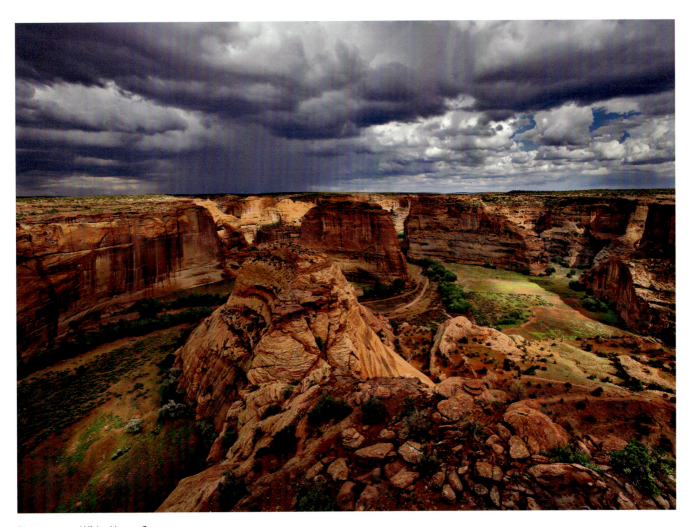

Figure 10-2: *White House Storm*

A large part of the process of developing your vision takes place without a camera in hand. It doesn't even have to happen where you take your photographs. It can happen wherever you have time to think, in a place that is quiet and conducive to reflection and where you are not distracted by anything else.

In a way, you have to engage in critical thinking about your work. You have to think about what you have done so far and about what you want to do next. You also need to think about what inspired you to start creating photographs in the first place.

Critical thinking is also about thinking differently. It is about thinking of solutions and possibilities that have not been thought of previously. In many ways, being creative is synonymous with thinking differently. To think differently you have to think differently from "something". You can't think in

the abstract without some point of reference, some point of departure, some school of thought to guide you, or without affiliating yourself, to a greater or lesser extent, with a specific art movement.

Creating a vision cannot be done in a vacuum. To develop your vision you must take into consideration both what you want to do and what has already been done by other artists. Something is different only if it has not been done before, or if it has not been done the way you are doing it. A work of art is original because it is *different* from the works of art that preceded it.

This means that you have to know where you are coming from, what your point of reference is, what your roots are, who your colleagues are, and who is working in the same style as you. In short, you need to know where you fit in. This is why the next section is important. If you are not sure about how thinking differently and who you are ties together, I recommend paying close attention to the following section. I also recommend completing the Skills Enhancement Exercises provided at the end of this chapter which targets this crucial aspect of developing a vision for your work.

Going Back

I don't photograph the world as it is. I photograph the world as I would like it to be.

MONTE ZUCKER

A number of things can help you go through the challenging endeavor of finding your vision. The first thing is to remember your original source, or sources, of inspiration. I cover this subject in chapter 8, "Finding Inspiration". If you haven't read it already, I suggest that you take the time to read (or reread) this chapter now, and that you complete the Skills Enhancement Exercises listed at the end of chapter 8.

Another way that can help you find your vision is to refer back to the reasons you started photography in the first place. Most likely, you started photography because you wanted to represent the world around you differently than others had done before, or because you wanted to express a personal way of seeing. Maybe you became interested in photography because you wanted to capture the fleeting events in your life for posterity. Maybe you became involved in photography because you wanted to document the street life in a big city, or because you wanted to share with others the beauty of a sunset or the stunning quality of a grand landscape.

Maybe you started photography because you love animals and you wanted to share this passion with others through your images; or because you love spending hours creating a still life, lighting it, and then creating the finest photographs of this still life; or you wanted to create the finest portraits possible; or you love the purity of color, or the endless tones of black and white prints. Maybe you became involved in photography because you constantly marvel at the endless possibilities offered by toning and other alternate approaches and because you want to share your talent for creating images that use these tones differently than you have seen done by others.

If you are like most, at first your equipment was minimal, most likely inexpensive, and maybe given to you by parents, friends, or relatives. The purchase and ownership of expensive camera equipment may have come later. This ownership may have brought with it

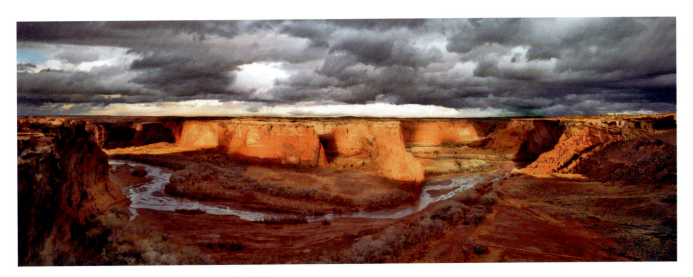

Figure 10-3: *Clearing Spring Storm*, Canyon de Chelly

a passion for fine cameras, lenses, computers, printers, and other equipment associated with photography.

Over time this passion for the equipment may have overshadowed your initial reasons for choosing to do photography in the first place. The passion you had for representing the world around you may have slowly given way to a passion for the tools rather than for the outcome that these tools can produce. In turn, your inspiration may have shifted from being inspired by the subject to being inspired by the camera. Transferring passion from subject to equipment is not the only reason we move away from our vision. There are many other events that can cause this to happen. Life has a way of taking us away from what we originally intended to do and making us do things because we have to rather than because we want to.

This is a common situation that many photographers face. The way out of it is to first accept it for what it is. Don't refute the facts; just accept them. Then, go back in time in your mind and remind yourself of the reason you started photography in the first place. You may be able to do so simply by thinking about it and by remembering events that took place a long time ago. You may also have to go back through your archives so to speak, or make a trip to the place where your first photographs are stored and look at the photographs you created when you first started. In those photographs, embedded in the paper and the emulsion, are the sources of your original inspiration and the results of your original creative urge. Inside them is an inspiration coming solely from your subject and from your emotional response to this subject. Back then you probably did not think you would ever own expensive gear. Back then the equipment was simply a means to an end. This was as it should be. Cameras are not jewelry or collectables, they are just tools. These tools are a means to an end, and this end is to achieve a personal style.

Back then you did not have the responsibilities that you have today. Your artistic goals were not overshadowed by the concerns that came later on and that may still be there today. If you were like most you had more time than money, a trend that tends to reverse itself as life goes on.

This is the first photograph I created using the light quality I described in my previous example "White House Storm". I created this image shortly after moving to Chinle, Canyon de Chelly, Navajoland, in 1997. Tsegi overlook, where the photograph was taken, was only ten minutes from my house. I was on my way to pick up my wife, Natalie, when I noticed the dramatic clouds. I realized that if the sun came out, a truly incredible lighting effect would take place. I immediately decided to drive the short distance to the rim of Canyon de Chelly to wait and see if the sun was going to appear.

I waited perhaps half an hour until the sun broke through the clouds. What I witnessed then remains one of the most incredible scenes I have ever seen. "Clearing Spring Storm, Canyon de Chelly" is the result and this image explains what I saw better than any text I can write. I took a number of photographs, the best being the second or third shot. Before that there was not enough sunlight. Afterwards there was too much sunlight. The best photograph was just inbetween, when light and shadow areas were evenly balanced, creating tension and beauty at the same time and making me deeply aware of the utterly temporary nature of natural light at transitional times when storms are moving away.

What is most interesting when I look at this photograph today and reflect upon it, is that this light quality came to define my vision and played a key role in shaping my personal style. However, I did not see it that way back then. When I created this image, the most important aspect of it for me was the panoramic composition. Certainly, the light was important and I was aware that the light made the image. However, it was the panoramic format that I thought was going to define my style, so much so that I purchased a Fuji 617 camera following the creation of this image and proceeded to create a series of panoramic images with it.

As things turned out, I tired of the panoramic format relatively quickly, perhaps within two or three years of using the Fuji 617, and eventually stopped using it. However, to this day I continue to seek the light quality in the image above, regardless of which camera I use.

What was happening then was a misconception on my part regarding what my personal style consisted of. I thought my style was coming from the format of my images, while it was actually coming from the light quality in my images. The format is a superficial aspect of my vision, while the light is a fundamental aspect, one that will not go away because it is not based on temporary preferences. Rather, it is based in a deep-rooted appreciation of light that goes back to the day I started photography.

Your Personality

A photographer's work is given shape and style by his personal vision. It is not simply technique, but the way he looks at life and the world around him.
PETE TURNER

Developing a vision for your work is showing to others, through your photographs, what you see in your mind's eye. It is therefore about you. It is about how you see the world, about what you see that others do not see, and about your emotional response to the scenes that you photograph. In many ways it is about your personality.

In the process of developing this vision you must therefore be yourself and demonstrate your personality. Art, when everything else has been said and done, is about you. As an artist, you need to demonstrate your personality to your audience through your work.

The audience that is seeking original art wants something that escapes the commonplace. They want something that they do not find in the prepackaged, mass-produced, and impersonal artwork found in volume retail stores and other mass-appeal locations. They are looking for art that is original, hand-made, and demonstrates the personality of the artist who created it. They expect artists to be original and to express themselves through their artwork. In other words, this audience expects the artwork to be an expression of the artist's personality. If this is not the case, if the artwork is impersonal, the artist is perceived as being a lesser artist. An artist "sans" personality in a way. An artist who is far less interesting than an artist "avec" personality. In other words, something is missing and this missing something is fundamental to art.

Worse yet, if the personality of the artist demonstrated through his art is missing, it will not be missing just from the artwork. It will also be missing from the way this artist talks about his art. It will be missing from the way this artist relates to others and to the world at large. In short, it will be missing from everything this artists does, regardless of how much contact this artist actually has with the public.

Some readers may find this to be somewhat of an exaggeration. After all, some readers may believe that doing beautiful or interesting work is enough and that this work does not have to be about themselves and that it does not have to demonstrate their personality. This is a true statement, provided that your goal is not to express your vision, and eventually your personal style, in your work.

How can you express your vision and demonstrate your personal style unless you bring your personality into your work? As we saw, vision is by nature personal and personal style is about you. There is no way around it, unless you decide that expressing your vision and achieving a personal style is not something you want to do. But if it is something you want to do, then expressing your personality in your work is necessary. You don't have to express all the aspects of your personality, in fact few artists do so, but you are going to have to express some choice aspects of your personality.

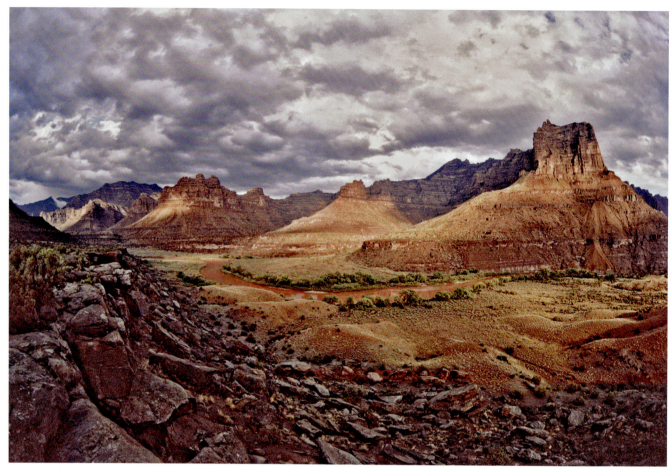

Figure 10-4: *Storm Along the Green River*

Making Your Vision Reality

To create one's world in any of the arts takes courage.

GEORGIA O'KEEFE

To continue the discussion started in the prior section, in a sense, your audience seeks to admire and acquire objects that have a soul. Rationally speaking, objects, including works

of art, do not have a soul. They aren't alive, they don't breathe, and they aren't made of living cells. They don't think, and thus, from a Cartesian perspective, they are not able to invent themselves. Irrationally speaking, however, works of art can be perceived as having a soul. This soul, if present, is imbued into the work of art by the transfer of the artist's personality and passion. This soul is brought about by the care and the craftsmanship used

to create the work. This soul is present in the artwork because a part of the artist's soul was transferred into the work during its creation. This soul is the personality of the artist. It is the demonstration of personal choices and the decision to implement a personal idea rather than someone else's ideas. In a way, what surprises us (and even shocks us) when we encounter a work of art for the first time, is the implementation of the artist's vision through the demonstration of this artist's style, ideas, and personality.

What surprises us is that the choices made by a specific artist are radically different from the choices we saw other people make in regard to the same subject. What captures us is the unabashed display of this artist's personality through his or her work. What delights us is to see something depicted in a way that we have never seen before, a way that we know we will only see in this artist's work. The outcome of vision implemented in a work of art is a new and different way of looking at the world. It is the creation of a new reality, a new world, into which the artist invites his audience.

"Storm Along the Green River" is the third of three examples in this chapter where I captured this light quality in a photograph (figure 10-4). I was going to say "in a *successful* photograph", when I realized that I had not seen this light quality in any other instance.

Of the three examples in this chapter, this may be my least favorite. This image has always been a challenge to process and print due to the enormous range of contrast between shadows and highlights. Just like "Clearing Spring Storm" it was created with a 35mm camera, but this time on transparency material rather than print film, a decision that further increased the contrast present in the scene. The storm moved in and out quickly and I didn't think about bracketing the photograph. I didn't take many photographs of this scene (maybe a total of three at most) because this was toward the end of a river trip and I was running out of film. In fact, I ran out of film the next day and had to borrow someone's disposable camera because I was feeling overly frustrated not to be able to photograph.

Of the three examples, my personal favorite is still the first one, "Clearing Spring Storm, Canyon de Chelly". This shows how difficult it is to express a personal vision of the landscape when the light plays a preponderant role in the expression of your vision. First, the light I seek happens very rarely. Second, when it does happen I may or may not be there, and if I am there, I may not be standing at the right place at the right time. Third, I still have to compose an enthralling image that uses this light effectively, because light alone is not enough—the subject and the composition must be there as well.

If the composition is not powerful enough, if the subject isn't there, one can have the best light in the world and still not be able to create a good photograph. I can remember numerous instances when I watched beautiful light play upon the landscape without knowing how to photograph because I couldn't find a satisfying composition, or simply because the subject wasn't there in the first place.

Doing the Work

If the vision is strong enough, and your goals are steady, and you believe, pretty soon you bring other people with you.

Mike Rounds

The work begins after you have decided to develop your personal vision. Part of this work—at least half of it—consists of reflecting critically upon what your vision is, as I explained previously. Part of this work—the other half of it—consists of physically creating photographs that express the vision you defined as the result of your critical thinking.

How the physical creation of new images takes place will be discussed at length in the next chapter, "Achieving Your Personal Style". However, at this time, I want to mention a few specifics about work as it relates to vision.

The goal is to create what I would call a *mature vision*, meaning a vision that is not superficial but deeply rooted; a vision that is meaningful to both the artist and his audience; a vision that is complete.

The two parts of this process—reflecting upon your vision and then creating new images based on the outcome of your reflection—must be brought together. In practice, the two parts of this process are not really separate. Instead, they are intertwined, because these two parts coexist and inform each other: critical thinking leads to the creation of new work and this new work, in turn, leads to further critical thinking. It is an interactive process that, on the one hand, consists of reflection, and on the other hand, consists of creating new photographs. At times the two take place simultaneously. For example, this occurs in the field when the sight of a new sub-ject leads to new ideas that are immediately concretized in the creation of new images.

The reflection part does not have to be purely mental as well. In other words, the critical thinking aspect of your work does not need to take place only in your mind. Instead, I recommend you write down the thoughts, the ideas, and the insights that your reflection brings upon your past and current work. You can also use a voice recorder to preserve your thoughts, a process that some prefer because they want it to be faster than writing.

Whatever approach you prefer I do recommend that you engage in a recorded description of your vision. Remember that, as we saw previously, vision is something that first exists in your mind's eye. Vision is abstract and known only to you until it is translated into a medium that can be shared with others. Writing or audio recordings represent such a medium. Once you have written or recorded an audio description of your vision, you can share this description with others, either in print or in oral form. At any rate, this vision is no longer something that exists only in your mind. It is something that has been formulated as a text.

Certainly your goal may not be to create literature, although there is nothing wrong with doing so. Your goal may be solely to create photographs. However, having a written description of what your vision is, of what you want to express, and of what you want your new photographs to be like, can only be helpful. Think of this writing, if not as literature, then as a road map to new images or as a blueprint for your upcoming work.

Do Not Lose Your Vision

*The true tragedy in life is not death but that which
dies inside of us while we are still living.*

NORMAN COUSINS

The conclusion to the previous section is that
you will not find your vision by attempting to
photograph or work with a subject that is not
yours. And you will not express the fullness
of your vision working with a subject that you
do not love or that you are not excited about.
You must be photographing what you love and
what you are passionate about for your vision
to fully express itself and become a reality.

There is a difference between liking some-
thing and loving something. For example, I
like to photograph sports cars. However, I
do not have a burning passion for sports car
photography. The interest is there because I
like sports cars, not because I want to express
a personal photographic vision regarding the
cars. For me, the problem is that a car is not
something that I can modify at will. A car is
more the mark of its manufacturer than the
mark of the photographer who takes a picture
of it. Eventually, for me the subject becomes
repetitive. There are only so many headlights,
fenders, emblems, engines, body shapes, side
panels, etc., that I can photograph until they
become a blur of similar subjects and I become
bored working with them. In the end, I prefer
driving cars more than photographing them.

I am sure a car photographer who truly loves
this subject will disagree with me and will find
just as many positive reasons to photograph
cars as I have listed reasons not to photograph
cars. If such is your situation just know that I
applaud you. I applaud you because you truly
love what you do and you will not let someone

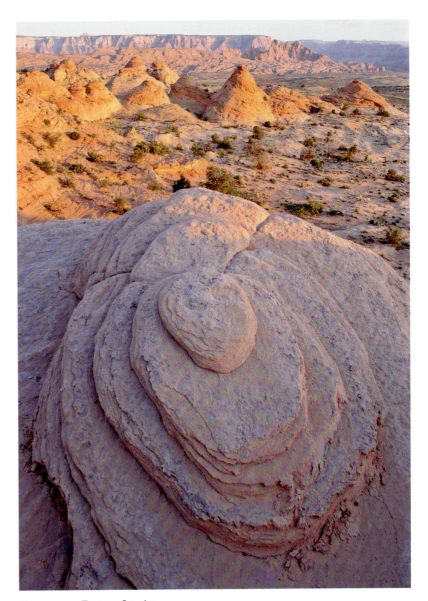

Figure 10-5: *Teepees Sunrise*

else's opinion of your favorite subject change your mind.

Such is the case for me with landscape photography. I have not tired of doing landscape photography since I started in 1980. In fact, I have not tired of admiring the landscape since the day I was born, or rather since the day I was able to understand what nature is, whenever that happened. To me the landscape is never the same. The seasons, the time of day, the variations of light, weather, and other natural conditions mean that the same exact situation cannot happen again. It also means that even though I spend a lot of time outdoors, I am unlikely to witness the same event several times. Each day, each new instance of a natural event is unique.

Furthermore, I find that the possibilities for personal expression in landscape photography are equally endless. Each new idea, new camera, improvement in equipment, new piece of software, new location, and each visit to a previously visited location means that a new level of artistic achievement can be reached if I put in the required amount of time and effort. These new tools and visits to the places I love, when combined with my passion for the landscape, generate new ideas that, in turn, bring renewed inspiration. I haven't tired of this subject since I started working with it, and I doubt I ever will. For me, this is what I love to do, and because of this passion, my vision for the landscape is the clearest of any of the subjects I have worked with so far.

Out of all the lenses available to me, the wide angle is my favorite. In many ways I consider it part of my personal style, largely because it allows me to express my vision in ways that other lens families do not give me access to.

For me, the grand landscape is the primary subject. For me, photographing the whole of the landscape, the entire scope of land formations in front of me, is fulfilling my vision.

Often, I want to create a visual comparison between what is close and what is far; what is in front of my feet and what is miles away. At such times the only lens that will let me do that is the wide angle. The wide angle also imparts dynamism to the scene by emphasizing the sense of depth and exaggerating the relative size of the objects in the scene. By doing so, it pushes the everyday view we have of the world further away, and creates images that are more surreal than real.

Skills Enhancement Exercises

Describe Your Vision in Writing
- Think of the following writing exercise as exploratory writing. Approach it as a brainstorming session.
- Keep in mind that no one else but you will see this writing or hear this audio recording. You do not have to share it with anyone unless you wish to.
- Write down as many ideas and as many things about your vision as they come to you. Don't edit, don't erase, and don't correct typos. This is not a PhD dissertation. This is just to help you find out where you want to go with your work.
- There is no right or wrong. You can sort things out after you are done. Do not stop writing until you have written everything you want to write about your vision.
- I recommend you do this exercise in a place where no distractions will occur. Make sure to turn off the phone, the door bell, etc., so that you won't be disrupted in any way.

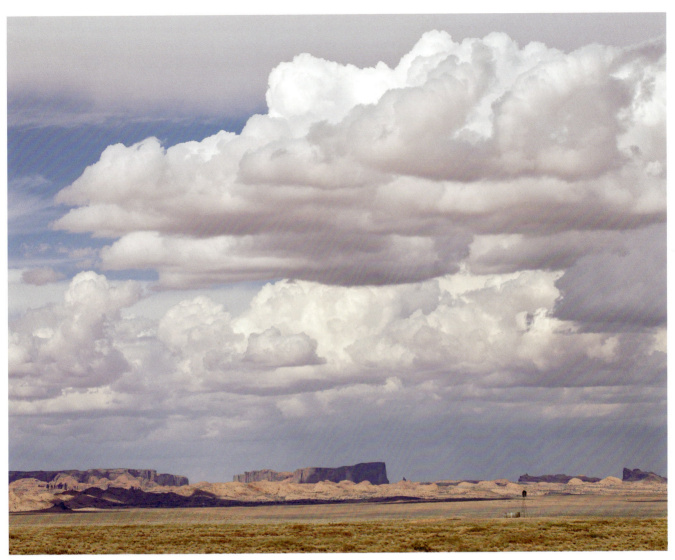

Figure 10-6: *Comb Ridge Clouds*

Describe Your Style

- Describe the kind of photographs you've always wanted to create, then describe the photographs you are currently creating
- Is there a difference between the two? If yes, describe what this difference is.
- Try emulating some well-known photographers' styles. Take their style apart and describe each of their features. List their main characteristics, what strikes you as important and so on. The subject is not as important a style characteristic as you might think. A Van Gogh self-portrait and a Van Gogh landscape are immediately recognizable as two pictures done in the same style and by the same artist.
- Look at your favorite photographs, posters, and paintings by others. Try to determine what characteristics make them unique.

Visualize the Entire Field of Photography

- Imagine you are looking at it from 10,000 feet above the earth
- Visualize the different areas of photography: wedding, jounalsitic, fine art, product, studio, sports, etc. See where you are and where you want to be. Now narrow your vision to this one area.
- See if there is a category that does not exist. If so, create it and give it a name.
- The goal is to find out where you currently are in photography, and to find out if this is where you should be or if there is another place where you'd like to be more.

To me, the image "Comb Ridge Clouds" (figure 10-6) captures much of what I love about Navajoland: the sense of space, the immensity of the landscape, the wide open range of Navajoland, the sandstone formations that dot the land, and the cloud formations that are typical of Navajoland skies.

Yet, to some viewers less experienced in seeing this landscape, this image may lack interest because it does not show the sights that have made Navajoland famous such as Monument Valley, Canyon de Chelly or other places.

The fact is that it does, but in an unconventional way: Comb Ridge is the eastern boundary of Monument Valley and is visible from the main overlook of Monument Valley. However, this image does not show the part of Monument Valley that has become the most famous, the Mitten Buttes, and in this respect it may fall short of being interesting to those who seek a more conventional representation of this location.

To me, this image is a vivid representation of my vision for Navajoland because it shows an aspect of Navajoland that I had not seen before I created this image. It shows a landscape that is not what I would call the *touristic landscape*. It shows a view of Navajoland that many drive right past without stopping, and most do not see its worth as an image or a photograph. It is uniquely my vision.

Conclusion

Many ideas grow better when transplanted into another mind than in the one where they originated.

<div align="right">EMERSON</div>

As an artist your heart must be into your work. When it comes to developing your vision, this vision must reflect what is in your heart. One thing I learned many years ago is that it is not possible to make good art if your heart isn't in it. Even if you try to do so, your audience will see you are not totally involved, and as a result people will eventually distance themselves from your work.

I remember a story told to me by a friend who was a musician and who, a number of years ago, was involved in a dance music project. Two groups of people were involved: musicians who did not know the dance scene very well and DJs who knew the dance scene but were not musicians. Eventually, when the piece was completed, they met with the recording company, which as it turned out was a major record label, and played the demo tape. The record label representative said he liked the demo but that it wasn't for them. Then he asked, "Your heart is not in this, is it?" My friend said it wasn't, that they were doing this mainly for the money. The producer then said, "Come back when you have something you really care about". The project didn't go any further. This was not their vision, their heart wasn't in it, and they didn't have the necessary motivation.

Art only works if your heart is in it and if you really care about what you do. Art is successful when it demonstrates your passion, your personality, and your vision. If you are not passionate about your work, if your heart is not in it, your audience will be able to tell.

For your vision to be unique it has to be implemented through a style that is unique to you, a personal style. How this plays out and how you can achieve your personal style is what we will explore in the next chapter.

11 Achieving Your Personal Style

The great thing about this thing we call art is that it has no rules.

Kim Weston

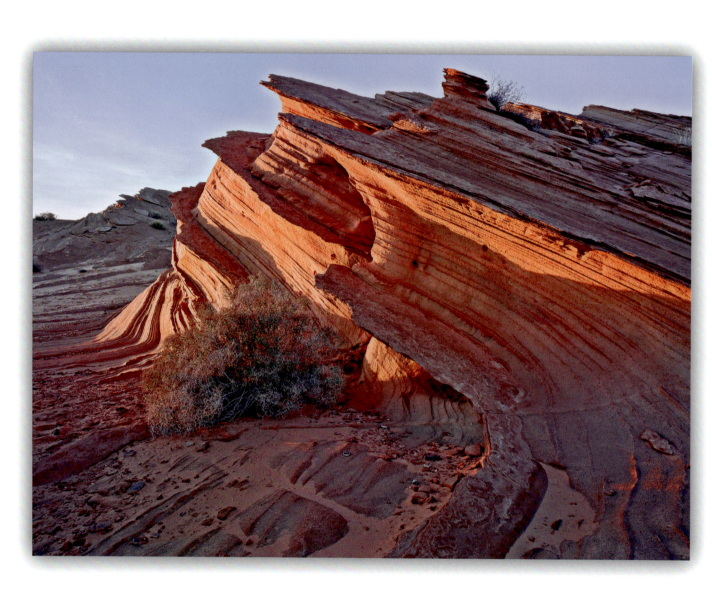

Introduction

Personal style is the venue through which you share your vision with your audience. Your personal style develops, expands, and becomes more unique as you continue making your vision a reality. As we saw in the three previous chapters, vision and personal style are related to inspiration and creativity. The more fertile your inspiration and creativity are, the faster your vision and your personal style will grow.

Achieving a personal style represents a significant amount of work. As you work toward making your vision a reality, you will become bolder. To compensate for the detractors that will most likely come your way, you will find courage and motivation in your successes at describing your vision and sharing it with your audience.

As you become bolder you find new ways to express and share this vision. Each new artistic statement, each new piece, will be another step toward achieving your personal style. Each attempt is but one small step, but the sum of your attempts creates a stairway that will lead you to heights you could not have climbed in a single step. The only way to get to the top of this stairway is work as hard as you can at developing your style.

About four years ago I wrote my first essay on personal style and it was published in my book *Mastering Landscape Photography*. If you have not read this essay I recommend you do so because it features information that is not repeated in this chapter. Following is the result of my continued thinking on this subject over the past few years.

This is the conclusion of the four parts of the artistic process about inspiration, creativity, vision, and personal style.

What is a Personal Style?

I am steadily surprised that there are so many photographers that reject manipulating reality, as if that was wrong. Change reality! If you don't find it, invent it!

Pete Turner

A personal style is the translation of your vision into an actual work of art, or in this instance, into a photograph in this instance. It is the translation of your ideas into something that others can see, something that you can share with your audience, something that represents the closest rendition of your vision that you are capable of producing at a given time.

The language you are using to create this translation is photography. Photography is a visual language that uses composition, tone, color, contrast, subject, light, angle, approach, and more to translate your vision into images that others can see. As with any translation, something is often lost, modified, or left out. Therefore, each new translation, each new photograph, is a new attempt toward a more accurate translation or toward a translation that your audience understands better. It is also a new attempt at defining the language you are using to make this translation. As an artist who is expressing your vision through a personal style, you are not just sharing a message through the language of your choice. As your vision becomes more refined and unique, so does your language. Eventually, the language you use becomes yours only. You invent it as you move toward an ever-finer representation of the ideas in your mind.

You are both the inventor of a new vision and the inventor of a new language to translate and express this vision. You are the

Figure 11-1: *Sandstone Swirls*

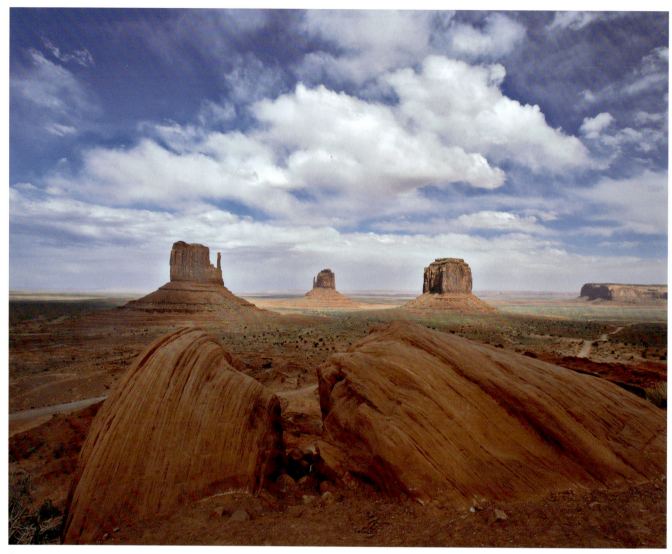

Figure 11-2: *Monument Valley Afternoon*

inventor of the image as well as the author of the facture of the image. Your personal style is a visual language in a way that you use to communicate your message—your vision—to your audience. In other words, you are not just the author of the work of art. You are also the author of the visual language used to create this work of art. Therefore, you are indebted to your audience because if you create a new language, your audience needs to make the effort to learn this new language.

This language may be fairly transparent or it can be quite complex, and you are responsible for either teaching your audience how to read this language, or having others help your audience understand your language. This

is because your audience needs help understanding the structure of the language you are using. This is what was missing in much of modern art, for example. For a long time no one was available to explain the language of modern art to the audience and as a result modern art was, and to a large extent still is, incomprehensible to a considerable part of the population.

The process of developing a personal style is a process of evolution, of continual refinement, and of fine-tuning the expression of your vision. A true personal style represents the outcome of this process: a consistent and ongoing expression of your vision. First, it is an approach in which the technical and artistic challenges have been resolved in a satisfying manner. Second, it is an approach that demonstrates a consistent solution to these problems, a solution that is implemented in a similar manner from image to image, throughout your entire body of work.

The "Monument Valley Afternoon" image (figure 11-2) shows one of the most recognizable locations in the world and an icon of the American Southwest. I often say that it is easy to create a *good* photograph of Monument Valley because it is so dramatically photogenic, but it is difficult to create an *outstanding* image because so many good ones already exist.

This is one of my most recent attempts at creating another image from this location. While it is not for me to decide the level of achievement of this image, I can say that I find it pleasing, in large part because it was taken in mid-afternoon, a time that poses challenges for color photography because the light at that time is relatively flat and unsaturated.

What makes this image successful are the cloudy conditions present on that day. I waited until the sun lit the middle butte and

I used the rocks in the foreground as leading lines toward this butte. I also selected a time when the clouds were grouped in the center of the image rather than when they were moving out toward the sides or the top of the frame.

The combination of leading foreground lines, the lighting on the middle butte, and the cloud's position are what creates the fundamental structure of this image. My only regret is that I could not get only the middle butte in the light. The two others were also partially in direct light and if I had waited any longer the clouds would have been gone. One's desires sometimes go beyond what nature can do.

Finding Your Own Way of Seeing

We often hear of "camera angles" (that is, those made by a guy who throws himself flat on his stomach to obtain a certain effect or style), but the only legitimate angles that exist are those of the geometry of the composition.

HENRI CARTIER-BRESSON

Achieving a personal style does not mean creating photographs that are outlandish, that rely on theatrics to be created, or that solely depend on bizarre content to be interesting. Style is relying on solid values and concepts. Style is creating a firm foundation from which you will create your work.

Achieving a personal style is first and foremost achieving a personal way of seeing. This is the avowed goal of numerous photographers. However, few actually reach this goal. Why? First, because there is a lack of methodology in regard to helping photographers to develop a vision and achieve a personal style. Second, because many photographers underestimate the difficulty of the task: developing

a personal style is a lot more difficult than it seems. And third, because there is really no comprehensive study of what is required to achieve a personal style. The literature on the subject is slim and the small body of work that exists treats the subject as if it were as simple as going out, getting a few tips here and there, and then being on your way to finding your own way of seeing and developing your own photographic style.

It is not that simple. In fact, it is not simple at all. The process that leads o finding one's way of seeing is long and arduous, and follows a logical progression. One has to understand what is involved as well as which pitfalls await one on the path to developing a vision and ultimately achieving a personal style. These pitfalls are specific and once known can be avoided. We will be looking at a number of them in the next sections. And no, it is not as simple as going out there and taking photographs while making good use of a few tips on composition and on seeing like a camera. Those are prerequisites, and if followed will result in better photographs, but they are not enough to result in developing a personal style.

The issue of personal style has always been present in art. However, it may have been less important in the past when photography was practiced mainly by trained artists with relatively few "aficionados" joining in. This situation changed during what I like to call the "darkroom craze" that took place from the 1960's to the 1980's, although even then the commitment in space (one had to build a darkroom) and time (developing film and prints is time consuming) was significant enough that only the super-motivated were joining the ranks of the practitioners. The digital revolution changed all of that. Suddenly anyone with a personal computer—which means just about anyone—and a digital camera or a scanner could claim to be a photographer because they could process and print their own photographs themselves for a relatively low initial investment in time, space, and funds.

The many possible variations that one can apply, inflict, or otherwise subject a digital image to (depending on how you prefer to put it) means that, potentially, a personal style is only a mouse click away, or a filter away, or a new piece of software away. This pushes the notion of personal style to the forefront. Questions related to personal style quickly surface such as: Do I have a personal style? Am I really that creative? Can anyone else do what I do? Is it me, is it the filter, the software, the camera, or something else? Can I do it again? Do others like it? What do you, the master, think of my work? Do I have talent? Am I a genius? The fact is, if you need to ask any of these questions you most likely do not have a personal style. What you have is access to software that can do things to photographs that were never possible prior to digital photography. Doing something that is unusual, something that is noticeable, does not mean you have a personal style. This is an issue that has been present long before digital photography came about. It means you did something unusual and noticeable to your photographs. That's all. It makes you wonder if you have a personal style, which is probably the most important consequence. However, developing a personal style is still a long way away. It is also very different than using strange compositions, applying cool filter effects to your images, or being "creative" during image conversion and processing.

Style Develops through Work

You work on an idea, your first interpretation is very raw and you work it and you work it and it gets polished and polished. It gets to a certain level and then it comes down off that peak.

Kim Weston

A personal style is primarily achieved through work. This work consists of developing the vision you obtained by following your inspiration and expressing your creativity. You cannot force personal style into being, because in many ways style finds us more than we find it. What you can do is work as hard as you can at expressing your vision. You may not even know for sure when you have succeeded in developing a personal style. As artists, we do not always recognize when we have developed a style; in many instances someone else has to point this out to us.

As you work, keep in mind there are no shortcuts to style. Some people erroneously believe they can follow a number of strategies to achieve a style such as copying someone else's style, following a rulebook to style, following technical instructions to get a specific look, emulating a style, and so on. Unfortunately all these shortcuts are ineffective because they are based in duplicating a preexisting style developed by someone else. None of these approaches will result in creating your own style.

A personal style is the expression of your vision. It is also the expression of your personal taste, of your personal choices. In this respect it is as unique as your handwriting. While using someone else's style as a point of departure is possible, such an approach needs to be considered as a starting point and not as a final destination. It should also be remembered that achieving a style is a journey rather than a destination, and that the most important aspect of this journey is your willingness to work as hard as you can at developing your own style.

Your Personal Style Filter

Your style provides you with a set of guidelines or photographic approaches that you have developed through countless hours of trial and error, and these provide you with what I call your personal style filter. This is a filter that exists in your mind rather than in front of your lens. However, you look through this filter and see the world through it just as well as if it was installed in front of your lens. This filter consists of your way of seeing the world, from idea to print. It starts with your vision for your work and ends when the final print is matted and framed. It includes each and every part of the photographic process, both technical and artistic. It includes fieldwork and studio work because an artistic photograph is not completed when you click the shutter. A fine art photograph is completed only after you are done making all the improvements to tone, contrast, and color, and after you have created a print that expresses what you saw and felt in the field.

As you work with this personal style filter, you need to photograph what you like rather than what you think you should like. Over time you will begin to develop a consistent way of seeing. You will discover that certain elements or characteristics are being repeated in your work without your awareness. When this happens you will have made one more step toward achieving your style.

Your personal style can also be revealed to you through others. Listen carefully to what others say about your photographs because they can help you identify specific characteristics of your work that you may not have noticed.

Show Your Personal Style throughout Your Work

Your personal style should be present throughout your body of work and not just in individual photographs. This aspect of personal style is very important and it extends beyond subject matter. The style of an artist will carry over into the depiction of different subjects by the same artist. For example, a Van Gogh self-portrait and a Van Gogh landscape are immediately recognizable as two pictures done in the same style and by the same artist. The brushstrokes, the colors, the subject, and overall the facture of the paintings are, to the connoisseur, immediately attributable to Van Gogh.

Style is something you carry inside yourself and that you use in any image you create. Thus, it is in your entire body of work, and not just in individual images, that your personal style should come through. This is because a style is specific to a particular photographer first, and to a particular photograph second. For example, we say, "This is a photograph by Cartier Bresson" instead of "This is a photograph of Paris". The location and the subject are subsumed under the style of the photographer.

Only on rare occasions, when we are dealing with photographs that have become world famous, does the subject take precedence over the photographer. Such is the case with "The Baiser de l'Hotel de Ville" which has become so famous as to immediately imply the photograph taken by Doisneau in front of the Hotel de Ville in Paris. However such images are rare and it may be a long time before you can think of your work as being included in their company. As a result, it is best to focus only on your body of work as being representative of your style and leave individual photographs aside for now.

The Coherence of a Style

Over time you will begin to develop a consistent way of seeing, which will include making specific choices in order to best express your vision. These choices address technique, subject matter, and personal approach. In my first book, *Mastering Landscape Photography*, when I wrote about personal style, I suggested making a list of these various choices, and I continue to believe that such a list can be helpful. Now, four years later, I have expanded on that basic premise, and I recommend that you develop a style that expresses your vision. Only when you see this style emerge—either because people tell you that you have a recognizable style or because you begin to see this style yourself—do I recommend that you make a list of your style's attributes. This list will help you to more accurately identify what your style consists of. It will also allow you to define what can be done to further refine your style, to make it stronger, or to make it more accessible to your audience.

As you make this list, ask yourself why you are including certain elements, techniques, or approaches, in your style. If you can't answer that question, neither can your viewer. The fact that we usually equate personal style

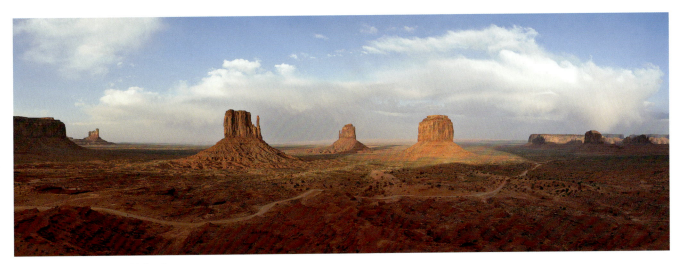

Figure 11-3: *Monument Valley Panorama*

with mastery suggests that achieving a style requires inborn talent, personal reflection, and long-term practice; all three being attributes of mastery.

This "Monument Valley Panorama" image (figure 11-3) is an 8-frame stitch done in Photoshop CS3 from Canon 1DsMk2 captures. The photographs were taken hand-held. I did not have to worry about parallax errors since all the elements are located at infinity focus. I intended this image to be merely a test of the stitching capabilities of the new image merge function in CS3. However, the resulting image exceeded my expectations and although it really needs to be seen enlarged to be fully appreciated, I decided to use it as an illustration in this chapter.

What I like about this image is the flow of movement in the clouds, the light, and the sandstone formations. The clouds are nicely centered in the image, without being unexpectedly cut by one of the borders, something that is challenging to achieve in a wide panorama. The light is brighter in the center of the image than on the edges, thanks to the tallest buttes being in direct light at the time of exposure.

The relative size of the sandstone formations gradually recedes as one moves from the center of the image toward the right and left sides, thereby reducing the importance of the buttes on the sides while placing the ones in the middle on center stage. Finally, the tones and the contrast level throughout the image are quite even, without one area being significantly darker, lighter, or more colorful than a similar area elsewhere in the image, adding the final touch that brings the image together.

The problem with such a wide panorama (this one covers about 160 degrees) is that it is very easy to create an image that is a collage of disparate elements rather than an image of a single scene. It is therefore important to make sure that all the elements in the image work together.

Projects, Goals, and Deadlines

I often painted fragments of things because it seemed to make my statement as well as or better than the whole could... I had to create an equivalent for what I felt about what I was looking at... not copy it.

GEORGIA O'KEEFFE

Because style develops through work, creating new photographs regularly and having a regular schedule is important. The best way to guarantee a regular work schedule is to design a project that has specific goals and deadlines. Setting up such a project is important because while developing your vision is an exploratory process, it cannot remain an exploratory process forever. Eventually, tangible results have to be obtained and the goal—which is to formulate your vision and to create works of art that depict this vision—has to be reached. Vision, by nature, is not bound to hard facts or to physical realities. It is for this reason that setting a goal is important. If you do not do so, you may forever wonder what your vision is.

The expression of a personal vision is, in a way, the work of a lifetime. However, just like building a monument or a house, this work is done one stone at a time. In the case of photography, this work is built one image at a time, and, more importantly, one project at a time. What I am saying here is this: do not think of your vision as being expressed all at once. Think of it as being expressed through a number of individual projects. The exact number of these projects is relatively unimportant. Each of these projects must be completed by a set deadline, because without deadlines little or nothing will get done. Deadlines force us to get started, adopt a certain rhythm, and set the necessary pace to reach our goals and finish our work in time. In a twisted sort of way, deadlines create motivation.

It is therefore important to set a deadline for each of your projects. It is also important to define precisely what each project consists of, something we will look at in detail in the next section. Make this deadline reasonable, that is give yourself enough time to complete the project, but do not make it unreasonably long. A deadline that is too far into the future stops being a deadline and becomes a distant event that we do not need to concern ourselves with right away.

A reasonable deadline for most projects is anywhere from a couple of weeks or months to less than a year. If you find that your project is going to take several years, break it into smaller parts so that each of the parts can be completed in a few weeks or a few months at the most. This is important in order for you to see progress. If your project is too long, the lack of progress will frustrate you. By breaking your project into smaller parts you are making each deadline closer to you and hence easier to reach. Reaching deadlines is important because each completed deadline acts as a motivational reward. It feels good to complete something, even if this something is part of a larger project.

It feels even better to complete an entire project, hence the value of setting relatively short-term projects. Short-term projects also allow you to witness the quality of your work sooner, and hence give you a positive indication about what you have achieved. They let you see the quality of your work and the type of results you are able to generate at this time. Once completed, these short-term projects allow you to make the necessary corrections to fix things that went wrong, improve results

that did not match your expectations, and further develop ideas that may have had a less than perfect result. In turn, you can implement these corrections in your next project by designing a new project that will push your limits even further and allow you to get closer to achieving your personal style.

Expect Ebb and Flow

Vision is the true creative rhythm.

ROBERT DELAUNAY

In the process of completing the projects you have designed, you have to expect ebb and flow. There will be times when your creativity and your ability to express your vision have no bounds. There will also be times when your ideas will run dry and when you will not be able to think of anything new no matter how hard you try.

This is normal. Expect it and work with it. Ride the tide when creativity runs wild. Write down all the ideas that come to you, develop them, work with them, and create new photographs. Don't try to control it, limit it, or somehow stop it. Definitely don't stop it! Work longer and harder on those creatively driven days to make sure you record and start working with all the ideas that came to you. That is time to rejoice in the apparently limitless wealth of new ideas and inspiration. Enjoy it. Don't be critical. Don't judge if it is good or bad. Take it all in. There will be time to sort it out later.

During dry spells, do not try to force creativity to come if it doesn't want to. Instead, work on the ideas you had during the "high-tide" time. You most likely have a backlog, so work these previous ideas out. Work on the projects

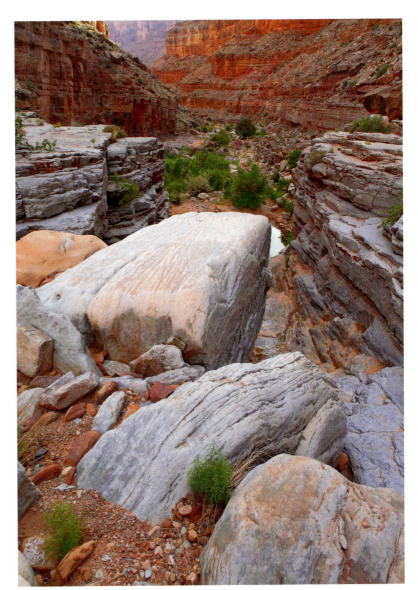

Figure 11-4: *Along the San Juan*

you started but failed to complete, or go back to your notes and start another project that you didn't have time to do back then. This is a good time to work on your previous creative ideas. A dry spell is a good time for putting your head down and for doing the "dirty" work; the construction work, so to speak.

I regularly photograph remote locations because they offer opportunities to see a place without being influenced by images created by other photographers before me. The location seen in the image called "Along the San Juan" (figure 11-4), one of the tributaries of the San Juan River, is a case in point. I have not yet seen an image of this location from another photographer. I am not saying no other photographer went there because most likely some did visit this location. I just have not had a chance to see their images. This is important because in such a situation your imagination, and your ability to create an image, must operate without outside help or influences. You have to visualize images completely by yourself. When these images are successful, they are of course that much more rewarding, both as memories of places that are difficult to reach and that cannot be visited as often as one would like, and as evidence that your visualization skills were effective.

Unlearning the Rules

I decided to start anew, to strip away what I had been taught.

GEORGIA O'KEEFE

To get better at photography you have to learn both the technique and the art. You have to master technique until it becomes second nature so that you can focus on artistic expression without being bothered by technical considerations. However, most of the time you basically learn to do what others have done before you. You are learning their rules and their approaches. If you chose a good teacher, these rules are most likely valid and efficient, but they are not yours.

To achieve a personal style you are going to have to unlearn many of these rules. You are going to have to put them behind you so that you can develop your own set of rules, because achieving a personal style means making your own rules and developing your own approach to photography. Only by unlearning and then creating your own rules will you be able to create something new, something original, and something that has not already been done by somebody else.

One could ask, "Then why learn since we are later going to have to unlearn?" This is a good question and if the premise behind it was correct, we would save huge amounts of time. Unfortunately, one cannot unlearn without first learning. Learning is necessary. One has to know the rules in order to break them.

Unlearning is not the same as not learning. Unlearning is the process of going beyond what we learned; of going further than what was taught to us. In this context unlearning means making our own rules. Unlearning is not a destructive process. Instead, it is the process of building upon the knowledge imparted to us by our teachers. What we learned becomes the foundation on which we build our own knowledge. By doing this we add the knowledge that we created ourselves to the knowledge that was created by others.

The fact is that we cannot totally forget what we have learned. We cannot wipe this knowledge off our minds the way we would wipe a blackboard or a slate clean. What we can do

is put aside (or use as a foundation) what we have learned and replace it with our own style, set of rules, and way of making art, so that what we originally learned is no longer at the forefront.

Changing the Rules

One of the biggest mistakes a photographer can make is to look at the real world and cling to the vain hope that next time his film will somehow bear a closer resemblance to it...If we limit our vision to the real world, we will forever be fighting on the minus side of things, working only to make our photographs equal to what we see out there, but no better.

Galen Rowell

We previously discussed the concept of breaking the rules. Changing the rules is different from breaking the rules. Breaking the rules means doing the opposite, or doing something totally different, than the established rules. Changing the rules means creating a new reality by looking at a specific situation differently. It means implementing your own ideas instead of following someone else's ideas.

Many artists, inventors, or other creative individuals got started making their own rules because they did not like the rules established by others. They did not want to follow these rules because they did not think these other people were doing things the way they should be done. Enzo Ferrari and Ferrucio Lamborghini from Italy are good examples, as is Ettore Bugatti from France. All three designers offered new approaches to automobile design and construction, because they were dissatisfied with the approach taken by others. While they started as apprentices or employees of already-established automobile companies, they eventually founded their own companies in order to implement their ideas.

In fact, designers or engineers that decide to start their own companies usually do so because they are dissatisfied with what exists around them. In many instances, they work for someone else in the same field until they decide to go their own way. This decision is usually motivated by the desire to do things better or differently or to start something new altogether. These decisions are made as a reaction to what exists. Without a reaction toward what is already in place at a given time, there would be no progress and new styles would fail to emerge.

My current style is as much a reflection of what I like as it is a reflection of what I do not like. In many ways I want to provide to my audience with an alternative to what was there before I got started, as much as I want to provide myself with the satisfaction of creating my own world, my own reality. The choices I make are influenced both by what I like and by what I dislike. Finding out what I dislike allows me to make a selection just as well as finding out what I like. In fact, what I dislike is often a more powerful motivation to do my own thing than finding out what I like.

Dissatisfaction with what exists and finding examples of what others do that you like gives birth to ideas. But ideas are just a starting point, a place of departure, a beginning. The development of these ideas is what truly matters. This development, and the hard work that accompanies it, represents the journey toward a true style, a style that no one else has, a style that is unique to you: a personal style.

The fear that many upcoming photographers have about breaking the rules is often due to

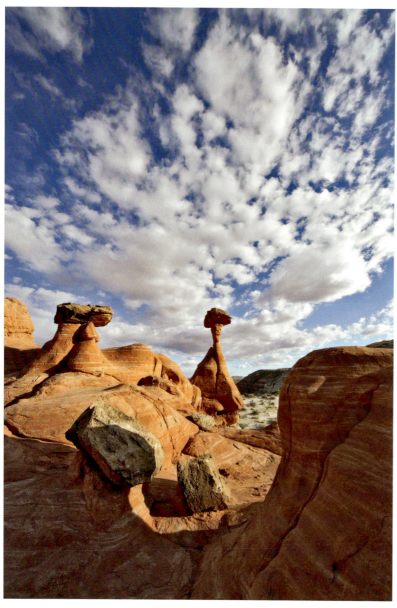

Figure 11-5: *Hoodoos and Clouds*

the fact that they haven't yet created their own reality. At this stage of their career, they rely on the reality of other photographers or other artists to find both vision and inspiration. In other words, the vision and the inspiration for their work does not come from their own experience. Instead, it comes from the work of others.

When this is the case, the artist is more concerned with being faithful to the vision of others than with being faithful to their own vision. Often, these artists have spent little or no time developing their personal vision. As a result, they follow the rules set by these other photographers and they are hesitant, or even unable, to break these rules.

In turn, this concern for being faithful to someone else's vision manifests itself in a certain level of insecurity regarding their efforts to emulate the work of others. Since the reality they are depicting is not their own, there is constant concern whether their work comes across as real or not. This concern is often passed as being a concern for the artist's faithfulness toward his subject. However, this is an inaccurate description of the problem. In the situation I just described, the artist is concerned with being faithful to someone else's style, someone whose work they admire and want to emulate. The inability of the photographer to break the rules set by the artist they want to emulate makes it very challenging for them to be creative and to do original work.

The "Hoodoos and Clouds" image (figure 11-5) was created on the same day and in the same location as the next image in this chapter (figure 11-6). I also used the same wide-angle lens and the same camera. The difference is in the timing (this image was created first, the next one approximately 15 minutes later) and in the composition of the

elements in the image. In this first image I kept the appearance of the relative size of the two hoodoos similar. The larger element is the rock at foreground-right. The two rocks in the middle of the image are given a lot of importance, because they look like they are sliding off the sandstone bench on which the hoodoos are located, thereby indicating the direction of things to come, which is that hoodoos eventually collapse, leaving their fallen capstones to tell their tale.

The cloud formation brings the image together because it fills the sky and because it is centered in the image. The interesting shape of the cloud formation, which metaphorically resembles a feather or an arrowhead, adds further interest. Without this cloud most of the drama would be lost. Finally, the colors and tones are consistent throughout the image, bringing unity to the composition.

Be Bold and Audacious

Be bold, and mighty forces will come to your aid.
 GOETHE

Personal style is rooted in originality and innovation. Therefore, personal style is demonstrating your personality while creating original artwork.

In order to develop a style you must do something different from what others have done before you. In many ways, this means that you must take a risk. Nothing-risked means nothing gained. You must also be bold and, to some extent, audacious in the choices you make for your art. Being bold is not a concept that is often mentioned in art. Most of the time, art is presented as being about aesthetics. For example, my own website presents my work under the heading of "Beautiful Landscape", and my avowed goal is to share the beauty that I see in the landscapes I photograph.

Yet aesthetics are only one aspect of art, and while this aspect is put forth, I also take a bold approach to landscape photography. Aesthetics are what an audience looks at first and so aesthetics are as much about the audience as they are about the artist. However, boldness in art is primarily about the artist. It is about how the artist approaches his art and about how the work is created. Being bold has to do with the artist's intent for the work, while aesthetics has to do with the audience's reaction to the work.

Being audacious is doing something that others did not think you would do. It is trying something because there is a chance it will succeed, while knowing that complete success may not be possible. In other words, one has to try it and not be afraid to take a chance. To some extent, audaciousness in art also means that the artist must be willing to deal with a certain level of controversy. The potential for controversy can be seen as detrimental to the artist. This can be the case depending on how the artist handles and copes with controversy and with adverse reactions to his work. However, it can also be beneficial to the artist in terms of causing the audience to rethink their positions regarding the subject and the artistic approach used by the artist.

Controversy can also be beneficial in terms of generating exposure, an approach that has been used by artists in the past for this very reason. However, to generate exposure only for exposure's sake, without having a solid work of art as the source of this exposure, usually means short-lived exposure instead of long-term artistic recognition. Long-term

artistic recognition requires something else besides drama and controversy. It requires work that is recognized as being art and not merely as being controversial. As time goes by tempers cool down and the work is studied for its content more than for its intent. When this occurs, work created solely to generate controversy is usually forgotten because it does not pass the test of time.

Don't Sell Your Soul

Don't make music for some vast, unseen audience or market or ratings share or even for something as tangible as money. Though it's crucial to make a living, that shouldn't be your inspiration. Do it for yourself.

BILLY JOEL

The anecdote of the artist asked by a patron to "match the painting to the couch" is a classic. I have been faced with this situation a couple of times and my answer has always been to turn down the potential customer's request. Why? Because my work, as I explain in this book, comes from my inspiration and my inspiration does not come from the color of a potential customer's living room furniture.

The fact is that inspiration and making sales are two entirely different things. The former is about *art* while the latter is about *business*. I discuss the differences between the two at length in my essay "Being an Artist in Business", so I won't repeat it here. This essay is available on the Web and in my book *Mastering Landscape Photography*.

What I want to emphasize here is that it is easy to lose your inspiration for monetary gain. While matching the color of an image to that of a couch seems relatively benign, if

you do so, you are renouncing the inspiration for a specific image by agreeing to modify it for the sole purpose of making a sale. My recommendation is to explain exactly that to your potential customer. If they walk away without buying something, they are basically saying that your source of inspiration is of no concern to them and that what they expect of you is to jump when they say "jump!" and not waste their time by asking "why" or "how high?"

I advise you to just say no to such requests and wait for the proper customers to come along, the ones who respect you and your work and who understand that artistic inspiration is something not to be fiddled with. If this results in a reduced number of sales, simply increase your prices. True inspiration, unwavered by couch colors, comes at a price.

Don't Worry about Creating Masterpieces

The most important ally in the study of painting is the art of thinking. Excepting natural talent of genius, individuality in thought is, without any doubt, the greatest single factor in creative work.

EDGAR A. PAYNE

As an artist I find it more important to ask myself, "What is the source of my inspiration?" than to ask, "What are my masterpieces?" Answering the former of these two questions may lead to possible answers for the later while answering the later may only result in self-delusion. This is because one cannot say that the body of work of a specific photographer is devoid of masterpieces unless one first defines what a masterpiece is. Doing so would be like deciding that someone is a

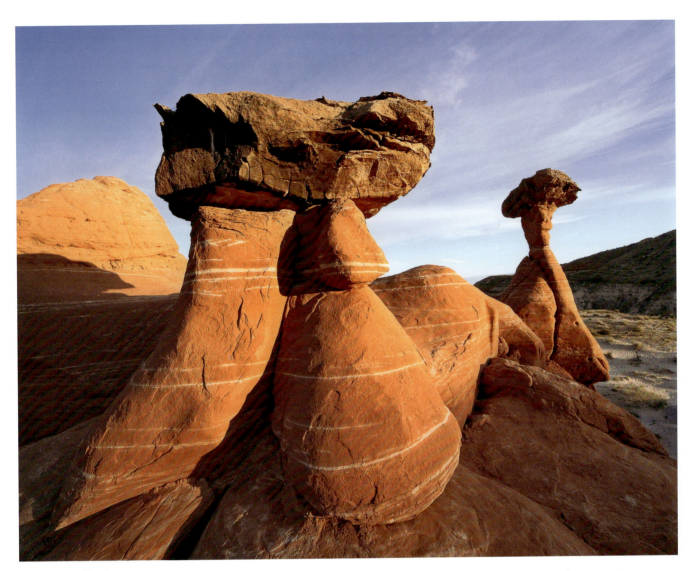

Figure 11-6: *Hoodoos*

referee without first making sure that person learned the rules of the game to be played.

The problem is that defining what a masterpiece consists of is very difficult. Most "definitions" are little more than best-seller lists. What sells well is not necessarily the finest work of a specific artist. Examples abound of artists whose work was not recognized during their lifetime and yet it became highly prized their death. On the other hand, examples abound of "so-so" artists whose work sells extremely well. Therefore, saying that a work of art is a "masterpiece" is putting a label on the work more than anything else. It is a fairly arbitrary and subjective decision made by a specific person, or a group of people, for

specific reasons. Such decisions are often temporary.

As artists, wondering if our work is a masterpiece (whatever that may be) is unnecessary. What we know for sure is that out of the thousands or millions of photographs we will take, only a small percentage will end up being recognized as having made a contribution. What those photographs are is best left for others to decide. In my view the most effective way to improve our photography, and to achieve a personal style, is to continue creating new work while pushing aside such concerns.

Moving Out of Your Comfort Zone

One photo out of focus is a mistake; ten photos out of focus are experimentation, one hundred photos out of focus are a style.

ANONYMOUS

I discussed the concept of comfort zone in chapter 9, so I will only go back over it briefly here. The fact is that to develop a personal style you have to move out of your comfort zone. Why is that? Because you need to create something new, something you have never done before, something the outcome of which is unknown to you. You have to create something that is outside of your comfort zone.

Think of your personal style as your personal potential. One of the most powerful things that can stop you from realizing this potential is failure to move out of your comfort zone. If you always stay within your comfort zone you will simply not be able to develop a personal style. There is no way around this.

As someone once told me as he attempted to defend his comfort zone, "I am in a comfortable rut". My answer was, "Comfortable, maybe, but a rut nevertheless". Unless this person gets out of this rut, he will not be able to develop a personal style.

I recommend that you reread the section on comfort zone in chapter 9 and that you conduct the Skills Enhancement Exercises at the end of that chapter. Both are invaluable in helping you to assess your current comfort zone and start the process of moving out of it.

Someone once told me that photographers like hoodoos, but that print collectors are only moderately interested in them. While this may be true, it is also true that print collectors are interested in the expression and the style of the artist, regardless of subject matter.

Hoodoos make a very interesting photographic subject, due in large part to the variety of dramatic shapes offered by the various types of hoodoos. Images of hoodoos can also be composed in a variety of ways, either outlined against the sky or against a sandstone cliff, or presented as a grouping by playing the shape of one hoodoo against that of another, or by creating a visual comparison of shapes and textures.

In this image (figure 11-6) I used the shape of the foreground hoodoo to lead the viewer's eye toward the faraway hoodoo by creating an imaginary diagonal line from the bottom-left to the mid-right side of the image. The striation in the thin clouds at the top-right adds movement to the image, because the clouds are moving in a direction that is parallel to the hill at mid-right and to the capstone of the faraway hoodoo.

Careful image construction is something that is very important to me, and the way I composed this image is no exception. I also waited until the last possible moment to make the exposure. A few seconds later and the sun

had set below the sandstone bluff behind me, engulfing the hoodoo formation in a shadowy shroud. While this situation could be the subject for another image, it was not part of my vision at the time.

Don't Try to Please Everyone

Do not quench your inspiration and your imagination; do not become the slave of your model.

VINCENT VAN GOGH

Inspiration thrives when you are excited about what you do and when you are excited about the prospect of showing your new work to those who will appreciate it. On the other hand, inspiration can be easily thwarted if you expect part of your audience to be displeased or when you expect criticism of your new work. At such times it is important to remember that you will never be able to please everyone. No matter what you do, some people will love your work while others will dislike it. This may sound depressing if you are new to this aspect of art, but unfortunately it is a fact of life as an artist. The solution to this problem is to develop a thick skin and to learn how to put this out of your mind.

The fact that negative comments will come your way no matter what type of artwork you do often comes as a surprise to beginning photographers. To illustrate it, I regularly use my own experience as an example. I do landscape photography, and my images aim at representing beauty. My website, www.beautiful-landscape.com, is named after my main purpose for my work.

You would think that such an endeavor would bring little or no criticism or negative feedback. Whenever I announce a new series of images, or publish a new photograph, there are people who email me, or contact me in one way or another, to let me know how much better my work would be if I did "this or that" to it. Some simply tell me that my work is not good, using far less considerate terms than I am writing here.

You can afford to ignore a certain amount of background noise, or in our case, negative feedback, and still continue to move forward regardless of how adamant some of this feedback may be. As the proverb goes, "The dogs bark but the caravan goes on". After all, everyone is entitled to an opinion and it would be nonsense to believe that everyone has the same opinion or that everyone loves what you do. What matters is that you love what you do and that your audience loves what you do as well. It is up to you whether or not you consider those who regularly criticize your work as part of your audience. Personally, I don't consider them as part of my audience and I recommend that you follow suit.

Just remember that trying to please an audience who has proven to be impossible to please is not conducive to renewed inspiration. Inspiration, when it comes from your audience, comes from an audience that praises you for the work you just did and asks you to go further with your vision. It doesn't come from an audience that can't be pleased no matter how hard you try.

While some criticism and gripes may be legitimate, and while listening to such criticism and gripes can help you improve your work, I have found that many criticisms are simply not worth paying attention to. If you do want to pay attention to criticisms, group them into categories and address or answer each category once. As you will soon discover, the same categories come back regularly and

once you have answered them you can simply give the same answer over and over again, or forget about them altogether.

In regard to negative criticism I want to point this out: you wouldn't purposely listen to music that depresses you and makes you feel worthless, would you? This is exactly what you do when you listen to negative criticism. You are listening to words that are depressing and that make you feel worthless. These are not words of praise for your efforts. These are words putting your work, and yourself, down. These are words that do not respect how hard you worked and that have no intent on helping you go further, push you forward, or fuel your passion. Let it go. Don't listen to it.

Expect Detractors

You have to dream, you have to have a vision, and you have to set a goal for yourself that might even scare you a little because sometimes that seems far beyond your reach. Then I think you have to develop a kind of resistance to rejection, and to the disappointments that are sure to come your way.

GREGORY PECK

As an artist striving to achieve a personal style, you have to expect detractors. You have to expect some people to question your vision, to argue that it is not worthwhile, to tell you they will have none of it, to state you will lose them as customers, and to otherwise try to throw you off. Take it for what it is: an attempt at making you feel that your vision isn't worth much, if it is worth anything at all.

I am qualified to talk about this subject having received my share of such comments, either in person, over email, or on the phone. If anything, they have further convinced

me that my vision was real, that I was on to something unique, that I wasn't following the norm, that I was challenging the status quo.

For example, my open attitude regarding my process, and my statement that I enhance and manipulate my work in order to express the emotions I felt when I recorded the original camera image, has been the source of endless comments from numerous other photographers and photography enthusiasts.

The publication of chapter 12 on the subject, titled "Just Say Yes", in which I detail precisely how I respond to questions regarding whether I manipulate my work or not, was a watershed event in this regard. I had one person email me, for example, to say that he hoped I would not regret publishing this information. I had another person tell me that publishing this piece, and explaining my position, was going to be "my downfall". In response to these negative comments, I can say that I have no regrets and I am still here doing better than ever. These people had mistakenly confused art and facts.

Let me explain. What I do is art. First, I make no secret about it. This is stated in the heading of my website, and my educational record is a who's who of the art schools and the artists I have studied with.

Second, etymologically speaking, art is artifice. It is an impression, a gloss, and an illusion. Art is not real. Art is the imitation of reality. It is an imitation that better shows us what reality is, but it is an imitation nevertheless.

In artistic photography, which is what I am doing, claiming to show a factual reality would be foolish. I have never made, nor will ever make a claim that this is my intent. Instead, the claim I make is that through my art I express the emotions that I experience when

I visit the places I represent in my work. The claim I make is that the images I create represent my memories of the places I saw. I strive to create images that depict not only what I saw with my eyes but also what I felt, heard, tasted, and experienced through all my senses: images that depict my emotional response to the scenes I photograph.

I make no claim of being objective or factual, nor do I claim that my photographs can be used to factually and objectively depict the locations that I represent. My goal isn't to create images that are to be used in textbooks, or in scientific reports, or in geological, anthropological, archeological, or other scientific studies. My goal is to create photographs that are more akin to paintings, rather than the mainstream perception of what a photograph should be. In fact, my photographs are not influenced by what people think photographs should be. My photographs are simply the end result of my vision expressed through my personal style; as a representation of my inspiration channeled through my creative capabilities.

Similarly, I certainly don't aim to create images that will be used in news publications, which is where my detractors fail miserably. Their point would be correct and appropriately taken if such was my goal. Then, and only then, would I regret making the statements I made. A news photographer is expected to be accurate and objective. A news reporter is expected to try his best at being impartial, at not letting his emotions control his work. A news photographer is expected to not manipulate his work nor to enhance his images. The reason for these expectations is that news photographs are expected to represent actual facts and represent events as they happened. They are not expected to represent events as

the photographer remembers them. They are not supposed to be embellished, modified, or changed in any way. They are not supposed to be an emotional response to the scene photographed. Instead, they are supposed to be a detached record of actual events, events in which the photographer was just an observer, or at most a participant-observer.

As an artist I have no such constraints or responsibilities in regard to my own work. As an artist I can pretty much do whatever I please to my photographs. As an artist I can enjoy total creative freedom regarding the subject I photograph, the way I represent this subject, and any other creative aspect of my work. My only requirement, if there is one, is to be totally, fully, and absolutely open about the fact that my work is not an objective representation of my subject. My only responsibility is to make sure that my audience knows, without the shadow of a doubt, that my work is art and not a factual representation of the locations I represent. My only responsibility is to explain that my photographs depict how I felt when I was capturing the image; that my images are a representation of my full sensory experience; and that my images represent a total commitment to my emotional response of the landscape.

As you become further involved in presenting your vision to your audience, opportunities for affirming your vision will become more numerous. In a sense, every detractor becomes an opportunity for you to further explore aspects of your vision that you may have missed, you may not have thought of discussing previously, or may not have realized was unclear. Each detractor becomes an unwilling ally by presenting you with yet one more opportunity to explain what it is that you are doing. Every misrepresentation

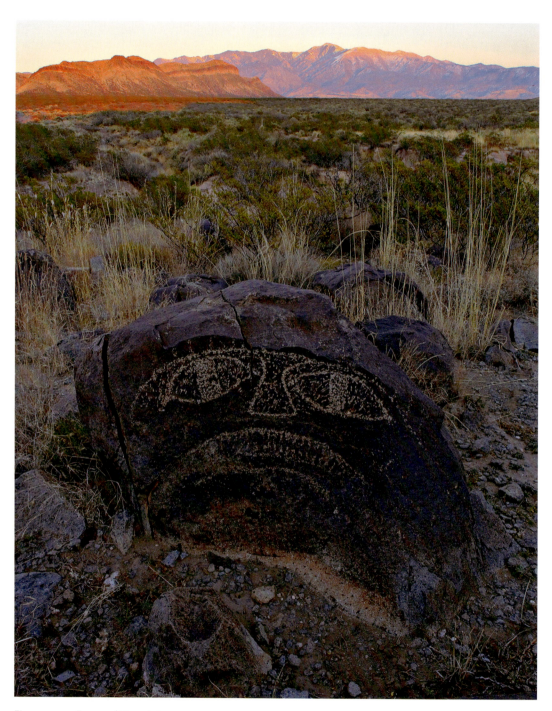

Figure 11-7: *Face and Mountains*

of your images and every misleading statement made about your work becomes a new opportunity to set the record straight, to explain things in greater detail, and to make more people aware of what you do. Every new detractor brings with him or her a new audience to whom you can explain what you do. Keep in mind that in this new audience there will most likely be people who like your work and who will be pleased that you are defending your approach.

Don't assume there is nothing you can do in the face of detraction, misrepresentation, or misleading statements made about your work. There is a lot you can do. While people will listen to detractors or read what they write; they will listen even more closely to what you have to say, or read even more carefully what you write. These people are just as interested in your defense as they are in the accusations made against you. Your response and attitude in the face of detraction speak volumes regarding how you feel about your work. Your words and actions are the finest way to show your audience that you are passionate about your art and that you are committed to your vision.

If you put forth a strong defense and bring to the table irrefutable arguments in support of your art and of your artistic stance, you show your audience how much you care about your work, how important it is for you to defend it, how much it matters to you how others feel about it, and how important it is that others understand what you are doing. You show that you stand behind your work, you're proud of what you do, and you're not about to let someone tear it apart without a fight.

Your attitude becomes one more reason for others to become passionate about your work. Your attitude becomes part of your work to some extent. Your attitude shows to your audience the attitude you expect of them. It shows them the way. It makes them want to be part of what you do because you are proud of what you do and because you are ready to defend it, no matter what it takes. People like those who stand for what they believe. People are also willing to hear both sides of the story. People reserve the right to make up their own mind. It is not who speaks first that matters, it is who speaks best. Above all, what matters most is who speaks the truth, who speaks from the heart, and who speaks about something they truly care about. And in this instance, this someone is you, the artist. If you truly believe in your work and if you truly believe that your work matters to you and to others, you must say so when confronted by detractors.

Images of rock art, Native American petroglyphs (images carved on rocks), and pictographs (images painted on rocks), have been a staple of my personal style for years. While subject alone is not enough to define style, working with a specific subject for years does create a solid link between an artist and his subject. I approach rock art the way I approach the landscape. My goal is to express my emotional response to the rock art surfaces I photograph rather than create a scientific record of these surfaces.

Skills Enhancement Exercises

Musicians always come up with stuff I couldn't imagine, using my instruments. I can get a sense of whether something would be a good musical resource, but I don't do music. I'm a toolmaker. It's always amazing what someone like Herbie

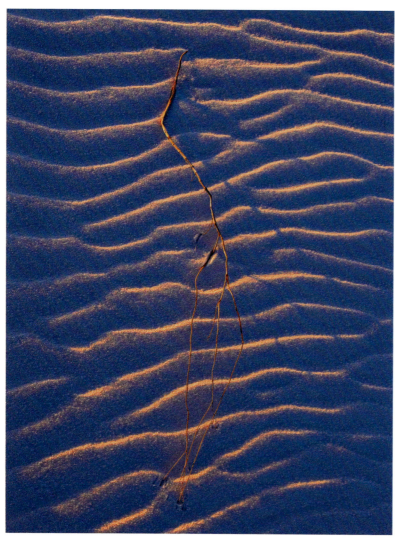

Figure 11-8: *White Sands Branches*

Hancock, Wendy Carlos, or Stevie Wonder can come up with. What they'll do when you put something new in front of them is they'll turn a couple knobs and listen, and immediately get a sense of where to go. The muse talks to them.

BOB MOOG,
INVENTOR OF THE MOOG ANALOG SYNTHESIZER

Design a Short-term and a Long-term Project
- Be specific about the nature and the scope of your project
- Write a description of your project
- Set a deadline for completing it
- Do this for a short-term project: a month or two maximum
- Do this for a long-term project: a year or so maximum

Describe Your Comfort Zone
- List everything that you are comfortable doing related to photography and to your work
- List everything that you are not comfortable doing related to photography and to your work

Repeatedly Visit a Location You Like to Photograph
Each time you return to a favorite location, create an image that is different from all the other images you previously created at this location. Make this an absolute rule and don't break it! This approach will force you to look at familiar places in a new way each time you visit them. It will force you to search for something new, something you haven't seen before. You'll have to search for new compositions that you failed to see or didn't think of previously. You will search for new light and for a multitude of other things.

Because you cannot take the same photo twice and because you cannot take the photos you have seen from other photographers, you are forced to invent your own images of this place. As time goes by and you continue following this approach you will develop your own personal way of representing a particular place. You'll develop your own personal vision of this place, and you'll not only create images that haven't been seen before, you'll create your own images of this place. Not only will you be creative, you'll also be original. Originality is one of the trademarks of a personal vision—one of the tests you can use to decide if you have a personal style or not.

Follow Your Creative Impulses

Thinking can help creativity, but that is only one aspect of it. Another aspect is to not think, and instead to act from the heart, to act impulsively. This impulsivity is based on your emotional reactions rather on the desire to create something that others will like.

Master Technique to Focus on Art

Work toward freeing your mind of technical considerations by mastering technique so that you can focus your energy on the artistic aspects of the image. This is a skill that you gain through practice, until technique becomes second nature and your mind is free to focus entirely upon artistic considerations.

Take Notes in the Field

Carry a pen and paper at all times so you can jot down ideas as they come to you in the field. Carry a voice recorder so you can record ideas as they come to you in the field. Develop these ideas into longer pieces of writing when you return to your studio, hotel, etc. Write down your goals so that others can understand and visualize it themselves.

Listen to Music while You Work

Many photographers regularly listen to music while they work. The combination of musical compositions and visual art works well together. One influences the other and music has a relaxing and energizing effect that provides increased creativity and inspiration while creating images. Today, with digital music players, one can listen to music through a computer while working in the studio and then take the same mp3 files in the field on an iPod. Listening to music anywhere while creating photographs has never been easier.

Invent a New Way to Work

Invent a new way to work, to take photographs, and to process your images; a way that is yours and no one else's. This may mean changing the equipment you use or changing the way you use your equipment. It may mean designing a studio that fits your personality, or buying property where you are comfortable working and in a location that inspires you.

Take Your Time

Just like you can't schedule creativity, you can't rush personal style into being. Artwork that is in the making asks for its own time. You have to operate by listening to the piece you are creating, and not just by listening to your own schedule, your desires, or your deadlines. Deadlines do help make things happen and many artists would never get started, or never finish their projects, if it wasn't for deadlines. But deadlines can also kill art by making you want to complete a project too fast without listening to the work.

Rhythm, in a way, also has to do with deadlines. There is nothing like a deadline to hasten us toward completion of a project, and indirectly generate the necessary inspiration to find the way to complete this project. Deadlines generate rhythm and impose a specific pace; rushed if one procrastinated or if the deadline is too short, or, more rarely, slower if the deadline provides more ample time or if one started the project early.

The image, "White Sands Branches" (figure 11-8), is another one of my rare closeup shots. I use the same approach to photograph both details and grand landscapes. I could, for example, have used this detail as a foreground element in a wide-angle, near-far composition. But, I decided to focus solely on the foreground here because my vision for this image was not of a near-far composition. Instead, my vision was of a closeup showing the relationship between the shape of the branches and the sand ripples, both lit by glowing sunset light. My vision was also about emphasizing the difference in color between the warm sunset light on the branches and parts of the sand ripples, and the cool blue of the shaded areas.

Conclusion

It seems that perfection is reached not when there is nothing left to add, but when there is nothing left to take away.

ANTOINE DE SAINT-EXUPERY

The achievement of a personal style means following your inspiration and vision, being creative, trusting your own instincts, leaving your comfort zone, not being afraid to take chances, and making your own rules. Your personal style is an extension of your personality. As such your personal style is as unique as your handwriting. The mistake many people make when it comes to personal style is thinking that they must have a model and that this model will help them find the right and wrong ways of making art. Such a model does not exist because art has no rules. Art is whatever you want it to be. As long as you approach art in this way, the achievement of a personal style will come to you. If you forever try to follow the rules or try to copy someone else's work, your work will remain commonplace and predictable. To be unique, to surprise yourself and your audience, and to achieve your personal style, the artwork you create has to be yours.

Think of art as being the one place where anything goes, where you can be yourself and do what you want, whatever that may be. Think of personal style as being able to create something unique and extraordinary; something that does not exist in any way, shape, or form; and something that others will want to own and admire.

Personal style is therefore about being cutting edge. As such it carries with it the risk of exposing yourself to potential disapproval, because anything that is cutting edge is bound to elicit extreme responses, either total acceptance or total rejection. Mild responses are rare once an artist develops a true personal style and this is one of the reasons why so many hesitate at doing what it takes to achieve a personal style. In other words, they are concerned, and rightly so, that the responses to their work will be polarized rather than neutral.

Having a defined and recognizable style means making decisions regarding what you photograph and knowing what your subject is. If you are unsure of your subject your audience will be unsure of it as well. As a result, it is unlikely that this audience will support your work. Why? Simply because if you are not sure where you are going others will not be sure whether they want to follow you or not. You are supposed to be the master, to decide where you are going and to show the way. The audience expects you to make these decisions and to lead them on the path to an understanding and an appreciation of your work. For this reason they cannot lead you. This is neither their role nor their inclination. This is not their purpose for looking at your work. Instead, it is your responsibility to lead them.

You must make decisions about your choice of subject, your approach, and eventually your personal style. Doing so is crucial because failure to make decisions in these areas will result in the lack of a following on the part of your audience. If you don't know where you are going, or if you believe that not making a choice will preserve all options for future decisions, your audience will drop you like a stone, and they will move on to see the work of those who have a firm idea of what they are doing. Audiences like artists who know where they stand, even if the stance of this artist may be counter to the taste of a specific audience, or the art may be shocking or unconventional. People admire artists who take firm position because this is what is expected of an artist. In a sense, polarization of the audience is a logical outcome of art.

This four-part chapter is now complete. Although my focus has been photography, most of what I presented here is applicable to other artistic mediums and the process I described is applicable to art in general.

This book is not only about photography and composition. It is also about the purpose of art and about the reasons we create art. We create art to share a message with our audience. In the context of the visual arts, which include photography, we create art to share a different way of seeing, a different way of representing things visually. Creating art is about expressing our personality and our vision of the world.

Section D:

You and Your Audience

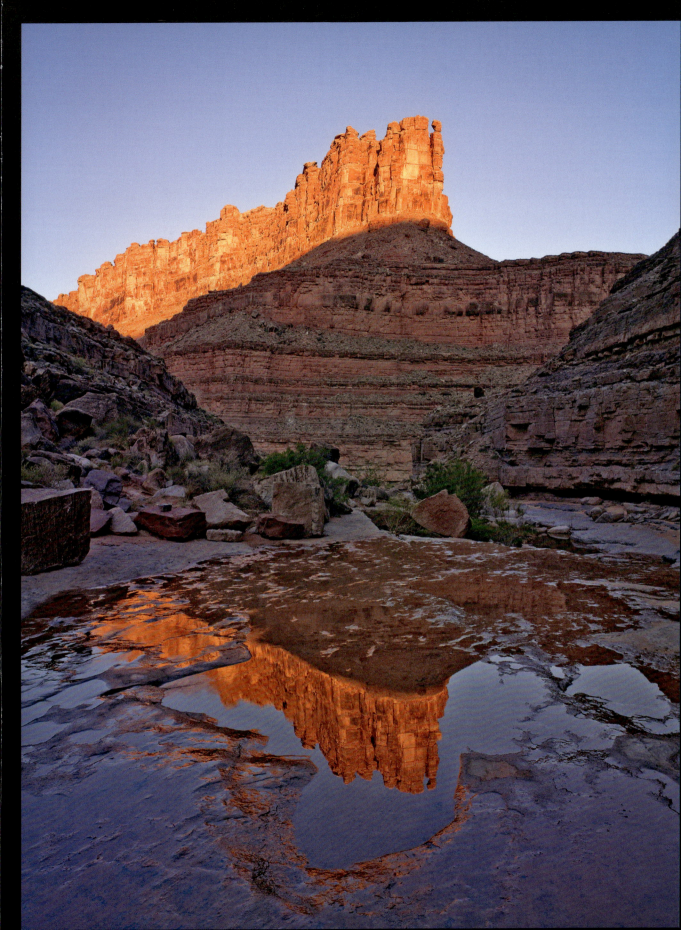

12 Just Say Yes

If you can't see it, it doesn't count.

Ctein,
talking about photographic technique

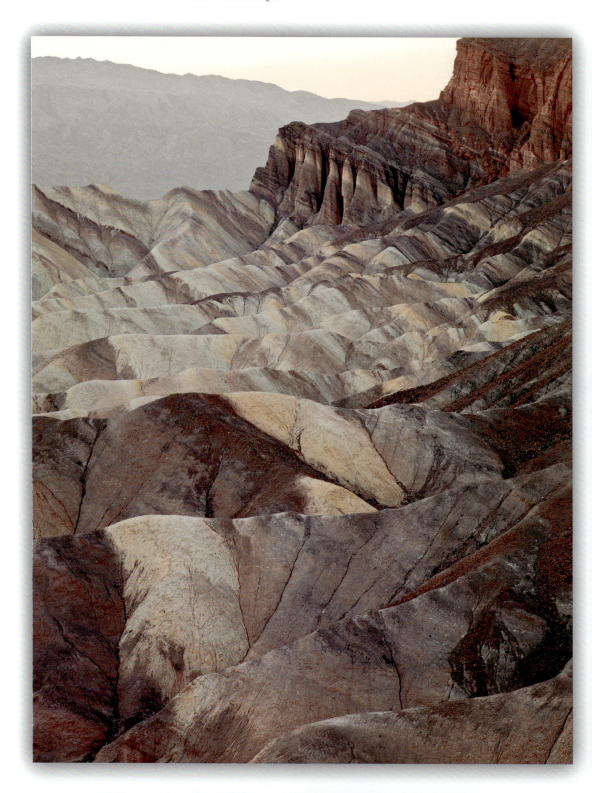

Introduction

As a digital photographer, if you haven't already been asked this question you eventually will: "Do you manipulate your photographs?" Sometimes it comes under another aspect: "Do you change the colors?" And occasionally it goes straight to the heart of the matter: "Is this real?"

A certain percentage of the public believes that fine art photographs must represent reality. There are those who do not know there are differences between what is seen and what the camera captures. Finally, there are individuals who do not understand that a photograph is a two dimensional representation of reality and not reality itself, because reality is far more complex and perceived by us through five senses and not just one.

Some people are willing to change their minds when these things are explained to them. Others have their minds made up and do not want to be bothered by the facts. Those are the ones that I am referring to in this chapter.

This part of our audience believes that photographs must represent reality and to achieve this they believe that photographs must remain unaltered and printed exactly the way they come out of the camera. While this may be true for certain types of technical photographs, when it comes to art and to my work I believe the exact opposite to be true, namely that photographs *must* be altered in one way or another in order to have a chance to represent the reality that I perceive.

My premise for this chapter is that a fine art photograph, created by an artist with the goal of expressing himself or herself, is a representation of this artist's view of reality, a representation of this artist's vision, and not a representation of the world as others may see it.

Ultimately, this is a matter of opinion, and personally, my opinion is that a photograph cannot capture reality as we experience it physically and I can back it up with facts (as I have done so in chapters 2 and 3 of this book). However, I found that debating this point with people who do not agree with me isn't necessarily the smartest decision. So, I propose here a different approach, one that works great for me.

A Little Bit of History

For a long time I didn't know what to say when confronted by people asking me if my work was real, if I manipulated the colors, or if I changed something in the scenes I photographed. In fact, as a fledging artist unsure of where I stood, I felt threatened by these questions and was more concerned with defending myself than with anything else.

At that time I believed that explaining my artistic approach would help. So I answered by saying that the color changes, the manipulations, or the modifications I made to the image were representative of my style and that my goal was to show how I saw the world.

I also explained that I preferred to call what I do "enhancements" rather than "manipulations", because the later seemed a derogative statement while the former seemed positive and complimentary.

Unfortunately, my efforts were to no avail. These fine differences in terminology were lost on these people. Furthermore, their minds were made up and they did not want to be bothered by the facts. My facts may have been accurate, thought-out and sophisticated, but

Figure 12-1: *Dusk at Zabriskie Point*

they were facts nevertheless. While they may have had a chance to be heard in an academic setting, they were completely useless in a real world situation.

I also thought doing all this would help in regard to selling my work. I believed I could change people's minds and once that was achieved they would buy my photographs. What I discovered was how many people have their minds made up and don't want to be bothered by the facts. I also discovered that people who do not believe what you say, or who do not like what you do, will not buy your work. After all, I am selling art, and to buy art someone has to like your work, which means they like both you and your work. When people don't like one or the other, or worse yet, don't like either, trying to make a sale is not possible.

What I didn't know at the time was that the majority of those asking these questions were primarily interested in starting an argument. They asked if my photographs were real, not because they were interested to know what my answer would be, but because they didn't like my vision of reality. Certainly, a few really didn't understand how my work was created, and they were satisfied with my answer that this was my style, my vision of the world. I am referring here to the others—those who wouldn't accept my answer as valid.

I finally saw the light and decided on a different course of action. I decided that in response to obvious suspicion regarding the honesty of my answers, I would give the most direct and least questionable answer possible. I decided I would act as if I were in a court of law, where the party being questioned, the party whose actions are at stake, is asked to answer with a simple yes or no. In short, and to get to the point, I decided to *just say yes*.

The Art of Saying Yes

When you are asked, "Do you manipulate your colors?" and you answer yes, you create an entirely different situation than when you start explaining why you do what you do. When you say yes, you state the facts and nothing but the facts: "yes, I do manipulate my colors". Although the person asking the question may not like your answer, it is difficult for them to question this answer without questioning your personal integrity.

When you do explain why you do what you do, you are in effect trying to legitimate your actions. In that case, three things need to be explained. First, trying to legitimate your actions implies that you know they may not be perceived as legitimate. Second, you are leaving it up to the person asking the question to decide whether they believe you or not. Third, you are opening the door for a lengthy discussion because the person asking the question now has the option of taking apart your answer point by point.

In other words, although I was speaking the truth when I explained myself, I was giving control to the person asking the question. Once I had given my answer, they were in control because it was up to them to decide whether or not they believed my explanations and how they were going to respond. I was also confusing the matter by explaining in a lengthy manner what could have been answered with just one word: yes or no. They had grounds to question my integrity regarding what I was really doing in my work.

When I decided to just say yes, I took control of the situation. When someone answers a question in the most straightforward manner possible, the only options are to either believe or not believe this person. If you don't believe

what a person is saying, then you must come back with a question as straightforward as their answer, and most likely you will hesitate doing so because you will risk getting a second answer just as straightforward as the first one. You also run the chance of coming across as insult. After all, someone you just met answered your question in the most straight-forward manner possible. This person may, if pressed further, ask why you don't believe them. Or they may ask if you are suspicious by nature or if you have a problem with what they do. Finally, they could ask if there is some-thing wrong with you in the first place.

For example, if someone asks me, "Do you manipulate your colors?" and I answer yes, and if they then ask, "Is that so?", my answer would be another yes. I could say, "Yes Sir" to emphasize my answer, or just because I feel that they need a longer answer, but that's all I would say at a show of my work. If they ask "How do you manipulate your colors?", I would answer "In Photoshop". And if they say, "Oh, I see, you use Photoshop!" my answer would again be yes with or without "Sir". Of course, the exact words used and questions asked vary in their grammatical construction according to the situation, but in my experience, and my experience is extensive, this is how things tend to go.

Drama

Let's back up a little. My creative writing teacher at Northern Arizona University, Allen Woodman, defined drama as being, "two dogs, one bone". As we all know, such a situation can quickly lead to a dogfight because most dogs will want that one bone for themselves. Dogs rarely share with other dogs.

With humans, fights often occur for the same reason: two individuals both wanting the same thing for themselves. If we meta-phorically apply it to the situation discussed in this chapter, photographers or photogra-phy enthusiasts often enter into a conflict regarding the subject of reality in photographs because they both believe they describe reality in their work. However, their work differs radi-cally, although they both photographed the same subject. In this situation, who is right? Who can claim to represent reality? Clearly, it must be one or the other but not both.

However, my answer does not point to a conflict. My answer is not "Yes, I represent reality". My answer is, "Yes, I do manipulate my work". And, "Yes, I manipulate reality". Therefore, my reality may be different from yours.

At conferences, I give a much longer answer, explaining, "In fact I clone, change the colors, alter the contrast, even remove houses that look ugly in the middle of a pristine wilder-ness. In short, I modify reality. What you see is not what I photographed. What you see is how I felt when I created the image. What you see is the world as I see it and as I want to show it. I feel great about doing what I do. In fact, I love it and I have never been hap-pier since I gave myself the freedom of doing so! Not only that, but I write essays describ-ing precisely not only how I do what I do, but teaching others how they can do it too. I even give workshops and seminars and conference presentations about both the techniques I use and the philosophical and rhetorical views that underline my position. And if there is anything else you would like to know about this subject that I have not covered yet, don't hesitate to ask. I may have overlooked some-

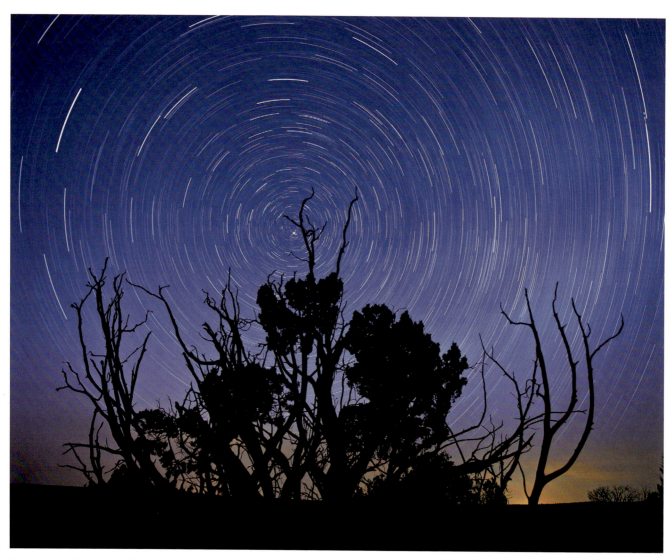

Figure 12-2: *Kyaatataypi Night*

thing, and if so, I will be glad to address it right away".

What I am saying, to go to the root of my message and of my artistic position, is that there isn't just one reality. Instead, there are multiple realities. And if we limit this discussion to just myself and the person asking questions such as those mentioned above, then there are at least two different realities; theirs and mine. We both see the world in different ways. I see the world the way it is depicted in my work, and they see the world whichever way they like. That is OK. They can have their reality, I can have my reality, and I don't see a problem with that whatsoever.

I don't claim there is only one reality, and in fact, I really don't care. All I know is that I love my reality. It makes me feel great, makes me want to get out of bed in the morning to create more of it, makes me want to go further in describing in greater detail exactly what it consists of, and above all it makes me want to experience it as much as I can.

Technique Is Meant to Be Seen

There is another aspect to this discussion about manipulating images, and that aspect is technique. Technique is meant to be seen and should be visible. If this technique involves manipulating or enhancing the image (depending on which side of the fence you stand on) then this enhancement, or manipulation, must be visible. Why? Because I want others to see it—I want my audience to see what I did to the image, and how I made my vision a reality through the use of various techniques. I want this to be visible, so in April 2006 I began providing the master file to my images with print purchases. I do this

so others can learn how to do what I do, but also to show how I did what I did. That is, I am taking advantage of one aspect of digital technology, which is that the digital image file can be duplicated countless times and still be as good as the original. Such is not the case with a negative or a transparency, whose quality degrades dramatically with each copy made from the original.

There is also a matter of quality. The only way to tell if a technique is good, effective, or has been mastered by the practitioner, by the master, is to see it for ourselves. Otherwise, we rely on the words and opinions of others. Mastery is something that must be witnessed, something that must be seen. If one wants to be recognized as a master, one cannot have as a goal to make his technique transparent. One must try as hard as possible to make his technique something that can be seen, something visible to all.

Technique, in other words, must be or become part of the work. It must not be just the path that leads to the creation of this artwork, rather it must be part of the artwork. To return to my main point in this chapter, and to just saying yes when asked if my work is enhanced or manipulated, I must give this answer in order to tell my audience that it is my intention to make my technique visible. Indeed, I often emphasize my answer by saying "Yes!" In writing, there is no other way to show this subtle difference besides placing an exclamation point after the word yes, but this slight change conveys my love and passion for the work that I do and for my desire to share this with my audience.

Audience

There is another aspect to the "Just Say Yes" idea, and it is the audience I am addressing. I am addressing an audience who loves what I do. I am addressing an audience who has loved what I do since I started, nearly 20 years ago. I am addressing an audience who is growing daily and who wants to see me go further in my approach, in my practice, and in my style. An audience who knows that I manipulate colors, change things around sometimes, and who actually loves that I do what I do. I am addressing an audience who loves my work for what it is.

Yes! I manipulate my work, change the colors, and much more; and yes! I feel great about doing so; and yes! I am proud of it and have no remorse; and yes! I have no intention of changing this approach. In fact, this is my style. This is me.

If you are a photographer, I strongly encourage you to follow this approach. If nothing else, it will free you and liberate your creativity. Remember that you must be free in order to be an artist. If you do not feel free to create whatever your heart desires, then you might call yourself an artist, but you are not really an artist. Art is personal expression. It is the expression of your personality, your vision, your view of the world, and your perception of reality. Art is freedom.

In Closing

Bringing a conclusion to this chapter is difficult because there is a lot more I could say on the subject (yet, some may argue such a chapter should never have been written). There is much to be said and this does need

to be written, because finding the proper answers to the questions that are asked of us can be very difficult. As I said earlier, if you are a photographer and you show your work to others, regardless of whether or not you sell your work, you will inevitably be asked these questions. As the saying goes: it is not a matter of *if*, it is a matter of *when*. And when the time comes, be prepared to answer, otherwise you will join the ranks of the stumped. I don't know about you, but personally I hate being stumped.

So yes, this chapter definitely has a reason to exist. This reason is to help you find out where you stand and to help you find your own answers. My answer is "Yes!" because I do believe, and for good reasons, that I manipulate reality. Your answer may be different.

My goal is to create images representing the world not as it is, but as how I see it, how I feel when I am in a specific location and how I perceive this location as a whole—the melting sap of pinion pines on a warm summer day; the call of a blackbird bouncing off a canyon wall; the heat waves floating in front of me over the bare sandstone; the multitude of sensory inputs that are, by nature, non-visual. After all, a photograph is nothing more than something we can look at. Yet, the reality of the world is much more than that. We experience this reality through five senses: smell, touch, hearing, taste, and sight. A photograph makes use of only one sense, thus it represents a limited perception of the world. I wish those who argue that unaltered photographs can represent reality would understand this. But it is not in my power to change their minds. Therefore, I limit myself to just answering "Yes!" when they ask me questions about whether or not my work is manipulated.

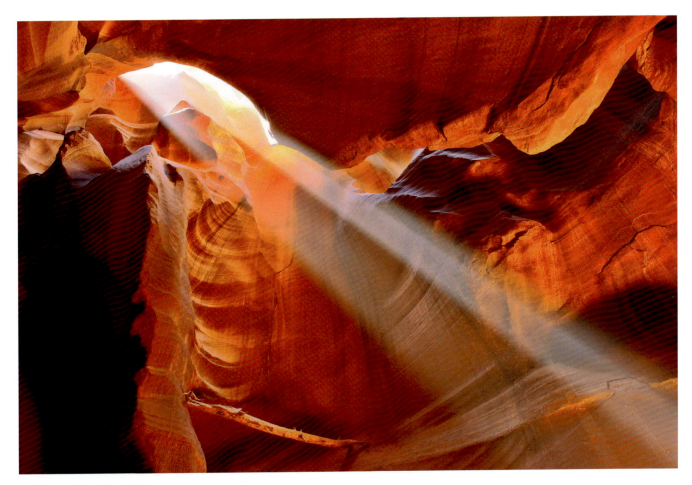

Figure 12-3: *Antelope Light*

Of course my work is manipulated. How could it be otherwise?

In general, it is best not to act defensively when you find yourself confronted by someone asking questions such as the ones mentioned in this chapter. These questions are often aimed at making you take a defensive position. Unfortunately, if you do so, you will find that you have to defend yourself in regard to actions you are perfectly free to conduct. Actions that are nobody's business except your own.

The best solution for those who really don't like your work and who don't want to be bothered by learning the facts is for them to move on and look at the work of an artist they like. Therefore, if they ask you questions, there is no reason for you to feel threatened or to act in a defensive manner. Just tell them the truth, and accept that they will believe whatever they want to believe.

13 Of Audiences and Bestsellers

There are always two people in every picture: the photographer and the viewer.

ANSEL ADAMS

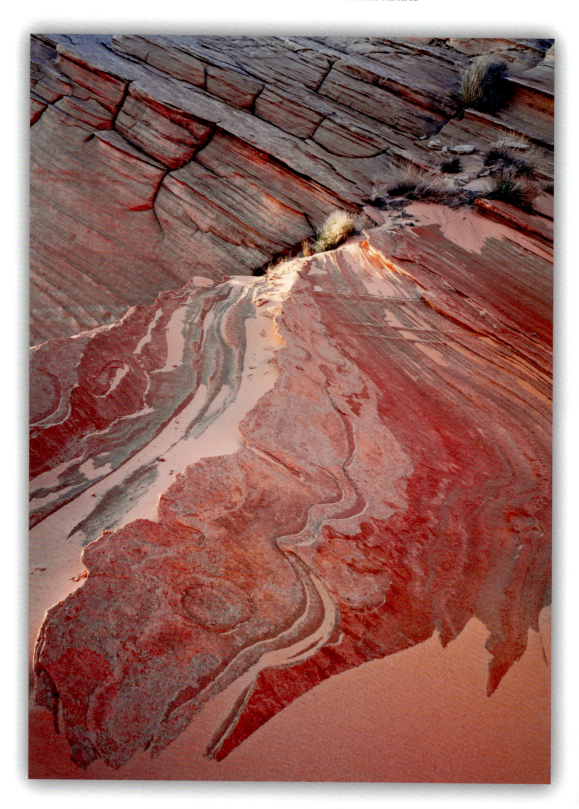

Introduction

The concept of audience is one of the most difficult ones to come to terms with for artists and photographers. In fact, finding and defining an audience is one of the most difficult aspects of doing art.

This problem is not unique to photography. It is just as problematic for artists working in other mediums. Many writers, for example, have difficulties coming to terms with the concept of audience. When I taught Freshman English (English 101) in college, while working as a graduate teaching assistant during my Masters and PhD studies, audience was one of the most difficult subjects I had to teach. Not because I didn't know how to teach it, but because students were reluctant to consider their essays to be written for an outside audience. In their minds, I, the teacher, was their audience. They did not need, did not want, and were not interested in considering any other audience for their work.

I was their audience because I was grading their papers. Therefore, my students wrote for me. They were less interested in writing what they believed in, than in writing what they thought I wanted to read. No matter how much I would explain that they were graded on the quality of their arguments (much of teaching English 101 in the United States is based on a rhetorical approach, so much so that Rhetoric Departments are responsible for training English Teaching Assistants) and not on what they thought I wanted to hear, most of them still could not write for any audience other than myself. Regardless of how often I would point out that after graduation they were going to write for a "real" audience and not for a teacher, they still continued to write for me. I was their audience because I was

giving them a grade. The fact that they would write for someone else in the future—their bosses, co-workers, employees, business associates, publishers, or simply (and more to the point) an audience that was interested in new ideas—*their ideas*—did not phase them one bit. They were writing to get a specific result, which was getting a grade, be it an A, B, or C, depending on whether they wanted to excel or simply pass the class.

Who Is Your Audience?

I think ultimately if you have a very high expectation of your audience and you know exactly what it is you're trying to express through the medium of film, there will always be an audience for you.

ATOM EGOYAN

It would be far fetched to say that photographers face the same problems as my freshman English students did. They don't, at least not directly. For one, many photographers study on their own. Few take formal classes and those who do are graded more on technical and artistic content than on whether their work is meeting the needs of a specific audience. And of course, during workshops grades are not given.

Still, the concept of audience is a thorny one. I teach it in just about all of my workshops, and every time I get raised eyebrows and objections from some of the participants.

The most frequent objection comes from participants who mention that they do not need an audience. They photograph for themselves, and are not trying to show their work to anyone else. They just want to become better so that they can enjoy creating better images and better prints.

Figure 13-1: *Sandstone Patterns*

Fair enough. After all, as I often say, this is a free country and we can do whatever we please. The problem is, these same participants bring prints during the group print review that is part of each workshop. At that time, they do have an audience which is the group of participants who are attending the workshop.

In other words, at the time that you show your work and ask for comments, an audience is intrinsic. Not wanting or needing an audience stops the minute you show your work to someone else. This is the very first boundary between audience and no audience. Until then, you are your own audience. Afterwards, your audience consists of other people. If you do not want an audience, then you should not show your work to anyone else.

For most of us, this sounds ludicrous. In fact, it is hardly a possibility. We all want to show our work to others, even though "others" may be a relatively small group of friends and relatives. This shows that having an audience is an ineluctable aspect of doing photography or of engaging in an artistic endeavor.

We create art, and we take photographs, because we want to share our work with others. If this were not the case, we would never show our work to anyone else. The minute we do show our work, we acknowledge this fact and we accept that we need an audience.

This could be the end of the problem. Unfortunately it is not. At that point, having acknowledged that they do need an audience, many beginning photographers bring up the fact that this audience doesn't have to be specific. They are not choosy, therefore anyone interested in looking at their work is part of their audience.

Interestingly enough, this is the exact same point that my English 101 students would

make when asked to define their audience. They would say: "My audience is anyone interested in reading my paper". I would explain to them that since they are free to pick any subject they like, not everyone will be interested in reading what they have to say about, for example, seat belt laws (a popular subject at the time), abortion, finding a cure for AIDS, or any other specific topic they might choose. Clearly, only those interested in these subjects would take the time to read their essays.

The same applies to photography. Whatever subject you photograph, only people who have an interest in this subject will look at your photographs. Certainly, others may encounter your images in passing, but unless they have an interest in the subject of your work, they will not take a longer look at your images and try to understand their meaning. If you do fine art, which is the approach I teach, you know fine art photographs need to be looked at and studied for some time to be truly appreciated. Doing so requires more time than someone who discovers your work by chance and who has no real interest in your subject.

What does this mean? Simply that unless you place your work in front of an audience that is interested in it, you will not have a valid response to your work. What is a valid response? It is a response given by those who took the necessary time to look at your work and to try to understand what you have to say in your photographs.

The same applies to writing. Unless one reads an entire text, one won't be able to make informed comments and develop an informed opinion about it. Of course, this concept is easier to grasp with writing because we all know that reading an essay or a book takes time and concentration. On the other hand, many believe that a customary glance, done

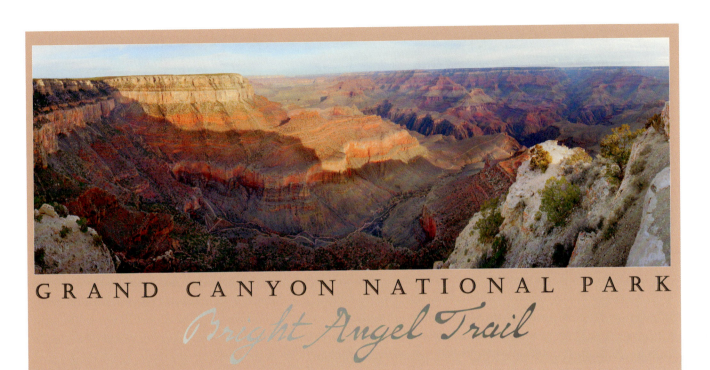

GRAND CANYON NATIONAL PARK
Bright Angel Trail

Figure 13-2: *Bright Angel Trail Panorama Poster* – South Rim of Grand Canyon National Park

quickly in passing, is all it takes to understand the message in a fine art photograph. Reading a photograph can be just as time consuming as reading an essay or a book. It's just that this reading takes place differently. Instead of reading words and sentences, one reads visual metaphors, the arrangement of objects and elements into a specific composition, the use of a particular color palette, the choice of a certain type of contrast, the use of a specific type of light, and so on. Doing so is time consuming and requires knowledge of photography, just like appreciating a fine text requires knowledge of literature. In the end, only those who have the required knowledge, time, or interest will do so. Those people are your audience.

I created this poster for sale in Grand Canyon National Park after I realized that it was one of my bestselling images. It shows the

Bright Angel Trail, the most heavily traveled trail in Grand Canyon, in its entirety, from the El Tovar on the South Rim (at left in the photograph) to the Bright Angel Lodge on the North Rim (at extreme right in the photograph).

This poster required approval by Park Rangers prior to being sold in the park. Approval was granted on the basis that the image was not manipulated in any way. Since over 180 degrees of view are shown in this image, a single photograph couldn't capture the entire scene. I therefore used a Seiss rotating panoramic camera to create the original photograph. Stitched digital captures would not have been accepted because they would have been seen as having been manipulated.

The image was taken at mid morning, not because that was the best time of day for color or light quality, but because it was when the

trail could be seen in its entirety. Too early in the morning and it would be in deep shade, too late in the day and it would be washed out by direct sunlight. Clouds also helped soften the deep shadows that usually fill the inner canyon.

Finally, this image was taken in March, because spring and fall are the times of year when most people hike the Bright Angel Trail, when the temperature is still cool. Most hikers start early in the morning and find themselves in the middle of the trail by mid morning. They do this to avoid hiking in direct sun (the majority of the trail is in the shade in this photograph). Similarly, cloudy days are a blessing since there is less or no direct sun. Because the Grand Canyon is a mile deep, temperatures at the bottom are often 30 to 40 degrees higher than on the rim, hence the importance of hiking in cool conditions.

As you can see, this is an example of where decisions were made not so much from an artistic point but mainly from the perspective of pleasing the audience. As an artist I would have preferred to show this scene in a very different way. I may also have decided not to take this photograph at all.

The Concept of Audience

Documentary photography is the presentation or representation of actual fact in a way that makes it credible and vivid to an audience at the time.

DAVID HURN

My approach to the concept of audience stems from the example I just gave. Your audience is people who are interested in the subject that you photograph, in your approach to this subject, or in both.

From this interest in your work, and from devoting the necessary time to fuel this interest, comes what American author, Barry Lopez calls "indebtedness to our audience". This indebtedness goes like this: we are indebted to the audience because our audience gives time, effort, and attention to us and to our work. In turn, we must repay our audience by giving them our very best effort at creating our work. If we do so, we will repay the debt we owe to our audience and the process will continue. The audience will give us their time and attention in return for work that continues to further our vision and meet our highest standards. If we break this unspoken contract, we will leave this debt unpaid and we will face the possibility that our audience will lose interest in our work.

There remains the issue of what the promise we made to our audience actually is. This promise varies from artist to artist. In terms of subject matter and personal emphasis, this promise is infinite in nature. There are endless sources of inspiration, creativity, and motivations that an artist can tap into for his or her work.

However, and for all artists, this promise is about creating art that furthers the artist's vision and personal style. And yes, for this approach to work the artist must have developed a personal style, which is why this chapter comes after my discussions on inspiration, creativity, vision, and personal style.

Selling Out

I am a typed director. If I made Cinderella, the audience would immediately be looking for a body in the coach.

ALFRED HITCHCOCK

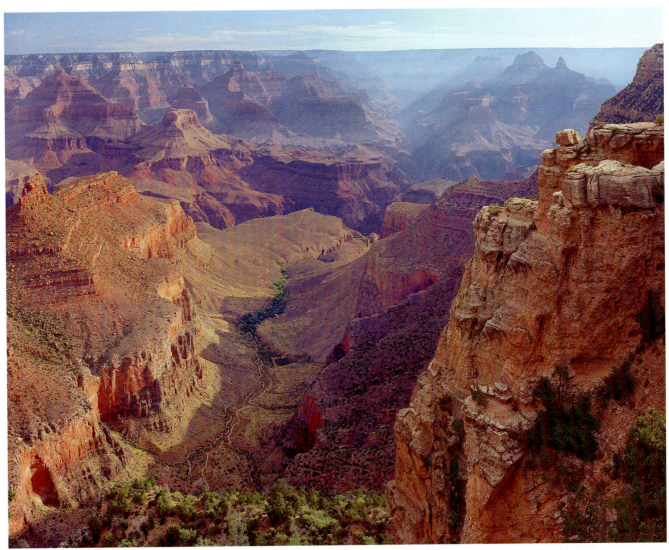

Figure 13-3: *Indian Gardens* – South Rim of Grand Canyon National Park

Whenever I mention that as artists we repay our debt to our audience through our work, the response I frequently receive from other photographers is that this relationship is similar to selling out to an audience. By selling out, these photographers mean doing something purely to please the audience and often solely for financial gain. Some consider this as "selling one's soul" when referring to a purist approach to art.

The fact is that developing a relationship with an audience is crucial, both to the creation of art and to the creation of a discussion about one's art. Does one sell out by creating art and by initiating a dialogue with his audience? Absolutely not! Not any more than an author sells out by writing a series of books on a specific subject for an audience that appreciates this subject.

So why are some beginning photographers saying that one sells out by doing so? Because, I believe, it is another argument toward negating the need for an audience. These beginning photographers think they do not need an audience because having an audience—any audience—is going to make them sell out. In turn, they think anyone who has an audience has already sold out.

This whole issue about selling out because one has an audience is not only ridiculous, it is also backwards. One needs an audience to move forward because, without people interested in one's work, and without people commenting on one's work, one will have a very difficult time creating anything. Audience interest and commentaries are the motivation behind creating new work. If you make a living by selling your work, you would not be able to do so without a buying audience.

Figure 13-3 shows another view of the Bright Angel Trail, this time taken from the viewpoint in front of the El Tovar Hotel at the Ground Canyon. This image shows the trail, the rim, and Indian Gardens and Plateau Point, two popular destinations for day hikes that are located below the rim. This photograph was extremely popular with El Tovar guests because it shows the view they could see from their room (if they had a room with a view on the canyon), or from the north porch of the hotel (where my art show was located), or from the rim since the El Tovar overlook is only 50 feet from the hotel itself. In other words, this was the view that all hotel guests saw during their stay. Again, it was taken during the day, this time around 9:00 a.m. Since most visitors see the Grand Canyon during the day, this image closely matched their visual experience of the Grand Canyon. As with the previous image, more consideration was given

to the audience than to my artistic impulses and vision. I personally preferred other images of this scene taken at sunrise or at sunset but those other images did not sell as well.

Artists Seek a Response from and a Dialogue with the Audience

We create art, meaning we create photographs, paintings, sculptures, musical compositions, literature—you name it—because we want a response. We create art because we want to start a dialogue. A response from whom? A dialogue with whom? A response and a dialogue with an audience interested in what we do. To say that we are "selling out" the minute we participate in this fundamental aspect of art reduces the purpose of art to a minimum: It creates an environment of distrust and suspicion, and it defeats the purpose of art which is to allow people discover a work of art simply because they like the work, are curious about it, and want to experience it personally.

Of Bestsellers and Art

The artist is nothing without the gift, but the gift it nothing without the work.

EMILE ZOLA

In no other domain is the belief of "selling out" more prominent than when it comes to discussing the concept of bestselling images. Bestsellers seem to raise more questions than any other subject when it comes to mixing them with an audience.

I find that somewhat surprising since bestsellers are nothing more than a given item

which pleases a large number of people. Bestsellers have everything to do with business and little to do with art. They are found in any business endeavor, be it selling photographs, cars, books, pet supplies, Halloween items, etc. Bestsellers are a fact of life when it comes to business. Certainly, they are business assets because one can depend on them to bring in a regular income. However, one also knows that creating a bestseller is not a straightforward process. Knowledge is involved, but luck is involved as well. In the end, it is a trial and error process, not a scientific endeavor. Whatever the field you are in, which items turn out to become bestsellers is usually a bit of a surprise. While there are givens to what the public likes, such as price point, features, novelty, and so on, creating a package that includes all of these and goes beyond what the competition offers is not only difficult, it is also a bit of a gamble.

How to Create a Bestseller

It is even more of a gamble when it comes to art because in addition to taking into account the business side of things, one also has to take into account the artistic process. Since art and business rarely mesh well, conflict is often part of the process. Yet, one can count on a certain number of variables if one wants to manufacture a bestseller. How those variables play out in the context of art and business is what I will cover now.

There are two ways of creating a bestseller. The first approach is to give people exactly what they want. The second approach is to create exactly what you, the artist, want to create and then let your audience decide if they like it or not. The first approach is focused on the audience. The second is focused on the artist. I have used both approaches, in the order that I just mentioned here, therefore I am qualified to talk about both from an informed perspective. I have also created bestsellers with both approaches combined.

Let's start with the first approach, creating exactly what the audience wants. The first issue here is finding out what the audience wants. Clearly, to find that out, you must know who your audience is. This demonstrates, once again, that you have to have an audience and you have to know who this audience is. This is the approach I followed when I sold my work at Grand Canyon National Park from 1997 to 2002. For five years I not only tried to create bestsellers for Grand Canyon visitors, I also tried to outdo my previous bestsellers so I could reach an ever-higher sales success.

I knew who my audience was. It was visitors to Grand Canyon National Park, people who loved the canyon, who saw it from the rim, or hiked its trails, or both. It was people who wanted to bring back a souvenir from their visit to the Canyon. People who preferred to bring back a fine art photograph rather than, or in addition to, a t-shirt, postcard, or other mass-produced item.

I also knew what they wanted. If they had looked at the Canyon from the rim, what they wanted were views they had seen from the overlooks where they had been during their visit. If they hiked the trails, what they wanted were views either of or from the trails they hiked.

I knew that the bestsellers would be photographs of the most popular overlooks and trails. It would be the overlooks seen by the largest number of visitors and the trails hiked by the largest number of backpackers. My

job was cut out for me. All I had to do was get to work and photograph these places in the manner that would be most appropriate. What would that manner be? Here too the answer lay in looking at the problem from the perspective of my audience: the manner most appropriate would be to show these locations as my audience experienced them. In the end, what mattered was that they saw in my photographs what they had seen themselves, and felt what they had felt themselves. What mattered most was that I could achieve a representation of what their experience of the Canyon had been. If I could do that (and do it well), I would have a bestseller.

That is exactly what I did the first year I sold my work at the Grand Canyon. Over the next four years I assembled a collection of images that featured the most popular trails and overlooks, and because this collection met the needs of my audience, financial success followed. In other words, I gave to the audience exactly what they wanted.

Now, let's talk about approach number two and how this approach differs from the first. This second approach, as I mentioned before, consists of creating exactly what you want to create and then letting your audience decide whether or not they like it. While the first approach is focused on the audience, this approach is focused on the artist. In this approach the artist creates work focusing on his inspiration, vision, and personal style rather than on what his audience might desire. This is the approach I follow today. Why did I change? Essentially because I got bored with the approach I described previously. For a while it was fun to try to create images for the purpose of seeing how well I could meet the audience's needs, but after doing that for a while, and after being successful at it, I realized the further I went with that approach, the further I also moved away from doing what I really wanted to do. For example, if I photographed a little-known location, the chances of those images selling well were small because my audience was not familiar with it. Similarly, if I enhanced or modified a photograph too much, for example if I altered the contrast, color palette, color balance, or other artistic variables, my sales would also suffer because the image no longer closely matched the scenery that my audience had seen during their visit.

In other words, following the first approach, which is giving the audience exactly what they want, meant walking away from doing the kinds of images I wanted to create. It also meant creating images that were fairly close to reality, images in which the contents of the photograph closely followed the contents of the natural scene I had photographed. As I began using more and more image enhancements, modifications of color, contrast, stitching, and other techniques to affect the composition of my images, this requirement was met less and less.

The issue was significant, and for some time I was not sure how to solve it. Telling people that my work was about enhancements and modifications to the image in order to express what I felt rather than what was there did not necessarily do it. People wanted images that represented what they had seen, which meant they wanted to purchase images that were fairly close to reality.

In the end, the solution was for me to change audiences, something that was achieved by no longer selling my work at the Grand Canyon. Although this change took place against my will when Grand Canyon National Park changed their policy and would

no longer allow artists to sell their work in the park, I later realized that it helped my career in many ways since I may not have quit the show on my own accord.

When asked where figure 13-4 was taken, I always answer "On the Playa in Death Valley National Park". The next comment I usually get is, "There wasn't that much water when I was there!" or "Where is the playa?" Both of these questions point to the fact that this image is less about Death Valley than about my artistic inspiration. The Playa is a huge area that basically includes the entire bottom of Death Valley, which is the entire flat, dry lakebed area that composes most of the Valley. In other words, this image could have been taken from many places in the Valley, and it would be very challenging to direct someone to precisely where it was taken. In fact, I myself have had a hard time going back there since I usually can't remember exactly where I was (today with the advent of global positioning software (GPS) that problem would be solved).

There is much more water in the picture than there usually is in Death Valley. In fact, there is hardly any water in Death Valley, which is why it is called Death Valley! People have died there because it is such a hot, dry, unwelcoming environment. And yet this image is all about water, blue sky, and fluffy clouds. It is clearly meant as an interpretation of the scene and not as a literal representation. Clearly, my goal was not to show the valley in a stereotypical fashion, as a dried-out landscape with sparse vegetation and blazing sunlight.

When I created this image, my vision was quite different. I thought of the poem by Robert Frost, *The Path Less Traveled*, and as I worked I tried to compose an image in which two small

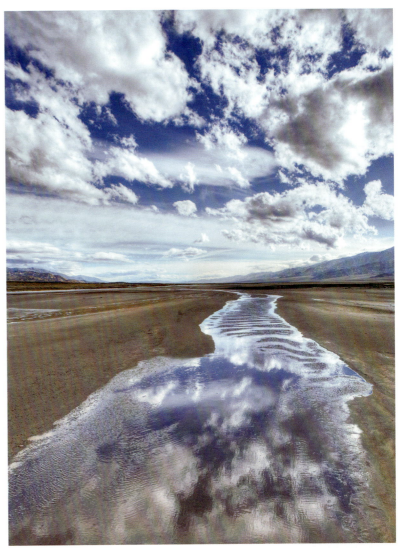

Figure 13-4: *Playa Reflections* – Death Valley National Park

"rivers" merged together offering a metaphorical version of a path made of water. In the end, that approach didn't work and I created this image which shows a single path, metaphorically speaking, in which the cloudy sky is reflected in the water. I see it as a path toward an unknown, but welcoming, destination. I also see it as a merging of the sky and earth—a sort of symbiosis. I'm sure other interpretations that are just as interesting are possible.

Start a Discussion with Your Audience

Every image he sees, every photograph he takes, becomes in a sense a self-portrait. The portrait is made more meaningful by intimacy—an intimacy shared not only by the photographer with his subject but by the audience.

<div align="right">DOROTHEA LANGE</div>

There is a good reason why the necessity of having an audience is upsetting to beginning photographers: finding an audience is difficult. So difficult, that some artists never find an adequate audience and have to live with an audience that is either very small, adverse, or not in a position to purchase their work.

Van Gogh, to take but one example, never found an adequate audience. While he did have an audience, it was very small. His brother, Theo, was his main audience. While living in southern France, at the end of his life, a couple of collectors either purchased his work or traded goods or services for his paintings. In the end, his work never generated the response which I believe all artists seek. Van Gogh's response was essentially coming from his brother. He never had a major show of his work and he did not live to see his work fetch unbelievable of prices. In fact, it took another generation before that was to happen. Of course, as we all know, when the response to Van Gogh's work came about, it took the world by storm, and today just about everyone has something to say about his work. Van Gogh has become a household name and his audience is enormous.

That is an extreme example and few artists find themselves in such a situation. However, it demonstrates the difficulty of finding an audience, of generating a response to one's work, and of starting a conversation about this work. These things are far from being easy, and for some it may never happen. This can be for diverse reasons. It may be because, like Van Gogh, one's work is misunderstood and perhaps far ahead of its time. It may be because the work doesn't attract a buying audience and that without an income the artist is unable to continue. It may be because the work is not palatable to any given audience, or that it goes against the grain and is unwelcome in the society as a whole. Or as I think is often the case, it may be because the effort to reach a particular audience was not made. It may be that too many artists are responsible for not seeking to start a discussion nor to seek a response. Notice that I didn't say "want a response", because I think all artists want a response. I said, "seek a response", because too many artists believe that the response will come without having to do anything. Unfortunately, such is not the case. One has to seek a response, and to do that one has to place their work before an audience that is likely to be interested in their work.

How to Find an Audience

A lot of my audience are in their 50s. But they want me to pretend to continue to be pretending.

<div align="right">PETE TOWNSHEND</div>

I am often asked, after making the points I am making in this chapter, how one actually finds an audience. The process is simple: you show your work and by showing your work you find your audience. Let me explain.

As you show your work you define both your subject and your approach. One cannot photograph everything, and successful shows are rarely, if ever, about photographs that do not

fit into a category, or are not about a specific subject, approach, or project. In other words, a show is about a subject, or an approach, and ideally follows the completion of a specific project. Going over what a project consists of is beyond the scope of this book, but I do cover the subject in my other writings, as well as in my tutorials and during my workshops (see my website for more information).

The title you give to your show is important, as is the venue at which your show is held. Since I am not trying to be specific about subject matter, approach, and style, we are talking about a very wide range of locations and venues, all the way from a street fair to a well known gallery or museum. It also includes printed publications, such as books and magazines, as well as electronic publications, such as websites and electronic documents (PDFs or digital books for example).

The subject of your show, the venue where your show is held, the promotion that is done to advertise this show, as well as any other variables related to this show will attract a specific audience. For example, if your show is held in a gallery, it will attract the audience that frequents this gallery and that regularly attends openings.

Another way to explain this is to say that in order to find an audience you will have to participate in the ongoing discourse about art by showing your work and by having people look at it, comment on it, and if you are selling it, by buying or not buying it. There simply is no other way to reach an audience. The choice you have is in the venues you choose to show your work, but the fact remains that you have to show your work somewhere. You can't expect people to show up at your door and ask to see the contents of your print file!

In a sense, this does give validity, in a strange sort of way, to those who say that they do not need an audience. Keep your work to yourself, show it to no one, and if you do not need an audience you will find this situation most satisfying. On the other hand, if you find this situation unsatisfying, you do need an audience. If such is the case, displaying your work publicly by using one of the venues mentioned above is the way to go.

As I typed the location where I created this photograph (figure 13-5) I was thinking that it could have been taken anywhere. While the exact rocks depicted in it may be found along the San Juan River in Utah, similar rocks, or rocks just as colorful, can be found in many other locations.

All this to say that this image is not about the location. It is not about rocks either because it would not do too well as an illustration in a geology textbook for example. Yet my publisher chose this image for their 2009 Calendar. It is also very popular with collectors.

This image is about color and composition. It is the juxtaposition of the three shapes at the top and the contrast between these shapes and the shape of the rock below them. It is about the fact that all four rocks are of different colors. It is about how these four colors are in harmony, each reinforcing the visual presence of the other instead of clashing with them.

In the end this photograph is also about me. I could have walked by these rocks without seeing them, or without giving them the attention required to make a photograph. The fact that I preserved their visual appearance, on that day, along the San Juan is what eventually makes us look at them. It is not a photograph that one buys because one has been there. It is a photograph that one wants because of what it says.

Skills Enhancement Exercises

This chapter wouldn't be complete without a set of Skills Enhancement Exercises. I designed the following exercises with the aim of helping you to define your audience and to find an audience for your work.

Describe Your Ideal Audience

Describe the audience you would love to have, the audience for whom you create even though you don't know for sure if they will ever see your work or know about you. Describe the audience you believe would understand what you are saying and would be responsive to your message.

Describe a Specific Member of Your Audience

Describe a person (this may be a combination of several people you have met) who has the qualities and characteristics of your ideal audience. To offer an example among many possibilities, this could be a compilation of the following:

- Someone who understood your work but wasn't able to verbalize his understanding.
- Someone who could verbalize what they thought about your work but spent little time looking at it and lots of time talking about it.
- Someone who is a collector of your work and purchases from you regularly, however you haven't had a conversation with this person about your work.
- Someone who is knowledgeable about photography and understands your efforts perfectly yet doesn't buy your work or comment on it except in technical terms.

- Someone who talks to others about your work in a positive fashion, but his interest in your work stops there.

What Does Selling Out Mean to You?

In this chapter I talked about selling out. What do you consider selling out to be? What does an artist have to do to sell out? Describe what their actions and their work would be like if they, or you, sold out.

Your Bestsellers

Do you have bestsellers in your body of work? Or, can you imagine an image that you believe would become a bestseller if you created it?

In this exercise, describe the bestsellers you have, or the bestsellers you want to create. Be as specific as possible and include subject, location, light, time of day, image size, presentation, and any other variable you can think of. Finally, describe the audience that would purchase your bestseller.

Conclusion

As an artist, having and knowing your audience is important. In the beginning, you may be able to get away from having an audience. If you are not interested in sharing your work with others and if you photograph solely for yourself, this is indeed possible. Similarly, in the beginning, many photographers use a *found* audience rather than a *sought* audience. Colleagues, friends, and family are what I call a "found audience", and they are available because they are a part of your life. In other words, these people are willing to look at your work because they know you, not because they have a vested interest in photography.

Eventually, these solutions to the problem of audience fade away when you start to seek more promising venues for your work. If your goal is to show your work in a gallery, a museum, or an art show; or if your goal is to sell your work through a stock agency, in stores, or in other commercial venues, you will need to know who the audience is that goes to these specific places in order to find out if your work is well-suited for the location. If you overlook researching the audience of the venues at which you seek to show or sell your work, you'll face serious disappointment and you'll most likely fail in your attempt at having your work accepted at these venues.

When you show your work in a gallery, show, store, or other location, the audience of the location becomes your audience; therefore there better be a match between what that audience likes and expects to see in these venues and what your work consists of. If a match is not there, the audience will disregard your work, at best; and at worst, they will question why your work is there in the first place. That is, if the curator, store owner, show organizer, etc. has accepted your work to begin with. Since they know the audience that visits their venue, it is unlikely they would accept work unfit for their venue. If your work isn't a good fit, you would most likely be rejected and you may be left to wonder why: Not knowing who your audience is would be the reason.

Certainly, in a given venue there may be more than one type of audience present. For example, I met people at the Grand Canyon who were interested in purchasing photographs that were artistic rather than touristic. In fact, I made quite a few sales to members of that audience since, toward the end of my participation in the show, I showed work that addressed both audiences. But the fact

Figure 13-5: *Four River Rocks* – San Juan River, Utah

remains that the majority of the audience for a given location will fit into one particular category. While a few sales may be made to an artistically oriented audience in a touristic venue, the majority of that audience is looking for touristic photographs.

Ultimately, you need to go where your audience is. Not doing so will cost you, not only in terms of sales, but also in terms of your own development as an artist. In my case, selling in a touristic location made it very challenging to push forward with my artistic work. In the end, I had to face the fact that the problem wasn't with the audience as much as it was with my *choice* of audience. Once I accepted that fact, the solution was clearly to change the audience I was trying to reach, which was far easier than trying to change the audience's minds!

The Numbering Affair

All art is a vision penetrating the illusions of reality, and photography is one form of this vision and revelation.

ANSEL ADAMS.

Introduction

This chapter stems from my ongoing reflection on the subject of limited edition prints. To limit or not to limit, that is the question! This chapter also comes out of what I see as the increasing importance of the "limited edition debate", for lack of a better term (there's really no specific name for this debate which is mostly informal, though important at this time).

The clincher for me was the realization that at a time of constant technical improvements, limiting and consequently discontinuing new printings of an older image (and by implication eventually discontinuing landmark images) was preventing the creation of better and better prints of a given image.

Much thought is being given today to the issue of numbering prints. Photographers that decide to sell their work ponder endlessly whether or not to release their prints in limited editions. Such is the issue that worries many photographers today. It's worth mentioning that photographers that don't try to sell their work suffer no such quandary, because they simply print their work, wasting no time on how many prints of a single image they make. Instead, they concern themselves with print quality rather than with print quantity.

Truth be told (extend your hands in front of you, palms facing each other as you say this): numbering photographs is a marketing game. It serves no purpose in regard to the quality of a print. Instead, it is used to artificially increase the perceived value of a particular image while the photographer is alive.

The marketing principle goes like this: reducing the quantity by a measurable amount will allow the photographer to increase the perceived value, and thus the selling price, by a commensurate amount. In other words: the smaller the edition, the higher the price of each print in the edition. An edition of ten would allow each print to be priced higher than an edition of 100, which in turn would be priced higher than an edition of 1,000 and so on. The respective price of each print is set by the photographer, the gallery, or both. Pricing is no small task, and is often just as challenging as setting the number of an edition. However, pricing is a different issue that I will not debate here.

The question then becomes how large (or small) should a given edition be? The answer, for the most part, is in the photographer's expectations for upcoming sales. In other words, how many prints of a given image can a photographer expect to sell? 10? 100? 1,000? More? Smart marketing dictates that you need to find that number and set the edition just at this number or slightly above (in case you were pessimistic). You noticed I said "smart" marketing. I did so because it may, after consideration, not be so smart, which is an issue I will return to later in this chapter.

Manipulation and Art

This numbering scheme sounds manipulative, doesn't it? If it does, that's because it is. To prove it, let's back up a little. Why do we collect or purchase fine art photographs? Is it because they have a number on them (Ansel Adams prints don't have numbers), is it because we expect them to increase in value (many prints do not increase in value), or is it because we love the image? Truth be told (extend your hands forward again with palms facing), most people collect or purchase

Figure 14-1: *Bristlecone Pine and Snow*

images because they love them. And while the investment value might be a concern, few if any (at least collectors who intend to display their prints and not keep them in dark storage) purchase a photograph solely because it is limited in number.

This is not to say that the numbering approach doesn't generate extra sales, because it does. This is simply to say that loving the image, and enjoying the work of specific artists, is the number one reason collectors purchase prints. Numbering comes later in the selection process, after someone has decided that they love a specific photograph enough to purchase it. My belief is that once someone has decided to acquire a specific photograph, the presence (or absence) of numbering is the final element that closes the sale.

A Short History of Numbering in Photography

The fact is that numbering photographic prints is a fairly recent development. Some of the photographs that have become most valuable today were not numbered, but they are limited in number simply because the photographers stopped printing them, usually because they are deceased. Most of the biggest names in photography, such as Ansel Adams and Edward Weston, did not number their prints and only limited the edition number of portfolios. Adams actually said (I paraphrase), "Why limit the number of prints one can make from a medium that is, by nature, unlimited and in which each print of an image is potentially as good as all other prints?"

Alfred Stieglitz, who owned Gallery 291 in New York City and was influential in introducing photographers and artists to the American public, offering Ansel Adams his first show in New York City, said, "My ideal is to achieve the ability to produce numberless prints from each negative, prints all significantly alive, yet indistinguishably alike, and to be able to circulate them at a price not higher than that of a popular magazine, or even a daily paper. To gain that ability there has been no choice but to follow the road I have chosen".

I believe this quote needs some explaining. For one, Stieglitz endorses the no-numbering approach, in this way following (or influencing, as it may have been) Adams' position. Both believed that photography should be left to do what it does well, and that is produce limitless numbers of prints each of the same quality. The outcome was the possibility to offer a large number of prints for a low price per print.

Certainly, this approach means a large quantity of sales while at the same time retaining a high quality of printing. I personally find this endeavor very challenging. Of course, it all depends on what quantity we are talking about. In the case of Stieglitz, the quantity of prints of any given image is relatively small. Therefore, I believe that Stieglitz did endorse quality while refusing to number his prints. Adams followed the same approach. Even though Adams' prints were not numbered, his most popular images hardly exceed a quantity of 1,000 prints. Whether or not that is considered a large quantity depends on how you feel about the number, but we are talking here about a world-renowned artist printing his most famous images. I am sure we can all find examples of far larger editions of lesser-known images.

As I explained earlier, I believe that numbering is done for marketing purposes to artificially increase the value of a print while the

Figure 14-2: *To limit or not to limit?*

photographer is still alive. Why while he is still alive? Because after he has passed away, the edition is by nature limited to the number of prints made by the photographer during his lifetime. But things do not stop there.

I own an 8 x 10 Edward Weston print that was printed by his son Cole, which I purchased because I love it. This print, just like the prints made by Edward himself, is not numbered. In fact, I doubt that any print from a negative made by Edward Weston has ever been numbered. The value of this print at the time I purchased it was $3,000, while prints made by Edward himself were at least twice that for the least expensive, and many times more for the most expensive. These are respectable prices for 8 x 10 prints by Edward Weston, and this

shows that print value is not only (or not so much) controlled by numbering and artificial control of the number of prints made of a given image. In this instance, the value of a non-limited print done by the son of the photographer remained quite high despite the fact it was not printed by the original artist and was not numbered or limited in any way. This is due to the power of the image, the extraordinary quality of the print, the name of the photographer, and the recognition bequest upon him by the photographic and artistic community. That alone, to me and to many collectors, is enough to justify making a purchase. We don't need a number in the lower left hand corner of the print (or on the back as the case might be) to further motivate us to

purchase the image. In other words, who cares how many prints were made when they are as stunning and beautiful as this one?

The fact is that we know, maybe not explicitly but certainly implicitly, that photographic artists make relatively few fine art prints of individual images, because this is fine art photography and because artists have a difficult time selling their work. The art market is a rarefied market, one in which most artists sell just a few prints of any given image. Even the biggest names out there make fewer than a thousand prints of their most famous images. Very few exceed this number.

Art will be art—a field in which high numbers are not only uncommon but are nearly unheard of. Those who believe they must have a number on their print to show as evidence that the artist won't be printing tens of thousands of copies of a given image are not only uneducated in the nature of the art world, but they must be dreaming. Tens of thousands? I wish! It would be a very different business then.

At certain art shows, such as the one shown in figure 14-2 in Scottsdale, Arizona, artists are required to offer limited editions in order to be invited to the show. However, when sales are brisk, the number of various photographs for sale is high and the editions are relatively large. One can reasonably wonder whether these limited editions offer added value to the audience or not. Are the limited editions a guarantee of quality (or even quantity) or are the artists doing what is asked of them in order to join a potentially lucrative selling venue?

Of Quality and Quantity

The issue of quality versus quantity is central both to my own work and to my teaching. I practice what I teach, and I teach what I practice. I see no other way, not being prone to double standards. Life is just too short and having two different ways of doing any given thing is just too complicated. Plus, it's unethical and shows a lack of integrity. My first encounter with the issue of quantity took place when I started selling my work. My goal, little did I know, was to sell a print to everyone on the face of the earth. I know this sounds silly or delusional, but such was the case. The fact that I sold my work at the Grand Canyon, a location known worldwide and the destination of five million international visitors each year, actually made this goal not so outrageous. Regardless of the accuracy of my thinking, the fact is that I was well on my way to doing so when the workload nearly killed me. Did I make 1,000 copies of any given print? I may very well have. The fact is, I didn't count. My goal was to crank out as many prints as I could in the shortest amount of time—something that became a real challenge, as I could not keep up with the demand.

I realized my error early enough to correct the course of my career. I also realized that aiming for quantity was an exercise in frustration, one that would destroy my health and greatly reduce the value of my work. Most importantly, I realized I could not generate both quality and quantity—at least not without hiring employees and designing a system in which others would be responsible for many of the less critically creative tasks, which was something I wasn't willing to do. As a result, I became a proponent of quality work rather than quantity. This means that no shortcuts

are taken during any phase of the creation of the image, from conception, to capture, to processing, curating, matting, etc. My goal is not to save money or time in the process. Instead, my goal is to use the finest tools and supplies, and to take the time necessary to create the finest quality artwork possible, bar none.

By nature, this means reducing the number of prints, and because each print takes longer to make, there will be fewer prints made. Because more time is spent creating each print and more expensive equipment and supplies are used, the price of each print will be set higher and fewer people will be able to afford them. In marketing terms, in a quality-based model, the income is made from a few sales at a high price per sale. This marketing model is by its very nature limited and therfore doesn't need to feature limited editions in order to work. It is used widely in the fashion designer industry, for example. While I believe it might exist, I have never seen limited editions of dresses, purses, shoes, or other clothing.

Quality instead of quantity also dictates that the artist continuously seeks to create new images that further his vision. Therefore, instead of spending all his time in the studio, the artist needs to divide his time between fieldwork and studio work; between the printing of previous images and the creation of new images. Upon return to his studio, the artist needs to work on his new images. This approach forces a reduction in the number of prints made from any given image since the artist is placing his efforts as much on new prints as on previous prints. In fact, as is often the case, artists place more emphasis on newer work, focusing on printing their latest images rather than their previous images—an approach that further reduces the number of prints made from any given image.

Since this process automatically reduces the number of prints made from any given image, why further complicate things by numbering each image? Isn't this enough to guarantee that collectors will have collectible pieces? Here too we can see how numbering is a marketing decision rather than an artistic decision. (Nothing wrong here, mind you. Marketing is still legal in the United States.) However, and since we are talking business and not art, the question begs to be asked: does it work? More specifically: does numbering limited edition photographs result in more income for the photographer?

There is nothing that says it cannot work or that a higher income can be achieved. On the other hand, there is nothing, per se, that says it is the only marketing model by which photographers can receive higher prices for their work. In a quality versus quantity marketing approach, in which both seeking the finest quality (as I do) and numbering prints (as I don't do) are used, commanding higher than average prices for your work is important. It is important because, since you cannot realize your profit margins on a large number of sales, you must realize this profit on just a few sales.

The Problem

The limited edition approach in photography was defined at a time when chemical photography had reached its apex and before digital photography was introduced. At that time, which we could define as being from the late 1970s to the early 1990s, the limited edition marketing model worked great. In fact, it worked better and better as chemical

photography became more mainstream and better known, and was practiced by larger numbers of photographers. Why? Because the more photographers are out there competing to sell their work, the more the buying audience wants justification for the work. And numbering is that: a justification for the price and the quality of the work.

The argument goes like this: if it is limited it must be good. And if it is good it must be expensive. And if it is expensive it needs to be limited. And if it is limited it must good ... It is a circular argument, but circular arguments sometimes work, unfortunately.

The problem changed when digital was introduced. While chemical photography was stable, with few major changes taking place in regard to quality improvements, digital was (and still is) in a state of constant change at every technical level. Print permanence, color gamut, contrast control, paper choices, dynamic range, bit depth, and just about every other fundamental technical aspect of digital photography has changed dramatically since digital photography became a reality for photographers. Simply comparing a print made in the mid 1990s to a print made today will prove this point. Even comparing a print made in the early 21st century, say 2002, to a print made in 2009 will prove the point. In fact, comparing a print made last year to a print made this year may even prove this point. It all depends on how closely you want to look at the differences between prints.

Art collectors, and particularly fine art print collectors, look at the differences between prints very closely. They are meticulous in their study of a print. Most of them can recognize fine variations of tone and color that would elude more casual observers. Some of them carry a loupe. They know what makes

a good print, and they search for the finest prints. They look for prints that they can fall in love with because of the variations of color and tonality that are captured in the print, and because of the emotion that they feel when they look at the image.

Thanks to digital photography, bringing these fine variations of tone and color, and bringing the emotional content of a print to life is becoming something that photographers have more and more control over. Why? Because the technology, the tools, and the supplies are constantly being refined.

Painters do not face the same problems as photographers when it comes to guaranteeing the originality of their work. Each and every painting is an original. This can be easily verified by looking at the paint on the canvas. No possible mistake there.

However, there is no guarantee that a given painter will not paint the same subject, or the same composition, over and over again. Magritte is famous for doing so. He made no secret that he filled order after order of his most popular paintings. Each was an original, but each was also similar to the previous renditions of the same image. The brushstrokes may not have been the same, but the images were.

This brings up the question of where the quality of originality begins and ends. Does this originality reside in the medium or with the vision of the artist? Clearly, any piece can be reproduced time and time again, regardless of the medium. Certainly, a photograph is easier to reproduce than a painting since the photographic reproduction process can be automated while a painting requires manual work. However, the possibility is there with painting, even though it may entail more effort.

The Conflict

The fact is that any piece of art can be reproduced. Evidence of this is all around us and it is a universally accepted fact. Still, some artists who release a print today, and who hope for their image (as they should) to sell out quickly, do so in limited editions by setting a specific number for each image. How, in this situation, and provided that the print sells out (which is the goal after all) will these artists be able to take advantage of the constant improvements made to digital photography by printing a better version of their image in say, a year's time? Truth be told (extend your hands): they will not be able to offer a better print of this image because their edition is sold out and they have promised not to make any more prints of this image.

First problem, then conflict. *Problem* because the goal is to do quality rather than quantity. While the quantity may be there, through the numbered edition approach, the quality won't be there very long because of the constant improvements in digital technology. *Conflict* because while these artists want to guarantee the finest quality to their customers, they actually make it impossible to continue offering this finest quality since they have to stop printing an image not because they cannot print it any better, but because they came to the end of the edition. This has nothing to do with art. At this point marketing has taken over and art has been pushed aside.

Of course, every problem has a solution. Unfortunately, some of the solutions to this problem are not very elegant. One can, and many in fact do, release the same image in various sizes, thereby allowing themselves to start a new limited edition. The "edition by size" approach is widely used. Artists don't

Figure 14-3: *Natalie Briot and Michael Stoyanov* – Scottsdale Arizona

feel all that good about it and clients are suspicious of its validity. If an image is offered in, say, five different sizes, from 11 x 14 to 40 x 50, and if each size is offered in a limited edition of 100, is this edition still truly limited? And if a new size is created, say 18 x 24 instead of 16 x 20, because the 16 x 20 size

has sold out, is this an honest practice or is it just a way to continue offering a best selling photograph in a limited quantity? Finally, what if the 18 x 24 size sells out? Do you invent a new size and continue playing this game?

Good question. My answer is to just say no to limited editions. It will make your life simpler and you won't have to deal with questions that challenge your integrity. And above all, if you do digital photography, like I do and like most photographers do today, you really don't have another choice unless you sell a print every couple of years in which case you should either reevaluate your marketing skills or stop selling your work.

Certainly, you could argue that by setting a relatively high number of prints in an edition, larger than you can reasonably expect to sell, you keep open the possibility of improving the print quality as the technology improves while not selling out the edition. However, the problem I have with this approach is that it is a marketing model that is based on planned failure, not planned success. I believe it is much better to plan on being successful and to act accordingly.

The other problem with the planned failure approach is that limited editions are expected to sell out. That is the nature of limited editions. Limited editions generate interest because of the rarity of the work, therefore they need to sell out for the marketing model to work. If you offer limited editions and none of them are sold out, the purpose is defeated. What do you think of artists who offer limited edition prints that are constantly available and whose editions never sell out? If you are like me, you don't think very highly of them. Do you want to be one of them?

The Art Show Conundrum

An interesting aspect of the numbering conflict is presented by art shows that require artists to offer limited edition prints in order to be included in the show. This does not include all the shows offered in the United States, or in the world, but it does address a significant number of them. Most importantly, the shows that require artists to offer limited editions are usually high-end shows, meaning they have a higher level of reputation and clout.

The logic behind the requirement that all prints be released in limited editions in order to be sold at specific shows stems from the desire to prove to the audience that the artists in the show do not print limitless numbers of the same images. While this goal is certainly commendable, it does force artists who desire to enter these shows to number their prints since this is a sine qua non condition for being invited to these shows. Number your images and you will be considered for acceptance in the show. Do not number your images and you are automatically rejected, regardless of the actual quality and artistic value of your work, and regardless of your personal career path and achievements.

In other words, these shows have built a door through which artists must pass in order to be invited to display and sell their work. This door can only be opened with one key: offering limited edition prints. If you do not offer limited edition prints you will never pass through this door. This basically means artists who take the position I offer in this chapter cannot participate in these shows unless we decide to sell only portfolios, an approach that is certainly possible.

What are you to do if you desire selling at such shows? There is only one approach

possible: number your prints. Just keep in mind this is purely a marketing decision you must make in order to sell your work at these shows. In other words, in order to reach the audience these shows cater to, you must number your prints, which is purely a marketing decision.

To Limit or Not to Limit?

Taking into consideration all that has been discussed, what are you to do? My recommendation is to make a decision based on your beliefs on this subject as well as on your personal situation. If you want to participate in art shows that require artists to offer limited editions, the decision will be to offer limited editions. If you sell so many prints that you want to limit how many copies of one image you print, again the choice may also be to offer limited editions.

This is the position adopted by a number of contemporary artists such as Rodney Lough or Michael Kenna. They release their images in limited editions citing as their motivation their desire to not spend the rest of their lives printing the same image over and over again. This is certainly a valid reason to limit the size of an edition. The problem? It really only applies to a very small number of artists. Most photographers have the exact opposite problem, which is that they would love to print more copies of the same image but cannot find enough collectors to purchase their work.

Another possible approach is the "pricing based on sales" approach. Under this marketing model the price of a specific image goes up progressively as the image becomes more popular. If a piece becomes very popular, it ends up becoming very pricey. It is then up to

the buying audience to decide if they are willing to pay the premium for a specific piece, or if they would rather purchase a piece that is less popular but more reasonably priced. Under this model the edition size sort of takes care of itself since as the prices go up sales are expected to go down proportionally. Christopher Burkett uses this pricing approach for example. Often images sold under this approach will be divided in tiers, such as Tier 1, 2, 3, etc. Images are moved from one tier to the next according to how well they sell. The price of each image increases as they move from the lower to the higher tiers.

It may help to know that not all well-known and successful photographers, dead or alive, have offered, or currently offer, limited editions. In fact, many of them don't. I mentioned Ansel Adams and Edward Weston, certainly two of the most famous names in landscape photography. However, other landscape photographers, such as Charlie Cramer or Michael Reichmann, do not offer limited editions either. To help find out where you stand on this issue, I recommend that you compile your own list of photographers who do or don't release their photographs in limited editions. I also recommend that you include your favorite photographers in this list, as it will be more meaningful to you that way.

What I also recommend, keeping in tune with the ever-changing nature of the digital photography medium, is that you affix to the back of your prints a label stating, as is traditionally done, the title of the photograph and your personal information. I also recommend that this label details the relevant printing data for each specific image. This data can include the following: the printer brand, type and inkset used, the paper manufacturer and

type, any finishes applied to the print such as protective coatings, the type of profile or the rip + profile used, the version of Photoshop, or other imaging software used to prepare the master files, etc.

This list can be expanded and customized to fit your needs so as to include any and all information that you find relevant. What is important is that it does provide information about the materials, the hardware, and the software used to make the print as well as the date the print was done. Certain artists also include the print number, which is how many prints of this image were made at the time a specific print was done. This information is usually provided by saying that this print is "Number 17", for example, of this particular photograph.

This approach is different from releasing a limited edition because no limit is placed upon how many prints of a given image will be made. However, it does provide information about how many prints of a given image are out there. I also suggest that you make the total number of prints available to customers who request this information after making a purchase, since this numbering approach only informs the buyer about how many prints of a specific image exist at the time their order was placed. It does not provide information about the number of prints released afterwards.

Finally, if you do release a limited edition, for example of a portfolio, keep the number of pieces reasonable. This number will vary from one photographer to another, but small numbers are preferable in my view. Personally, I think that editions of 50 are a good number for editions of prints 16 x 20 matted size or so, and that smaller editions, of 25 or less, are preferable for larger pieces such as 20 x 30 and larger matted sizes. Creating very large

editions that may never sell out casts doubt on the validity of limited editions as a whole.

Figure 14-4 shows my current print label, which is affixed to each print sold, either on the mat backing board when the photograph is sold matted, or on both the backing board and the back of the frame when the photograph is sold framed. The technical information is typed individually for each photograph and changed as needed to reflect the exact technical information about each print.

Conclusion

The practice of numbering comes out of a static approach to photography, an approach in which the artist believes that he has made the best possible print from a specific image and will never be able to do any better. This no longer holds true today in a world where technical advances are made almost daily.

Numbering also results from an approach in which realizing a desired income today is more important than achieving the finest print quality tomorrow. While more somber in nature than the first reason, this is unfortunately also the case. Eventually, the artist's integrity and the artist's income suffer.

When I realized all of this about two years ago, I decided to stop numbering my prints. I now only number my portfolios, the way Adams did, because they are collections of prints and not single images. Portfolios represent a body of work that was completed at a specific date and time. Certainly, the quality of the prints in the portfolio can be improved as the technology changes. However, so far I have not re-released a portfolio in order to offer a new print quality and I have no plan of doing so. The portfolios remain the same,

each of them a testimony to the print quality that could be achieved at a particular date and time. However, the prints from portfolio images that are sold as single prints do benefit from the latest advances in printing and are continuously improved. These are not numbered. All prints, either in portfolios or not, come with a label similar to the one shown in figure 14-4.

I do number images that are limited by nature; for example, photographs that were painted upon or to which something was added after the print was completed, either with pencil, paint, gel, etc. These may be referred to as mixed media, although I am not so fond of this name. I refer to them as pieces that were completed with non-photographic means. I do very few of these at the time of this writing, but this may change in the future. These are usually produced as single pieces and therefore are numbered "1 of 1". They fall between paintings and photographs in this respect. I expect we will be seeing more of this type of work in the near future. Kim Weston for example is currently working on images that fall in this category. It may bring an interesting twist to the numbering issue as well as some interesting questions. If a work of art is unique, is there still a reason to number it? Is there a need to limit what is already limited or to make obviously unique what is already unique?

The renaissance of alternative printing processes also offers an opportunity to create work that is by nature limited. Platinum palladium printing for example, is a meticulous, lengthy, and expensive printing process. The resulting prints are beautiful, but the nature of the platinum palladium process means that these prints are limited in quantity. Why? Because this process cannot be automated the

Figure 14-4: *My Personal Label*

way inkjet printing can be automated. It is designed to yield one print at a time. Furthermore, each print will come out slightly different from the next, even when printed from the same negative.

What I am saying here is there are approaches that allow photographers to create unique works without having recourse to limited editions. These approaches, such as combining photography and painting or using alternate printing processes, for example, will result in a limited quantity of work because they cannot be automated.

How you approach this issue is a matter of personal choice. It does appear that there are few, if any, compelling reasons to limit how many prints of a given image you can make. To limit an edition is to prevent yourself from printing an improved image in the future, or to give yourself undue headaches, or both. Why take this route when collectors make purchasing decisions based on how much they like the image, and when digital technology is evolving so quickly as to virtually guarantee us the capability of creating better prints tomorrow?

Section E:

The Relationship Between the Technical and Artistic Aspects of Photography

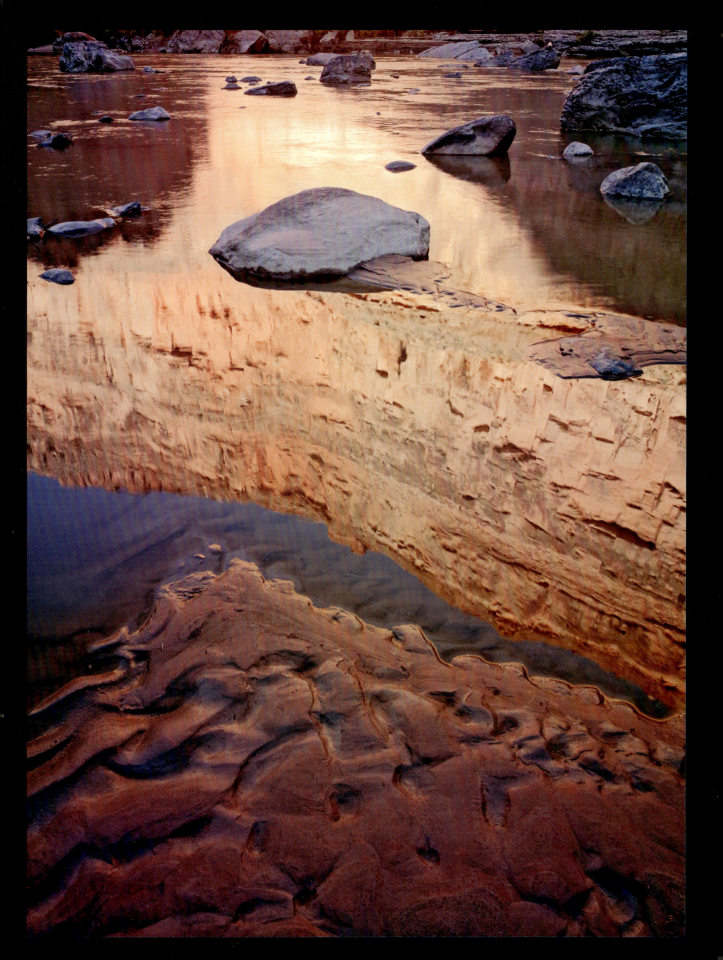

15 Technical and Creative Field Checklist for Fine Art Photography

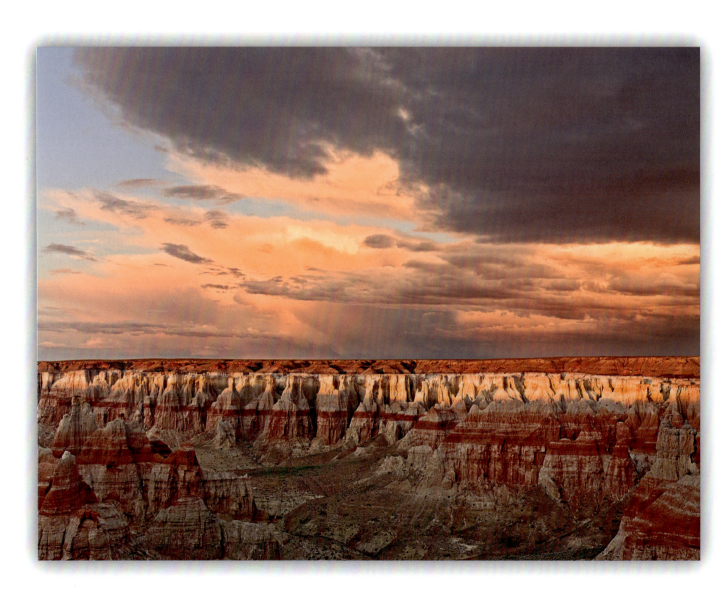

Introduction

Good plans shape good decisions. That's why good planning helps to make elusive dreams come true.
 LESTER ROBERT BITTEL

In art, having an organized plan is a challenging endeavor because the end product—the artwork—is unknown to the artist until it is complete. Much of the artistic process depends on inspiration, and inspiration is not prone to following a plan. The best laid plans in art often fail to work because inspiration does not show up, or because something more exciting happened that took our attention away, or because somehow things did not play out the way we expected.

The variables I just mentioned can turn ideas into confusion. At that time we need something to hold on to, something to guide us while we work. I find that one of the most useful things to keep in mind and to refer to while working in the field is a list of what we need to consider and to achieve. This list is the subject of this chapter.

A Few Notes about this Checklist

Before diving into the list itself I want to point out a few things that I find to be of particular importance regarding this list. First, the list is divided in two parts: technical and artistic. This is because fine art photography is both a technical and an artistic endeavor. For this reason we must divide our attention equally between these two aspects.

Second, the art list is longer than the technical list. I did not realize this until I was done writing the list. At first it surprised me, but upon reflection I realized that this is the way it should be. While I often say that ideally we should have a 50/50 spread between art and technique, in the end the art is where we should place most of our efforts.

Third, the technical list needs to be learned only once while the artistic list is the one you have to go back to each time you create a new image. In a way this stems directly from the second point above. The technical aspects of photography will not change. Once we learn how to choose f-stop, shutter speed, ISO settings, and so on, this knowledge will remain the same. Of course, certain technical aspects have been and will be improved upon, but for the most part the technical aspects are there to stay. The only time you would have to relearn these is when you use a new camera, and then it would be essentially at the level of finding out where these controls are on your new camera and what has been improved.

On the other hand, one needs to look at the artistic list over and over again because it features questions that can be asked forever. These questions can, and most likely will, have different answers each time you ask them. Also, these answers will change because we change as we go through life, as we experience different things, and as we get older. In turn, the way we view the world and the way we represent the world in our photographs and in our art changes.

Fourth, your personal style is largely defined by your answers to the questions on this list. It is also defined by what you like and dislike. In other words, how you use this list will have a direct effect upon your personal style. Defining a personal style is making choices, and this list is about making specific choices in specific situations.

Fifth, this checklist is your "blueprint" to the studio work you will do after your

Figure 15-1: *Mesa Sunset*

fieldwork has been completed. In other words, you can use this checklist to think about how you will perform RAW conversion, image optimization, and printing when you return to your studio. This list is therefore the first step towards achieving a print that expresses what you saw and felt in the field when you took the photograph.

Sixth, this list allows us to talk about photography both from a technical and from an artistic perspective. Too often, photography is approached uniquely as a technique and photographers often talk about their work only in technical terms. This list allows you to talk about photography both as a technique and as an art form.

Field Checklist

Technical Aspects

1. **Just Say No to JPEGs**
 - Shoot in RAW format; not JPEGs
 - All DSLRs shoot in RAW format. JPEGs are the result of in-camera conversion.
 - When saving in JPEG mode the camera does not save the RAW file (unless set to save both JPEG + RAW)
 - It is best to make your own conversions
 - Shooting RAW and processing your own conversion means you'll have access to the original RAW file in the future

2. **Select an Adequate ISO Setting**
 - High ISO mean high noise in your photographs
 - You cannot change ISO after taking the photograph
 - Tripod: use 50 or 100 ISO to minimize noise

 - Handheld: use ISO to get the desired shutter speed and f-stop
 - Tripod: set your camera to shutter speed priority so that the aperture stays constant
 - Handheld: set your camera to aperture priority so that the aperture stays constant
 - Your slowest shutter speed should be equal to the focal length used
 - ISO settings affect the RAW file

3. **Level and Secure Your Tripod**
 - Tripod is stable and legs are extended evenly
 - Horizon is level in photograph
 - With slow shutter speeds, wait a couple of seconds before releasing the shutter to let tripod vibrations stop
 - Blurred images cannot be corrected in postprocessing
 - Make sure you have a quick release plate for your tripod on all your cameras

4. **Focus Carefully**
 - Consider both auto focus and manual focus
 - With auto focus lenses, turn on manual focus
 - Focus cannot be corrected in post processing

5. **Choose Your Shutter Speed Wisely**
 - Low shutter speeds are no problem when using a tripod
 - Tripod shutter speed can be anywhere from 1/30 to several seconds or minutes
 - Make sure you use mirror lockup to avoid vibrations
 - High shutter speeds are necessary when shooting handheld

- Handheld shutter speed can be anywhere from 1/30 to as fast as you want
- The rule of thumb when handholding is to use a shutter speed equal to the focal length of your lens

6. **Select Proper F-Stop**
 - F-stop settings define depth of field
 - The larger the number, the larger the depth of field
 - Check the f-stop and the focusing distance for each photograph
 - Focus manually to set the hyperfocal distance
 - Hyperfocal distance is halfway between closest and farthest object in the scene
 - Use a large f-stop (16, 22, etc.) when using the hyperfocal distance
 - The best quality is usually found at the mid f-stop point such as f8 (depends on the lens)
 - Use f8 if you do not need depth of field
 - Use wide f-stops (f2.8, etc.) if you are shooting handheld in low light and need a fast shutter speed
 - Depth of field cannot be corrected in post processing except by blending images

7. **For Near-Far Compositions Use the Hyperfocal Focusing Distance**
 - Works best with wide angles from 35 mm to 14 mm or wider
 - Focus on the portion of the composition that is 1/3 from the bottom of the viewfinder
 - You may have to set your camera to manual focusing
 - Set the f-stop to f16, f22, or smaller aperture depending on your lens

- At a small aperture such as f22, 1/3 of the distance in front of your focusing point and 2/3 beyond will be sharp
- Use the depth of field preview button if there is one on your camera or lens

8. **Expose Correctly**
 - Check the histogram for each new composition or change of light
 - In case of doubt about the proper exposure: bracket (3 or if necessary 5 images)
 - Exposure affects the RAW file
 - Clipped areas cannot be recovered in the studio except by blending exposures

9. **Watch Your Histogram Like a Hawk**
 - Your histogram tells you how your photograph was exposed
 - You cannot change the exposure after taking the photograph

10. **Know What a Good Histogram Looks Like**
 - Set your camera to display the tri-color histogram (RGB)
 - Single channel histograms do not tell you if one of the three colors is clipped
 - Shadows are on the left side; highlights are on the right side
 - Ideally, you want no clipping on either the right or left side
 - If you have to clip somewhere, it is better clip the shadows than the highlights
 - If you want detail everywhere in a clipped histogram, bracket your exposures then merge them together through HDR (5 or 3 bracketed exposures)
 - Keep in mind that in-camera histograms are generated from a small JPEG

- You most likely will have more information than is shown in the RAW file, however play it safe by not clipping the in-camera histogram

11. **Create a High Dynamic Range (HDR) Image**
 - Do you like HDR?
 - Does the dynamic range require HDR?
 - Or can you have all the details you want in a single capture?
 - Check if your histogram is clipped on the right, the left, or both

12. **Select Proper Shutter Speed**
 - For slow shutter speeds on tripod use mirror lock up
 - Know how to set camera on mirror lockup (menu item)
 - For handheld select a speed equal to the lens focal length or faster

13. **Use All Your Lenses**
 - Carry a full range of focal lengths in your bag at all times
 - Your lenses don't do much good if they stay in your bag or at home!
 - There are three main categories of lenses: wide angle, normal, and telephoto
 - Consider all your lenses as possibilities for composing an image in any situation
 - Make it a habit to try seeing the same scene through normal, wide, and telephoto lenses
 - A good approach is to start with the wide angle then progressively go to longer and longer lenses, which will allow you to extract smaller scenes within the whole scene

- You can also follow the invert approach: start by isolating elements with telephoto lenses then progressively widen your field of view by moving toward normal and wide angle lenses
- Select your lens based on your desired composition

Artistic Aspects

1. **Basic Decisions to Make**
 - Do you want to photograph in color?
 - Do you want to photograph in black and white?
 - Do you want to photograph in color monochrome (sepia, blue, gold, etc.)?
 - Do you want to photograph in infrared (with modified digital camera)?

2. **Color Palette**
 - Consider the color palette desired
 - Consider the color palette present in the scene
 - Consider how color palette will be adjusted in the studio

3. **Color Saturation**
 - Do you want saturated colors?
 - Do you want unsaturated colors?
 - Consider how saturation will be adjusted in the studio

4. **Density**
 - How dark or light do you want the image to be?
 - Lighter than you see, as it is in front of you, or darker than you see it?
 - Consider how image density will be adjusted in the studio

5. **Contrast**
 - How much or how little contrast do you want?
 - Consider how contrast will be adjusted in the studio

6. **Hues**
 - How many hues do you want? Many, a few, or just one?
 - Consider how you will adjust, increase, or reduce hues in the studio

7. **Color Balance**
 - Which color balance settings are you going to use for this scene (daylight, shade, other preset, custom)?
 - Consider how you will adjust color balance in the studio
 - Color balance settings do not modify the RAW file

8. **Composition**
 - Consider which composition you are going to use
 - Remember that composition is not just the organization of objects in the frame
 - Color, hue, contrast, and light are all part of composition
 - Consider panoramas and stitched images as part of composition

9. **Shoot Through an Opening—A Window Within the Frame of the Image**
 - These "frame within a frame" type shots lead the eye into the photograph

10. **The Image**
 - What is your image about?
 - What do you want to say with your image when it is finished?

- Could you give it a name, a working title, as you take the photograph?
- Which questions are you trying to answer with this image?
- How personal is the image you are creating?
- Have you seen a similar photograph taken by another photographer before today?
- Or, is this the first time you see such an image, meaning it is totally original?
- Do you really want to take this photograph?
- Do you intend to print this image?

11. **Be Creative**
 - Try something you have not tried before
 - Break the rules you have followed so far
 - Combine several aspects of composition into a single image
 - Don't try to second-guess yourself; just take the photograph
 - Field work is creative time, not critical time
 - Critique your work later, in the studio, not in the field
 - Take a lot of photographs and sort them out later
 - Learn to perform the technical aspects quickly
 - Focus your efforts on the artistic aspects

12. **Have Fun**
 - Don't get overwhelmed by this list
 - Work on one part at a time
 - Set goals and deadlines for the completion of each part
 - Have fun!

16 Image Maladies

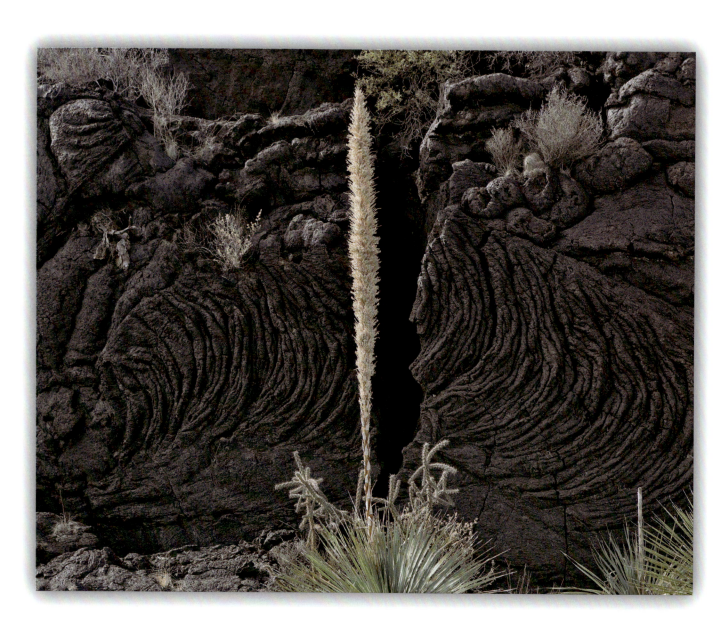

Introduction

In this book I approach composition as consisting of all the elements that have a visual effect on the image. This means we are not looking just at the arrangement of objects in the scene, or just at the traditional rules of composition. Instead we are also looking at color, contrast, cropping, edge treatment, and many other aspects of image making often disregarded by more traditional approaches to composition.

How these elements are handled by the photographer makes an enormous difference in the look of the final image. It also involves both technical and artistic knowledge, not just one or the other. If these elements are not handled properly, issues do arise. In effect, when an image is afflicted by one of the maladies mentioned in this chapter, the composition of this image suffers as well. The maladies outlined here are not simply technical issues. They are also artistic issues which affects how the image is perceived by your audience. I like to call these issues *maladies* rather than *problems*. Malady is a non-loaded term, meaning it has an open meaning instead of a directly negative connotation.

Maladies can also be diagnosed while problems often are here to stay. Finally, each malady I discuss has a remedy, something that points to a positive solution. I will be going over what I consider the most important image maladies. For each malady, I will offer a remedy. If applied as indicated, this remedy will cure the specific malady for which it was designed.

I compiled this list of image maladies while doing student print reviews. As I completed hundreds of print reviews, I noticed the same maladies came up regularly and students were unaware of them for the most part. This told me these maladies are not something the untrained eye can diagnose on the spot. Instead, one needs to know what to look for, and one needs to know what remedy to apply.

Heavily Cropping Images

This first malady affects images in which the main interest is lost within the framing of the image. In other words, the image shows far too much of the location. The photographer saw something, but the photographer did not get close enough to the subject, did not use the proper lens, or somehow failed to focus the image on the part instead of the whole.

In this first example, I was attracted by the backlit trees that were in front of the canyon wall. The wall was in the shade while the trees were receiving the last rays of the setting sun. It created depth and contrast as well as a significant difference of color saturation between the trees and the sandstone wall.

My first attempt was to photograph the entire rock formation with the trees in front of it (figure 16-2). However, I quickly realized that this diluted the interest of the image significantly. It was not clear which element was the most important.

Next I used a longer lens to simplify the image and reduce the elements in the image to the two trees in front of the sandstone wall (figure 16-3). This was better but still too complex. Again, it was not clear which element was the most important.

Finally, I used my longest lens, a 250 mm on my Hasselblad medium format camera (I was shooting with the P45 Phase One back attached to the Hasselblad) and simplified the image even further (figure 16-4). This time

Figure 16-1: *Yucca, Valley of Fires*

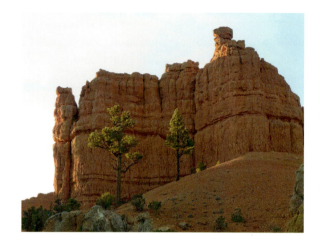

Figure 16-2:
Canyon Wall – 1

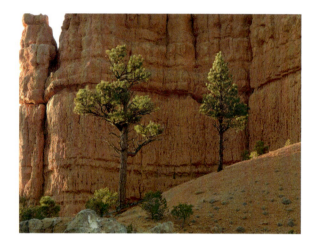

Figure 16-3:
Canyon Wall – 2

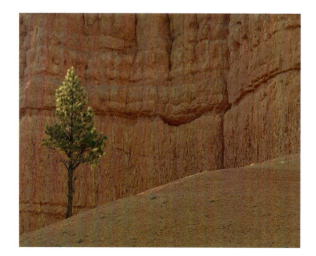

Figure 16-4:
Canyon Wall – 3

I showed only one tree along the sandstone wall. This image is the one that works the best for me. First, it is simplified to the extreme for this situation. I could not remove more elements without removing something essential to the image. Second, it allows for a powerful contrast of shapes between the tree, the sandstone wall, the curved hill at the base of the tree, and the S-curve line behind the tree on the wall. Finally, it gives the strongest sense of light quality difference between the open shade area that the majority of wall, hill, and tree are in, with just enough direct sunlight (backlight) to outline the shape of the tree and hill, and to separate them from the background.

This malady of showing too much of a scene is a typical case of seeing the forest instead of an individual tree that has a very unique characteristic. The remedy is to crop the image heavily. Sometimes, the image resolution makes cropping the image possible. Other times, the resolution is not high enough to do this. In that instance, the remedy is to return to the scene and reshoot the image.

Of course, the conditions may have changed, as in this next example, where the ice was melting while we photographed (figure 16-5). In this instance the resolution was not high enough to successfully crop the image. Fortunately, we noticed this malady while in the field by looking at the image on the LCD screen. The remedy was to walk closer to the center of interest and take a second photograph with a longer lens.

The first photograph shows the entire scene—the creek, the boulders, and the grass—very much as it would look to someone coming upon this landscape. However, something did attract the attention of the photographer, and this is the area marked in red at

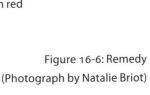

Figure 16-5: Malady with the cure indicated in red
(Photograph by Natalie Briot)

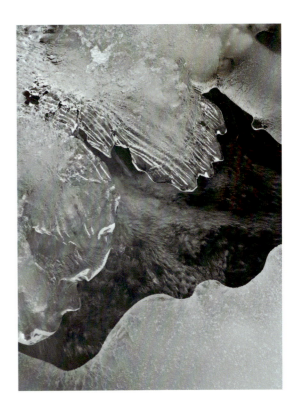

Figure 16-6: Remedy
(Photograph by Natalie Briot)

the center of the photograph. But this detail is lost within the surrounding landscape. In fact, it is safe to say that it is only visible to the photographer. This is a situation in which heavy cropping is necessary.

The second photograph shows the result of this heavy cropping (figure 16-6). However, in this instance cropping was done in the field, not in the studio. The photographer realized that this detail would be lost unless a much closer view was created. So the photographer walked closer to the detail they wanted to photograph, and created the second image.

Images Affected by Edge Maladies

Edges are very important in a fine art print. Unfortunately, edges are often given little importance by photographers. This is due to several factors. For one, many DSLR cameras show only part of the final frame. Some amateur camera models show as little as 80% of the image. Professional cameras show much more of the image, up to 97% or so. Still, they do not show 100% of the image captured by the camera. This means that the exact borders of the image may not be visible in your viewfinder. As a result, your image may suffer from edge maladies.

Another reason for this malady is simply due to not paying enough attention to the borders and corners of the image while

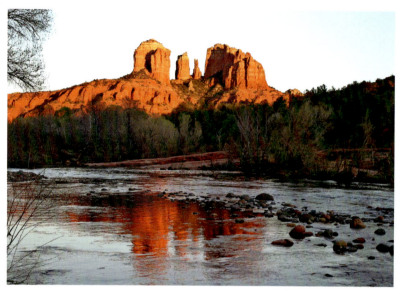

Figure 16-7: Malady

Figure 16-8: Remedy

shooting. This is particularly easy to do if you are not used to studying the entire image area. It is also easy to do when working with a camera that has a small viewfinder. Professional DSLRs, medium format, and large format cameras are much better in this regard because their viewfinders are much larger than amateur cameras.

If you cannot see the whole image while you are photographing, the remedy is to clean up the edges afterward in post processing.

In the next example, we see a tree popping out unexpectedly in the top left corner of the image (figure 16-7). This tree has no trunk, no main branches, and seems to be composed only of twigs floating up in the air at the top of the image. Of course, we know this is probably not true. We know the twigs we see in the photograph must be attached to a branch that is attached to a trunk that is rooted in the ground. Yet, if we just stick to the visual information in this image twigs are all we have.

In other words, there is not enough visual information about this tree to justify its presence. It is therefore best to crop it out, or clone over the twigs. In the case of this edge malady, the remedy I chose was to crop the image off, which successfully cleaned up the edges.

Another solution to prevent this malady is to include more of the tree. In figure 16-9 we have an example of edge malady prevention by including enough of a tree to make its presence a legitimate and important visual element of the photograph. Keep in mind that in an image all we have is what we can see. Therefore we must see enough of it!

Figure 16-9: Example of edge malady prevention

Globally Oversaturated Images

This third malady comes from the way the image was converted and processed, either in the RAW converter, in Photoshop, or in both. Saturation is the source of frequent image maladies. It is just too easy to add saturation in the attempt to create interest in a photograph.

The fact is that saturation is best used in moderation. Also, keep in mind that the saturation slider control goes two ways: more saturation *and* less saturation, which is just as important . Which way you use this control must be decided judiciously.

The remedy for a case of global oversaturation malady is simple. Just desaturate the image and the malady will be cured. Keep in mind that prevention is truly the best remedy. Therefore, careful use of the saturation level will prevent your images from developing this malady in the first place. Certain things are best used in moderation.

Locally Oversaturated Images

Local oversaturation can be the source of maladies just as much as global oversaturation. The remedy to local oversaturation is to use the selective color drop down menu in the saturation dialog box and saturate or desaturate colors individually instead of all at once.

Local oversaturation often affects the color of objects in the distance. In the landscape, objects and natural features located far from

Figure 16-10: Malady

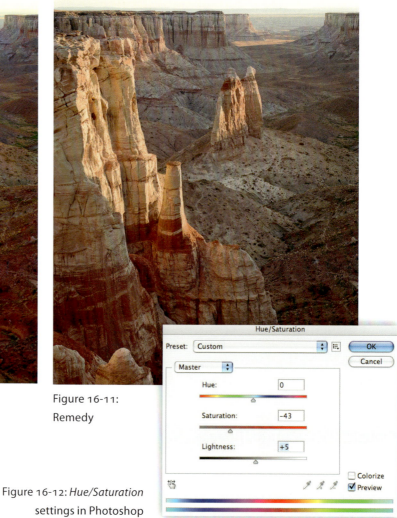

Figure 16-11:
Remedy

Figure 16-12: *Hue/Saturation*
settings in Photoshop

the viewer are less saturated than objects that are located close to the viewer. However, image processing software cannot tell which objects are close and which objects are distant. Therefore, all objects are saturated equally unless the photographer decides otherwise.

Distant shadows are a frequent cause of local oversaturation maladies. When global saturation is applied, all shadows go deep blue. While this is okay for the shadows of nearby objects, it is not okay for the shadows

of distant objects. These are expected to be less saturated because atmospheric haze, which is caused by particles in the air, reduces saturation further and further as the distance between the viewer and the object gets greater.

The solution is local desaturation of the blues. This is achieved by selecting *blues* in the saturation dialog box and desaturating them until they exhibit a believable saturation level.

Figure 16-13: Malady

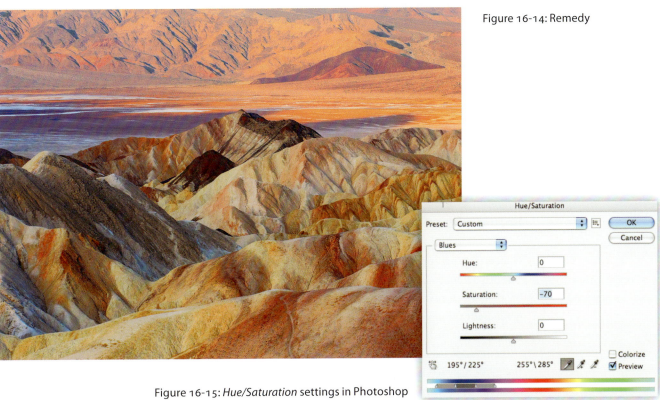

Figure 16-14: Remedy

Figure 16-15: *Hue/Saturation* settings in Photoshop

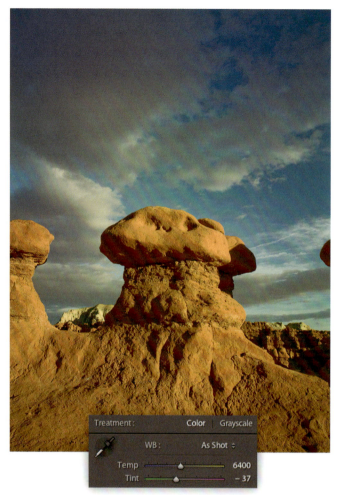

Figure 16-16: Global Color Cast – *Goblins Valley* Malady: Original setting in RAW converter

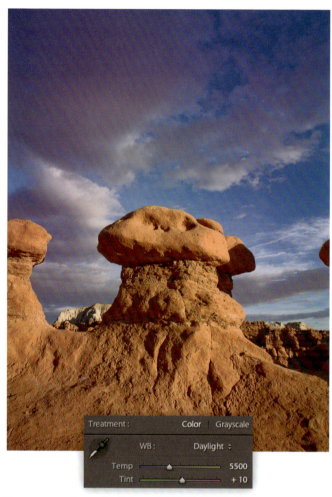

Figure 16-17: Remedy: Adjustment in RAW converter

Images with a Global Color Cast

Digital photographs often have a global color cast. This malady is caused by in-camera white balance settings that are not optimal for a given light temperature and lighting conditions.

The remedy is to correct the white balance in the RAW converter. It is imperative that this is done in the RAW converter and not after RAW

conversion. Why? Because in the RAW converter we are working on a single channel file and can therefore affect the color balance in the most efficient manner. After conversion, we are working on a tri-color file (red, green, and blue) and color balancing must be done on all three channels, which makes applying the remedy more difficult.

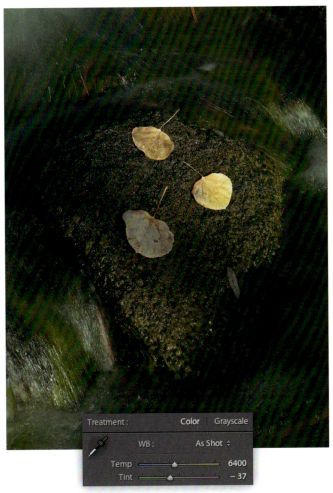

Figure 16-18: Global Color Cast – *Boulder Creek*
Malady: Original setting in RAW converter

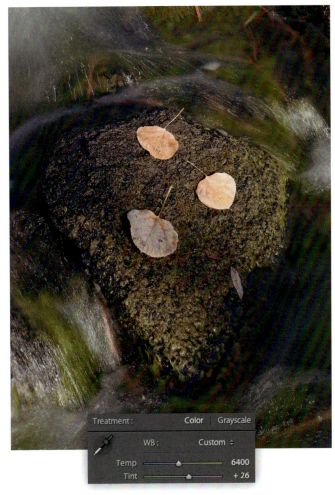

Figure 16-19: Remedy: Adjustment in RAW converter

Images with a Local Color Cast

Local color casts are as much a malady as global color casts. The remedy is different and also more complex. Since we cannot work on the image color as a whole, individual colors must be targeted in order to deliver the remedy.

As with many aspects of digital processing, there are several possible ways of doing this. One can use curves, for example, and remedy the problem by designing curves that target localized color areas of the image.

Another approach, which is the remedy I selected for figure 16-20, is to use the *Selective Color* tool in Photoshop. Selective Color allows you to work on specific colors by modifying

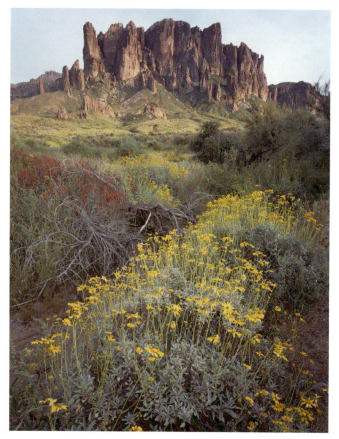

Figure 16-20: Malady

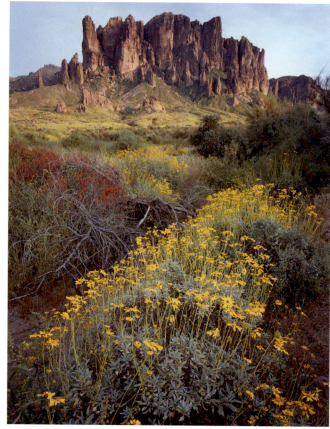

Figure 16-21: Remedy – Used *Selective Color* tool in Photoshop

the cyan, magenta, yellow, and black components of each color. Once you familiarize yourself with this approach, it becomes possible to remedy local color casts effectively by removing the opposite color in the color you want to correct.

For example, removing cyan from reds will make the reds more brilliant. Similarly, removing yellow from blues will make the blues more brilliant (and vice versa), and removing magenta from greens will make greens more brilliant (and vice versa also).

Spending time working with selective color will allow you to familiarize yourself with this effective remedy to local color casts.

Remedy Recipes Used in Photoshop

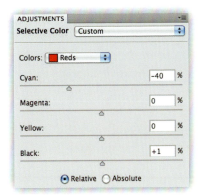

Figure 16-22: To correct color cast:
Adjust Reds

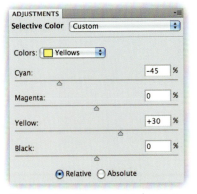

Figure 16-23: To correct color cast:
Adjust Yellows

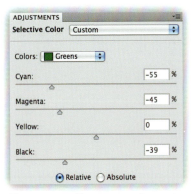

Figure 16-24: To correct color cast:
Adjust Greens

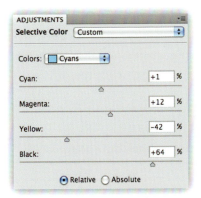

Figure 16-25: To correct color cast:
Adjust Cyans

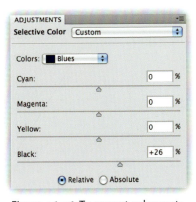

Figure 16-26: To correct color cast:
Adjust Blues

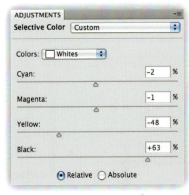

Figure 16-27: To correct color cast:
Adjust Whites

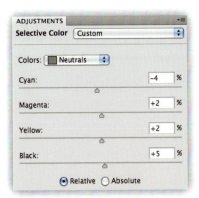

Figure 16-28: To correct color cast:
Adjust Neutrals

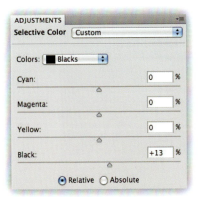

Figure 16-29: To correct color cast:
Adjust Blacks

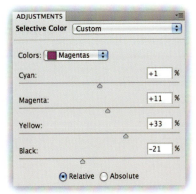

Figure 16-30: To correct color cast:
Adjust Magentas

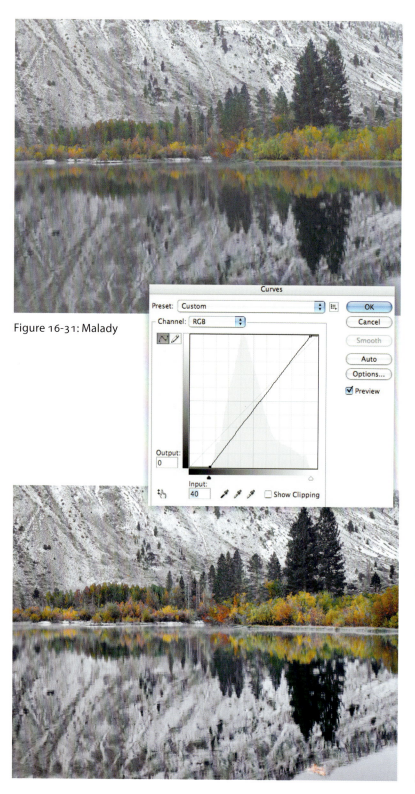

Figure 16-31: Malady

Figure 16-32: Remedy: Use of *Curves* adjustment in Photoshop

Images without Black and White Points

All photographic images have two crucial tone settings: the black and the white point settings. Unless you desire otherwise for matters of personal style, the black point should be set to 0, or very close to that, and the white point set to 256, or very close to that. If such is not the case, your image will look very dull. This malady is caused by not having a true black, or a true white, or both. The remedy is to apply a curve to the image through which you set the black and white points appropriately.

 To do this make sure you select the background layer of your image and open a new curve adjustment level in Photoshop. Then, hold down the option key (alt key on a PC) and drag the right triangle (located at the bottom right of the curve dialog box) to the left. The image will turn white. Drag the triangle slider until you see the first colors show up on the image and then stop. At that point release the slider. You have set a true white point for the image.

 Do the same for the black point by dragging this time the left triangle slider while pressing the option/alt key. The image will turn black. Drag the triangle slider until you see the first colors show up on the black screen. At that time release the slider. You have set a true black point for your image.

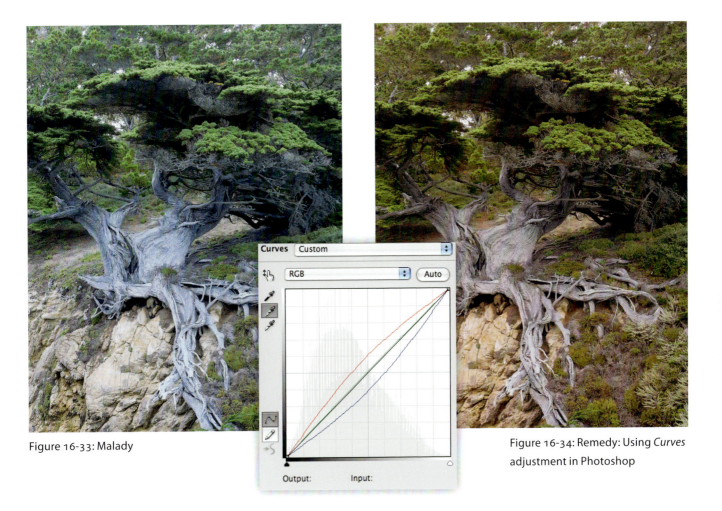

Figure 16-33: Malady

Figure 16-34: Remedy: Using *Curves* adjustment in Photoshop

Images without a Gray Point

After the black and white points, the gray point is often responsible for image maladies. This is because an image must be perfectly color balanced to exhibit maximum health status. We have previously color balanced the image in the RAW converter. Sometimes doing so will suffice in preventing gray point maladies. Unfortunately, at other times, another remedy is necessary.

Follow this approach to check the gray point healthiness of your image: open a new curve

adjustment layer in Photoshop and select the gray eyedropper (it's the one located between the white and black eyedropper in the dialog box). Double click on the option box and check that the red, green, and blue settings are all set to 128. This is halfway between 0 (black point) and 256 (white point) which means it is 100% medium gray.

Once this is done, move the gray eyedropper onto your image looking for a neutral area. This can be a neutral gray area, but it can also be a pure black or pure white area. It doesn't matter if this area is light or dark. All

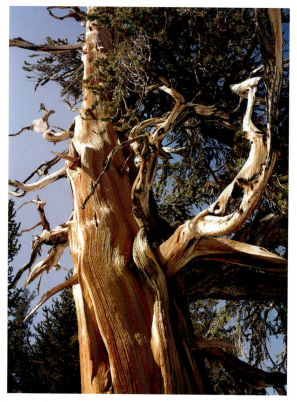

Figure 16-35: Malady

Figure 16-36: Diagnosis for clipped black points

that matters is that it is not supposed to have any color in it. Snow, dark shadows, dead tree trunks, and other neutral color areas work very well for this purpose.

When you have found such an area click on it with the eyedropper. If your image has a serious color cast (as in my example) you will see it immediately become gray balanced. If the change is significant, and if you have become accustomed to the color cast, it may take some time for you to accept this change as being better. This is because our eyes adjust to color casts to the point that we no longer are aware of them.

If you cannot find a neutral color area in your image, click anywhere in the image with the gray eyedropper then close the curve dialog box. Create this curve as an adjustment layer then go to the layer opacity control (at the top of the layers palette) and reduce the opacity of the curve layer until the image looks properly color balanced.

Either of these two remedies will work in curing the gray balance malady. The health of your image hinges on completing this step properly!

Figure 16-37: Diagnosis for clipped white points

Figure 16-38: Remedy:
Reconversion in Lightroom

Images with Clipped Black and White Points

Contrast maladies are the next item on our way to the perfect image. The most serious of these maladies are images with clipped black or white points, or both.

This malady is diagnosed by looking at the image curve. In Photoshop, simply pull up the curve dialog box, hold down the option key, and click alternatively on the black and the white triangles at the bottom left and right of the curve diagram. If the black and/or white points are clipped, colors will appear on the black and white screens. If no colors appear in the screens, that indicates neither the black nor the white points are clipped. If colors appear, the black, white, or both points are clipped.

When either the black or white points are clipped, details in the clipped areas are permanently lost. No amount of processing can create detail because there is no detail in the file. The remedy to this problem is to reconvert the photograph in Lightroom (or in the RAW processor of your choice) so that the image is not clipped.

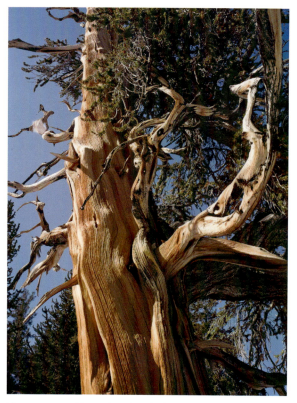

Figure 16-39: More pleasing, balanced image

Figure 16-40: Remedy verification in Photoshop: no more clipping

Images with Too Much Global Contrast

Images with too much contrast causes them to lose details in highlights, shadows, or both. Images that have too much contrast can still have a proper black and white point, making this malady different from the one we just saw.

The remedy is to apply a contrast reducing curve, such as the one shown in this example. This is typically an S-curve, meaning a curve that goes up in the shadow area and down in the highlight area. Moving a curve upward brightens the area targeted by the curve while moving a curve downward darkens the area targeted by the curve. However the best cure is prevention. Prevention in this case is avoiding converting an image in such a way that it exhibits excessive contrast. Doing so during RAW conversion is easy if you watch the histogram for your image and if you make sure that the highlight and shadow clipping indicators are turned on. This is differently in the many RAW converters available. In Lightroom, for example, it is done by clicking on the left and right triangles located at the top of the histogram window. Once these indicators are on, bright colors (usually red for highlights and purple for shadows) will show

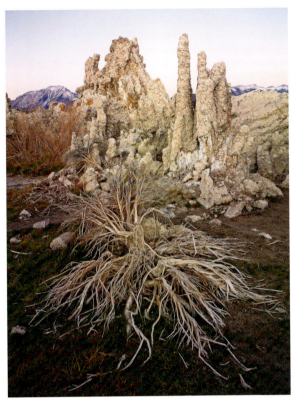

Figure 16-41: Malady

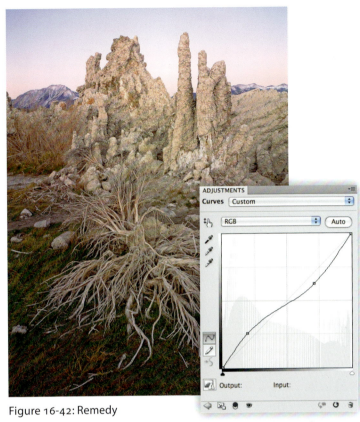

Figure 16-42: Remedy

Figure 16-43: *Custom Curves*
adjustment in Photoshop

up in your image if either your highlights or shadows are clipped. You can then brighten your shadows and/or reduce the brightness of your highlights as needed.

Clipping means that one or several of the colors in your image is going beyond the boundary of your color space. Color spaces are finite, and while some can hold more colors than others they all have a limit. Once a color goes beyond the limits of a color space and the image is converted, these colors as well as the details in the clipped areas are lost forever. You cannot recapture them except by reconverting the RAW image.

A preventive measure, designed to give you as much latitude as possible in preventing loss of color and detail, is to use a large color space during RAW conversion. I recommend using ProPhoto RGB, a very large color space that is available in just about every RAW converter. ProPhoto RGB will hold the colors captured by just about all digital cameras available today. Other smaller color spaces may not. There is no point spending a lot of money on a camera able to capture a large number of colors if you convert your images in a color space that cannot contain them!

Figure 16-44: Malady

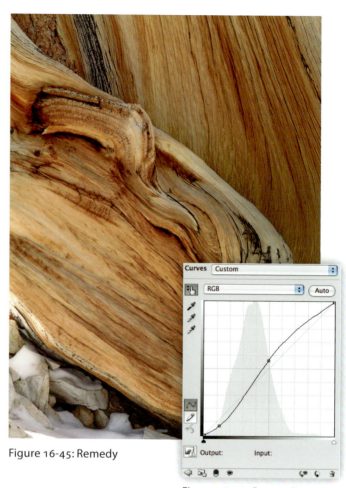

Figure 16-45: Remedy

Figure 16-46: *Custom Curves* adjustment in Photoshop

Images without Enough Global Contrast

Like an image that may have too much contrast, an image may not have enough contrast. This malady, which is the inverse of the previous one, is just as critical. The remedy is similar to the one described earlier. The only difference is that the S-curve goes down in the shadow area and up in the highlights area in order to increase contrast.

On both low and high contrast example images, the white and black points are set properly on the malady images. All the tones inbetween pure black and pure white are wrong. These are pale and need to be increased in contrast. Also notice how increasing contrast increases saturation. In all of the examples provided in this chapter, the only difference between the malady and the remedy images are the changes shown in the Photoshop or Lightroom dialog boxes. No other changes were made to the before and after examples.

Images with Too Much Local Contrast

This malady is characterized by an excess of contrast at a local level instead of a global level as we saw previously. This situation occurs frequently when two different types of light are present in the same composition. Usually, the two different types of light are direct light and shade. Having these two different lights in the same scene results in high contrast in specific areas of the image. While some areas are free of maladies, other areas suffer from excessive local contrast.

The remedy is local contrast reduction. Often, this malady is remedied through the creation of a complex contrast mask. However, there are two much faster and effective remedies: the first one is to use fill light or shadow recovery in the RAW converter. The second is to use the *Shadow/Highlight* function in Photoshop.

Too Much Local Contrast :
Reset black point

The black point correction in Photoshop is necessary because a high level of *Fill Light* in Lightroom weakens the blacks resulting in a conversion that does not have enough blacks. This correction can be done in Lightroom by adding black (see the **Blacks** slider in figure 16-48) but I prefer to do this in Photoshop with a *curves* adjustment layer because it is a far more accurate approach.

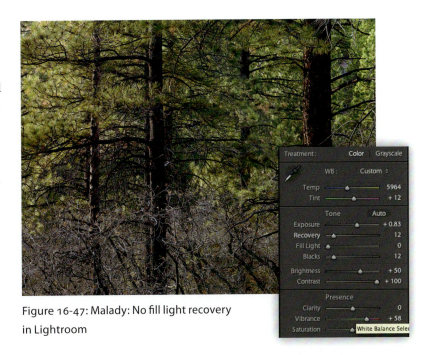

Figure 16-47: Malady: No fill light recovery in Lightroom

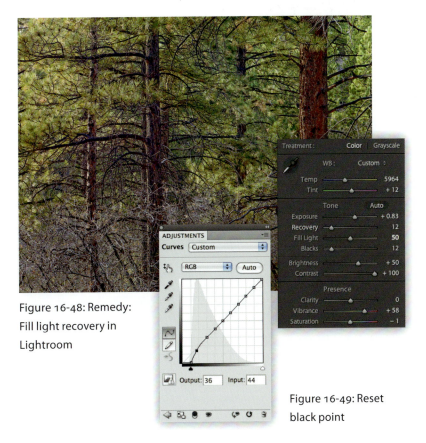

Figure 16-48: Remedy: Fill light recovery in Lightroom

Figure 16-49: Reset black point

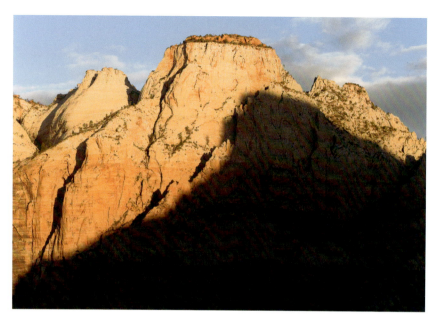

Figure 16-50: Malady

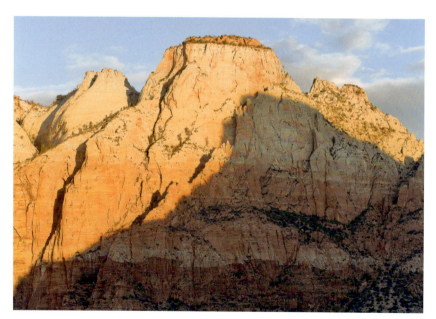

Figure 16-51: Remedy

Figure 16-52: Use of *Shadow/Highlight* tool in Photoshop

Too Much Local Contrast: Shadow/Highlight

The second remedy is to use *Shadow/Highlight* in Photoshop, which is what I did in this second example. Applying *Shadow/Highlight* with the settings shown on the dialog box is the only thing I did to this image. There are no other changes made to the image. The result is nothing short of astonishing. Details in the shadows, which would appear to be hopelessly lost, emerge as if a miracle took place. The result is an image whose composition is transformed. Instead of having a beautifully lit canyon wall (this is Zion National Park at sunrise) next to a huge, ugly shadow, we now have a beautifully lit canyon wall next to an open, glowing shadow. This shadow does retain the quality of a shadow (it is still dark) but because it is now much lighter than before, the details of the canyon wall are visible in the shadow area and this makes all the difference.

On the dialog box at the right, notice that only the shadows were altered. No adjustments were made to the highlights. Also notice in the *Adjustments* section at the bottom of the dialog box an amount of +50 was entered in the *Color Correction* slider. This color correction saturates the areas that are affected by *Shadow/Highlight*, giving color to the shadow areas. If an amount of 0 had been entered, the shadows would have been gray and desaturated. They would have looked dead. This is a very important point because without saturating the shadows the image would have developed another malady which is local lack of saturation. We certainly do not want to cure one malady while generating a new one!

Images Converted (or Saved) to a Small Color Space

The color space to which you convert your images is critical. For fine art images your images should be converted to a large color space and in 16-bit mode. An excellent color space, and the one I use for my work, is Pro-Photo RGB.

A large color space in 16-bit mode is necessary in order to hold the maximum possible amount of colors. Most digital cameras produce colors that exceed the colors that a small color space can contain. If you convert your images to a color space smaller than the color space of your camera you will lose some of the colors captured by your camera. Since you paid a good amount of money for a camera capable of capturing a large amount of colors, it makes little sense to not use a color space capable of displaying these colors.

Finally, most digital cameras capture colors in 10- or 12-bit mode. Therefore, you will also lose colors if you convert your RAW files in 8-bit mode. For these reasons you need to convert your RAW files to a large color space in 16-bit mode. Not doing so can cause loss of color as shown in the example below. You also want to save your conversions in a noncompressed format, or in a lossless compressed format. For this purpose saving images in PSD (Photoshop), TIFF, or DNG are the three best choices.

Finally, you want to make sure you have set your camera to save your photographs in RAW format and not in JPEG format. All digital cameras captures images in RAW mode. However, when you set it to save images as JPEGs it does an in-camera conversion to JPEGs, discards the RAW, and saves only the JPEG. The problem is that JPEGs are compressed images

Figure 16-53: Malady: Image converted to sRGB in 8-bit and saved in JPEG format. The black and white points are clipped because the color space is unable to hold all the colors captured by the camera.

Figure 16-54: Clipped black points

Figure 16-55: Clipped white points

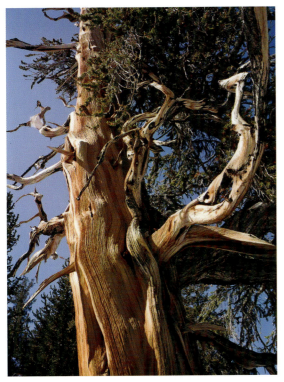

Figure 16-56: Remedy: the image was captured in RAW format, converted to ProPhoto RGB in 16-bit and saved as a TIFF file. The conversion settings used are the same as for the "malady" image.

Figure 16-57: Remedy verification in Photoshop: no more clipping

and are saved in sRGB color space, a very small color space designed primarily for the web, not for fine art images. Saving your original images in JPEG format almost guarantees that color and contrast information will be lost. It also gives you far less latitude in correcting the image color balance and exposure later on.

In the end, saving your photographs in JPEG instead of RAW format, or converting it to a color space smaller than your camera's color space, will result in colors being clipped in the highlights, shadows, or both. An example of this is seen in figures 16-53 through 16-57.

Image Density

Assessing the proper density of an image (density is the lightness or darkness level of a given image) is difficult. Doing so is best done by comparing one of your prints to a print by another photographer that has the right density, meaning this other print is neither too light nor too dark.

There are many remedies to an image that is too light or too dark since density adjustments can be applied in many ways in Photoshop and in RAW converters.

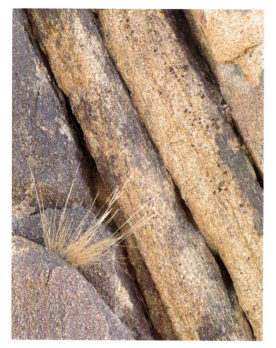

Figure 16-58: Malady:
too light

Figure 16-59: Correction using
Exposure adjustment in Photoshop

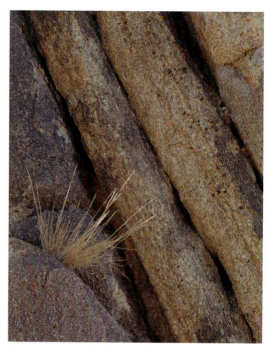

Figure 16-60: Malady:
too dark

Figure 16-61: Correction using
Exposure adjustment in Photoshop

For this example, I chose to use the *Exposure* adjustment layer in Photoshop because adjusting exposure most directly relates to adjusting the brightness or darkness of a photograph, either during image capture or during postprocessing.

However, other image adjustments are just as efficient. These include: curves, levels, brightness/contrast, and more.

Land and Sky

On one level, photographic images are metaphorical representations of the real world. As such they embody the metaphors we believe in and use in our everyday life.

In the Western world an important visual metaphor defines the relationship between land and sky. In the Western world view, the land is where we live and where we are buried.

Figure 16-62: Just right. Dark and light image maladies cured

The sky is where heaven is located and where our souls go after we die (according to this worldview). Following this metaphor, the sky is nearly always shown as brighter than the land in Western world landscape representations.

Whenever a photograph departs from this approach, by representing the land as brighter than the sky, it departs from this widely accepted belief and challenges the viewer's expectations. This is OK if such is your intent or if you do not subscribe to the Western world view for personal reasons. However, if this is an accidental outcome and you intend to follow the Western world view, then having the sky darker than the land becomes a malady.

Clearly, the remedy is to darken the land so that the "normal" order of things is restored. The simplest way of doing so is through a curve targeted to affect only the shadow areas. If this approach does not work, then a darkening curve followed by local masking of the areas you do not want to change is the second best option.

A Challenging Endeavor

Implementing these remedies in your work can be easy or it can take time. It will require that you make changes to your workflow and to your approach to composition and to image processing.

Change is difficult. And change that affects a process as personal as the creation of art is particularly hard. It's not harder than other types of change, but it is definitely not easy.

In the process of implementing change, certain attitudes will foster success while others will foster failure. I listed some of these attitudes below, focusing on those that I consider the most important.

- It is necessary to change your mindset, not just your tools
- It is necessary to learn that part of your goal is directing the eye of the viewer
- Learning how to create images free of maladies is a difficult endeavor
- It is going to be a lot of work
- Making a list of what you want to work on and following this list can be very helpful
- Keeping an open mind and having the desire to learn will allow you to progress faster

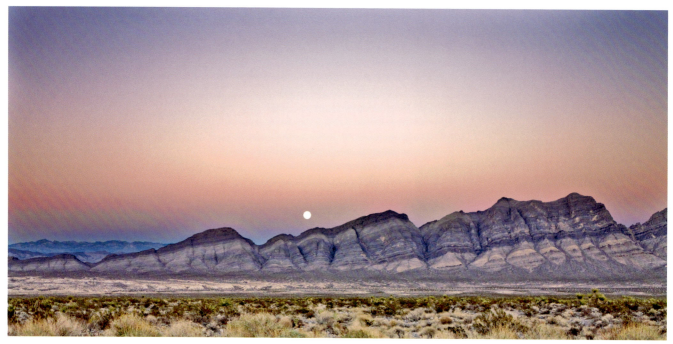

Figure 16-63: Malady: land lighter than the sky

Skills Enhancement Exercises

I like to include exercises, because there is nothing more effective than exercises in helping you learn the concepts described in these chapters. Below are two exercises designed specifically to help you in diagnosing and curing image maladies:

1. Find out (diagnose) which maladies your work is afflicted with. Once this is done, find out the appropriate remedies for these maladies and proceed to apply them to the afflicted photographs.
2. Make a selection of your best work among the photographs you took during the past year. Keep this selection at or below 25 images. Make sure all the images in your selection are free of maladies.

Conclusion

As we just saw there are many types of image maladies. In fact, there may be more than the ones I listed here, and if you find one significant enough to warrant being on this list please contact me and let me know about it. You can email your new image malady at *alain@beautiful-landscape.com*.

However, each of these maladies shares something in common: they all affect your images adversely. Similarly, the goal is the same with all of them: finding an appropriate remedy so they go away, once and for all. Your images will be all the better for that.

But why is it that we cannot prevent these maladies from happening in the first place? Why is it that we have no software to keep them from showing up? I think it is essentially

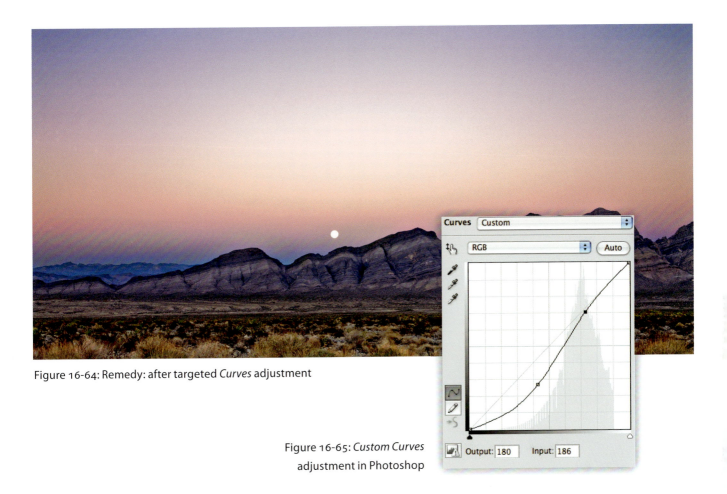

Figure 16-64: Remedy: after targeted *Curves* adjustment

Figure 16-65: *Custom Curves* adjustment in Photoshop

because of how hard it is to see these maladies. If you conducted the exercises above, and you found some of these maladies in your images and then applied the proper remedies, you most likely were surprised that you hadn't noticed these maladies in your images prior to reading this chapter.

The fact is that diagnosing what is right and what is wrong in an image is not intuitive. We were not born with that knowledge. Instead, we have to learn it. And learning it can only happen through practice; by learning to

diagnose image maladies and knowing which remedy to apply.

I use the words "malady" and "remedy", but you may call these image challenges by other terms of your choice. Personally, I like the words "malady" and "remedy" because they are memorable and positive. Clearly, other terms that work just as well are used commonly in the world of photography. All that matters is that you create images that are as good as they can be.

17 Memories of What I Have Seen

Introduction

Some photographers see the natural world as a gentle place best represented by soft pastel tones in slightly overexposed images with very low contrast and soft light. Other photographers see the natural world as place where drama unfolds, a place best represented by bold colors in deeply saturated images with high contrast and strong light. Personally, I see the world as being a multitude of visages and appearances. At times it is a gentle and kind place, best represented by soft, pastel, unsaturated tones, or even shades of gray. At other times it is a poignant place, best represented with high saturation, contrast, and colorful tones, or deep blacks and pure whites.

The fact is that, eventually, I do not photograph the world only as I see it. I also photograph the world as I feel it, as I experience it. This is why I perceive the world as having a multitude of appearances, moods, and feelings. The world may at times be soft and delicate, or at other times it may be bold and saturated. But whatever it is, I know what it is not: the world is never static, never the same. Instead, it is ever changing, ever able to surprise. It is the record of these surprises that make a photograph truly captivating.

I also feel indebted to my audience. To say that the natural world has one aspect and one aspect only, as some photographers do, is to limit how others—my audience—can approach this natural world and experience it for themselves. To create this artificial limit is to try to impose a vision exclusive of other visions. This is often done by saying that the photographer's images represent reality and have not been manipulated.

Reality?

I am always surprised when a photographer says they have a personal style and they reproduce the world "as it is". Why don't they see the contradiction in this statement? After all, how can one represent the world as it is and have a personal style at the same time? It is an either/or situation, isn't it?

There is a simple test to prove my point. Let's take ten amateur photographers, all with the same cameras, lenses, and tripods. Let's fly them all to the same location, say Monument Valley, and let's ask them to take one photograph from the same viewpoint at the same time. Finally, let's have the same lab print all ten photographs straight from the film or from the RAW files.

What result would we get? As you can surmise, we would have ten different photographs. The differences would include changes in framing and composition, color variations due to film, sensor type, white balance, etc.

Now let's take ten professional photographers, fly them all to the same location, have them take only one photograph, but this time let them use whatever gear they want, process their images any way they like, then print them any way they desire. The variations we would have when comparing the resulting prints would be far more significant than with the previous test, because more variables are allowed.

In short, in comparing the first and second test, what we see is that there is no way to get the same exact photo by two different photographers, let alone by ten, even when shooting the same thing with the same equipment at the same time and having the processing done by the same outside source.

Figure 17-1: *Bryce Canyon Arch*

What we also learn, is that when you look at the work of professional photographers, the differences from one photographer to the next are pushed much further apart. In fact, if we were to conduct a third test, this time by inviting the world's ten best landscape photographers, flying them all to Monument Valley, and having each take one photograph in whichever way they please, while staying at the same viewpoint, what we would have would be the greatest variation from image to image that we can ever have because now we not only have all the variables present in test number two, we also have the variables introduced by individuals who have a very well-defined personal style, a style developed and refined over a lifetime of practice, thinking, research, exhibitions, and sales of their work.

The more experienced one becomes in photography, the more one's personal style becomes refined, developed, and present in one's work, until the work of that one person becomes instantly recognizable by others, even when the name of the photographer is not mentioned.

If one accepts that the results of such a test are as I say they are, then it is not possible to claim that a single photographer's representation of the world is "exactly the way things are in nature". Why? Simply because it is now obvious that no two photographers ever get the same photograph of the same subject, even when they strive to represent this subject "as is". And of course, only some photographers have representing the world "as is" as their goal. Others, much more numerous in my estimation, have as a goal to interpret the world according to their vision and their personal style.

To me, this means that photography, when approached as an artistic medium, is able to represent not only what one sees but also what one feels. I will expand on this statement shortly, but first, I want to mention that the thinking I just outlined wasn't always mine. I also want to mention that for a long time the goal of my photographic attempts was to purely and simply duplicate the work of other photographers I admired, such as Ansel Adams or David Muench. I hesitate to give names, but I think it is important that I do. The question may be asked regarding "why those two?" Maybe because they are very popular and because their images are being disseminated worldwide, and because it was therefore logical for me to be in contact with their work. Maybe because there is something in their work that moves me. Maybe because I somehow bought into their style, thinking it was no style, thinking their work represented nature "as it really is". Maybe because I had to have influences, like we all do, because this is the way things are. Maybe because I had to have someone whose work I would come to know better than anyone else, hoping that someday I would go further, go beyond the images they created, go beyond the unimaginable.

Five Senses

Today I approach photography as an artistic medium through which I seek to express the entire scope of my feelings and emotions regarding the scenes I photograph. To me, the image captured from the camera is only a start. Why? Because the camera captures only what is visible, what is in front of the lens. My feelings however are much more than just what is visible in front of me. My feelings include the sound of birds and of the wind, the

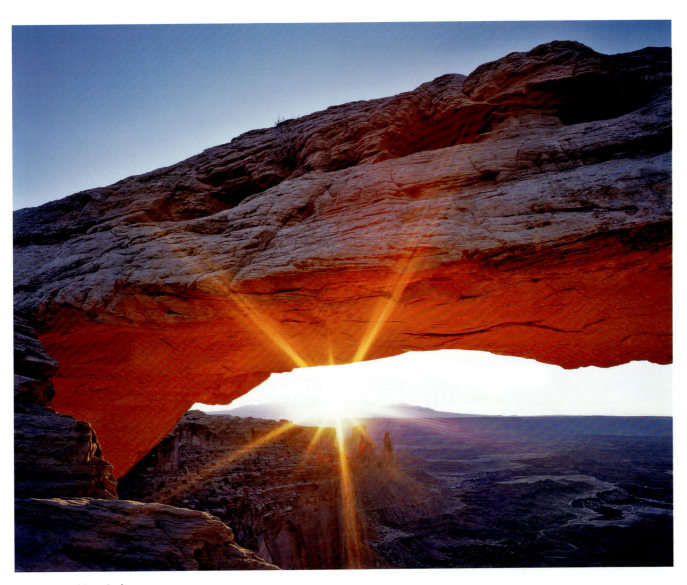

Figure 17-2: *Mesa Arch*

smell of pinion sap, the feeling of warm sandstone radiating the heat of the day as sunset draws near, the taste of sand in my mouth, the feeling of wilderness that a landscape barely touched by man evokes, and the emotions that overcome me to the point of feeling motivated to spend the countless hours necessary to create an image that evokes all of that.

But furthermore, and to question the validity of the camera as a recording device, these feelings include my *memories* of specific colors, colors that the camera rarely captures perfectly. The color of sage after a summer rain, loaded with humidity, darker and more brilliant than when dry. The color of sandstone in the open shade, slightly more saturated than in direct sun, and yet neither red nor yellow nor brown, but a subtle shade that is a combination of all three colors and more. The nearly black tone of a pinion pine trunk where the bark died but still clings to the tree, a subtle black retaining a shade of brown and a hint of gray, that unmistakable note that final decay—the step before bark turns to dust—has begun. The shade of blue of a crisp, fall evening sky, a deep blue that contains magenta and cyan in subtle proportions, with a touch of black for density. The clean white of a perfectly exposed cloud, right on the verge of being clipped, and yet safely contained within the density range of the scan or the RAW conversion, a white that may need to be cleaned up later to removes traces of black and cyan that dull its brilliance. The bright red of an Indian Paintbrush flower, so naturally saturated that its color is easily clipped, and yet delicate enough to hold traces of black that can be reinforced to give it the weight it deserves. The subtle gray-blue of Beavertail cactus needles, so brilliant that even in the open shade they come close to being overexposed, showing up as highlights in a closeup photograph, and yet not highlights in my perception and my memory of the scene.

Conclusion

How do I go about making the hundreds, if not thousands of choices that are necessary in order to reinterpret the scene so that the resulting print shows what I felt and remember and not just what the camera recorded? I have spent the last 20 years answering this question, studying all aspects of photography and practicing my craft. The answer, when technical and artistic matters are mastered, is eventually being able to *remember* how it felt to be there, being able to *remember* what the colors really looked like; what exact shade of green the sage was, what combination of red, yellow, and brown the sandstone was. In short, the answer is fundamentally within me. I know what the answer is. That part, though in itself not so simple, has, at this point in my life, become relatively easy. It is the process of translating what is in me onto the white sheet of paper that is difficult. It is how well this step is completed that makes all the difference. And in the end, it is how much and how well I *remember* that truly matters.

18 Conclusion

Art washes away from the soul the dust of everyday life.

PABLO PICASSO

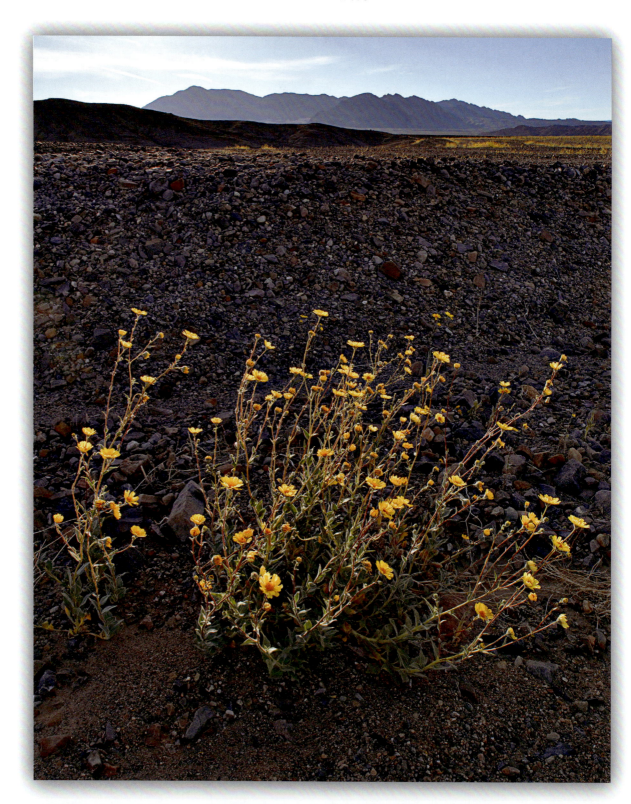

Art and Technique

Art is the most intense mode of individualism that the world has ever known.

OSCAR WILDE

We are now at the end of this book. It has been a long journey, but I believe a fun and an enlightening one as well. At this time I want to bring up some points that I find to be particularly important when looking at composition, personal style, and inspiration from a certain distance; both from the perspective of a practitioner and of an observer.

Fine art photography is a technique-hungry medium, a medium in which improving your technical skills will bring visible improvement to your work. However, one cannot make progress through technique alone. One must also address the other essential aspect of fine art photography, and that is the artistic aspect. This second aspect addresses you, the photographer, the artist, directly and personally. Why? Simply because while technique comes out of a set of learned skills, art comes out of your personality. Your artistic preferences define who you are, and in turn, they define your personal style. It is because we are all different, because we all have different preferences, that each of us has a personal style.

In the end, fine art photography is a combination of art and technique. I like to say that a masterpiece is an equal combination of both: the masterful use of technique to express a powerful message. The universality of this message—how well people from all walks of life can relate to it—defines how successful the work will be. Of course, commercial success or failure, as well as exposure, play a role in the success of a work of art. However, this is a matter of marketing, something that I am not looking at in this book, but do teach in other tutorials.

The Creative and Critical Modes

Great things are done by a series of small things brought together.

VINCENT VAN GOGH

For an artist, creativity is often in conflict with critical evaluation. Unfortunately, the two do not work well together. In fact, they dislike one another and are best called upon individually, one at a time.

When working in the field, I recommend that the creation of a photograph be considered creative time, and that the selection of the best photographs from a shoot be considered critical time. I also recommend that the two be done separately. That is, I recommend that you do not select your best photographs while you are photographing. Instead, photograph to your heart's content, making sure you consider both artistic and technical aspects, and later, either in the evening or when you are back in your studio, decide what worked and what did not work, as well as which images you want to convert and optimize and which ones you want to reject.

When working in the studio, converting and optimizing your photographs, I recommend you follow a similar "separation of the tasks", so to speak. Here too, when working on the photographs you previously selected, convert them to your heart's content and experiment with different conversion settings, different color balances, contrast, saturation, or preset

Figure 18-1: *Death Valley Panamint Daisies*

effects. Similarly, when optimizing your photographs in Photoshop, use adjustment layers to try different options and effects. Afterward, when your creativity starts to wane, put on your critical hat and decide which version you like the most. At that time, look at the images not from a creative perspective, but from a critical perspective and ask yourself which ones are the most successful, from both a technical and from an artistic standpoint.

If you are constantly critical, you will never be creative. And if you are constantly creative, you will never be critical. The creative and critical aspects work hand in hand with the artistic and the technical aspects. In order to create work that is both artistically inspired and technically excellent, you have to be creative and critical in your work. However, you cannot be both at the same time.

By keeping the creative and the critical separate, you are preventing the two from clashing and competing with each other. It is difficult to be creative if you critique your photographs while you are creating them. Similarly, it is difficult to be critical if you create new images while critiquing them. Critique and creativity are both indispensable and inherent aspects of the artistic process. However, by keeping them separated you will save yourself from being subjected to the stress of having to deal with both at the same time. This stressful situation affects many artists who try to do both at once.

Vision and Composition

A work of art which did not begin in emotion is not art.

PAUL CEZANNE

The original inspiration and vision we have for an image, while capturing the photograph in the field, is our guide throughout the process of converting and optimizing the photograph. We need, in the composition and the optimization of the image, to find a way to return to the original vision that our eyes gave us, and somehow overcome the differences in seeing that the camera introduces.

Eventually, composition is an interpretation of the scene you want to photograph and of the subject that inspires you. This interpretation is by nature personal to the photographer—to you—and because of this, it will vary greatly from one photographer to the next. When creating fine art images (which is our sole focus of this book) we have the freedom of altering the "real" scene, of interpreting the original subject matter.

This interpretation is based on your personal vision and your personal vision is based on your source of inspiration—on what motivates you to photograph in the first place. In turn, your inspiration is motivated by your creativity. Finally, your level of creativity is dependent on your ability to step out of your comfort zone. Because of the complexity of this process, understanding how your inspiration, creativity, and vision interact and dovetail into each other is very important.

Of equal importance is the necessity to know what this personal vision is. Many ask themselves if they have a personal vision. My opinion is that the answer to this question is

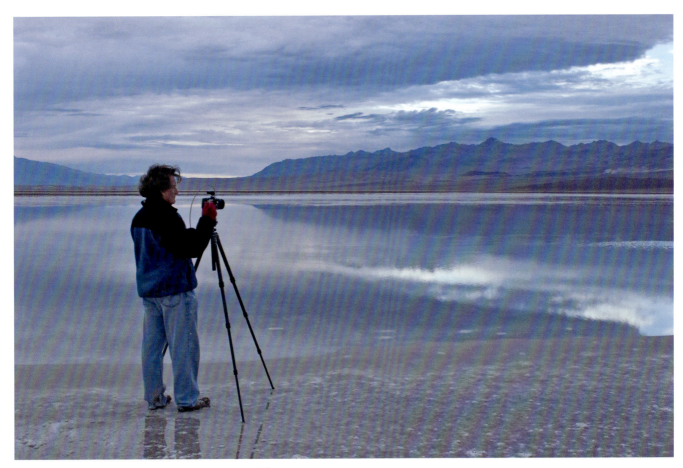

Figure 18-2: Alain photographing at sunrise in California
(Photograph by Bill Hankins)

yes. Yes, we all have a personal vision of the world. However, the most important question is what does this personal vision consist of? What is it about? How do you describe it? Finding the answer to this second question is what really matters. Often, the answer will come to you while you work at your art, while you create new photographs.

The process of describing your personal vision is neither simple nor facile. However, there are ways to make this process easier.

One way to make this process less daunting is to work under the guidance of a photographer who has successfully completed this process. This is the exact approach we follow in my workshops and seminars. In my workshops, students work on finding out what their personal vision is and on writing down a description of this vision. Students also work on developing a detailed list of upcoming work, with the goal of refining their personal vision and making it a reality.

Your Journey

It's on the strength of observation that one finds a way. So we must dig and delve unceasingly.

CLAUDE MONET

There can be many levels of interest in a photographic image, both technical and artistic. These levels of interest range from how the image was processed and optimized; to the selection of color palettes, light, contrast, and tone; to the creation of visual metaphors, intriguing contents, and more.

All these make the possibilities offered by composition, as we studied it in this book, virtually endless. Faced with this multitude of possibilities, finding what you like, what you want to do, and how you want to use these possibilities becomes a very important priority.

Your guiding light should be your original inspiration, as I described in the chapter devoted to inspiration (chapter 8). Doing the exercises provided at the end of each chapter will be extremely helpful. These exercises were designed to focus your efforts upon the most important aspects of each area of composition, creativity, and personal style, and completing them is a requirement if you want to get the maximum out of this book.

However, no matter how helpful all these materials might be, there may come a time when working alone is not enough. You may need help from someone else, or you may need to be part of a group working in a similar direction and on similar projects. At that time you may find that joining a photography club, or working with other photographers in your area, is the way to go. Or you may choose to attend a workshop held by a professional photographer.

Briot Workshops

Similarly, you may find that attending one of our own field workshops, or one of our seminars, is the next step in your photographic journey. Our workshops and seminars are designed around the concepts outlined in this book and in my first book, *Mastering Landscape Photography*. In other words, if you enjoyed reading this book, you will enjoy attending our workshops. I say "our" because the workshops are taught by myself and by my wife, Natalie. Natalie is trained as an art teacher and offers her own perspective and approach to our students.

Our workshops build upon the concepts outlined in this book. However, they go further than this book by providing you with personal feedback and comments upon your work and your photographs. Often, there comes a time when it is necessary to know exactly where we stand in regard to our work. There comes a time when it is necessary to ask someone who has the knowledge we want to acquire, how well we are doing and how we can reach the next step with our work. This is something that we offer in each of our workshops, and if this is what you need and are looking for, I recommend you contact us directly by phone or email. Our contact information is on my website at www.beautiful-landscape.com.

Prologue

Originally from Paris, France, I have lived in the United States since 1986. I live in Arizona and my favorite photographic locations include Navajoland, where I lived for seven years, as well as the rugged canyonland wilderness of Southern Utah and Northern Arizona.

I currently work with a Linhof large format 4 x 5, a medium format Hasselblad with a Phase One P45 digital Back, and a Canon Digital 35mm. The choice of which camera I use is based on my vision for each image.

My goal is to create the most exciting photographs possible. My equipment, be it cameras, software, printers, etc. is chosen for its ability to make this possible. My vision of the landscape is of a place of beauty, a place where we can experience a direct contact with nature, a place where we can find respite from the pressures and stresses of the 21st century, and a place where I can find inspiration and freedom of expression.

I started studying photography in 1980 in Paris. Prior to that, I studied painting and drawing at the Academie des Beaux Arts, also in Paris. In the United States I received my Bachelor and Master Degrees from Northern Arizona University, in Flagstaff, and then I worked on my PhD at Michigan Technological University, in Houghton, Michigan.

Today, I consider myself not just a practitioner and a professional, but also a student of photography. I write extensively about photography both from a technical and from an artistic perspective. My writings are inspired by my work, my teachings, my research, and my study of photography. My essays are available on my website, www.beautiful-landscape.com, on many other websites on the Internet, in print, and in my first book Mastering Landscape Photography.

I approach photography as a fine art. I do not approach photography as a form of scientific or forensic recording. Therefore, I feel totally free to interpret my subjects as I like and to modify colors, elements and other aspects of the image. My work is the result of what I capture in the field and what I do to the image in the studio afterwards. I expand on this concept in my essays.

I make my living selling fine art prints and teaching workshops and seminars. I also offer tutorials on CDs and DVDs. All these are available on my website at www.beautiful-landscape.com. My teaching covers every aspect of photography including fieldwork, studio work, matting, framing, marketing, etc.

I welcome your comments and questions. Feel free to email me at alain@beautiful-landscape.com. I look forward to hearing from you.

Alain Briot
Vistancia, Arizona
June 2009

A New Beginning

We have now come to the end of this journey, to the end of a book that took me a very long time to research and write.

Art is a journey, not a destination. Therefore, make sure you enjoy this journey every step of the way. Understandably, there will be rewarding times and challenging times. As you go down the path, there will be moments of joy and moments of restrained enthusiasm. There will be elation and there will be difficulties. These are all part of life and they have to be expected even though we would prefer that things be more level and constant.

As you embark in this journey, keep in mind that art, in the end, is a positive endeavor and that difficulties that arise with art can be solved with art. The solution, more often than not, is to go back and try again. It is amazing what not giving up can do. Success, in the end, is a matter of not giving up. Finally, keep in mind that difficulties with the technical aspects of photography can surface as well. Both aspects—technical and artistic—offer rewards and challenges.

Having reached the end of this book I wish you success in your artistic and your technical journies in the world of fine art photography. If I can help you make this journey more rewarding, more enriching—better—please don't hesitate to contact me.